D1283665

CRITICAL LABORATORY

CRITICAL LABORATORY

The Writings of Thomas Hirschhorn

THOMAS HIRSCHHORN

EDITED BY LISA LEE AND HAL FOSTER

AN OCTOBER BOOK

THE MIT PRESS
CAMBRIDGE, MASSACHUSETTS
LONDON, ENGLAND

MIT Press books may be purchased at special quantity discounts for business or sales promotional use. For information, please email special_sales@mitpress.mit.edu or write to Special Sales Department, The MIT Press, 55 Hayward Street, Cambridge, MA 02142.

This publication is made possible in part by the Fondation Jan Michalski pour l'Ecriture et la Littérature, Switzerland and the Gladstone Gallery, New York.

This book was set in Bembo by the MIT Press. Printed and bound in Canada.

All pictures courtesy Thomas Hirschhorn, unless otherwise mentioned.

Library of Congress Cataloging-in-Publication Data

Hirschhorn, Thomas.

[Works. Selections. English]

Critical laboratory : the writings of Thomas Hirschhorn / Thomas Hirschhorn ; edited by Lisa Lee and Hal Foster.

 pages cm

"An OCTOBER Book."

Includes bibliographical references and index.

ISBN 978-0-262-01925-5 (hardcover : alk. paper) 1. Hirschhorn, Thomas—Themes, motives. I. Lee, Lisa, 1978– editor of compilation. II. Foster, Hal, editor of compilation. III. Hirschhorn, Thomas. Less is less, more is more. IV. Title.

N7153.H57A35 2013

709.2—dc23

 2012046927

10 9 8 7 6 5 4 3 2 1

Contents

Contents

Contents

ACKNOWLEDGMENTS

I am really happy that this book could be done. Many people have contributed
to it, and I am grateful to all of them. I especially want to thank the following
people. First of all, I would like to thank Hal Foster for his invitation to do the
book and to include it in the OCTOBER Books series. His fingerprints are to
be found everywhere in this project. I would like to thank Lisa Lee for her
extensive work of reading, structuring, and editing, and for her hard-core con-
tribution at all stages in the process. I would like to thank Mara Goldberg,
Emmanuelle Giora, and Romain Lopez, who helped to collect texts, images,
and information, who caught many errors, and who contributed mightily to the
book. I would like to thank the various people who allowed me to write them
in letters, to address them in statements, and to talk with them in interviews;
their open eyes, their open ears, their open spirits, and their open hearts permit-
ted me to write, knowing there would be an addressee. I would like to thank
Michel Blancsubé and the Fundación Jumex, Mexico, for allowing a picture of
the work *Critical Laboratory*, which belongs to their collection, to be used for
the cover. I would like to thank Roger Conover, chief editor at the MIT Press,
who guided the book during its conception and its fabrication; I would also like
to thank Justin Kehoe of the MIT Press and Adam Lehner of *OCTOBER*
magazine for their assistance. I would like to thank all the translators, who made

the manuscript coherent despite my writing in different languages. I would like to thank my gallerist Barbara Gladstone of Gladstone Gallery, New York, and Vera Michalski-Hoffmann and the Fondation Jan Michalski pour l'Ecriture et la Littérature, Switzerland, for their generous support of this book. Finally, for their constant support of my work, I would like to thank Anna Kowalska, my friends, and my family, especially my mother, Margrit Hirschhorn-Castelberg, as well as the numerous people who became interested in my work, who believed in it and took it seriously, and who have always remained loyal to me.

Thomas Hirschhorn
Aubervilliers, May 2012

This laboratory is utopian and realistic at the same time.

—Thomas Hirschhorn

The paraphernalia of a makeshift laboratory fill a room awash in dim red light. Clandestine analytical work is underway, involving the intense scrutiny of texts and images. Like specimens or pieces of evidence, books, magazines, documents, and photographs are pressed under glass, reflected in mirrors, or subjected to the one-eyed gaze of desk lamps. Throughout the room, thick strands of red plastic extend downward from the ceiling. When terminating on the surface of a book or photograph, these plastic cords act as physical manifestations of theoretical and conceptual connections; when coursing into the open mouths of bottles and canisters, they evoke some elemental force (perhaps that of thought itself) to be collected and conserved. Thematics of authenticity and simulacra, encoding and decoding, deconstruction and analytical reconstruction play out across the room's many elements, which together constitute the artwork *Critical Laboratory* (1999).[1] Its creator, Thomas Hirschhorn, describes this compact yet expansive work as a "space aside" in which research is undertaken. The subject of that research? Criticality itself.

In this collection of Hirschhorn's statements, letters, project proposals, and interviews—the first to date—the realm of the word constitutes for this artist a critical "space aside," apart from the work but intimately bound up with it. Writing is a crucial tool at various stages in the life and afterlife of Hirschhorn's works. As the initial articulation of the governing ideas and constituent forms for a given project, a proposal or statement commits to paper the will that drives a work that has yet to come into being. To borrow Hirschhorn's own metaphor, it is the stone thrown ahead, whose trajectory is to be followed in the realization of the work.[2] In the case of the "Presence and Production" projects in public space, Hirschhorn's writings, in the form of private correspondence or open letters, are the means by which he appeals to potential collaborators and host communities.[3] This same correspondence, along with the other documents and photographs generated over the course of the temporary projects, contributes to the apparatus of memory through which the works endure after disassembly. The writings thus bear conceptual import, just as they serve logistical functions. Indeed, the logistical (as regards issues of placement, materials, installation, security, etc.) overlaps with the conceptual; and neither, for Hirschhorn, is ever far from the political.

The written page is a site in which Hirschhorn exercises his criticality and self-criticality. Writing enables him to gain distance from his work: he judges his own motives, assesses his works' successes or failures, and derives lessons for future action. He may also turn a critical lens upon the institutions of art and the conventions governing the global art market. In this way, Hirschhorn pushes back against the forces with which he is necessarily involved and in relation to which he must negotiate his place. Most expansively, his writing attests to Hirschhorn's persistent desire to conceive his work and his artistic stance in response to—and specifically as a form of resistance against—contemporary social, political, and economic contexts.

Although Hirschhorn insists that writing is "an exercise outside [his] work," his texts nevertheless exert tremendous influence on the reception of the work. Hirschhorn's determination to "invent [his] own terms,"[4] an intent to wrest interpretive power from critics and art historians, has been successful

to the extent that his terms and formulations demand to be reckoned with, even by skeptics. The interest generated by Hirschhorn's writings is due less to some general aura surrounding the authorial voice, than to the specific nature and force of his articulations. Hirschhorn is notably unafraid to make a grand claim, to adopt an unfashionable term or stance, or to put forward a provocative, perhaps even preposterous, proposition. In an age of cautious relativism and of the codification of an academic language of art, Hirschhorn's bluntness and refusal of distancing mechanisms have the capacity to jar the reader from merely polite engagement. His tendency to express himself in short, grammatically unembellished constructions, his coining of pithy sayings, his use of anaphora, and his penchant for reiteration produce urgent and emphatic rhythms.

Critical Laboratory: The Writings of Thomas Hirschhorn brings together a large and representative selection of Hirschhorn's scattered texts, returning many to circulation and presenting many in English for the first time.[5] Hirschhorn has long distributed his texts in the form of pamphlets or press releases accompanying his exhibitions. Individual texts have been published in catalogs and journals, where they have been more permanently archived, perhaps, but nevertheless dispersed. The writings gathered in this collection span two decades, from 1992, around the time of Hirschhorn's earliest exhibitions, to 2012. The full range of his output is discussed: single-channel videos, works on paper, large- and small-scale public projects, and museum and gallery exhibitions. In tone, the texts vary from the introspective to the plainly descriptive, from the solicitous to the assertive, and from the polemical to the strident. The textures of the writings differ depending on the language and date of composition, the type and purpose of the document, the private or public mode of address.[6] As editors, we have aimed to unify the texts without rendering them uniform.

The first section, "Statements and Letters," is devoted to those writings that address broad themes and problematics. Included are programmatic statements about typologies and works in specific media as well as declarations of

aesthetic philosophy, political positions, and art historical commitments. The second section, "Projects," gathers occasional texts relating to specific artworks or exhibitions, chronologically arranged. In some cases a single project is represented by more than one document, each of which brings to light a different dimension of the artwork's relationship with institutions and publics.[7] The third section, "Interviews," introduces other strong voices that challenge the artist to elaborate upon his positions. The interviews have been selected because they home in on particular concepts, develop themes in greater depth (such as Hirschhorn's attitude toward the museum and his engagement with art historical precedents of the avant-garde), or tackle controversies that have surrounded his work.

The reader of *Critical Laboratory* is in a position to trace the development of Hirschhorn's ideas and artistic strategies—their coming into being, their transformation and refinement, their falling away. For example, in "Regarding the End of the *Deleuze Monument*," Hirschhorn reflects upon the premature disassembly of the *Monument* due to fallout from inadequate measures for protecting the work. Having decided that his weekly visits to the site of the *Deleuze Monument* were too infrequent, Hirschhorn concludes that in the future he would have to be present for the duration of such projects. The germ of the "Presence and Production" guideline, which has generated some of the artist's best-known projects in public space, can thus be located. Shifts in concerns can be noted as well. One observes in the early projects, for instance, Hirschhorn's preoccupation with accentuating the horizontal and vertical through lateral spreads and perpendicular stacking or leaning—a formal concern that recedes, or is perhaps subsumed, in the later works.

Ultimately, the continuities are most remarkable. From the earliest writings forward can be traced Hirschhorn's commitment to quotidian materials, to deskilling, to the centrality of political and economic thinking within (and as means of generating) form. Certain distinctive artistic strategies surface repeatedly. Hirschhorn often creates new forms through what might be termed the "materialization of metaphor." A "stain on the conscience" is rendered as an amorphous, physical mass; the assertion "art is a tool" is literalized in a room

full of construction implements; and psycho-emotional "hardening" is manifested by bulbous accretions of paper and packing tape.[8] What I propose to call the "spatialization of abstractions" constitutes a related strategy, in which democracy, utopia, and the depletion of history are conveyed in the space and structure of a hotel, a lounge, and a chalet, respectively. Particular themes recur in the documents gathered here and in the works described: the ideals and the institutions of democracy,[9] philosophy's ongoing relevance to art and life,[10] the ravages of human violence and injustice,[11] the proliferation of urban non-places,[12] and vernacular modes of making,[13] just to name some prominent examples. To draw out these themes is to map the constellation of concerns that animates Hirschhorn's practice as a whole, aesthetically and ethically.

Principal among these concerns is the place of art in the public sphere, which can be traced not only through the writings collected here, but also in *33 Ausstellungen im öffentlichen Raum 1998–1989*, a catalog of Hirschhorn's earliest works in public space.[14] We reproduce in full this extremely rare, out-of-print publication. Its material lexicon of raw-edged corrugated cardboard, casual photographs, transparent tape, and ballpoint pen will be familiar to those who know Hirschhorn's collage work; so will the visual lexicon of Hirschhorn's ungainly script, his errant and aggressive scribbles.[15] In the works pictured, Hirschhorn claims any passerby as his audience and any locale as his gallery, from the stairwell of an *habitation à loyer modéré* to a nondescript urban sidewalk. Yet, the publicness of his work cannot be limited to its presence in any particular instance of public space. Hirschhorn's desire to address a "nonexclusive audience" determines the materials, means, and forms through which his work takes shape. His head-on engagement with fraught political and economic matters of imperialism, warfare, globalization, urbanization, economic marginalization, and deterritorialization asserts the place of art in a public sphere that is understood as a site of critique, argumentation, and dissent.

So too one might understand Hirschhorn's prolific writing and his readiness to be interviewed as manifestations of that same impulse to effect "moments of publicness." In his writings Hirschhorn stakes his political and artistic positions, explains his motives, and lays bare the mechanisms of his

thought even when they are contradictory or insufficient. He writes in ways that explicitly invite judgment, ask to be held accountable, and call to be challenged. Writing might constitute for Hirschhorn a "space aside," but unlike the artwork after which this collection is named, writing is not conceived as a clandestine site. The reader is invited to enter the space of this "critical laboratory," at once utopian and realistic.

Lisa Lee

1.1 *Less Is Less, More Is More*, 1995. First Johannesburg Biennale, Johannesburg, South Africa, 1995.

LESS IS LESS, MORE IS MORE

What I want to do here is get down on paper why I almost always show many, very many, in fact, too many, works in my exhibitions. This is a criticism that is often leveled at me, but I don't have any difficulty living with it; I'm not trying to explain anything or defend myself. What I'm trying to do is write down—positively, assertively—what I had in mind, for example, in the case of *Less Is Less, More Is More* (1995). There's the old Bauhaus idea of leaving things out, of simplifying, eliminating. This leads to products, and to artworks, that may be elegant and chic, even pretty, but they aren't beautiful. Beautiful form is a fraud, and in art—and above all, in art's presentation in galleries, exhibition venues, and museums—this is pushed to the limit.

White walls, gray floors, large spaces, that's all fine, but then comes the problem: people put very little in these spaces, ideally as little as possible, presenting what's most important, most valuable. What I have difficulty with here is that this approach is totally systematic. You see it done over and over again, even today—in fact, especially today.

This insistence on value, this exclusiveness, this luxury is what scandalizes me. And the result is often exactly what people want: art exhibitions that

look just like art exhibitions, but only because of their form. Less is more: it's a designer's precept. I know a gallery isn't a worker's home, and a museum isn't a canteen; a gallery isn't a place where people really work. But galleries, museums, exhibition spaces are often more like upper-middle-class homes or white-collar residences than any of the above. It's all about "less is more" as an appropriate language of form, borrowed initially from art and then applied to other fields, such as design. Who buys art? What are they buying? I think more is always more. And less is always less. More money is more money. Less success is less success. More unemployed are more unemployed. Fewer factories are fewer factories. I think entirely in terms of economics. That's why I'm interested in this concept: more is more, as an arithmetical fact, and as a political fact. More is a majority. Power is power. Violence is violence. I want to express that idea in my work as well. I don't accept the dictatorship of the isolated, the exclusive, the fine, the superior, the elite.

And that's why when I show many, far too many, works, I'm making a political statement. That's why it's never right to call it "swamping," "flooding," etc. Ideas like that don't interest me, because they're passive: you (the artist) can't stop the tide of the work yourself; you're flooded, you have no choice, etc. No; what it's about is showing this excess actively, assertively; it's not about all-over composition, it's about economy, power, and a political position. I don't want to swamp anyone, flood them, overwhelm them; I want the show to be about individual works—not as a formal *diktat*, but to make the individual important in a conscious effort, using quantity to help the individual assert its own importance, but in relation to the others, not without them. That's how I see it, and though I admit that I've done it myself—shown a single work in a single space at an exhibition—I didn't see that as a distinction or added value. In this case, the individual work was a representative, a witness, no more and no less; a representative or witness that's very present, and reports on behalf of the others. That's important to me. Even though I know it's an approach that's very difficult to keep up, from the point of view of the whole of art history, it's still what I want to do. In my exhibitions I always try to find ways of making that possible for viewers. I work through presentation and

form—for example, on fabrics, on tables, as a cascade—by trying to work with limitations, to stress change; but I still let the presentation form remain what it is: the form, the mold, the vessel in which the work is contained. And for that reason alone, because there is a vessel there, my vessel, it can't overflow unless I want it to.

I like the Barnes collection, but not for the individual masterpieces that make it up. No; it's more the way the pictures are presented and put together: they're arranged by size, not by period or subject or artist. What this apparently silly, simple, strange decision—to arrange the pictures by size, all hung to the middle line—does is create an overall impression that's overwhelming, simply because there are so many pictures. It lets viewers completely isolate one picture from all the others—they pretty well have to if they want to focus on it. They have to forget the others around it for a moment, but then the overall impression returns again, like focusing your eye on a detail and then shifting back to the whole. In my recent exhibitions it wouldn't have been possible to take a single work away without being aware that something was missing. It would have left a hole, although the hole wouldn't have actually told you what was missing; it would just have given a few clues as to its size and its external form.

1995
[Translated from German by Michael Robinson]

1.2 *Fifty-Fifty*. Belleville, Paris, 1993.

FIFTY-FIFTY

What I call *Fifty-Fifty* are all the works in which only half of the surface (paper, cardboard, wood) is covered. It seemed sufficient to me to occupy only 50 percent of the supports and to leave the other half empty, at the disposal of the person looking to fill himself. Not literally. But with his eyes, he can complete the work himself. It's not finished, it's half-made. I like the term "fifty-fifty" because it speaks of sharing. Of course we know very well that economically and politically "fifty-fifty" does not exist. In a democracy we can only enact a decision with 51 percent; in a corporation it's the same principle. It's only in shady matters that you settle on "fifty-fifty." Someone's going to be taken for a ride. And yet, in this idea of equitable sharing, there resides a utopian, idealist idea. It's also the search for a balance, even if derisory—the balance of energies and forces that have to lead to equality.

I'm equal to the other. I'm in some shit, you are too. I'm weak, you are too. I'm lost, you are too.

January 1993
[Translated from French by Molly Stevens]

1.3 *Moins.* Pigalle, Paris, 1993.

MOINS

What I call *Moins* [Less] are works in which less than half the surface of the support is covered with tape and various printed matter (photos, advertising images, packaging, etc.). The proportion of the surface covered can vary, from almost half to almost nothing. Less and less. These are the *Moins* works. At the same time, the term "less" implies a relationship to something else; we say "less than," "at least," "unless," etc. It depends on my will to make less.

The supports are always remnants: remnants of cardboard boxes, remnants of furniture, construction materials, etc. I use them because of their availability and because of the fact that the materials and the formats are a given. These supports become autonomous from the moment I put something on top. They exist, not as remnants, but as works. *Fifty-Fifty* and *Moins* are classification names. I use them to differentiate my works as one would distinguish between "screw" and "nail." Besides, they are tools.

1993
[Translated from French by Molly Stevens]

1.4 *Les plaintifs, les bêtes, les politiques*, 1995. Excerpt of the book published by Centre Genevois de Gravure Contemporaine, Geneva, Switzerland, 1995. Courtesy Thomas Hirschhorn and Centre Genevois de Gravure Contemporaine, Geneva, Switzerland, 1995.

LES PLAINTIFS, LES BÊTES, LES POLITIQUES

This is the generic name for all the work I've been doing for a year on pieces of cardboard. These works—as opposed to *Fifty-Fifty* or *Moins*, which can be made on cardboard but also on other materials—are directly inspired by signs I see in the street, in the metro, cardboard signs made by people in need, needy people who have turned to these economic, efficient, beautiful means.

I like these signs because their makers don't care about aesthetics or design. The only thing that matters to them is communicating their message in order to get what they're asking for. They're beautiful because the terms of engagement overlap with the terms of sincerity. The result is pure.

Les plaintifs, les bêtes, les politiques are also born from an existential need on my part. I need to understand or, even more, to want to understand. I need simplicity; even simplistic views seem much more important to me and more accurate than what's said in general. I also need to work politically, concretely like an activist, but an activist without a cause and without an organization. Without structure, contradictory, low, bad, formalist, foolish, bizarre, not correct, without intelligence, without thought, without coherence, without a goal. Just a need to express my disorientation, my noncomprehension, my distress in the face of events, in the face of the world, in the face of the human condition. These works are images.

These works are not cataloged, that is, *un plaintif* can be *un politique*, or *un bête* can be *un plaintif*. It makes no difference knowing what's what; nevertheless, the works are made according to one of these criteria. These names are just there to define what we're talking about.

Les plaintifs, les bêtes, les politiques are works I made with the intention of printing them at their actual size and in their actual color. I want them to exist as documents. Facsimiled and once printed, they disappear as originals. The publication of these works is a means of distribution that complements my exhibitions, my actions, my videos, my catalogs.

November 1993
[Translated from French by Molly Stevens]

1.5 *Lay-Out*, 1993. Galerie Susanna Kulli, St. Gallen, Switzerland, 1993.

LAY-OUT

I know the concept "layout" from graphics. It is the overall design draft that precedes the model with the right images and the definitive text that then leads to the final maquette and ultimately to the printed result. It is an assembled inventory upon which a prescribed formatted image and masses of text are shifted around. A "layout" is nothing lasting, nothing that counts. One works with the wrong things in order to simulate. At the same time, one arranges and commits oneself; so, too, with my *Lay-Out*. I want to commit myself, I want to arrange, I want to make a *chef d'oeuvre*. At the same time, I know that it isn't possible, it isn't necessary. What is important is the desire to do it. That needs to be visible in my work. And in addition, I want to make a work that is impure, something that makes no claim; but having no claim does not mean having no ambition. I want to make an unclean work that doesn't protect itself, doesn't highlight anything, doesn't exclude, doesn't select, doesn't choose, doesn't glorify or sublimate anything.

A *Lay-Out* offers the possibility to try to do that. The recruit dismantles his rifle and must lay out the individual components on the tarpaulin for inspection according to a prescribed scheme. Someone who repairs his bicycle and needs to take it apart places the screws, nuts, and individual parts on a background so that he can screw them back together again. Street vendors present their wares according to how they will be most likely to sell. That's it: a *Lay-Out* could just as easily be composed differently; there are no compelling reasons to lay out individual works on textiles, cardboard, or paper one way or the other. There is, however, my reason. And for this reason, the *Lay-Out* follows strictly definitive assembled layouts, which in themselves fundamentally bear the assertion of their own existence.

1993
[Translated from German by Kenneth Kronenberg]

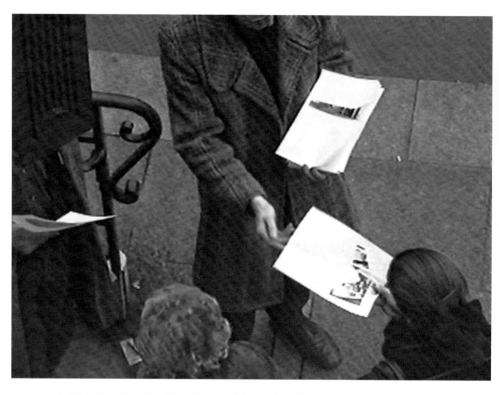

1.6 *Fifty-Fifty à Belleville*, 1992 (11 min., with sound). Still from video.

MY VIDEOS

I've made three videos up until this point: *Périphérique, Fifty-Fifty à Belleville, Les Monstres*. I wanted the same thing from all three videos: to put my work in movement or in a movement. I wanted my work to exist in space, even if for a very brief instant. In fact, they are collages. I stick my works against a background, in space, in time. That's what I want: to make collages. To again mix my work with other things.

In the video *Périphérique*, I wanted the work attached to the car's rear-view mirror to mix in with the forms and the signs, the colors of the city.[1] The work filmed doesn't move, but the background against which it is pasted moves. In the video *Fifty-Fifty à Belleville*, I wanted those sheets with the collages from the *Fifty-Fifty* series to move within the camera's field of vision, both through my will—I am handing the sheets to people—and through the will of the people who take the sheets. These two movements are what seemed important to me. The work moves. The work is in movement. The video *Les Monstres* shows how the garbage collectors take my work, hold it out, move in space with it, throw it out. Furthermore, the side of the work filled with the collage intervention is no longer always seen. So the collage can even be on the other side. In all three videos, I wanted to film in real time, so that the duration of the video doesn't depend on an arbitrary choice, but on a fact linked to what is happening: circling around the Périphérique; handing out leaflets until there are none left; filming workers from the beginning to the end of their stop. There are no cuts, no edits.

If I were to qualify these videos, I would want to talk about video-collages, because I'm filming a work or works of mine in a scene of my own making. It's not a documentary, even if you could say that I documented a situation, in a place, at a given moment. But it is not these unique situations, times, places that interest me. I see these video-collages as separate works that must exist as such. If it doesn't work, it's because of an error on my part regarding the fabrication (lack of distance). I obviously have to think a lot about how I can make these video-collages without falling into more loaded aesthetic formalism.

———

13

Of course the term is also difficult, but at least it isn't an unjust classification. It also must be added that I make my videos because there are no other means of getting the same result; neither photography nor a description can make this work. I wanted to make collages that I could only make in video. Of course not all of it really works. And so I'm not happy. I am not satisfied because it lacks frenzy—it's missing the fact that, in making these videos, I wanted to save my work, save the necessary. And I think these essential things don't happen, if you don't know my work in other respects. What is essential, what is necessary, is seeing my work move. The desire to give a real dynamic, not a formal one; you don't really see any of this. These videos need more energy.

December 15, 1993
[Translated from French by Molly Stevens]

THE NEW VIDEOS

Here, at the Künstlerhaus Bethanien,[2] during my absence, my videos were shown as part of an event called *von kurzer Dauer*, which means "of short duration." In fact, it seems that my videos were much too long in duration. People were said to have left rather quickly after watching a few seconds. But that's not so new for me. My videos are boring, repetitive, too long. But what can I do? I want to make something simple, so simple that it becomes boring. So, do I lack talent, or am I a bad technician? Or what?

I think that simplicity is boring. Or rather it's perceived as boring because it doesn't bore me. But then again, I'm never bored, maybe because I don't expect anything, or nothing much; it's when I'm made to believe in a great thing that I start really feeling bored stiff. Because I don't believe in it—in the sublime, in the marvelous, in the great, in the extraordinary. That's why I make boring videos, which I, of course, don't want to make boring.

To me, there are so many things happening in these videos that I actually think there's too much happening. Because video is so complex, I'm under the impression that I'm not controlling anything, and I like that; that's why, before shooting, I very clearly decide: no cuts, original sound, duration determined by something external, extremely limited camera movement, no zooming, etc. And even after all that, it doesn't work. I know it beforehand; but you can't do better. For, it's less good after, or else I decide not to show the video.

My videos are always imperfect, but it's not that I want to make them imperfect. It's what I said: I can't do more without betraying myself, so they stay that way. What matters to me in these videos is the confrontation or the juxtaposition of my work with other things and with the sound and the movement and the duration; my videos are an affirmation of the mix of my work with other things; it's a work unto itself. And I can only realize it in this way with this medium. I also want to say: I don't protect myself with my videos; in my videos, I show myself in as much shit as elsewhere.

In any case, you can't make better videos than music videos, but they have another problem: the video is good, the music is not good. I prefer not to

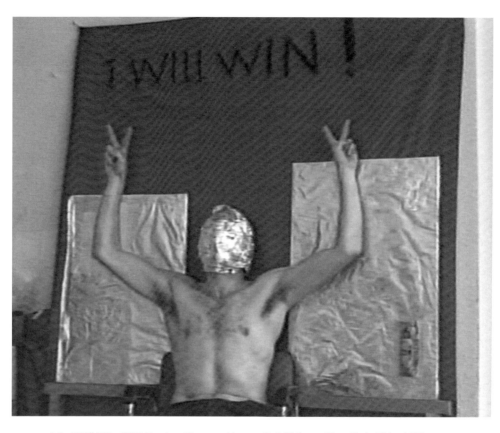

1.7 *I Will Win*, 1995 (4 min., 30 sec., with sound). Still from video. *Early Video 1995–1997*. Courtesy Thomas Hirschhorn and Artview/bdv, Paris, France.

pretend. I understood that sound plays a very important role in video, not in film. So I want to do the same: the last video I made is called *Nice to Meet You.* It's thirteen minutes. You hear an extract from the Rolling Stones' album *Sympathy for the Devil* twice: "Pleased to meet you, hope you guess my name." And you see a part of a jukebox, on which I put one of my recent works and next to it a pretty young woman leaning her head slightly into the image. Aside from the woman's slight head movements, nothing happens; my work remains stable, the music repeats once, it's coming out of the jukebox. I want to make a love collage with these three things. The music that I love, the woman that I love, my work that I love. Obviously you're not supposed to take this as something autobiographical, because in reality it's only an attempt. Yes, an attempt. Because you have to try.

August 31, 1994
[Translated from French by Molly Stevens]

THE MUSÉE DE L'ART BRUT IN LAUSANNE

I've always heard great things about the Musée de l'art brut in Lausanne. Until I went there myself and had a look. This museum is a catastrophe! It is a terrible attack against art. Against *art brut*. It simply has to be said, loving Wölfli and wearing Chanel simply doesn't cut it. I also want to make it clear: this museum is a preindustrial, precapitalist, pre-bourgeois attempt to separate art from art brut. This vulgar "chalet-style exhibition" with haystack charm, where one is permitted to poke around, simply cements a way of static thinking. It seeks to exclude; it wants to sell art brut as something popular. All one has to do is look at the museum shop: a scandal! Here art brut artists are displayed like animals in a zoo, complete with explanatory plaques. Art has no explanation, art needs no defense, art does not require "being put in context." Because of this, not only is art brut messed up and abused; but also, in this museum, art itself is maliciously and deviously fought against. Art is the free interaction with what is one's own. This has always been the strategy of the standardizers, of those who act as proxies, of option writers—in short, the strategy of the bourgeoisie and of capitalists, who believe that they can limit freedom by denying funding, so that interaction with what is one's own becomes unfree and, as a result, no longer has anything to do with art. Many art brut artists have understood that and have created magnificent works even though the price—isolation and a lack of recognition—was very high. That these artistic stances are now herded together into a museum and displayed more poorly than in the shabbiest museum of erotica is proof that the old recipe of exclusion and of suppression is still in use. And it works.

Recently, I attended an opening where an artist told me that her gallerist had strongly advised her to stay away from art brut for career reasons. It seems to me that what makes art brut so chic is that people believe it can be adopted like some stray dog. Except that you can't look for a stray dog, but have to take him when he comes. In art brut, however, the same selection criteria are used as everywhere else, such as size, coloration, density, technique, etc. And because the art brut artist is unfree, one can do with him what one wishes,

comment, attend to the work, and then construct hierarchies of quality. This type of adoption has nothing to do with the love of art, but much to do with egoism. Instead of buying a Cartier watch, one engages with art brut, which basically comes to the same thing. One distinguishes oneself! That is art brut snobbism! What I want is finally to see our museums and exhibition spaces display art that has energy. Art with energy in it! Art that has nothing to do with conservative criteria of quality, art made by artists that is without quality. Art that remains without quality because with quality, all that is created are new ghettos. I also want that, in art, everything is compared with everything else. That in art, a power-hungry phrase like "these things can't be compared with each other" no longer makes sense and no longer intimidates!

1993
[Translated from German by Kenneth Kronenberg]

LETTER TO CORALY (ON JOSEPH BEUYS AND "CAPITAL")

Dear Coraly,[3]

The other evening you asked me to help you discover Joseph Beuys. I don't believe that it is possible, because an artist is discovered through his work. At Beaubourg there are actually one or two of his works that are worth seeing, especially the *Fond IV* piece.[4] But what I will do is try to tell you why I love him. To be precise, if I say I love him, it's not only because of his work or because of his life or because of what he wanted to achieve. I love him personally because this artist enabled me to approach art without having a complex, without artistic elitism. His art personally concerns me, it tells me something, it means something to me, it helps me. His work helps me, me personally, to live and to work. If I am trying to write all this to you here, I am nevertheless aware of the quasi-impossibility of what I'm attempting; it's very subjective and perhaps even naïve. Indeed, what I feel and what I have received from Joseph Beuys may be too partial, compartmentalized, or, who knows, even reductive, but the fact remains that I'm the one who thinks this way, and therefore this letter is also a way of helping me realize how I feel about Joseph Beuys. Generally speaking, the letters I write to others are also letters to myself. It's certainly selfish, but that's how it is. At least that way I don't have to think about an answer or a negative reaction. It's perhaps like some kind of a self-analysis of a peasant or some existential resourcefulness. What do I know? Joseph Beuys made a work called *Das Kapital* or just *Kapital*; anyway, this work, now in Schaffhausen in Switzerland, is a capital work to me. Not only the work itself, but everything it says concerning the term "Capital." And it is absolutely clear to me that this understanding—certainly very particular—of the Beuys term "Capital" has helped me to develop my own work and to hold out. First of all, Beuys explains that in using the term "Capital" he is referring neither to the capital of capitalism nor to the capital in the Marxist understanding as described in *Das Kapital*. Beuys had always proclaimed the failure of the two proposed reductive systems. Beuys said that Art is the real concrete capital. It is very important to understand today that he was

not thinking of the canvases, eventual sculptures, or other things that one can sell. No, the creative process which leads to making art—that is Art, that's the Capital. Obviously, capital has nothing to do with money. Capital is not money. In my opinion, this is something so essential to understand, once and for all, that when you really have understood it, everything changes. Everything changes. Coraly, that's what I've understood. And nobody else ever told me, and if an artist is capable of telling you or showing this to you so evidently in his work, then that artist really counts. Because the strength of Beuys's work is in the way it changes everything about practice, making everything different in everyday life; and for me, art that does this is really great art. It is not art for art's sake, which has once again become fashionable during this end of the century, or art made to improve or to endure everyday life. It is art that changes the human being. How can one understand Beuys's assertion that each person is an artist? Precisely because the term "Capital" is the energy, the creativity, that belongs to every human being. And not the talent. Not the know-how. Not the money. Not the education. Not the social background. And because this energy, this creativity, these capacities exist in each one of us, perhaps not in the same way, obviously not, more or less, rather this than that, rather later than earlier, rather less than more? Because these energies are the capital of each person, it is necessary to realize that it's the real capital, and once one realizes it, the act is such a creative and artistic act that the person is indeed an artist. This person can be working as a cashier, a scientist, a driver, a graphic designer, or a musician, but this person is an artist. Concretely, this means understanding oneself as an artist with one's own capacities and being aware of them, aware of one's capital, and aware that this capital is not the money that one may or may not have. The awareness of one's own capital is very important because it changes relationships. It means that nobody has more power over others because of a capitalist capital or an institutional or moral capital. The only capital that counts is one's own capital and one's awareness of it. This obviously puts people on equal ground. That's how I understand the sentence: Every person is an artist. Concretely speaking, I am working to be aware of my capital. You know, very basically, if I think of all the works I

have done, *Fifty-Fifty* and other works stored here and there, I think that I am not without capital, even if I am in financial debt. I have put my energy into my work, I have been creative, I have created, and now this is my capital. It is very important not to think it's capital that can be sold and become money, no. I've done my work, it stands there, it's my wealth. Others have other things. Thinking is wealth. Making bread is wealth. Etc. I like to look at the barmen behind the counters in large cafés, to watch them always doing something, always moving, always busy with a task. They are artists. I hate people that can't do anything because they don't have money. It's either an excuse to do nothing or, worse still, accepting that money is the real capital. That's being capitalist. But there are so many ways to show, through cinema, painting, and even business, how the role given to money shouldn't be taken seriously. I've always been fascinated by people who have made a fortune out of nothing. It's something I like about America, and I think these people are artists. Besides, Andy Warhol said something similar, that the artist of the future is the businessman. This too should not be taken as cynicism. Andy, I love him in any case, and others too. Joseph Beuys enabled me to live without becoming cynical, he enabled me to live without complexes, and he enabled me to exist in spite of the doubt—which is good to have about one's work—but without letting this doubt destroy my energy to create. Well, this may now seem to be over-praising, but, you know, I need to do it, because Beuys is sometimes attacked and relativized by my artist comrades or by other people. I am absolutely sure of my love for him, it will last forever, I know it.

1994
[Translated from French by Emmelene Landon]

Am I Casting Pearls Before Swine? And Why?

I will try, as I have done several times before, to set down a few self-critical and analytical thoughts about my exhibition at Filiale Basel, which opened three days ago. I'm doing this consciously, shortly after the exhibition opening, *à chaud*, so to speak, when there haven't yet been any significant echoes or reactions. My attempt here is neither final nor definitive.

This is not the first time that something happened in regard to the exhibition that raised a question that is posed to me in all its hardness: What is the purpose—for my work, for me at this point—of doing an exhibition in a site like the Filiale? First, I will explore this issue before going into my work specifically. Right now, I think that this exhibition is not in the right place. My work belongs elsewhere. My work belongs in a housing project, in a cafe, in the bathroom, in a pharmacy, in a condemned building, or perhaps in a kunsthalle, a museum, or in a gallery—in the best of them. This has nothing to do with schizophrenia, nothing at all. It's about exposing my work to the greatest possible confrontation. And that occurs either in a museum or in the local bar. But not in a small art institution or alternative art space. To exist, my work, and I am sure of this, doesn't need advantageous spaces, white walls, or other intimidating settings. If that were the case, I might as well quit right now. Nor does my work need another dirty, niggardly, poorly lit space. My work doesn't need any specific guarantees in advance.

So, why then my discontent, why the feeling of uselessness, this feeling of disappointment that I had at the opening in Basel? I believe it has to do with a big problem that I am working through, the problem of how I value my own work. It is important to say at this point that it's an artistic problem, not a personal one, to whatever extent that can be said. If I think that Robert Walser's work is great, it's not without reason. I also know that this problem is particularly important for the development and originality of my work. Furthermore, I hate the brilliance and the attitude of not showing a speck of doubt on the part of many stupid artists, which never really comes from their own work but comes from their reactionary worldview.

1.8 *Rosa Tombola*, 1994. Filiale Basel, Basel, Switzerland, 1994.

But how can I be efficient in my work? I need great discipline, yes, discipline, in order not to give in to this tendency of mine to be bad, to do things badly, to belittle myself, to relativize my own work. That's what it's all about. It's not about changing my work, which emerged from that and therefore maintains itself and justifies itself. It's not about changing oneself personally or changing one's behavior. It's about maintaining distance from one's own work and always creating anew. And this distance was not there, or at least not sufficiently there in Basel.

I can now say that the issue was a timing issue. What is clear is that an exhibition at Filiale should have been done two or three years ago, naturally with other works. But now my work has achieved an importance and a complexity, not to mention a difficulty. In short, my work challenges. I don't want to escape the problem by reducing it to a question of exhibition scheduling. I'm also convinced that my work at Filiale is good and is not made worse by what to I described above; but I did make a mistake, which is now becoming clear to me to its fullest extent. What is painful is that there was no error in the work or in its presentation. It was an error of over-generosity, of wanting to do too much, of wearing myself out, of self-abnegation. And I am certain I made no "artistic" error or a strategic error. I thought either incorrectly or too little about how my position in this exhibition context might be misunderstood as a result of a lack of distance between the work and the viewer. The problem is not spatial; it is not about lighting. It is that my work in this exhibition is prone to misunderstanding, as has sometimes occurred in the past. ("He shows the works as if he doesn't care about them.") I don't care whether people "understand" my work; however, I do care when my work is misunderstood, which is why I must try to diminish that risk by being more disciplined in considering exhibition proposals in the future.

I know why things turned out as they did: because I had to fight for everything myself. Perhaps a new phase will start now. I must approach this phase with a clear mind in spite of my tendency. This new phase is not without reason; it has to do with my work, its power, its legitimacy, and not with the increasing attention it is being paid. And I should not cast this power, this

legitimacy that my work has gained, before such illegitimate, powerless, unengaged, paralyzed persons, who are interested in their own careers above all. It is my professional duty not to do it. I'm not only fighting for myself; I am representing others in the battle. I must at least do that for them.

I write as if I had to convince myself—that's how it is. For me the temptation is always there, like a drug, sometimes overwhelming, even if I know that it is an ethical, political position. And this position has nothing to do with a lack of ambition, no, nothing to do with masochism: it is speechlessness and lack of reaction facing this INJUSTICE, this total, ever-present injustice. That's why I work. Rage and revolt against the human condition are what drive my work.

To summarize: My over-generous political work does not really come to fruition to its full extent in places like Filiale. One error was that, besides my new work *Rosa Tombola*, I also showed a single work and three videos, all OK in themselves, but simply too much—as if I were satisfied with such an exhibition site. If I showed anything at all, it should have been *Rosa Tombola* alone in all its hardness. The error is very clear to me, even if the Filiale is satisfied with it. At present, I must exhibit a single rigorous work.

Back to the actual exhibition: It holds together. What I tried to do—to group the works according to their logic without systematizing—is OK. The horizontal and vertical set up, the layout of the works, took on a dimension that I hadn't expected. The cloth for *Rosa Tombola* is absolutely necessary, even though it was quickly spread out and hung, and the question that arises about painting therein is good. I think that this work is honest. I wanted to show as much as possible, as simply as possible, and as unpretentiously as possible. It is a new arrangement and a work-placed-in-space that counts.

To be cruel not only toward my work, but toward the work of others as well.

1994
[Translated from German by Kenneth Kronenberg]

WHAT I WANT

I want to make a simple and economical work; I want to make a work with what I have, with what is around me, with what is there. I want to make something mobile—mobile in the head. I want to make an impure work, but not out of cowardice or out of provocation. An impure work out of will, will stemming from the conviction that I cannot conquer the lie out of purity, but rather out of impurity. I want to make a work without pretension, but without pretension doesn't mean without ambition. I also want to make something unclean, dirty, unprotected, for I think you must not protect yourself or your work. Instead, you have to damage yourself, shoot yourself first before aiming at others; you have to be cruel, but first off with yourself.

Nothing must be sublimated, nothing must be heightened, nothing selected; leave everything low so that there isn't a high. Through low, not creating high; through low, creating the other low. And so a kind of equivalence, not equality, but saying once and for all: low because low, not because not high. And also: less is less, less is not more. I don't want to make something glorifying, gratifying, comfortable; but always to be thinking: better is less good. I also want my work to fight, fight for its own existence, fight for its survival. Then I want to overdo the overload, to overexert myself, as if to tire out, become tired, tire the eyes, the viewer's eyes, so that the work isn't lying anymore. Run on an expenditure that isn't calculating, that's doing too much, that rejects a possible but false exchange. I also want to remain fractured, in other words, that the work should not skirt its contradictions. Yet, I want to make a necessary work, a work that is something and that doesn't signify something. Something essential.

Remain honest, lucid, awake, make a work with all one's
engagement;
to be determined, go all the way,
do what needs to be done;
think that: better is less good;

remain fractured,

fight,

make it so that everything has to fight to exist,

first off, your own work;

show a lot, make yourself tired,

run on overload,

overload lets you tire out,

tiredness allows for no more lies,

to not lie anymore, not forget, work,

work, not make something that means something,

make a necessary work.

1994

[Translated from French by Molly Stevens]

Letter to Thierry (On Formalism)

Dear Thierry,[5]

In this letter I'll try to explain why I'm a formalist. Six months ago, at the Joseph Beuys opening at the Centre Pompidou, we had a brief discussion about my exhibition at the Jeu de Paume. You said about my works *Les plaintifs, les bêtes, les politiques* that one shouldn't play at being a SDF [*sans domicile fixe*: a homeless person], because you felt there were too many cardboard signs in my exhibition. The remark greatly affected me and seemed to me unfair. It would never have occurred to me as a criticism. And it's because of this that I replied, very defensively, that I am in any case a formalist. Which of course surprised you and seemed an unconsidered reply. Which is true, it was. It was a kind of shot into the crowd, just to hurt someone, if not you, then me. But afterwards, with hindsight, having thought about it, I now think my defensive behavior wasn't really wrong. Of course, I'll have to try to clarify what I mean by "formalist." On the one hand, it's the will to refuse to say that a work is political, or a politically committed work, or political art, because I don't believe in works that are self-sufficient in terms of their very content and that reject formal experimentation. I also think it isn't effective to declare straight out that a work is political, since if ever there is something political in a work (and when I say "political," I don't mean that one should make political art, but that one has to make art politically), then one shouldn't have to say it anyway. If, then, I want my work—which I hope is done politically—to get to grips with things, to have an effect, I must assert, perhaps even out of provocation, that it is pure form. This is not a strategic answer, or just words, or a definition. It has a lot to do with the notion of form and content, from which I've never distanced myself, and which I even think is the contradictory yet driving force behind my work as an artist. Even if I say I'm a formalist, however, my work, in the broadest sense, has at its core the revolting human condition, again and again—excuse me for this platitude. I can work as a formalist without being totally powerless. I don't want to defend anything here; I just want to define for myself my incredible need for form, for *Gestaltung*, and also

29

my other need not to accept the state in which I live and in which everyone else lives. And I think I must always try to let these two needs confront one another—not reconciling them, not resolving them. I like to think that as a formalist artist I can make monochromes and decorative canvases and interactive projects, that I can do whatever I'm in the process of doing, whereas as a political artist I'd have no such choice. Because for me what I do is about choice, like choosing to be an artist.

On the other hand, I would like to say a bit more about form, which concerns me very directly and which perhaps isn't coherent with the above, but which is just as valid. And that is: when I do what I do it's because I find it beautiful. I want to make work that's beautiful. It's as simple as that. I think what is beautiful is true. It may be a simplification, but I don't think it's that simple to make something beautiful, and I'm also convinced that the commitment is what makes the work beautiful. I think it's a lost cause to aspire towards beauty without total commitment: it would never be beautiful, at best only pretty. So when I made those *plaintifs*, *bêtes*, *politiques*, it was because I wanted them to be beautiful, and of course if one can now criticize them, even justifiably, such criticism remains inessential as long as form itself has not been criticized. All this may seem a bit confused; I'm aware of that. I know you can understand that for a work to be made there has to be a will, a determination that goes beyond what can be fully justified. I'm talking about approximating, the self-made, improvisation. The desire to be understood as expressed in street posters and signs pleases me aesthetically. For example, I like it when handwriting gets smaller towards the end of a word because otherwise it won't fit on the page when one has misjudged its length. I like lots of things like that, even though they're nothing new. And what I find really pleasing in these small things is that for me there is definitely a form, formalism—untamed, unexploitable, unhijackable formalism—and I accept the misunderstandings, the wrong, debatable things. I've written this letter mostly for myself, in the knowledge that I haven't gone much further in my thinking, but also to show in the future what I was trying to explain at this time about my formalist will.

———

1994

[Translated from French by David Wharry]

LETTER TO KONSTANTIN (ON "POLITICAL CORRECTNESS")

Dear Konstantin,[6]

This PC debate has been getting on my nerves for quite some time. My work has nothing to do with "political correctness," nothing whatsoever. The PC discussion is a sophisticated American invention to dissuade small-minded and fearful European artists from addressing the real questions in art. It's very cleverly done. Sensitive and critical artists fall for it most of all. But to be a good artist, it isn't enough to be sensitive and critical. Energies, liberties, and artworks are channeled and filtered through the notion of "political correctness," not considered in terms of the work itself. The bill is a stiff one in the end: the reactionaries have won, whether they come from the U.S. or not matters little since they've handcuffed the PC artists and given the non-PC artists a guilty conscience. To this end, they've lit a bonfire that will soon burn out, but which, for the moment, is fashionable. And let's not forget that the critics are pulling their weight in all this, and because the critics are always glad to get their hands on new arguments, new criteria with which to do their job of judging, they're more than happy with the new PC or non-PC arguments. And then what? What always happens when reaction is at work: it produces a counter-reaction, one that is pure shit. Because now we have the notion of the "politically incorrect," and wherever possible they're knocking together a career out of it. What a load of shit. Thanks a million for this American invention, which in Europe is especially influential in Germany.

I have my own personal defense against all this:

1. I don't use the terms "PC" or "non-PC."

2. I don't let myself be defined (whenever possible) and don't define myself in these terms.

3. If, nevertheless, I am defined in terms of "political correctness," I first butter the person up. If they say, "You're PC," I say, "I don't want to be, but it seems I must be, because I'm for justice and *Egalité*, because I'm against repression, against the deprivation of liberty that over two-thirds of the world population

still knows only too well. But it's <u>all the same</u> to me if I'm politically correct or not." Second, if someone says to me, "You're not PC," I say, "I don't want to be, but it seems I must be, since I like beautiful women, I'm a formalist, I'm fascinated by photos of dead human beings, I like the Chanel logo because it is the best typography, I like big cars. For formal reasons, I love woodcuts, graphics, and curves, because—stripped of meaning and content—I find them beautiful. I am fascinated by images of military machines and their aesthetic. I like images of poverty, filth, and destruction, and I don't care if this isn't politically correct."

April 12, 1995
[Composed in German; Translated from French by David Wharry]

ME AND THE MILITARY

I was a lieutenant in the Swiss Army. I don't have either a good or a bad conscience about it. The military was never a problem for me, either physically or psychologically. I don't have any religious problems with it. I have no problem hiking fifty, even one hundred kilometers. I like to shoot, and was good at it, especially with a pistol. I did have one problem: a political one. Not in the ideological-political sense. Rather, political in the true sense. As relates to the community.

The problem is that, as a Swiss military person (and this relates to the recruit right up to the general), one is forced to relinquish, to give up, one's political thinking. To an increasing degree as one goes up the hierarchy, one has to turn off political thinking, or use it only in ambiguous argumentation. In the Swiss Army, everything leads back to the individual: his qualities, his behavior, his capacities—that is all a mere counter-fire lit in order to cover up the actual blaze and its horrendous consequences. This is how a Swiss is completely depoliticized in the military.

I only became aware of this when I was made an officer. I am not proud of it, nor am I ashamed that I took this path, the entire path from recruit to lieutenant, totaling more than one year in which everything led back to my person. My resilience, my ability to concentrate, my organizational skills, my capacity to endure hardship. It had nothing to do with conviction. It was: me and the military. I recall my entire stint in the military as a very egoistic, egocentric, navel-gazing time. No questions or thoughts other than what concerned the tip of my own nose or the soles of my feet. It was a time of emptiness and isolation that was only intensified by external psychological and physical tests. With me these tests merely had the perverse consequence of further constricting the already constricted space in which I moved. All that mattered was to prove that one could do it! At the same time, this narcissistic attitude becomes a reward; in fact, self-confidence and self-regard are built upon it! All you have to do is go into a restaurant and happen upon a conversation among men in training. What is dangerous about the Swiss military is precisely and especially

34

that it apparently need not be taken seriously. That there is something folklorish about it. That one is forced to play peek-a-boo games, and does it!

It dawned on me only very slowly, that is how much I was involved with my own ego. By the same token, it never entered my head to free myself of my emerging doubts about my engagement with the help of a physician or psychiatrist. It also seemed to me that in my position of responsibility this would have been inappropriate. The strength to refuse military service and the decision to take this step came from the officers' table! Because that is where the conviction arose: I don't belong here! Sitting at the table with other officers made the impoverishment and the self-deception clear to me because I realized that I was at risk of losing myself. Spiritual impoverishment as a result of rigidity and sectarian thinking; self-deception with regard to their claims of liberality, openness, neutrality. That's how deep I was stuck in that crap before I was finally able to achieve clarity: military service is contrary to service to the community. It is completely apolitical and serves only personal careerism. Serving in the military cheats the community and cheats me. Nor does military service have anything to do with love of country or with self-defense. Military service is a key means for entrapping citizens in a corset of conformity out of a bad conscience, presented as folklore so that people can laugh about it. The fact that this has nothing to do with humor was something I realized as an officer. It is the most absolutely humorless and saddest activity one can take part in. It took time, a lot of time, but once I understood it, the decision was easy! I then refused to do further military service and did not report for further training courses. I was sentenced to six months in jail, of which I spent four months in the prison at Realta.

How was it even possible that I became an officer?

1998
[Translated from German by Kenneth Kronenberg]

LETTER TO PASCALE (ON BERLIN)

Dear Pascale,[6]

I've been in Berlin for three months now and soon winter will come, and I'm waiting impatiently because I can't wait for the leaves to fall from the trees and for this very green city to become grayer, darker, colder. Because I feel that it suits the city better. In summer, when everyone was outside for a few weeks, swimming in the many lakes here or eating outside in the innumerable cafes at night, I already felt that it wasn't the real face of the city. I do think that the gray of the houses, especially in the eastern part of the city, is very diverse, very colorful in fact, and that this noncolor, which is a bit melancholic, especially at night with the orange street lamps, lends a gentle sadness, livable, nonviolent, to the city. The city, yes, I think so, is not icy; it's just a bit cold, a bit dark, somewhat poorly maintained, at least in the neighborhoods that I like: Kreuzberg, Mitte, Prenzlauerberg. And in Treptow there's a crazy park with the Soviet War Memorial; in a park with trees, a large part in the middle is a kind of sculpture you can walk through. First you enter through a triumphal arch that celebrates the victory of the Soviet troops over Hitler's Germany, then comes a modest sculpture of a mother or woman alone, visibly waiting for the men who have left for war. I turn around ninety degrees and in front of me, some hundred meters away, two large ramps, about fifteen meters high, lead to a passage on the left and on the right; and all the way in the back, four hundred meters away, a huge statue of a soldier after the battle on a kind of hill of stairs, all round. The path leading to this monumental sculpture is full on each side with reliefs with quotes of Joseph Stalin, in German on one side, in Russian on the other. All of it is heavy, very heavy. The row of trees gives this large square, especially when the sun sets, an impression of being a huge boat half-submerged in the water or else an archaeological site partly discovered. I thought that I was on another planet or in another time. It's not really a fascinating place, it's more a strange combination of cemetery and carnival; besides, I think it is so because of the huge lie they want you to believe. (Hitler and Stalin did sign a pact of non-aggression.) And others too helped overcome

the Nazis. But obviously, like everywhere, the real events and the course of history are not important to teach, because it's easier to pay a park guard. I wonder how long this park will remain now. But I'd like to turn back to the gray city, cold but nonhostile; I noticed that I hardly see any homeless people here. I'm not saying they don't exist in Berlin, but I can still imagine that this city, with its alternative networks, the neighborhoods I mentioned above, either offers more possibilities of minimum tolerance or a kind of integration in its alternative structures; or that the city itself (there are no pedestrian areas, for example, with only streets with stores) does not centralize absolutely dead zones; or that living on the fringe is perhaps less brutally repressed here than in other cities.

Berlin, September 30, 1994
[Translated from French by Molly Stevens]

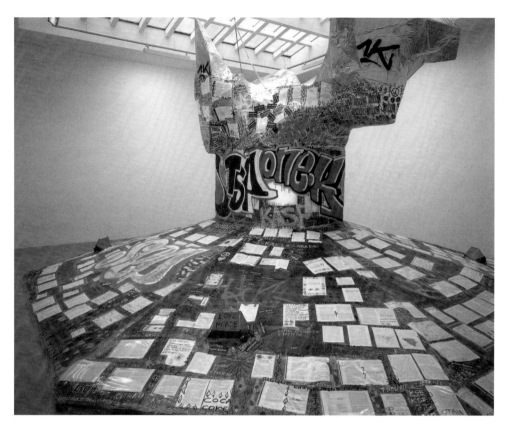

1.9 *Sculpture-Direct*, 1999. Galerie Chantal Crousel, Paris, France, 1999. Collection Fond National d'Art Contemporain, Paris, France. Courtesy Galerie Chantal Crousel, Paris, France.

"Direct Sculptures"

"Direct sculptures" are models of monuments. A direct sculpture is a critique of the monument. My critique of the monument comes from the fact that the idea of the monument is imposed from above. A monument is determined, produced, and situated by decisions from above, by power. And its forms correspond to the will to lead people to admire the monument and, along with it, the dominant ideology—whether it is a monument to Abraham Lincoln or Christopher Colombus, a monument to the memory of the first step on the moon or the commemoration wall in Washington, D.C., for those who lost their lives in Vietnam. Something demagogic always remains in a monument. I want to fight against hierarchy, demagogy, this source of power.

Direct sculptures, in contrast to "altars," "kiosks," and "monuments," are located in interiors, in exhibition spaces. Direct sculptures are in interiors because they are models. The direct sculpture is a physical result of a confrontation of two wills: the will that comes from below, the heart, and the will that comes from above, the power. One is the support, the other is the message. The two wills are condemned to exist together. They sow confusion. Confusion is the meaning of the direct sculpture. Direct sculpture has no signature; a direct sculpture is signed by the community; the spray-paint graffiti shows this. It is not a readymade. It gives a shape to a new type of sculpture: I mean a three-dimensional form coming from two-dimensional thinking that lends itself to receiving messages that have nothing to do with the purpose of the actual support. The message takes possession of the sculpture. The message appropriates the sculpture.

The direct sculpture that I showed first was inspired by what happened in Paris at the spot of the car accident that killed Princess Diana: on this location a monument exists that represents the flame of liberty. Because of the princess's death, this monument, which had been standing unnoticed for years, took on a new message. People started using this monument for their love messages to Princess Diana; they transformed it. This transformation is what interests me; Diana is of no interest to me. What counts for me is that this

sculpture is appropriated by its environment, signed, marked, changed, and no longer imposed by a force from above, but integrated, welcomed or not welcomed, confronted, by the heart, from below. There exist other monuments that inspired the direct sculptures: in the old east section of Berlin, there is a very large sculpture in homage to Ernst Thälmann, cofounder of the German Communist Party. This monument is about twelve meters high, and the bottom part is totally covered by graffiti, inscriptions and signs added by young people living in the surrounding buildings. The sculpture belongs to them because of the painted interventions; it belongs to them because of their graffiti. They appropriated it because it stands in their territory; they gave it a meaning. The sculpture now has a meaning, it became a monument that is just. I want to make monuments that are just. Direct sculptures are models for just monuments.

I made five direct sculptures during 1999, the first one at the Galerie Chantal Crousel in Paris, and the next four at Galerie Erna Hécey in Luxembourg.

February 2000
[Composed in English]

"KIOSKS"

This *Kunst am Bau* [commissioned art in public space] project was intended for the new building for brain and molecular-biology research at the University of Zurich. The work is a "work in progress" made for the entrance hall of this department. This hall is a public space, though it is mostly frequented by students, professors, and laboratory technicians. The project is to build eight kiosks within four years, a new kiosk every half year. The kiosk is set up each time in a different location of the entrance hall, which is designed in a specifically neutral and functional way, as is the architecture of the whole building. The kiosk is installed in this interior hall like a compact cell, an independent implant in the existing space, like an airport, train station, or hospital kiosk that sells newspapers, cigarettes, and candy.

I want to show its integrated presence in the building. Whether used or not, it just stands there, present. Thus, this kiosk is important as a mobile object, one that stands out from the existing surroundings by its handmade, quickly made form. It is in contrast with the architecture, with its top technical and functional quality. With this willed contrast, I want to propose an outlook on a different reality. This reality can liberate new or unknown energies. I want to confront the reality of this institution—biologists, technicians, researchers—with the reality of other researchers in other fields—artists, writers. They too make research. They too are committed in their research.

The small size of the kiosk is made to receive a single person so that he can isolate himself and concentrate on the information given in the kiosk—for one minute, for one hour, or for a whole day. The kiosk is a wood structure covered by cardboard and lit with neon lights. On the top, outside, there is a sign with the name of the artist or the writer. Inside, all the available books of and about the artist or writer, along with video tapes, are displayed to be consulted by the public. The inner walls are covered with photocopies of texts on his or her life, images, writings, and other documentary elements. Everything about the kiosk is made so that the person is plunged into a totally different world—the world of Robert Walser, for example.

———

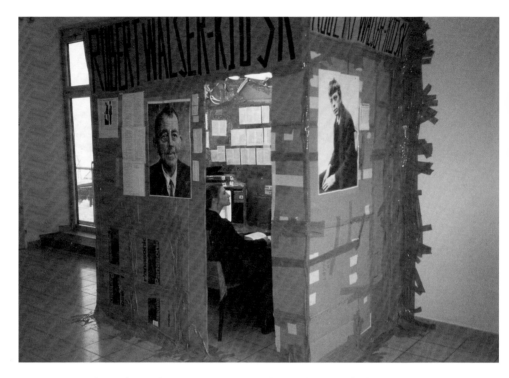

1.10 *Robert Walser Kiosk*, 1999. University Zurich, Zurich, Switzerland, 1999.

I want the visitor to discover or complete his knowledge about the artist's work. I want to cut a window onto another existence. The presence of a work of art within this scientific-work world wants to question the fact of being committed and engaged with a human activity and with the precarity of this activity.

This "work in progress," through its rhythm of rotation and its limited time, is a statement about artistic commitment in public space. That the project lasts four years is long enough to create awareness and memory but not long enough to create habit and lassitude. Too often, Kunst am Bau and work in public space create habit and lassitude. I want people to continue to be interested in artists and writers without kiosks. This work is being video-documented with the interventions of the spectators and users of the kiosks during the four years. This documentation will become an important element of the project.

The kiosk project is a commissioned project, resulting from a competition organized by the University of Zurich. It will run from 1999 to 2002. The kiosks are made for Robert Walser, Otto Freundlich, Ingeborg Bachmann, Emmanuel Bove, Meret Oppenheim, Fernand Léger, Emil Nolde, and Liubov Popova.

February 2000
[Composed in English]

1.11 Excerpt from the publication *Spinoza Monument: A Document*, "Point d'ironie" no. 23, October 2001, Paris, France.

"MONUMENTS"

I try to make a new kind of monument. A precarious monument. A monument for a limited time. I make monuments for philosophers because they have something to say today. Philosophy can give us the courage to think, the pleasure of reflection. I like the strong meaning in philosophical writings and the questions about human existence. I like full-time thinking. I like philosophy, even when I don't understand a third of its reflections. I'm interested in nonmoralist, logical, political thinking. I'm interested in ethical questions. That's why I chose philosophers for monuments. But in contrast to the altars, which are personal commitments, these monuments are conceived as community commitments. There is something really beautiful in the fact that human beings have the capacity to think, to reflect, and the ability to make their brains work. Spinoza, Deleuze, Gramsci, and Bataille are examples of thinkers who instill confidence in the reflective capacities: they give us the force to think, they give us the force to be active. I think that to read their books continues to make sense—to question, to reflect, to keep beauty vital.

The monuments are composed of two parts or even more. The "classical part," a form reproducing the thinker with his features, head or body; this part of the monument is a statue. Then there is the "information part," a new part in the monument, the material to be consulted: books, videotapes, statements, biographical documents. This information part with its material responds to the *why*. The classical part responds to the *who*. The information part of the monument is a physical place, a small construction (as in the kiosks) open twenty-four hours a day, seven days a week, where one can isolate oneself, sit down, study, and get information about the philosopher's work. This part of the monument with the documentation is a proposition to make the philosopher's work accessible to the public—to those who have never been in contact with philosophy, but also to those who are "professionals," specialists, philosophers, or amateurs. I want both aspects of the monument to be equally accessible.

I want to make it possible first to be in contact with information, to read about the work, the philosophy, and then afterwards to look at the statue. I

want the monument to be diversely accessible. Thus, the monument is not just standing there; it offers the possibility for the viewer to be informed—about its meaning and furthermore about the thinking of these philosophers. There is an active part and a passive part. This monument will not intimidate. It does not come from above. It is made through admiration; it comes from below. The monument will not remain there for eternity. The plastic aspect of the monument—cardboard, wood, tape, garbage-bag covering, neon lights—shows its limitation in time and enforces its precariousness. The form conveys the idea that the monument will disappear. What shall remain are the thoughts and reflections. What will stay is the activity of reflection.

The four monuments are to Spinoza, Deleuze, Gramsci,[8] and Bataille. I made the *Spinoza Monument* in the red light district in Amsterdam in 1999; I built the *Deleuze Monument* in a public housing project, Cité Champfleury in Avignon, in spring 2000. And I made the *Bataille Monument* for Documenta 11 in the Friedrich Wöhler housing complex in Kassel in 2002.

February 2003
[Composed in English]

"ALTARS"

An altar is a personal, artistic commitment. I want to fix my heroes. The altars want to offer a memory of someone who is dead and who was loved by somebody else. It is important to testify one's love, one's attachment. The heroes can't change, but the altars' location can change. The altars could be made in other cities or countries. The altars could be done in different locations: on a street, in an alley, in a corner. These very local sites of memory become very universal sites of memory by virtue of their location. That is what interests me. I choose locations that are not in the center or in a strategic point of a city, just any place. In the same way as people can die anywhere. Most people don't die in the middle of a square or on a beautiful boulevard; their deaths rarely happen in a strategic location; even famous people don't die in the city center. There is no hierarchy of location between anonymous and famous people. There are unexpected locations. The location is important not in relation to the layout of the city, but in relation to the people who died. This gives me the plan for locating the altars. These altars question the status of the monument today by their form, by their location, and by their duration. Thus, the choice of location is decisive for my statement on work in public space and my critique of monuments.

The form of these four altars comes from spontaneous altars that one sees here or there, made by those who wish to create a precarious homage to someone who died at that spot, by accident, suicide, murder, or heart attack (e.g., Gianni Versace, J. F. Kennedy Jr., Olaf Palme). The forms of these homages are alike, whether made for celebrities or made for the unknown: candles, flowers, often wrapped in transparent paper, teddy bears and stuffed animals, written messages on scraps of paper with hearts and other love symbols. With this wild mixture of forms, the messages of love and attachment to the deceased person are expressed without any aesthetic concern; it is this personal commitment that interests me. It comes from the heart. It is pure energy. One is preoccupied not with the formal quality of the elements, but only with the message that is to be conveyed. I have chosen artists I love for their work and

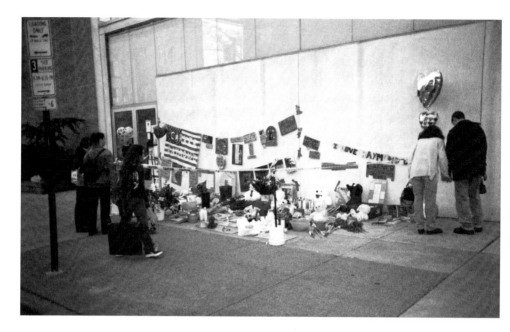

1.12 *Raymond Carver Altar*, 1999. The Galleries at Moore, Philadelphia, Pennsylvania, 2000. Private collection, New York.

for their lives: no cynicism, only commitment. The forms of these altars, which are profane and not religious, convey a visual form based on weakness. The forms and locations of the altars show the precarious aspect of the work. It is because of necessity and urgency that they are there. The cruelty and the non-spectacularity of these monuments make them untouchable by people walking by—proprietors, street-cleaners, dog-walkers, policemen. Everyone could be affected. Everyone is concerned. These altars will disappear sooner or later. The average duration of the altars is two weeks. The disappearance of the altar is as important as its presence. The memory of what is important doesn't need a monument.

I have made four altars for four artists and writers: Piet Mondrian, Otto Freundlich, Ingeborg Bachmann, and Raymond Carver. The *Piet Mondrian Altar* was shown in Geneva in 1997; the *Otto Freundlich Altar* was shown in 1998 in Basel and Berlin; the *Ingeborg Bachmann Altar* was shown in 1998 in Zurich and in Halle Tyrol in 1999 and in the Berlin subway in 2006 (U2-Alexanderplatz, curator: NGBK); and the *Raymond Carver Altar* was shown in 1998 in Fribourg, in Philadelphia (curator: The Galleries at Moore), and Glasgow (the "Vivre sa vie" show) in 2000, and near the South Public Library in Miami in 2002.

February 2003/February 2006
[Composed in English]

LETTER TO VÉRONIQUE (ON WRITING, JUDGING, READING, PUBLISHING)

Dear Véronique,[9]

You asked me to express myself on the subject of publishing. I want to try in these few sentences to express what I think regarding texts, catalogs, and editions, doing so once again using the "I" word—using "I," "me," and "I want" a lot. During our recent public talk at the Musée Rath, you often asked me questions starting with, "You said," "You wrote." You rarely said, "You did," very rarely. People questioning me after the talk asked me why the "me," why the "I want," implying that what this really expressed was introspection, egoism. I've always known that expressing one's thoughts in writing commits one, and that's what I've done. I like to commit myself, to set myself a task. I like to affirm. I like to throw a stone far ahead of me so I can try to follow its tracks. I have that will to commit myself, and that's why writing isn't difficult but necessary. It's an exercise outside my work, which nevertheless obeys the same law: the need to say something, the need to express something—something that might concern only a very, very few people. I make no pretense about how many people I'm reaching. But I express myself in writing with the same will that I have in my work, that is, by committing myself. That's why I use the words "I," "me," "I want." To commit myself. To be clear. So that my intent should be transparent, spoken, written in black and white.

I'm not afraid of misunderstandings, of confusion about what I write or what I do in my work. Nor am I afraid of being judged. I believe people try to escape from fear of being judged. I judge things a lot: what I see, read, hear, in music, films, art. I like judging. In fact, I find that it's one of the few things one can learn in art school: with teachers, with other students, to judge and be judged—how to forge a judgment. Everyone who creates has to face the judgment of others. It is demanding and necessary to judge a work and not the person who made it. I began writing precisely because I felt there was a total lack of judgment in general or specific texts on contemporary art. I found art critics were either complacent, unserious, or cowardly. I also thought that

soothing texts crammed with references, quotes, and comparisons were mean-ingless! I therefore began writing about my work myself. Obviously these aren't the critiques of a historian and theoretician. They are the critical and self-critical texts of an artist—of an artist not bothered about style, or even spelling, or quality writing, but only concerned with energy, with his determi-nation to put himself down in writing. I think all my writings have been fail-ures as far as comprehension via words is concerned. This is why so many people ask me questions in interviews that begin, "You said," "You wrote." Nevertheless, this exercise, this will to write, has brought me close to people I love: writers, authors, philosophers. I know now that their work is very important, and very hard . . . I like their work because I don't understand it, or rather, I understand it just a little bit. And the fact that I don't totally under-stand it encourages me to get to know them. That's how I approach their works. I feel like a human being when I'm reading something that I don't understand, but know I will eventually understand. I like Robert Walser, Emmanuel Bove, Spinoza, Deleuze, and Bataille. If I've worked several times with writers, it's because I feel close to their universe, to their questions, to their work as writers full stop—a far cry from journalism, from communica-tion, from art criticism. Their texts stand up on their own. That's why my collaborations with Manuel Joseph,[10] Jean-Charles Masséra,[11] and Marcus Steinweg[12] were attempts to show that there are several angles, other scales, for asking questions about the world around us and the human condition. I've always thought that authors take this into account the same way I do. That's why I want to continue and intensify my work with writers, who aren't both-ered with the art world but with the world at large!

Catalogs generally have only one purpose: to reassure rather than to explain someone's work, to reassure the reader of the importance of the artist's work with the aid of underpaid art critics and journalists, who consequently haven't got the time to work out what they think because they haven't been able to deepen their knowledge of the work, or because this isn't necessary or even desired. A catalog has to be a tool. A catalog isn't a trophy or a promo-tional brochure. It should address itself to the world at large. I'm thinking

about all scales, the big libraries in art centers, galleries, museums. I'm thinking about the art sections in every bookshop in the world. I'm thinking about the Internet. What I like about art is its universality, its will to appropriate the world; to say, "Me," "I" am a part of the world. "You," "you" are a part of the world. Publishing books, to my mind, like any artistic activity, has to do just that: address the world, the whole universe. That is how publishing makes sense. "Publishing" covers photocopies, books, records, programs, flyers, posters, anything that can be limitlessly reproduced. And I think the word "publishing" only takes on its full meaning through distribution, in terms of broad dissemination. One publishes to disseminate. The greater the dissemination, the more justified the publication. I think it's important to go beyond the original. There's no limit to the number of copies one can make, except technical limits. The most important thing is the will to multiply an original and disseminate it as widely as possible. OK, I admit there are some constraints: financial, technical, temporal. A limited edition can never justify itself by any other limit, above all by that of an eventual buyer.

Paris, January 2, 2000
[Translated from French by David Wharry]

LETTER TO LAURENCE AND HANS-ULRICH (ON REMAINING ALERT)

Dear Laurence, Dear Hans-Ulrich,[13]

Again I'm afraid I have to disappoint you concerning your request that I participate in the exhibition at ARC[14] this summer with a three-by-four-meter poster. For two days I've been looking and searching, but I can't find the right image for it. It is not the images that I've done that are lacking, but rather artistic determination. I told you both over the phone that I'd find something, but I'm now going to have to go back on that, because I said it more out of courtesy than conviction. Why? During the weeks since you invited me to take part in this project at ARC, I've been given the impression that you absolutely wanted me to participate—which I find all the more flattering because I respect you. And above all, I don't want anyone to think that my nonparticipation is for any reason other than the infeasibility, for security reasons, of my project "Conduit."[15] People are already asking me why I'm not taking part in this exhibition, and "security" is the only reason I can give. There aren't any others! I therefore felt a bit cornered when you followed this up with your idea of a three-by-four-meter poster, which, true, wouldn't take much time or energy. The trouble is it isn't my project! I mean I would only be participating, rather than confronting myself, positioning myself, developing my ideas, proposing a reflection, concretizing a project. It would merely be participation, and participation that wouldn't require much! Really not much! And that's not what I want. I want to be judged on what I do and that's only possible with works done with total, 100 percent energy. I really think that right now to show a blow-up of a *plaintif, bêtes, politiques* or any other image produced for these posters wouldn't stand up in this light! I'm sure you'll understand, although it won't please you. Especially as I'm going back on an agreement. That's why I'm apologizing to you, and please don't see any other reason behind this, except that an artist, whose work is at present very much in the public eye, is trying to remain alert and lucid in and with all these commitments, proposals, demands, which is probably almost as difficult to do as the actual making of one's artwork.

« CONDUIT » esquisse

L'extremité du vers la vue.
 conduit

1.13 Preparatory sketch for "Conduit," 1999. Unrealized project.

Paris, April 12, 2000

[Translated from French by David Wharry]

I WILL NO LONGER EXHIBIT IN SWITZERLAND

I am purposely unaccommodating. I cannot accept the newly elected Swiss Upper House of Parliament[16] because nothing is more luxurious, nothing is more comfortable, and nothing is more egocentric than to be a democrat today. Democracy is not untouchable, since our current state proves that democracy is vulnerable. The problem of democracy is that it implies its own inviolability. My intent is not to go against democracy; my intent is to go beyond democracy.

I authorize myself in rashness, in blindness, and in headlessness to make a decision that requires me to go beyond myself. I want to challenge myself; I want to require more than I can ask for. I don't want what's possible; I want the impossible. Art does not want what's possible; Art wants the impossible. I WILL NO LONGER EXHIBIT IN SWITZERLAND: in Art, the impossible triumphs over the possible. This is the triumph over narcissism, over depression, over resentment, and over angst. I want to be inflexible because Art is not consensual, Art is not diplomatic. One cannot make Art with unthoughtful compromises. I will be accused of being a dreamer and of being unrealistic, but I simply want to risk a movement with an uncontrollable course. I want to assume a radical responsibility with total excess—I want to be responsible for something irresponsible and for something that destabilizes me but makes me agree with myself. I don't want to be critical, I don't want to polemicize, I want to agree with myself. For me, Art is a tool—a tool to confront myself with reality. Art is also a resistance movement; Art resists, Art is neither passive nor reactive, Art attacks. Through my artistic work I will grapple with reality in its complexity, its density, and its incomprehensibility. I will act in the midst of obscurity. I will be brave, I will not get lulled to sleep, I will continue to work, and I will be happy.

The most important thing about my Swiss exhibition boycott is that I WILL DO WHAT I ANNOUNCED. One can count on it, since I do not want to become a politician. Therefore, all the questions about the "how" and "where" and "when" are secondary at the moment; of primary importance is

the WHY. With my boycott I would like to show that there has to be an end to the creeping fascism. I know, and history proves it, that people like [Christoph] Blocher[17] will not change even after being part of the Upper House of Parliament. To believe the opposite is naïveté, blindness, or stupidity. Nobody in Switzerland seems to have learned from the situation. I put Blocher, [Jörg] Haider,[18] and [Jean-Marie] Le Pen[19] on the same level. Four years ago when Haider's party became part of the government, Robert Fleck[20] made a plea to boycott exhibitions in Austria. I agreed with his plea and have not accepted any exhibition invitations in Austria since 2000. I already knew back then that we Swiss would be next in the line of the European renaissance in anti-foreign and racist thoughts. Now it has happened and I will therefore be persistent. In a few years, Blocher, as the highest government official, will represent Switzerland, MY COUNTRY, and this I will not accept as a Swiss.

December 10, 2003
[Translated from German]

LETTER TO JULIA ET AL. (THERE IS NO IDEAL PLACE FOR ART)[21]

Dear Julia Wallner, Maria Pangratz, Wolfgang Jung,

Thank you very much for your critique. It is good that you have taken the time and made the effort to formulate your thoughts in writing.

Naturally, I don't agree with your critique, but not agreeing doesn't mean that you aren't right! I want to try to explain briefly why I disagree. Your objections relate only to the manner of exhibition, but you didn't say a single word, not one letter, about what my work intends to do—you don't critique my work in a single sentence—you merely make a critique of the exhibition design, with bourgeois aesthetic arguments such as "taking much away," "in competition with," "strong enough," "not to be brought together in this arrangement," "spatial combination," "reference points," "they interfere," "the resting within itself," "concede the entire space," and "clearly designed." These are all arguments from interior architects or museum scenographers, and in these arguments you are RIGHT! Except that's not what it's about! It's not that I want to be in the right! But naturally I have also thought about these matters; in fact, I have been thinking about them for a long time. It is about the work, it is always about the individual works: there are eight works in the exhibition, these works are presented in such a way precisely so as NOT to meet your demands, but rather so that each work is again forced to fight for its existence as a work of art. That's what it was always about for me: not dramatizing, emphasizing, selecting, or legitimizing; rather, placing in question, asserting, risking, attempting to create the conditions for a confrontation; not following the space, not grappling with it, not working against the space—IGNORING IT!

I don't believe that my work needs to be upgraded with lots of room, with lots of space, with lots of white. If my work can't endure interference, "competition," promiscuity, then it is simply bad! I want my works to prove that they "hold." I don't want to make things easy for my work; I want to make it more difficult because I know that there is NO IDEAL PLACE for art. That's simply how it is in a public space. Even in the most beautiful

museum in the world, nowhere is art privileged. This realization is fundamen-
tal for me; knowing it frees me from the entire mise-en-scène shit. I can make
it badly, I can make mistakes, I can live with faults, but I have to make it in
such a way that I do not betray my work! That way I can never escape being
weakened; my work can never escape uninjured. Art has other goals than to
be without error and without fault. I want to make a work where errors and
faults are NOT IMPORTANT! And I trust that my work has enough power
and energy to defend its mission—wherever and however. That is my secret,
and that is my hope!

March 4, 2005
[Translated from German by Kenneth Kronenberg]

1.14 *Dessin Jaloux* (Boost Tuning), 2006. Courtesy Gallery Alfonso Artiaco, Naples, Italy, private collection, Italy.

Works on Paper

The series of works on paper I have been doing for several years are <u>collages</u>.
A collage is an interpretation; it's a true, real, entire interpretation. An inter-
pretation that wants to create something new. Doing collages means creating a
new world with elements of this existing world. Doing collages is unprofes-
sional and it's easy. Everyone has once in his life made a collage and everybody
is included in a collage. Collages possess the power <u>to implicate</u> the other
immediately. I like the capacity of <u>nonexclusion</u> in collages and I like the fact
that they are always suspect and not taken seriously. Collages still resist con-
sumption, even if—like everything else—they have to fight against being
glamorous and fashionable.

I want to put together what cannot be put together; I think that's the
aim of a collage and it's my mission as an artist. The images that I put together
are from printed matter that had another existence before: photos or advertise-
ments, always printed, that I have taken from fashion and political magazines,
and images I have printed out from the Internet, sometimes enlarged via pho-
tocopy. The blue scribbling (markers and ball-point pen) is the flood of tears,
of sadness, the flood of the too much; it's the overflow. It is not blood; it's only
blue, red, or some other color.

I want to do a two-dimensional work that can be mentally deployed into
a third dimension. I want to break the scale and I want to break the angles and
the perspective. I want to put <u>the whole world</u> into my collages. I want to put
everything in, the whole universe. I want to express the complexity and con-
tradiction of the world in a single collage. I want to express the world that I am
living in, not the whole world as the entire world but as a <u>fragmented world</u>.
My collages are a commitment to the universality of the world. I am against
particularism, against information, against communication, against facts, and
against opinions. The question is not who is the victim, who is guilty, or what
is it about. It's about all of history and not just a single fact. With my work I
want to reach, to touch, history beyond the historical fact.

The question is always: What is my position? The question is about myself today. I want to confront the chaos, the incomprehensibility, and the lack of clarity of the world, not by bringing peace or quiet nor by working in a chaotic way, but by working <u>in</u> the chaos and <u>in</u> the unclarity of the world. I want to do something <u>charged</u> that reaches beauty in its density. I want to work in emergency mode, I want to do too much. The images that I use in a collage are an attempt to confront the violence of the world and <u>my own violence</u>. I am part of the world and all the violence of the world is my own violence, all the wounds of the world are my own wounds. All the hate is my own hate. I love Dada and the collages of the Dadaists, I love the beautiful collages of Johannes Baader and his *Das grosse Plasto-Dio-Dada-Drama*; it is an image that I always carry with me. I love John Heartfield and his work. He said, "Use photography as a weapon!" <u>I love to do collages, and I love to make this kind of work.</u>

June 2006
[Composed in English]

Artist Lectures

Since I started doing artist lectures (about ten to fifteen lectures per year), this exercise has become—with time—a <u>base</u> for my work, a tool to state my position and to answer the essential questions: What do I want? Where do I stand?

I do <u>different types of lectures</u> (nearly each time a new lecture). Either I give a lecture about my work in general, starting with pictures of the early works up to the most recent; or about one single work—especially if this single work is being exhibited—which allows me to talk about more general questions connected to my work; or else I give lectures about a theme with a choice of specific images—for example, my works in public space.

When I give a lecture about my work, I do it with the intention to propose, clarify, and impose my artistic project. I don't take part in round tables or panel discussions. I am willing to answer any question on any subject about my work, but I don't want to discuss in public what doesn't concern my artistic project. What I want is to <u>show my work</u>, I want to affirm it and I want to stand up for it. I insist upon my will to show pictures, and the artist lecture is an opportunity to show work that has perhaps not been made public. Showing pictures of my work is also important because I want to insist on the image of the <u>work done</u> and on the fact that the <u>work exists</u>.

What I want is to talk about the <u>necessity of being touched by grace</u>; I want to talk about <u>faith in art</u> and about the <u>need to be a warrior</u> as an artist. I want to explain the problems and dangers I must confront. I want to share, in a lecture, the fact that the affirmation and self-authorization which I myself need are a necessity in order to give form. Beside information about the work, it is the artist lecture's <u>form itself</u> that provides the tools to understand, to touch, and to confront the artistic project that is being presented. I like to attend the artist lectures of other artists (I remember in particular astounding lectures by Yinka Shonibare and Richard Prince).

What I want to convey through my lectures is that I am not a theoretician, a critic, or a historian. To be an artist means to constantly confront theory with practice, and this means going beyond the limit of practice and theory as

———

63

well. As an artist I have something to show and it is <u>my mission to show it</u>. I am an activist for work that shows itself, exhibits itself, and confronts viewers. What counts is to be precise and to exaggerate at the same time. In an artist lecture, as with my work, I want to be dense and charged, not to exclude anyone but to include all. I want the questions about the materials used, the forms given, about why forms are enlarged and why there are so many elements in my work—I want these questions to be evoked and to be answered. I also want to answer: Why do I integrate other elements in my work, for whom are the texts written, why is philosophy important (the Friendship between Art and Philosophy)? To give an artist lecture must also be of interest to me as well, because the questions I ask myself are: Am I making myself clear? Am I precise? Am I self-critical about my work without being defeatist or narcissistic? Am I able to convey the difficulty but also the happiness that doing an artist's work can bring?

What I want in my artist lecture is to trace my <u>line of force</u>. I want to draft my <u>field of action</u> and develop why I work like this. In my artist lectures, I want the gap between the shown image and the given information to be the smallest possible. I don't want to lose myself in speculation, analysis, or approximation. I want my artist lectures to be <u>statements</u> and <u>commitments</u> for myself, I want the artist lecture to commit me first of all.

October 2007
[Translated from French]

I Will Exhibit in My Homeland Again[22]

Since December 10, 2003, I stopped showing my work in Switzerland, my native land. I paid the price for my decision to boycott my country, because it had a significant impact on what I love doing most: exhibiting my work! This is precisely what a boycott is meant to do: the person who is doing it gets hit first. I am happy now <u>because I will exhibit in my homeland again</u> if invited to. I am happy because a determined boycott always succeeds—sometimes sooner, sometimes later.

After this unexpected reversal of the election results from four years ago, it is clear that the argument of that time—"We'd rather have him [Blocher] inside [the government] than outside"—no longer applies. The results of last fall's national elections have proved again how shortsighted and insidious this argument was.

It has now been recognized that a Swiss Federal president with Blocher's ideology is wholly unacceptable; he completely undermined Switzerland's "concordance system" when he was part of the Federal Council. To be a member of the opposition is OK; to be part of the government is OK. But to be both at the same time and in the same place is no longer acceptable, just as "concordance" with the demagogues is no longer possible.

No one needs to fear clear positions and straightforwardness. No one needs to be afraid of an engaged and clear political debate. Intimidation and threats can work only if something is rotten, so this makes Blocher's demise all the more encouraging—even though I know that his ideas need to be fought relentlessly and without weakening.

No democracy—not Swiss or any other—should become the "sacred cow" for which everything is sacrificed, making it impossible to look ahead or take innovative decisions. The slightest issue is supposed to be "democratically" decided upon, but a "democratized" citizen is no longer a genuine free democrat; he is a lobbyist domesticated and anaesthetized by the word "democracy." I want to be a democrat—I want to be a genuine democrat.

———

I live in France, but nevertheless I can see that in Switzerland—which is in a strong economic position—more and more people are afraid of the other, of the unknown, and, above all, of anything "that is not homebred." The country's increasingly isolationist politics—propagandized by Blocher, among others—have led to this fear, and I am ashamed that resentment and xenophobia can spread openly in my homeland, as we have seen happen in the elections last fall. The image of a fearful, guarded, narrow, and uptight Switzerland will soon travel across the world.

This poor image is of no help to anyone in Switzerland who wants to face the demanding challenges of the world today with courage, with creativity, with confidence in his own ability and creativity. And that's what we, the Swiss people, have: courage, confidence, ability, and creativity!

Switzerland is my country—Switzerland is <u>also</u> my country—and remains my homeland. I want it to be a place one can be proud of for its achievements and its values, which have been conquered and won, and are today developing and being shared. It is up to us to develop and share these values. Our "Swiss project" cannot be reduced to xenophobia and fear of the future. I shall do my best to stay alert and keep my eyes open. I want to keep on working, to be happy, and I will exhibit in my country again with joy.

December 14, 2007
[Translated from German]

Why "Where Do I Stand?" and Why "What Do I Want?"

Plan = Form

The point is to have a plan. The plan "Wo stehe ich? Was will ich?" [Where do I stand? What do I want?] is my plan. It makes clear my position. It isn't a historical or a scientific document, and this plan is not about facts and actualities. First and foremost, the plan "Wo stehe ich? Was will ich?" yields form. I want to give form. Form interests me; giving form is my work. With my work, with my art, with each of my individual works, and with each exhibition, I want to show that I take a position, and that I have a plan. The point is to commit myself as an artist, to say where I actually stand and what I want. And it is also about asserting as an artist that it is important to commit oneself. I think it is important to clarify my position, to assert it, and to defend it. For that I need help, I need tools, I need to know what my influences are, I need encouragement, I need to be aware of the dangers, I need to know my problems, and I need love—the love of art and the love of philosophy.

The plan is the first step toward a structure, a construction, a sculpture. The plan is two-dimensional; I have to transform it into the third dimension. All my works are plans or collages executed in the third dimension; I make collages in space. I never proceed from the volume; I always proceed from a plan—which I have in my head. The plan and the form are in my head first. What interests me is that the plan cannot be executed linearly, and it interests me that I have to interpret a plan. This interpretation must be a genuinely, truly, personal interpretation; it has to come from me.

Art is about having a concern, a problem, a mission, and it is about giving this concern, this problem, or this mission a form by necessity, headlessly, and with absolute urgency. The plan is one of these forms, an assertion, a challenge to myself: I have a plan, an idea, a project, a position. I must, and I will assert my position and defend my plan. And it is about posing the fundamental question for the artist, the large question, the only important question, and trying to

———

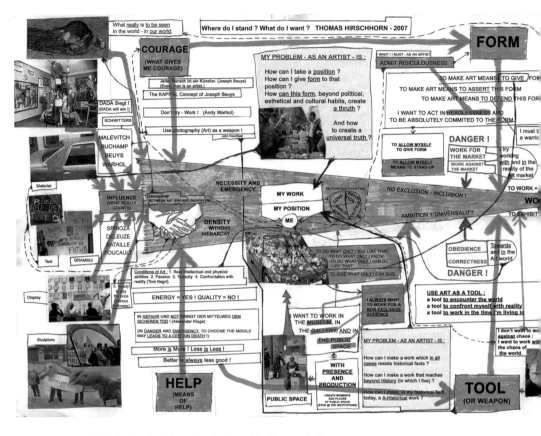

1.15 "Wo stehe ich? Was will ich?" (English version), 2007.

respond to it with and through my work. This question is: Where do I stand? What do I want?

For me, it is about whether I have the strength, the will, the passion, and the capacity to create a work—to assert a form that has bite and that demands as much of the observer as I demand of myself, namely, everything. This is what the plan "Wo stehe ich? Was will ich?" is about. I understand all of the criticism leveled against it, and I understand that it has faults and gaps, but I also know that everything in it counts, everything in it is important, and everything in it is right!

Weakening Oneself

I understand that people can be disappointed by my plan "Wo stehe ich? Was will ich?" But as is so often the case with my work, I am the first to be "disappointed." However, my problem is never this disappointment per se; my problem is—always and in all my works—to endure these disappointments, never to fool people, and to have the courage to persist in weakening myself. Yes, weakening myself in that I demonstrate, "Here I stand! This is what I want!" That is courage, that is the willingness to bear risk, that is an assertion.

I endure disappointment because the question I ask myself, "Wo stehe ich? Was will ich?" bears within it a challenge to others: "Where do you stand? What do you want?" This is the political aspect in the question: I pose it to myself—first—but I also pose it to others. Because I want to know: What is your form? What does your plan look like? What is at stake—for an artist, it's the groundwork—is to create a condition, to contribute something, and by doing so to ask the other about his contribution, to demand and to call it forth! That is the logic of the plan "Wo stehe ich? Was will ich?"

The fact that a piece of work leads to misunderstandings and false interpretations has been clear to me from the outset—and always has. But it is not my intention to dodge misunderstandings, false interpretations, and criticisms, and to evade them or to avoid them! What is at stake is to weaken myself, and in spite of misunderstandings and false interpretations, and despite errors (my

errors), and despite faults (my faults), to make a work that clearly comes from what is most my own. I must work with what is my own—with what is completely my own—in order to implicate others.

Friendship = Unshared Responsibility

I don't need philosophy to make art, I don't need philosophy to legitimize my work as an artist, and I don't need philosophy to inspire me. I need philosophy as a human being, as a man; I need philosophy in my life. This is why philosophy is only conceivable to me as friendship, as a movement parallel to art, a friendly movement in the same direction. I think that philosophy—like art—can create the preconditions for a dialog or grappling with the other, one-to-one.

And so—together with Marcus Steinweg—I made the "Map of Friendship between Art and Philosophy," among other maps. We want to give form to the friendship between art and philosophy; we want to commit ourselves. The "logo" of this plan is a handshake. In a handshake, two right hands clasp each other. I can't shake hands with myself; I need the other—the same—the other right hand to complete a handshake. That is the symbol—"logo"—of friendship; that is the symbol of friendship between art and philosophy. Both are needed in order to create something new and unique—a handshake. There is no bottom and there is no top, there is no before and no after, and there is no pure theory and no pure praxis. All there is is the dynamic that seeks to go beyond theory and beyond practice simultaneously. That's what's implied in the handshake. It is the symbol of agreement. That is the symbol, that is our plan.

We don't call these works "collaboration"; we call these works works created in "unshared responsibility." "Unshared responsibility" is when each takes unlimited responsibility for the work of the other. "Unshared responsibility" is to take responsibility for something that I didn't do. "Unshared responsibility" is not when one person takes responsibility for one particular part and the other for another part, which would then be divided responsibility. "Unshared responsibility" means making no compromises. "Unshared responsibility" means working in friendship.

The Meaning of Friendship

It makes sense—as an artist—to have a philosopher as a friend. Because a philosopher is interested in the big questions—as is the artist. It makes sense because the philosopher pursues philosophy passionately—just as the artist is passionate about making art. It makes sense because the philosopher must be persistent and insistent—just as the artist must. It makes sense because the philosopher must confront reality—just as the artist must—and it makes sense to be stubborn as an artist and as a philosopher in order to assert what he has made in the face of everyone and everything.

The friendship between art and philosophy is based on the fact that both art and philosophy are assertions. That is the field of force and direction of impact that I share with Marcus Steinweg. Art and philosophy make sense as assertion. Art asserts form; philosophy asserts concept. This assertion creates truth, the truth created by form and the truth created by concept. And it requires courage and will to persevere against what is called common sense, and to assert a form or a concept.

The philosophy that interests me is pure philosophy that acts and that creates something new, just as the art that interests me is active, is assertive, and creates new form. I understand art as the assertion of form and as a grappling with form—which is necessary for the artist. Form in the here and now, form in chaos and in complexity, and form in the opacity of the world.

I know what is required to develop an artistic logic: love, passion, hope, courage, capacity for risk, will to form, resilience, power to assert, headlessness, and absolute insistence on the autonomy of art. And it requires from the artist the willingness to be the first to pay for his work. I also know that the artist must be a warrior.

January 2008
[Translated from German by Kenneth Kronenberg]

Doing Art Politically: What Does This Mean?

Today the terms "political art," "committed art," "political artist," and "committed artist" are used very often. These simplifications and abbreviations have long been obsolete. They are cheap and lazy classifications. Not for a second do I think of myself as more "committed" than any other artist. As an artist, one must be totally committed to one's artwork. There is no other possibility than total commitment if one wants to achieve something with one's art. This is true for any art. Today there is great confusion concerning the question of what "Political" or "political" should be. I am only interested in what is really political, the "Political" with a capital P, the political that implicates: Where do I stand? Where does the other stand? What do I want? What does the other want? The "political" with a small p—of opinions, of commentaries, and of views of the majority—does not interest me and has never interested me. I am concerned with <u>doing my art politically</u>—I am not concerned with, and have never been concerned with, making political art. The statement "doing art politically—not making political art"—is a statement I took from Jean-Luc Godard. He said, "It is a matter of making films politically; it is not a matter of making political films." But what does it mean to do art politically?

Doing art politically means giving form.

Not making a form but giving form, a form that comes from me, from myself only, which can only come from me because I see the form that way, because I understand it that way, and because I am the only one to know that form. To give form—as opposed to make form—means to be one with it. I must stand alone with this form. It means raising the form, asserting this form, and defending it—against everything and against everyone. It means asking myself the question of form and trying to answer it through giving form. I want to try to confront the great artistic challenge: How can I give a form that takes a position? How can I give a form that resists facts? I want to understand the question of form as the most important question for an artist.

———

Doing art politically means creating something.

I can only create or fulfill something if I address reality positively, even the hard core of reality. It is a matter of never allowing the pleasure, the happiness, the enjoyment of work, the positive in creation, the beauty of work, to be asphyxiated by criticism. It is a matter of not reacting; it is a matter of always being proactive. Art is always action; art is never reaction. Art is never merely a reaction or a critique. It doesn't mean being uncritical or not exercising critique; it means being positive despite the sharpest critique, despite uncompromising rejection, and despite unconditional resistance. It means not to deny oneself passion, hope, and dreams. To create something means to risk oneself. I can only do that if I work without simultaneously analyzing what I am making. To take the risk, to have joy in working, to be positive are the preconditions for making art. Only in being positive can I create something that comes from myself. I want to be positive, even within the negative. Because I want to be positive, I must gather the courage to also touch the negative—that is where I see the Political. It means taking action, risking an assertion, assuming a position, a position that goes beyond mere criticism. I want to be critical, but I do not want to let myself be neutralized by being critical. I want to try to go beyond my own criticism, but I do not want to make it easier for myself through (narcissistic) self-critique. I never want to complain as an artist, for there is no reason to: I can do my work, I can create something.

Doing art politically means deciding in favor of something.

I decided to position my work in the form and force fields of Love, Politics, Philosophy, and Aesthetics. I always want my work to touch each of these fields. All four fields are equally important to me. My work does not have to cover each of these fields evenly. However, I always want all four fields to be touched. One, but only one, of these four form and force fields is the field of Politics. To choose the force and form field of Politics means that, in my work, I always want to ask the question: What do you want? Where do you

stand? It also means that I always want to ask myself: What do I want? Where do I stand? As is true of the field of Aesthetics, the force and form field of Politics can also be interpreted negatively. I am aware of that. But it is never about excluding or rejecting the negative; it is also about confronting the negative, working within the negative and involving oneself in it; and it is always a matter of not being negative oneself. Through my work I want to create a new truth beyond negativity, beyond current issues, beyond commentaries, beyond opinions, and beyond evaluations.

Doing art politically means using art as a tool.

I understand art as a tool to encounter the world. I understand art as a tool to confront reality. And I understand art as a tool to live within the time in which I am. I always ask myself: Does my work have the ability to generate an event? Can I encounter someone with my work? Am I—through my work—trying to touch something? Can something—through my work—be touched? Doing art politically means considering the work that I am doing today—in my milieu, in my history—as a work which aims to reach out of my milieu, beyond my history. I want—in and through my art—to address and confront universal concerns. Therefore I must work with what surrounds me, with what I know and with what affects me. I must not give in to the temptation of the particular, but on the contrary, I must try to touch universality. The particular, which always excludes, must be resisted. For me, this means that I want to do my work, the work that I am doing here and now, as a universal work. That is the Political.

Doing art politically means building a platform with the work.

Creating a platform enables others to come in contact with the work. I want all of my works to be understood as a surface or a field. This field or surface is the upper surface that enables access or contact with art. The impact or friction takes place on this upper surface, and through contact, the other can be implicated.

This surface—my work—must be a locus for dialog or for confrontation. I think that art has the power and capacity, because it is art, to create the conditions for a dialog or a confrontation, directly, one-to-one, without communication, without mediation, without moderation. As an artist I want to consider my work as a platform, a platform that is a clear opening toward the other. I always want to ask myself, Does my work possess the dynamic for a breakthrough? And I ask myself, Is there an opening, is there a path into my work? Does my work resist the tendency toward the hermetic? My work must create an opening; it must be a door, a window, or even just a hole, a hole carved into today's reality. I want to make my artwork with the will to create a breakthrough.

Doing art politically means loving the material with which one works.

To love does not mean to be in love with one's material or to lose oneself in it. Rather, to love one's material means to place it above everything else, to work with it in awareness, and it means to be insistent with it. I love the material because I decided in favor of it, and therefore I do not want to replace it. Since I decided in favor of it and love it, I cannot and do not want to change it. The decision about the material is an extremely important one. That is the Political. And because I made that decision, I cannot yield to wishes and demands for "something else" or "something new."

Doing art politically means inventing guidelines for oneself.

It means inventing one's own guidelines or appropriating them. My guidelines are acting in headlessness; "Energy = Yes! Quality = No!"; being weak but wanting to make a strong work; not economizing oneself; self-expenditure; "Panic is the solution!"; being both precise and exaggerating; undermining oneself; being cruel vis-à-vis one's own work; being tenacious; "Less is less! More is more!"; "Never won, but never completely lost!"; having the ambition to coin a new concept with my work; assuming responsibility for everything concerning my work; being willing to look dumb in front of my own work; "Better is

always less good!"; refusing all hierarchies; believing in the friendship between
Art and Philosophy; being ready to be the first to pay the price for my work.

Doing art politically means working for the other.

Working for the other means first of all working for the other within myself. It
also means working for a non-exclusive public. The other can be my neigh-
bor, it can be a stranger, someone who frightens me, who I don't know and
don't understand. The other is someone I did not think of and did not expect.
The non-exclusive public is not just "all" or "the mass" or "the majority"; the
non-exclusive public consists of the others, the sometimes more and some-
times less numerous others. Through and in my work I want to work for a
non-exclusive public. I want to do everything in order to never exclude the
other from my work; I want to include the other, always and unconditionally.
I want to include the other through the form of my work. The other is also
the reason why I make no distinction between works in public space, in a
commercial gallery, in an art fair, in a museum, in a Kunsthalle, or in an alter-
native art space. That is the Political. To work for the other enables me to
position myself as an artist on the outside of the spectrum of evaluation.

Doing art politically does not mean working for or against the market.

The question is much more about understanding the market as part of the art-
ist's reality and about working in this reality. Not wanting to work for or
against the market is not merely a declaration; it is the awareness that only
through autonomy and independence can art maintain itself beyond the laws
of the market. Only a direct and affirmed confrontation with the reality of the
market—despite the errors, the defects, the faults, and the injuries—makes it
possible to resist and to go beyond the market pressure. As an artist, I must not
become dependent. The artist always needs support and assistance, especially
during the initial years. Although I know the importance of this support and
assistance, I must never let myself or my work be dependent on them.

———

Doing art politically means being a warrior.

Aubervilliers, Summer 2008
[Translated from German by Michael Eldred]

———

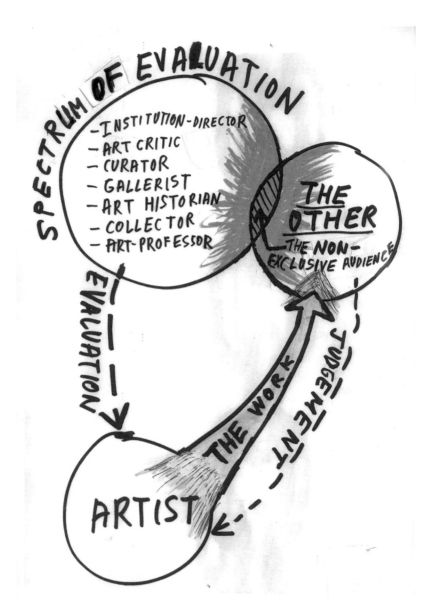

SPECTRUM OF EVALUATION

- INSTITUTION-DIRECTOR
- ART CRITIC
- CURATOR
- GALLERIST
- ART HISTORIAN
- COLLECTOR
- ART-PROFESSOR

THE OTHER
THE NON-EXCLUSIVE AUDIENCE

EVALUATION

THE WORK

JUDGEMENT

ARTIST

1.16 "Spectrum of Evaluation," 2008. Private collection, New York.

"SPECTRUM OF EVALUATION"[23]

I made the "Spectrum of Evaluation" diagram for myself in order to clarify for whom I actually want to work; it is a plan for me so that I may orient myself. With this diagram I want to explain what, for me, constitutes the "non-exclusive audience." The "non-exclusive audience" or the "non-exclusive public" is my own term, and I made up this term so that I could, for once, define who the public for my work should be. I wanted to establish who I will be turning toward, in and through my work; I also wanted to make a clear statement against the "exclusive public" or the "exclusive audience," AGAINST that which is "exclusive" in general. I continually read and hear the term "exclusive" used in art to argue, to intimidate, and to legitimize. I perceive that even in art "exclusivity" has become a positive criterion. That can't be, and that cannot go unanswered. I wish to counter it because art has nothing to do with exclusivity; ON THE CONTRARY, art is inclusive; art never excludes. In other words, the "non-exclusive public" is the opposite of a predetermined, selected, and initiated public. As an artist, it is essential for me to work for a "non-exclusive public."

Regarding my diagram and the circle that I have named "THE OTHER": "The other" is the one who is unknown, the neighbor, the next person, the foreigner, the person who is hostile to me, the person who frightens me, the uninvited, the person who appears unexpectedly, who happens to pass by, the unanticipated. "The other" is ALSO ALWAYS the one with whom I had not reckoned. I want to work for that person. This is the reason for the thick arrow in the diagram, "THE WORK," which goes from the artist to "the other." That has to be the dynamic: from the artist to the other. I want to give my work to the other. By contrast, the dynamic should NEVER go from the artist to the "spectrum of evaluation." It is essential that I, as an artist, am never located in the "spectrum of evaluation," and it is crucial that I have my own position. That is why it is necessary that I have my own POSITION, entirely my own, perhaps indefensible, but MINE. I must have my own circle in the diagram.

As an artist with a work, I am not "the other," nor am I a part of the "spectrum of evaluation" or the "spectrum of evaluators." As an artist, it is never my place to evaluate, and I never want to take part in the "spectrum of evaluators." The "spectrum of evaluators" is composed of those who know art, who absolutely love art—I assume so. In the diagram, I have noted seven professions, all of which have to do with art, and which are located in the "spectrum of evaluators" and collectively evaluate art. Not all seven of the professions are in the spectrum all at once—but still, at least in pairs they evaluate art. Those who are in the spectrum evaluate art together: they discuss, they consult, they analyze, they inform themselves, they argue, they exchange, and they COMPARE. But one can only evaluate and compare if one evaluates or compares comparable things. The artist receives the evaluation from the "spectrum of evaluators." However, the artist can't do anything with such "evaluations"; they don't get him anywhere because the artist makes something INCOMPARABLE, and what he makes CAN'T BE COMPARED.

By contrast, what I, as an artist, get from "the other" is a JUDGMENT; my work is JUDGED, which is how it has to be. That is what I work for. I want to be, and must be, prepared for this JUDGMENT. It is never about judging a person; that is the important thing, the beautiful, cruel, and most definitive thing; it is what I need, what propels me onward, what agitates me, that with which I may confront myself, that which makes me think. A judgment is final. And because it is a judgment and not a comparison, it is always also an engagement with the person who is making it. It is a headless, thoughtless engagement. Receiving a judgment is unbelievably valuable; through and with my work, I want to create the preconditions for a judgment. To receive a judgment for something I make is a gift, a personal judgment that comes from the heart. In order for me to receive such a judgment, I must have my own circle in the diagram. I will succeed only if I am outside the "spectrum of evaluators."

What is crucial in my diagram is the fact that the "spectrum of evaluation" OVERLAPS with the circle of the other; the core of the "non-exclusive audience" is located in this overlap. No one is excluded from my work, no one is excluded from being able to judge it. I do not wish to create a new or other

exclusivity with my diagram; on the contrary, I want to exclude nothing. But as an artist, I think I must determine the dynamic, the line of force, or the DIRECTION OF IMPACT. That is the reason for this diagram.

2009

[Translated from German by Kenneth Kronenberg]

"FORCE MAJEURE"

So-called force majeure does not exist, at least it doesn't exist in art. "Force majeure" is evoked more and more for a bunch of "good reasons" but especially so as not to feel and not to be <u>responsible</u>. In art, force majeure has no traction because the only force that counts is the one belonging to the work of art—the work of art, which possesses its own force, its universality, and its autonomy. And the artist is responsible for it. The artist is responsible even beyond his own responsibility. That is what art is: to be responsible for that which we cannot be responsible. That is why art and force majeure cannot be evoked together. It is a contradiction. Where art makes sense, force majeure makes no sense at all. The argument of force majeure hides (poorly) the deresponsibilization of Man. I want to be responsible for everything that concerns my work and also beyond. If I cannot be, and if force majeure is evoked, I am being prevented from taking this responsibility. They want to limit it or restrain it. This is unacceptable for an artist. That is why you have to resist deresponsibilization with full force. Art seems to me to be a precious tool for resisting it. Because art—because it is art—possesses the capacity to establish a dialog or a confrontation beyond all dangers, fears, and safety-making habits. Art and philosophy are the only resistance. They are resistances against those forces that are supposedly forces majeures.

March 2009
[Translated from French by Molly Stevens]

FOR THE FIRST TIME (ABOUT ANDY WARHOL)

In May 1978 schoolmates of mine from the Vorkurs [preliminary course] of the Schule für Gestaltung Zürich took me to the opening of an exhibition. It was the exhibition "Andy Warhol" at Kunsthaus Zürich, and it changed my life. It was not the first exhibition I went to, of course, but it was the first time I faced an artwork and was immediately affected. For the first time I felt implicated, for the first time I was touched by art. I was touched by the artwork of Andy Warhol and in particular by *129 Die in Jet*. I was dazzled, I was happy. *129 Die in Jet* implicated me!

I will always remember this specific moment as a moment of grace and solitude. I felt included in the work, included in art. I realized that art—because it's art—has the power of transformation. The power to transform each human being. I realized that art gives me the space to think on my own. From then on, art became for me part of the real—"the real" but not reality—and therefore I saw the possibility and importance of confronting the real. *129 Die in Jet* was the artwork that made me suddenly focus on this conflict.

It was not a coincidence that *129 Die in Jet* struck me so strongly, because Andy Warhol said "yes"—he agreed with the social and economic reality. He agreed with consumer society. Andy Warhol is the artist of agreement. To agree means to confront oneself with reality as it is. To agree is the condition for a possible acceptance or refusal of something. I understood that one can change something only if one agrees. To agree does not mean to approve everything. Being in agreement is the condition that makes rejection or acceptance possible.

Only he who agrees can change things, said the author Heiner Müller. To agree requires being audacious. The audacity to think that art—because it's art—is resistance. Art resists facts. Art resists political, aesthetic, and cultural habits. Through its resistance, art is movement, positivity, intensity, belief. Andy Warhol cooperated with reality in order to change it. So Andy Warhol showed me that reality cannot be changed unless you agree with it. In his work there is a kind of loss of reality, and it is precisely this loss that creates a new real in his work.

———

The image Andy Warhol painted in *129 Die in Jet* was taken from the cover of the *New York Mirror* on June 4, 1962, the day following an Air France Boeing 707 plane crash during takeoff from Paris to Atlanta. At the time it was the world's worst air disaster. *129 Die in Jet* was the first depiction of death in the work of Andy Warhol. To me, this work gives the sense of something futile and absolute. It reminds me that art—because it's art—is autonomous. Autonomy is what gives the artwork its beauty and its absoluteness. I also understood that art—because it's art—is universal. Universality means Justice, Equality, the Other, the Truth, the One World. Andy Warhol created something new. With *129 Die in Jet*, I understood something new. I understood that to make something big does not necessarily mean it is important. I understood that it means to be committed to something. But, simultaneously, an emptiness is created by this enlargement. Andy Warhol's painting showed me that commitment and enlargement remove the meaning. He suggested another kind of meaning, a different meaning. Andy Warhol was my teacher. Didn't Andy Warhol say, "Don't cry—Work!"?

Aubervilliers, April 2010
[Composed in English]

DOUBLE HAPPINESS (ON INTELLECTUAL PROPERTY)

"Intellectual property" is not my problem. It is <u>not a problem</u> because—as an artist—I am not working only with my intellect. As an artist, I am trying to do a work that goes beyond the intellect, that goes beyond theory but also beyond practice. "Intellectual property" is also not the problem because the problem is not the problem of "property," of "claiming what is mine," of what "belongs to me," of "copying from others," of "being influenced by," of "borrowing from others," because then one cannot move forward. Neither do I want to be obliged to play the defensive game of "protection" and "law." I am interested in the offensive, in the affirmation, in "standing up," in "self-construction," and in the affirmation of authorship!

Since the time of Marcel Duchamp and his very important work, we have known how significant and important authorship is. Marcel Duchamp did not deny authorship; he created a new concept of the author and established a new author-subject. Marcel Duchamp reaffirms <u>the importance of the author</u> by signing a readymade that has no signature; he does not eradicate the signature as a sign of authorship, but reinforces it by asserting it. Marcel Duchamp saw himself as an author, and he gave us the form to understand this forever.

I think as an artist my problem—the essential problem—is the problem of form. <u>The problem of art is the form</u>, and my problem is: How can I give a form that, in all cases, resists historical facts? How can I give a form that reaches beyond history—the history I am living in? And how can I give an ahistorical form in my historical field today? How can I give form to my position beyond political, aesthetic, and cultural habits? And how can I give a form that creates a universal truth? This is my big problem, the only one I want to have and the only one I want to struggle with.

A form—a new form, a given form, a worked-out form—has no property. <u>A form has no property!</u> Because it's really form, because it's a creation, because it's something that art can do—something specific to art. No great artist who gives or creates a new form claims to be the owner of this form, simply because it belongs to everyone! There is no "private property" in art. As

an artist, one is the author; one does not need to claim "property." The issue of intellectual property is not the problem because, if I try to give form and if one of these attempts creates a form, a new form, it is such an important achievement that any question about property is no longer important. Great artists achieve this by doing a work that belongs to me—to me as public, to everybody. Their artworks have the power—through their form—to implicate me so strongly that I myself feel as if they were mine.

Sometimes I see a form—not only a so-declared artwork—and I immediately feel, This is my work, this is mine, this is my form, I've done it myself! There is no question about property, because the form I see belongs to everybody as well as me. The grace of a form is that the public takes possession of it. It's a feeling of happiness, a double happiness—I am happy as the author and I am happy as the public. I am happy because <u>form is universal</u>; it therefore belongs to everyone and of course goes beyond the problematic of "To whom does it belong?" As an artist, I want to fight to give form, and if I achieve this, I don't need to worry about the ownership of my form, the artwork. The artwork is autonomous. It exists without its owner, without me—this is one of the most beautiful things in art.

2010
[Composed in English]

Letter to Nancy and Richard (My Guggenheim Dilemma)

Dear Nancy,[24] Dear Richard,[25]

As you know, I am one of those who signed the petition for the boycott of the Guggenheim in Abu Dhabi, to put pressure on the museum to do everything it can in order to remedy the labor exploitation on Saadiyat Island, to treat the workers as they deserve to be treated, and to protect their rights as workers. I am happy and willing to do everything I can do in order to achieve this; that's why I signed the petition for a boycott.

Nevertheless, there is a dilemma. The dilemma—my dilemma—is not about exhibiting, here and now, my work *Cavemanman* in the Guggenheim Bilbao, while at the same time boycotting the Guggenheim in Abu Dhabi. That is not my dilemma, and the dilemma is not about some other contradiction observers might point out, either.

The dilemma, my dilemma, the real dilemma, is the contradiction between the politics of "good intentions," "good conscience," "the engagement of the artist"—which I would call pseudo-politics or "making politics," for it implies narcissism and selfishness, but which I signed the letter for—and my belief and conviction that art, as art, has to keep completely out of any daily political cause in order to maintain its power, its artistic power, its real political power.

By signing the petition for this boycott, I am facing this dilemma, my dilemma. It's a problem without a solution; it's a dead-end. On the one side, I really want to do what I can, what I think is in my power, to fight for equality, universality, and justice. But I also know that it is easy to add my signature to this fancy artists' boycott. Too easy, because I know that when signing a boycott, I have to pay the price for the boycott—myself first—so that the outcome can be a real success.

Art—because it's art—resists a simplified idealism and a simplified realism, because it refuses aesthetic and political idealism and aesthetic and political realism. Art—because it's art—is never neutral, and art cannot be neutralized by doing politics. I want to admit that this is the dead-end I am in. I have to

———

face it. I have to confront this dilemma and furthermore—as an artist—I even have to assert it as my dilemma.

My hope is that something that makes sense remains. My signature for the boycott will make sense if it does change the conditions of the workers at Guggenheim Abu Dhabi. My signature for the boycott will make sense if the dilemma, the trap, and the temptation of politics allows me to confront the hard core of reality, which is the limit of such a boycott. And my signature for the boycott of Guggenheim Abu Dhabi will make sense if I have to pay a price for it.

April 2011
[Composed in English]

Letter to Elizabeth (Inventing My Own Terms)

Dear Elizabeth,[26]

I really think your question is pertinent: How does art shed light on philosophy, and, conversely, how does philosophy shed light on art practice? Do the two disciplines speak in parallel and never touch, or are there points of intersection where each can illuminate, provide models for, and critique the other? Yes, my answer is yes! through "Friendship" and by "Inventing my own terms."

Friendship between Art and Philosophy

My first response is: Friendship! Friendship between Art and Philosophy! Together with my friend Marcus Steinweg, a philosopher, we made a map: the "Map of Friendship between Art and Philosophy." With this map we wanted to make a visual statement of this friendship and work out, give form to, and assert why Art and Philosophy are linked together: Art and Philosophy are linked by a shared admiration and passion, not by influence, discussion, illustration, explication, or justification, not by these static and hostile terms from which one cannot build a friendship. Friendship is, or can be, built from shared admiration for somebody and passion for something. Friendship between Art and Philosophy does not mean that the artist needs the philosopher in order to do his own work, nor that the philosopher needs the artist to do his work, but it means that Philosophy and Art really share the same movement, the same dynamic, the same interrogations, the same problematic, the same headlessness, in order to accomplish the constitutive creative artistic act. This artistic act is the assertion of a new truth. In Philosophy this truth is a new concept, and in Art this truth is a new form.

Inventing My Own Terms

Terms and notions are important, both in Philosophy and in Art. I completely agree with you when you point out that Philosophy provides a popular source

———

of quotation and reference for artists, curators, historians, and theorists writing about art. But my response is: I want to invent my own terms in Art! Philosophers use words with precision and exactitude. Following their logic, philosophers are sculpting concepts in the strongest way they can. The words they use are powerful and important tools in order to create new terms in Philosophy. Philosophers are inventing their own terms. I—as an artist—admire that enormously. I can learn from Philosophy and from philosophers and try to use my own terms as well in relation to Art, in relation to my work and to myself as an artist. When people speak of "community art," "relational aesthetics," "engaged art," "political art," "participatory art," "educational art," these terms, all of them really, make no sense. But—as an artist—I have the possibility to invent my own terms, my own terms in Art.

In the "Map of Friendship between Art and Philosophy" there are ten terms Marcus and I worked out together. The Friendship between Art and Philosophy means the total sharing of these ten terms, in what we call "unshared responsibility." "Unshared responsibility" is the adequate term for our relationship, both in work and in friendship. "Unshared responsibility" means that each of us takes on—each one on his own—the entire responsibility for the work done. I take entire responsibility for the work contributed by Marcus, and Marcus takes entire responsibility for the work contributed by me—this is friendship. Each one—without sharing—is entirely responsible for the work of the other. There is no sharing of responsibility. There is a "nonsharing" and there is responsibility. This implies confidence and generosity. This means agreeing completely with the other. This means agreeing completely with the production of the other. I agree with Marcus's production—completely—and Marcus agrees with my production—completely. Agreeing does not mean approving, but agreeing means being responsible for—being responsible for something you are not responsible for. This is what goes beyond criticism and negativity. This is movement and belief. Beyond anything, in order to agree, I need, and Marcus needs, to be sovereign. There is no space, no will, and no temptation to neutralize the other. This is friendship. This is working in friendship. Therefore, the ten terms of our map are equally important to both of us;

there aren't five terms for Philosophy and five for Art. All terms are essential terms for Marcus as a philosopher as well as for me as an artist. To share this makes me happy; this is friendship and we materialized it—together—in our "Map of Friendship between Art and Philosophy." To answer your question as the artist, I will follow these ten terms, and remain faithful to our ten Friendship-terms: 1. Love, 2. Assertion, 3. Headlessness, 4. Form, 5. Autonomy, 6. Universality, 7. War, 8. Courage, 9. Hope, and 10. Resistance.

1. Love

I love Philosophy and I love Spinoza, I love Gramsci, I love Foucault, I love Bataille, I love Deleuze, I love Nietzsche, I love Badiou, I love Sartre, I love Arendt. I need Philosophy for my life, to try to find answers to big questions such as "love," to name one of the most important ones. And for this, I need Philosophy—please believe it! I am passionate about Spinoza because reading his *Ethics* had a real impact on me. I am passionate about Philosophy in general because I enjoy not understanding everything. I like the fact that in Philosophy things remain to be understood and work still needs to be done. I—as an artist—admire how great philosophers are interested in and committed to other thinkers and how these philosophers are the most able to explain with their own words the concepts of other philosophers. Gilles Deleuze is truly an important philosopher to me; he's really the one who convinced me to start reading Spinoza. You have to know, Elizabeth, I am not a reader and I don't pretend to be one. *Ethics* is overwhelming in form, logic, and clarity. *Ethics* is a powerful attempt to fight obscurantism and idealism, and today, more than ever, we need to confront this. Reading Spinoza means insisting on receptivity and sensuality without the idea of a certain type of infinity. Spinoza presents a concept devoid of transcendence and devoid of immanence. It is the concept—as Deleuze shows—of Here and Now, the concept of Life—Life as a subject without God. An active subject, a subject of pleasure and leisure. A responsible, gay, happy, assertive subject. To do artwork is only possible with love. I love Mondrian, I love Nolde, I love Schwitters, I love Beuys, I love Warhol, I love Duchamp, I love Malevich, I love Oppenheim.

———

2. Assertion

In Art the assertion of form is essential. Only when I assert a form—even if it is against everyone and everything—am I constituting a work of art. A work of art is always an assertion, and as an assertion it is a gift. A challenging and unexpected gift. A gift which—by its generosity—blows off any thoughts of calculation and economization. I want to give everything; I want to understand the form of my work as a gift. But the gift is not the work itself—the gift is the act of doing it and doing it that way! What I love about the notion of "the gift" is its offensive, demanding, and even aggressive part, the part that provokes the other to give more! It's the part which implies a response, a real and active response to the gift. The gift—or work—must be a challenge: this is why "auto-destruction" is unthinkable. To me, "self-cancellation" is connected to narcissism, to tearfulness. Those terms are not related to my understanding of Art as an assertion, an absolute assertion of form, as an engagement, as a commitment to pay the price, as a mission, as a never-ending conflict, as a strength, and as a position. In my work I assert forms that cannot be asserted, and this is—really—the assertion; this is the gift.

3. Headlessness

The term "headless" is also completely shared by Art and Philosophy. "Headless" does not mean stupid, silly, or without intelligence; "headless" does not mean being ignorant. I am not an ignorant artist—better not be ignorant, as an artist! Of course, I love the beautiful book *The Ignorant Schoolmaster* by Jacques Rancière and its fantastic, enlightening title, but I am not a schoolmaster—I don't even teach Art—I am an artist! I am and want to be a headless artist. I want to act—always—in headlessness; it's something important to me. I want to make Art in headlessness. "Headlessness" stands for doing my work in a rush and precipitously. Other words for headlessness are restlessness, insisting and insisting again heavily, acceleration, generosity, expenditure, energy (Energy = Yes! Quality = No!), self-transgression, blindness, and excess. I never want to economize myself and I know that—as the artist—I sometimes look stupid facing my own work, but I have to stand for this ridiculousness. I

want to rush through the wall head-first; I want to make a breakthrough; I want to cut a hole, or a window, into the reality of today.

4. Form

The essential question in Art is the question of form. How can I give a form that creates a truth? How can I give a form—today, in my historical field—which creates, beyond historical facts and beyond the actuality of today, a universal truth? These are the essential questions to me as an artist. I don't conceive my work as an outcome of philosophers' concepts or of theory. I am not illustrating Philosophy with my work. I am not reading Philosophy to do my artwork and I am not reading Philosophy to justify my work.

It is crucial not to forget that an artwork can be something that does not function. (I do not say that Art has no function, but Art does not have to function!) Today the question of functioning ("Does it function? Does it work? Is it—then—a success or not?") arises automatically and quickly as the criteria for "good" or "bad" art. This is stupid and easy.

Art is something which reaches us beyond such criteria. To believe in this power of Art is to me what "working politically" as an artist means: trying to resist, in and with the work, the pressure of functionality. I am often surprised by effortless, inexact, and empty terms or notions used in order to "explain" an artwork. I have to invent my own terms and I want to insist with my own notions. I know—as an artist—that to give form is the absolute necessity.

5. Autonomy

Art is autonomous, Art is autonomous because—and just because—it's Art. Another word for autonomy is "beauty" or "the absolute." To make it clear, I am not interested in "autonomy" as self-sufficiency or self-enclosure. I am for autonomy as a self-erection or self-expenditure. There is a difference between self-expenditure, being cruel vis-à-vis my own work, not-economizing myself, and what is called "self-cancellation" and "auto-destruction." I want to undermine myself—my person—in doing my work; I do not want to undermine my work! I don't want to take myself seriously in doing my work but I want

to do and take my work seriously! I believe in the autonomy of my artwork, I believe, I think, I know that the autonomous in an artwork is something that only can occur through grace. As an artist, I know that I have to be touched by grace. I have to be open—and I have to make an open and confident work—in order to be touched by grace!

6. Universality

Universality is constitutive of Art. It's something very important to me. One can say that Art is universal because it's Art. If it is not universal it is not Art, it's something else. I do oppose the term "universality" to culture, tradition, identity, community, religion, obscurantism, globalization, internationalism, nationalism, and regionalism. With my artwork—and not only with my works in public space—I experienced that universality is truly essential. There are other words for universality: the Real, the One World, the Other, Justice, Politics, Aesthetics, Truth, the "Non-exclusive audience," and Equality. I believe—yes, believe!—in equality. To me, equality is not a theory; it has to be achieved again and again, every day and with each artwork. I believe that Art has the power of transformation. The power to transform each human being, each one, and equally without distinction. Yes—equality is the foundation and the condition of Art.

7. War

As an artist, I need to be a warrior. To be a warrior means to fight for something, not against something or somebody. I want to fight for my form. I want to develop it, I want to propose it, and I want to defend it. It's war, but it's not war against something or against somebody—it's war for something and war for somebody. To be a warrior means not to complain if my form is not taken seriously or if it is criticized. To be a warrior means to be aware of all the obstacles that need to be overcome in order to assert my form. To be a warrior means to never complain about ignorance or adversity. It means to fight, to work, and to keep faith in my mission. To be a warrior means to be someone who has a mission, someone who wants something, who has pleasure and fun,

who has the power and the energy to accomplish a mission. Perhaps an impossible mission—never mind—but the important thing is the mission. Each artwork is impossible. It is impossible because it's not necessary to do a possible artwork! An artwork is an impossible form and an impossible assertion and it's impossible to defend. To me, doing an artwork is not "impossible but necessary" but "impossible and necessary." An artwork must possess both "impossibility and necessity." Don't they together make sense? Don't they together create density, charge, and energy? Don't "impossibility and necessity"—together—give beauty? A warrior— beyond impossibility—never gives up the search for beauty; that's why a real warrior has the advantage—already—to be fighting for something.

8. Courage

In Art and Philosophy I need the courage to stand alone, the courage to be isolated, to be lonely. I am aware that the words "lonely," "isolated," and "alone" can be interpreted as "romantic" or against "the collective," but that's not the point because I am not against the collective. I am interested in the hard core of a decided and assumed loneliness and an assumed personal position. There is one term that has been very important to me—for years—the term "precarity." My adherence to precarity comes from my life, from my experience, from what I love—from the precarious forms I love—and from what I understand of it. My adherence to this term does not come from books, philosophy, or theory. I am happy that philosophers and writers such as Judith Butler, Emmanuel Levinas, Hal Foster, and Manuel Joseph among many others, have developed and are developing thoughts about "precariousness," but I must tell you my involvement comes from myself; I learned it myself and there is not much more to learn. My tendency is even—I admit—to avoid going "deeper" because I need, yes I need, my own strange, wrong, headless, misunderstood, bad, stupid—but—my fucking own relation to preserve and develop. This is not against theory or a refusal of theory, absolutely not; this is being open to what comes from myself, to what comes only from my own:

I'm the only one to see it and to understand it like this, only I can do it, only I take it seriously, only I have the courage to give it a form.

9. Hope

I hope, I dream, I want to act, and I want things to change. That is why I read Philosophy. I am not interested in reading writers, philosophers, thinkers, as an artist. I am interested in them as a human being. I don't use their work for my work. I read it to try to stay alert, to keep my thoughts active. To read their writings keeps my brain working, that's why I do it. With his essay "La notion de dépense," Bataille opens a field of strength. Loss is not destruction, but loss is a form to impose, an economic balance based on human activity and not on capitalism. Bataille said there must be structure, there must be excess. Hope as a principle for taking action, for moving and going straight ahead. Hope does not mean "hopeful for something" or "hopefully something will happen." Hope means hope as real Hope. To breathe—every second—is the physical translation of the Hope I mean.

10. Resistance

Art is resistance, Art is resistance as such. Art—because it's Art—resists facts; Art resists aesthetic, cultural, political habits. Art—in its resistance—is movement, intensity, belief, positiveness. This I share with Marcus Steinweg. Pure philosophy is true, cruel, pitiless, philosophy that affirms, acts, creates. Philosophy is Art! The philosophy of Spinoza, of Nietzsche, of Deleuze, of Foucault is Art. I see the work of Foucault as Art—I see and can touch its resistance! It allows me to approach it, to seize it, to be active with it without understanding all of it. I don't have to be a historian, a connoisseur, or a specialist to confront works of art. I can seize the energy, the urgency, the necessity, the density of Michel Foucault's work—as of the work of other philosophers—it is charged. It's a battery. I can take this charged battery. It is pure energy, the energy of a singular commitment. It is the commitment to make a work of art. It is the affirmation that the work of art is philosophy and that philosophy is a work of art. I want to make a work, a work of art! I want to become what I am. I want

to become an artist! I want to appropriate what I am. I want to resist. This is my work as an artist.

December 1, 2010
[Composed in English]

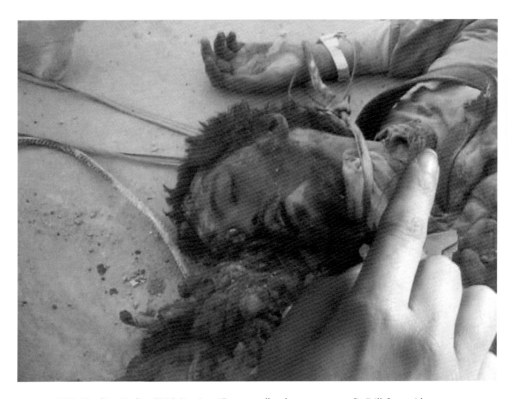

1.17 *Touching Reality*, 2012 (4 min., 45 sec., endless loop—no sound). Still from video. "La Triennale—Intense Proximity," Palais de Tokyo, Paris, France, 2012. Courtesy Galerie Chantal Crousel, Paris, France.

WHY IS IT IMPORTANT—TODAY—TO SHOW AND LOOK AT IMAGES
OF DESTROYED HUMAN BODIES?

I will try to clarify, in eight points, why it is important—today—to look at images of destroyed human bodies like those I have used and integrated in different works such as *Superficial Engagement* (2006), *The Incommensurable Banner* (2008), *Ur-Collage* (2008), *Crystal of Resistance* (2011), and *Touching Reality* (2012).

1. Provenance

The images of destroyed human bodies are made by nonphotographers. Most of them were taken by witnesses, passersby, soldiers, security or police officers, or rescuers and first-aid helpers. The provenance of the images is unclear and often unverifiable; there is a lack in our understanding of what the "source" is here. This unclear provenance and this unverifiability reflect today's unclearness. This is what I am interested in. Often the provenance is not guaranteed—but what, in our world today can claim a guarantee, and how can "under guarantee" still make sense? These images are available on the Internet mostly to be downloaded; they have the status of witnessing and were put online by their authors for multiple and various reasons. Furthermore, the origin of these images is not signaled; sometimes it is confused, with an unclear, perhaps even manipulated or stolen address, as is true of many things on the Internet and social communication networks today. We confront this every day. The undefined provenance is one of the reasons why it is important to look at such images.

2. Redundancy

The images of destroyed human bodies are important in their redundancy. What is redundant is precisely that such an incommensurable amount of images of destroyed human bodies exists today. Redundancy is not repetition, the

repetition of the same, because it is always another human body that is destroyed and appears as such redundantly. But it's not about images—it's about human bodies, about the human, of which the image is only a testimony. The images are redundant pictures because it is redundant, as such, that human beings are destroyed. Redundancy is important here. I want to take it as something important, and I want to see this redundancy as a form. We do not want to accept the redundancy of such images because we don't want to accept the redundancy of cruelty toward the human being. This is why it is important to look at images of destroyed human bodies in their very redundancy.

3. *Invisibility*

Today, in the newspapers, magazines, and TV news, we very seldom see images of destroyed bodies because they are very rarely shown. These pictures are nonvisible and invisible: the presupposition is that they will hurt the viewer's sensitivity or only satisfy voyeurism, and the pretext is to protect us from this threat. But the invisibility is not innocent. The invisibility is the strategy of supporting, or at least not discouraging, the war effort. It's about making war acceptable and its effects commensurable, as was formulated, for example, by Donald Rumsfeld, former U.S. Secretary of Defense (2001–2006): "Death has the tendency to encourage a depressing view of war." But is there really another view to have of war than a depressing one? To look at images of destroyed human bodies is a way to engage against war and against its justification and propaganda. Since 9/11 this phenomenon of invisibility has been reinforced in the West. Not to accept this invisibility as a given fact or as a "protection" is why it is important to look at such images.

4. *"Iconism"*

The tendency to "iconism" still exists, even today. "Iconism" is the habit of "selecting," "choosing," or "finding" the image that "stands out," the image that is "the important one," the image that "says more," the image that

"counts more" than the others. In other words, the tendency to iconism is the tendency to "highlight"; it's the old, classical procedure of favoring and imposing, in an authoritarian way, a hierarchy. This is not a declaration of importance about something or somebody, but a declaration of importance directed at others. The goal is to establish a common importance, a common weight, a common measure. But iconism and highlighting also have the effect of avoiding the existence of differences, of the non-iconic and of the non-highlighted. In the field of war and conflict images, this leads to choosing the "acceptable" for others. It's the "acceptable" image that stands for another image, for all other images, for something else, and perhaps even for a non-image. This image or icon has to be, of course, the correct, the good, the right, the allowed, the chosen—the consensual image. This is the manipulation. One example is the image, much discussed (even by art historians), of the "Situation Room" in Washington during the killing of Bin Laden by the Navy Seals in 2011. I refuse to accept this image as an icon; I refuse its iconism, and I refuse the fact that this image—and all other "icons"—stands for something other than itself. To fight iconism is the reason why looking at images of destroyed bodies is important.

5. *Reduction to Facts*

In today's world of facts, of information, of opinion, and of comments, a lot is reduced to being factual. Fact is the new "golden calf" of journalism, and the journalist wants to give it the assurance and guarantee of veracity. But I am not interested in the verification of a fact.

I am interested in truth, truth as such, which is not a verified fact or the "right information" of a journalistic story. The truth I am interested in resists facts, opinions, comments, and journalism. Truth is irreducible; therefore, the images of destroyed human bodies are irreducible and resist factuality. I don't deny facts and actuality, but I want to oppose the texture of facts today. The habit of reducing things to facts is a comfortable way to avoid touching truth, and to resist this is a way to touch truth. Such an acceptance wants to impose

on us factual information as the measure, instead of looking and seeing with our own eyes. I want to see with my own eyes. Resistance to today's world of facts is what makes it important to look at such images.

6. *Victim Syndrome*

To look at images of destroyed human bodies is important because it can contribute to an understanding that the incommensurable act is not the looking; what is incommensurable is that destruction has happened in the first place—that a human, a human body, was destroyed; indeed, that an incommensurable amount of human beings were destroyed. It is important—before and beyond anything else—to understand this. It's only by being capable of touching this incommensurable act that I can resist the suggestive question: Is this a victim or not? And whose victim? Or is this perhaps a killer, a torturer? Is it perhaps not about the victim? Perhaps this destroyed human body shouldn't be considered and counted as a victim? To classify destroyed human bodies as victim and not-victim is an attempt to make them commensurable. The victim syndrome is the syndrome that wants me to give a response, an explanation, a reason to the incommensurable and finally to declare who is "the innocent." The only surviving terrorist in the Mumbai killings in 2008 declared to the court where he was sentenced to death: "I don't think I am innocent." I think the incommensurable in this world has no reason, no explanation, and no response—before and beyond. In this incommensurable world, I have to refuse the commensurability of accepting classification as victim or not-victim. I do not want to be neutralized by what wants to make the world commensurable. I do not want to be neutralized by what wants to make the world commensurable. I refuse to explain and to excuse everything because of its context. I do not want to be neutralized by "the context." Looking at images of destroyed human bodies is important because I don't want to give up in response to the victim syndrome.

7. *Irrelevance of Quality*

These images—because they were taken by witnesses—don't have any photographic quality. I am interested by this. It is the confirmation that, in conditions of urgency, "quality" is not necessary. I have always believed in "Energy = Yes! Quality = No!" There is no aesthetic approach here beyond the objective of taking the photograph. Concerns of quality are irrelevant in the face of the incommensurable. The images of destroyed bodies express this. No technical know-how is needed. No photographer is needed. The argument of photographic quality is the argument of the one who stands apart, is not present, and who, on behalf of the "quality" argument, expresses his distance and his attempt to be the supervisor. But there is no supervising anymore; what is "needed" is to be a witness, to be there, to be here and to be here now, to be present, to be present at the "right time" at the "right place." Most images are taken with small cameras, smart phones, or mobile phones. They match our way of witnessing "today's everything" and "today's nothing" in daily life and making it "public." The irrelevance of the quality of these images is an implicit critique of "embedded" photo-journalism and journalism. This irrelevance of quality is what makes it important to look at such images.

8. *Distancing through "Hypersensitivity"*

I am sensitive and I want to be sensitive, and at the same time I want to be awake, to pay attention. I don't want to take distance; I don't want to look away and I don't want to turn my eyes. Sometimes I hear viewers saying, while looking at images of destroyed human bodies, "I can't look at this, I must not see this, I'm too sensitive." This is a way of keeping a comfortable, narcissistic, and exclusive distance from today's reality, from the world. From our world, the unique and only world. The discourse of sensitivity—which is actually "hypersensitivity"—is about keeping one's comfort, calm, and luxury. Distance is only taken by those who—with their own eyes—won't confront the incommensurable of reality. Distance is not given as a personal gift; it's

something taken by very few to keep intact their exclusivity. Hypersensitivity is the opposite of the "non-exclusive public." In order to confront the world, to struggle with its chaos, its incommensurability, in order to coexist and to cooperate in this world and with the other, I need to confront reality without distance. Therefore, it is necessary to distinguish "sensitivity," which means to me being "awake" and "attentive," from "hypersensitivity," which means "self-enclosure" and "exclusion." To resist hypersensitivity, it is important to look at those images of destroyed human bodies.

2012
[Composed in English]

Letter to the French Minister of Culture and Communication

Dear Sir,

The day before yesterday I received your letter dated May 2, 2012, announcing your intention to distinguish me as an officer in the French Order of Arts and Letters.

I thank you kindly and I am proud for my artwork. It makes me happy that the work I have been able to invent and develop here in France, the country where I live and work, has been taken into consideration by you, Sir, and by the French State that you represent.

However, it is my honor to impart to you my refusal to accept this distinction for reasons that I want to reveal to you:

During my youth in Switzerland in the canton of Grisons [Graubünden], I accepted, at my own will, the rank as officer in the Swiss army. Understanding later that I had chosen the wrong battlefield, I consequently refused to continue to serve the army, to belong to a corps or to an order.

It cost me four months in prison; then I left my native country to serve the only cause that seemed and still seems worth the trouble to me: Art. And it is here, in France—a country that has always been welcoming to me—that I was able to make my work emerge and it is today this country that brings you to honor me.

In no way do I want to be offensive, arrogant, or awkward, but I want only to stick to the line of conduct I chose at the time, that is, to not belong to an army or an order and not to be an officer.

What I want is to work, to fight for my mission in art—through my work—like a warrior, a warrior without a uniform and without medals.

I hope, Sir, that you understand the reasons for my refusal.

Please accept my humble respects.

Aubervilliers, May 9, 2012
[Translated from French by Molly Stevens]

33 AUSSTELLUNGEN IM ÖFFENTLICHEN RAUM 1998–1989

REPRODUCTION AND TRANSLATION OF *33 AUSSTELLUNGEN IM ÖFFENTLICHEN RAUM*

1998–1989

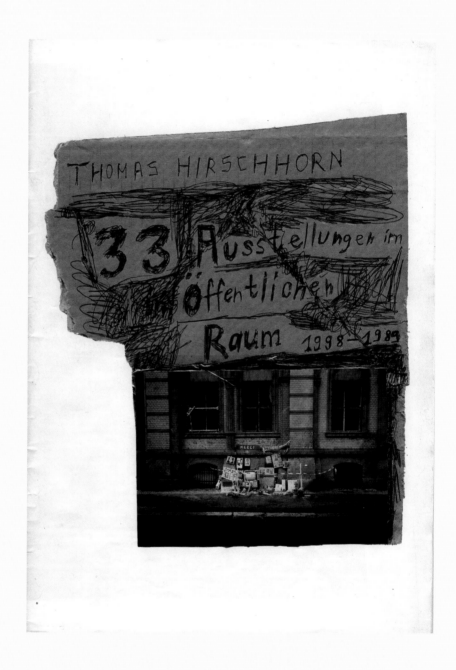

Cover:
Thomas Hirschhorn
33 Exhibitions in Public Space
1998–1989[1]

Pages 2–3:
The *Otto Freundlich Altar* was met with criticism from the chairman of the Jewish Cultural
Organization: "The serious intent of the artist cannot be gleaned from the hodgepodge of
cardboard signs and stuffed animals. The artistic means do not do justice to the systematic
murder of the Jews. Furthermore, the Jews do not remember their dead with altars."
Such criticism is completely beside the point! I worship the <u>artist</u> Otto Freundlich!
I love his <u>work</u>
The *Otto Freundlich Altar* is no Holocaust memorial!
[arrow] Excerpt
"I do not fear being broken because I constantly break myself, i.e., I do not live for my
private life but rather fight for the liberation of mankind and things from the habits of
possession and against everything that limits them, what is inconsistent with their true
nature." (Otto Freundlich)
At the post office
"Non Lieux"
Kaskaden-Kondensator
Basel in winter 1998
1st exhibition
Otto Freundlich Altar
1998
The same work in Berlin in fall 1998 at the Berlin/Berlin Biennale
[Top photo caption] On the Riehenstrasse

109

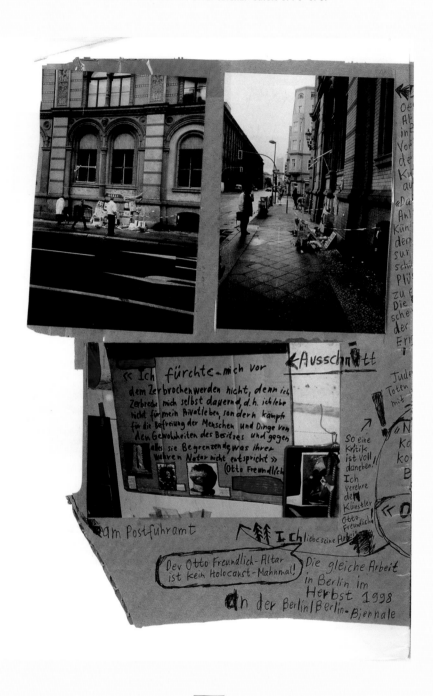

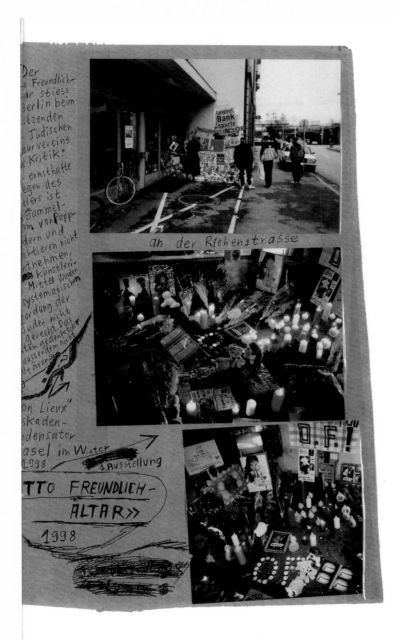

Page 4:
Ingeborg Bachmann Altar
Zurich 1998
On the occasion of the group exhibition "Freie Sicht auf's Mittelmeer"
(— weeks along the Kunsthaus façade)
Published in *Blick*
[clipping] The museum extends even beyond its gates: There, we see an apparently spontaneously created collection of expressions of condolence. One imagines that it is dedicated to some popular personality like Lady Di. Instead, it is a work by Thomas Hirschhorn, an altar to the writer Ingeborg Bachmann.
There are no boundaries here, no up and no down. The mountains have been exploded, and Switzerland extends all the way to the Mediterranean—at least in art.

Page 5:
Mondrian Autel [Mondrian Altar]
1997
(1st altar in a series of 4)
Centre genevois de gravure contemporaine
Geneva "été '97"
[arrow] In <u>Paris</u>
Farewell messages to Lady Di (Fall 1997)

Pages 6–7:

[arrow] By day

[arrow] At night

Skulptur-Sortier-Station

Skulptur Projekte Münster

Münster 1997

The individual alcoves:

1. The trophies

2. Robert Walser + E. Bove prizes

3. Otto Freundlich video

4. The tears alcove

5. Collector spoon with stalagmites / stalactites

6. Haizmann sculpture

7. VW, Peace, Chanel, Mercedes logos

8. Sculpture photos

9. Marlboro sculpture video

10. Exhibition model

[arrow] I built this sculpture based on the one in the *Degenerate Art* catalog.

[clipping] If, however, Haizmann, who at the time was celebrated as a "brilliant sculptor," had the idea of creating an "imaginary creature," then this monster, meant to be a fountain figure, would look like what this picture shows: And besides, this pathetic effort weighs several hundreds of kilos.

[arrow] Photo from the catalog: *Degenerate Art* 1937 Berlin/Munich

Page 8:
<u>At the Pantin market</u>
During 4 days (2 Saturdays, 2 Sundays)
I sold souvenirs of artists, writers, filmmakers, philosophers
as part of "Ici et maintenant"
A.P.S.V. Parc de la Villette
1997
Souvenirs du 20ème Siècle [Souvenirs of the twentieth century]
[arrow] my stand
[arrow] a fruit and vegetable stand

Page 9:
But I wanted to create a <u>real room</u>, a room that resists "virtuality"!
7/7, 24/24, Blauer Schwebender Raum [7/7, 24/24, Blue Floating Room]
<u>Kunsthof Zürich</u>
Ausstellungsstrasse
1997
I wanted to make a room that can be looked into day and night, a room in which I
wanted to show my work in a weightless condition. A room with its own physical law.
[arrow]

Pages 10–11:

Lascaux III, 1997 Bordeaux

The same work *Lascaux III* was exhibited for 1 day in 4 different places (in Bordeaux) in very little time. (Total, 9 days)

[arrow] on the place Saint-Michel (23 April 97)

[arrow] at the "Mériadeck" shopping mall (29 April 97)

[arrow] at "Burger King" (20 April 97)

[arrow] in an eighteenth-century apartment (26 April 97)

Cosquer Cave [arrow]

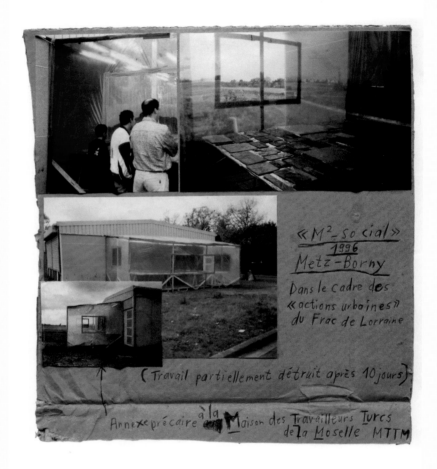

Page 12:
M2-Social
1996
Metz-Borny
As part of Frac Lorraine's "actions urbaines" [urban actions]
(Work partially destroyed after 10 days)
[arrow] Precarious extension to the Maison des Travailleurs Turcs de la Moselle MTTM
[House of Turkish Workers of Moselle]

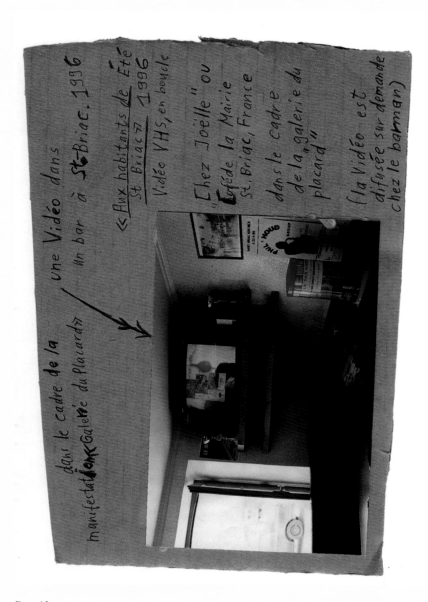

Page 13:
as part of the event "Galerie du Placard"
[arrow] a video in a bar at St. Briac. 1996
Aux habitants de St. Briac [To the residents of St. Briac]
Summer 1996
VHS Video, loop
"Chez Joëlle" or Café de la Mairie
St. Briac, France
As part of the "galerie du placard"
(the video is played upon request to the barman)

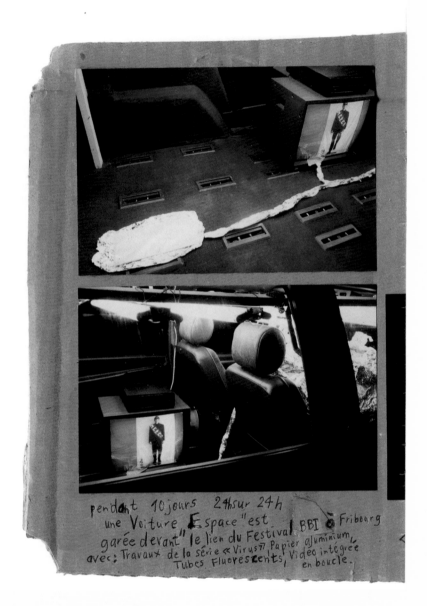

Pages 14–15:
During 10 days 24/24 hours
A Voiture "Espace" [minivan] is parked in front of the premises of the Festival BBI in
Fribourg with: Works from the *Virus* series, aluminum foil, fluorescent tubes, integrated
video playing in a loop.
Merci Bus 1996
Fribourg CH
BBI (Belluard Bollwerk International)
[arrow] Airbag in Action

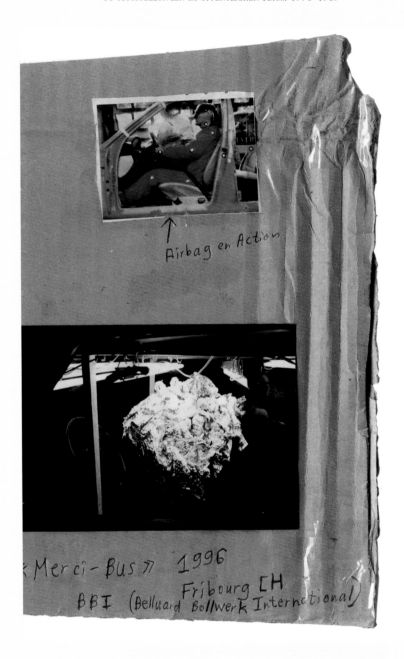

Airbag en Action

Merci – Bus 1996
Fribourg CH
BBI (Belluard Bollwerk International)

Pages 16–17:
The *Merci-Bus II*
Paris 1996
Tuesday 1 October "Zorba" Belleville
Wednesday 2 October "Aux Mousquetaires" Avron
Thursday 3 October "Au Clair de Lunes" Château-Rouge
Friday 4 October "Aux Myrtilles" Aubervilliers
Saturday 5 October "Bijou Bar" Pantin
Sunday 6 October "Saouira" La Chapelle

Monday 7 October "L'Atlantique" Pigalle

[photo caption] "Saouira" in La Chapelle

[photo caption] "Aux Myrtilles" in Aubervilliers

[arrow] During 7 nights the *Merci-Bus II* is parked in front of a different café in Paris or its outskirts

[photo caption] "L'Atlantique" at Pigalle

[arrow] view of the interior of the *Merci-Bus II*

[arrow] At the Bar "Aux Myrtilles"

Pages 18–19:
Guirlande des Larmes [Garland of Tears]
1996
Belle Fontaine Beach, St. Nazaire, France
[arrow] A garland in a bar
[arrow] "artificial" beach

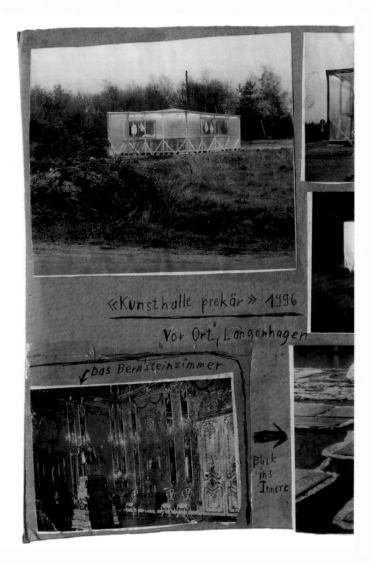

Pages 20–21:
<u>Kunsthalle prekär</u> [Precarious art gallery]
1996
"Vor Ort," Langenhagen
[arrow] The Amber Room
[arrow] View of the inside
At the edge of the Hanover-Langenhagen airport. An approximately 30-meter, illuminated, visibly accessible art gallery was built on a road, blocked by an earth mound, in the vicinity of the "car market."
[arrow] at night
[The *Kunsthalle prekär* was badly damaged after 10 days as a result of weather (snow, rain, wind) and was then taken down.]

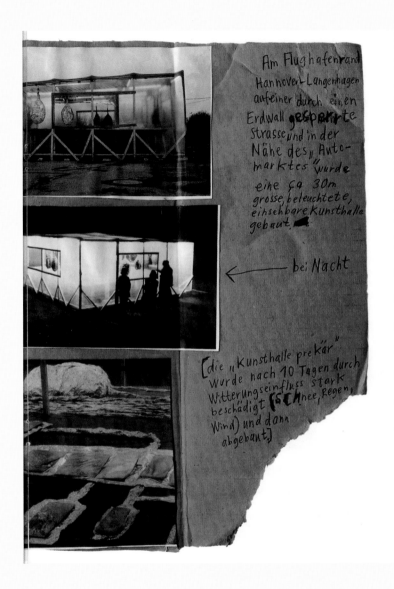

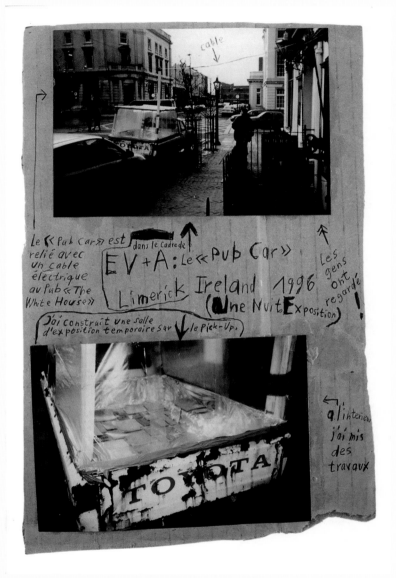

Page 22:
[arrow] As part of EV + A: The *Pub Car*
Limerick, Ireland, 1996
(One-Night Exhibition)
[arrow] An electric cable connects the *Pub Car* to the "The White House" pub.
[arrow] I built a temporary exhibition gallery on the pickup.
[arrow] People looked!
[arrow] I put works inside

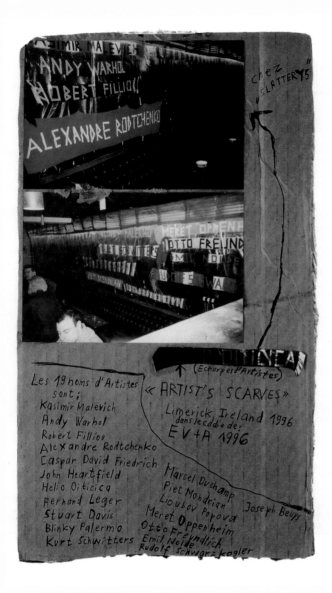

Page 23:
Artist's Scarves
Limerick, Ireland, 1996
As part of:
EV + A, 1996
At "Slattery's" [pub]
[arrow] (artist's scarves)
The 19 artist names are:
Kazimir Malevich
Andy Warhol
Robert Filliou
Aleksandr Rodchenko
Caspar David Friedrich
John Heartfield
Hélio Oiticica
Fernand Léger
Stuart Davis
Blinky Palermo
Kurt Schwitters
Marcel Duchamp
Piet Mondrian
Liubov Popova
Meret Oppenheim
Otto Freundlich
Emil Nolde
Rudolf Schwarzkogler
Joseph Beuys

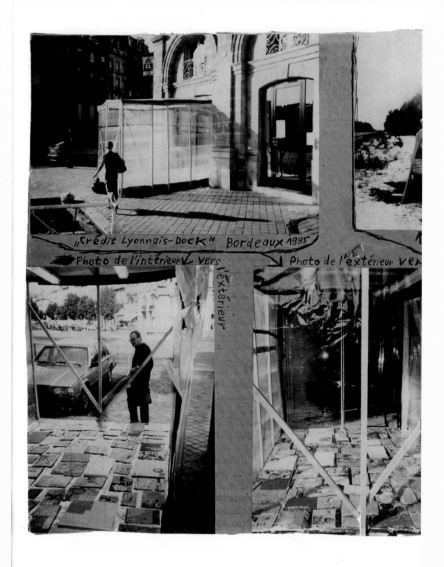

Pages 24–25:
Crédit Lyonnais-Dock, Bordeaux, 1995
[arrow] Photo from inside looking out
[arrow] Photo from outside looking in
[arrow] I saw this in Poland
[arrow] I saw this in "20 ans" at the exhibition "Shopping" in which I participated.
[arrow] She too
People looked at my work

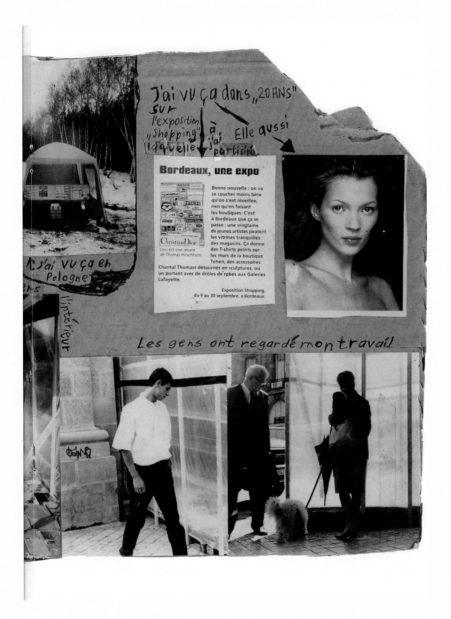

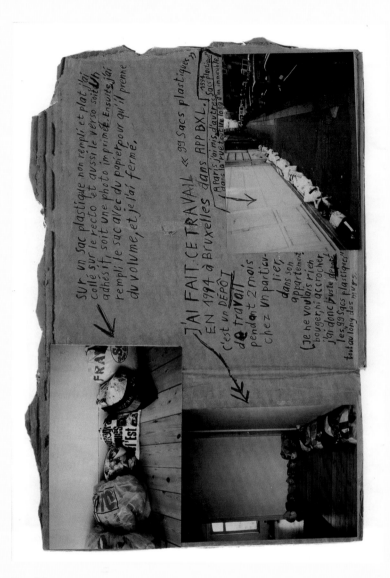

Page 26:

[arrow] On a plastic bag, not filled and flat, I stuck either some tape or a printed photo on the back and also the front. Then I filled the bag with paper so that it took on some volume, and I closed it.

[arrow] I made this work *99 Sacs plastiques*
in 1994 in Brussels in APP BXL.

It's a work <u>depot</u> for 2 months at a private home, in an apartment. (I didn't want to move anything or hang anything, so I just placed the *99 Sacs plastiques* all along the length of the walls.)

[arrow] 1994, in Paris, I placed the <u>*Sacs plastiques*</u> in the street, all along a building.

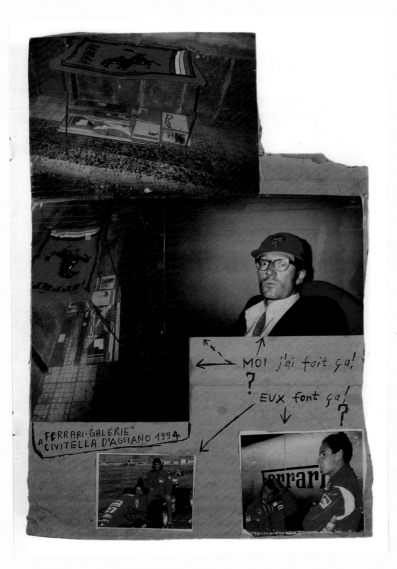

Page 27:
Ferrari-Gallery
Civitella d'Agliano, 1994
[arrows] I made this!
?
[arrows] They made that!
?

Pages 28–29:
Automarkt-Ausstellung [Auto market exhibition]
Civitella d'Agliano 1994
[arrow] Front hood
[arrow] Back hood
The car is used to exhibit!
[arrow] At the market, they exhibited their things.

I exhibited my things.
The same car [arrows]
in Kaliningrad with the Lenin statue
in Paris for the transport of my work
[arrow] Wilmersdorferstrasse 141, in Berlin in front of the house where Robert Walser lived

Page 30:

Auto-Nacht-Ausstellung [Auto night exhibition]

Civitella d'Agliano 1994

[arrows] I exhibited my work inside a car at night. The car was lit with a neon light placed inside on the ceiling of the car.

The car was parked in front of the village bar and the electricity was provided by the bar. The electric cable was the only connection to the bar.

[arrow] The bar in Civitella d'Agliano

Thank you

Page 31:
Exhibition at *Zorba*
1994
Paris
Bar, Café, PMU
I wanted to put my work like:
[arrow] 1. The standard measures you're required to have
[arrow] 2. The non-alcoholic drinks you're required to have

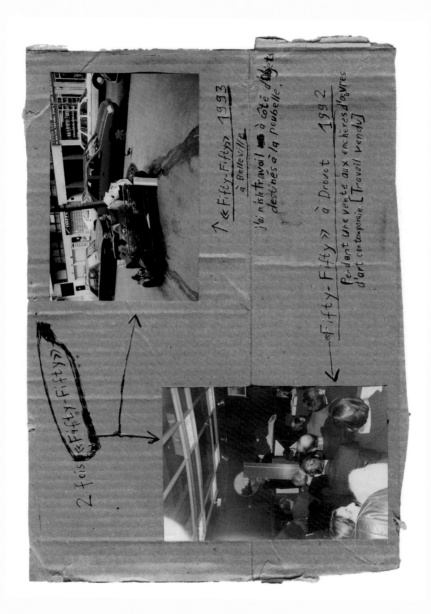

Page 32:
2 times *Fifty-Fifty* [arrows]
[arrow] *Fifty-Fifty*, 1993
in Belleville
I put the work next to objects being thrown out.
[arrow] *Fifty-Fifty* in Drouot, 1992
During an auction of contemporary art. [Work sold]

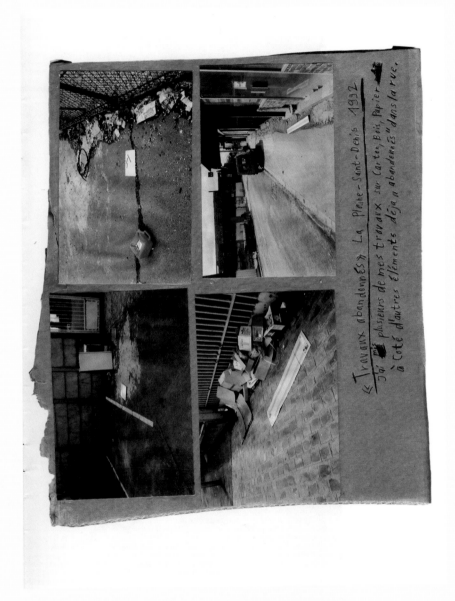

Page 33:
Travaux abandonnés, La Plaine-Saint-Denis, 1992 [Abandoned Works]
I put several of my works on cardboard, wood, paper next to other elements that were
already "abandoned" on the street.

———

Page 34–35:
<u>Bahnhofstrasse</u>, Zurich, 1992

At the entrances of stores and banks on the Bahnhofstrasse in Zurich, I set down works from the *Fifty-Fifty* series. These works (36 in all) were positioned like an umbrella one wants to leave outside so that it doesn't get the inside wet.

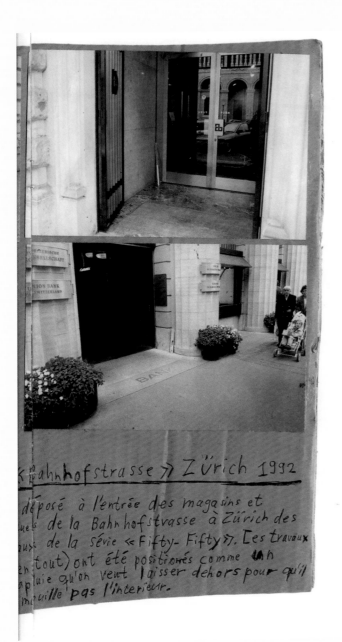

« Bahnhofstrasse » Zürich 1992

déposé à l'entrée des magasins et
...ues de la Bahnhofstrasse à Zürich des
...aux de la série « Fifty- Fifty ». Ces travaux
...en tout) ont été positionnés comme un
...pluie qu'on veut laisser dehors pour qu'il
...mouille pas l'intérieur.

Page 36–37:
<u>*Colonel Fabien*</u>, Paris, 1992
Around a square in Paris, I slipped original, A4 format works behind the windshield
wipers of the parked cars. (49 Works from the series *Fifty-Fifty* in all.)

« Colonel Fabien » Paris, 1992

Autour d'une place à Paris j'ai glissé entre les essuie-glaces
des voitures garées des travaux [19 Travaux de la série
« Fifty-Fifty » en tout]
6 originaux, Format A4

Page 38:

[arrow] A resident of China

[arrow] With my work I made a doghouse.

As part of "En vue des fondations d'une fondation et compte-tenu de la nature des travaux."

IAC

Naussac, <u>1992</u>

France

Page 39:
[arrow] St. Tropez 1992 Summer
My work <u>among the works by artists</u> exhibiting on the port of St. Tropez.
[arrow] With this intervention, I wanted to show that my work <u>is</u> also—
among the artists on the port of St. Tropez.
[arrow] He made that!

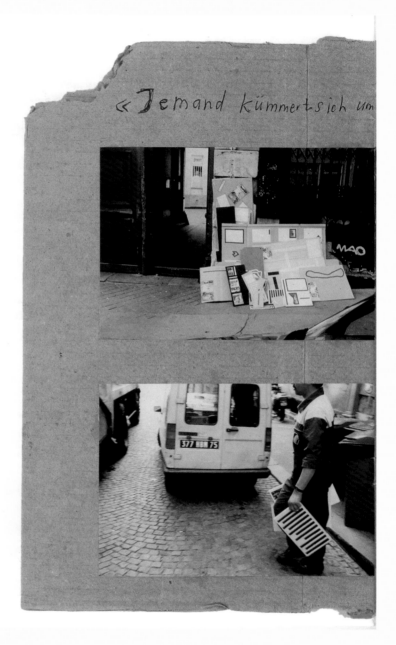

Pages 40–41:
Jemand kümmert sich um meine Arbeit [Someone is Taking Care of My Work], 1992 Paris

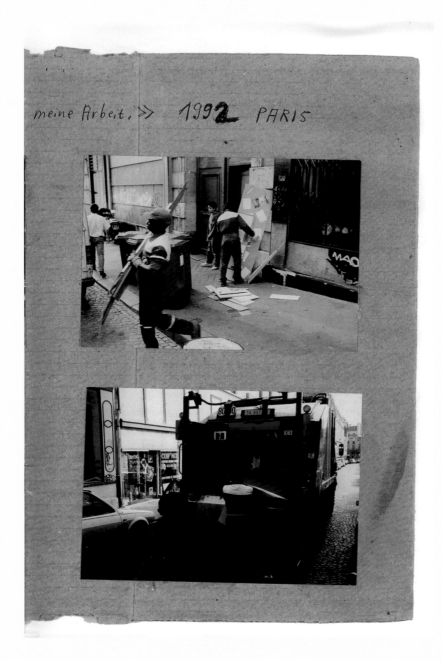

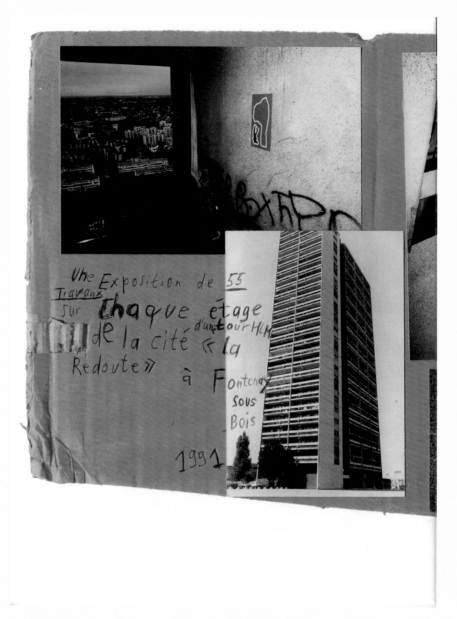

Pages 42–43:
An exhibition of <u>55 Works</u> on each floor of a tower of the housing project *La Redoute* in
Fontenay sous Bois, 1991
[arrows] In the staircase
[arrow] One of the works

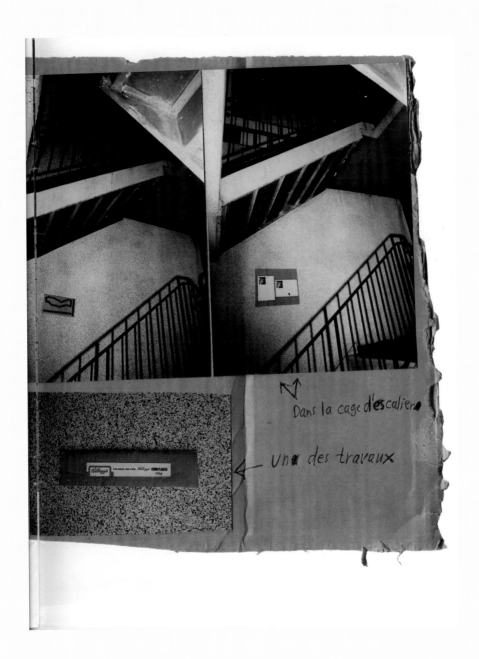

Pages 44–45:
4 Terrains Vagues, 1990 [4 Wastelands]
Paris
In 4 wastelands in Paris I exhibited one work.
I wanted to mix in my work.

« 4 Terrains Vagues » 1990
Paris
Terrains Vagues à Paris j'ai oposé un travail.
mêler mon travail.

Page 46-47:
6 Mots [6 Words]
Ireland, 1989

Page 48:
<u>Pour Dylan Thomas</u> 1989
Ireland (County Donegal)

[Translated from French by Molly Stevens and from German by
Kenneth Kronenberg]

3.1 View of the exhibition at Hôpital Ephémère, Paris, France, 1992.

PROJECTS

ABOUT MY EXHIBITION AT HÔPITAL EPHÉMÈRE (WHY I CHOSE
THIS EXHIBITION AS MY "FIRST EXHIBITION")[1]

The exhibition at Hôpital Ephémère was not the first but it was one of my first exhibitions. I chose this exhibition as my "first exhibition" because it was the first time I wrote a text about one of my exhibitions and about my work. With the following text and with writings in general, I wanted to clarify and understand what worked and what did not function with my work. The text helped me to have some distance from the work I had made. The writing helped me be aware of mistakes and what was lacking. Texts I write about my exhibitions also serve as encouragement to continue working.

I am not satisfied with my exhibition. This dissatisfaction does not come from the concrete result of the exhibition or from an obvious failure. On the contrary, I have the feeling that something concrete actually happened: the visits of Max Wechsler, Adrian, Ian, Francesca, Aude Bodet, and Madeleine Van Doeren, and Jean Brolly's purchase, and also my next exhibition project (Shedhalle, Zurich), and the prospect of future exhibitions in Lucerne, Bern, and Ivry. And then the discussions with the artists here, at Hôpital Ephémère, their invitation to talk about my work, and so on. But in spite of all these concrete and positive events and reactions, an "unsatisfied feeling" prevails.

I finally assimilated these events and reactions as positive, and they can be considered as positive even though these positive aspects are based on a misunderstanding. (Is this a committed misunderstanding or a speculative misunderstanding?)

My dissatisfaction comes from the part of the exhibition where the works are laid on the ground (*233 Travaux*). I wanted to be radical. I wanted my paper sheets, cartons, wood pieces to claim their presence in the exhibition autonomously, beyond justifications. I wanted to expose them to the danger of whatever would become of them. I entirely assumed the possibility that the work could be hurt by the context. I thought of the beggar that we bump into on a street corner and how we feel more embarrassed about having touched him than about his being a beggar. I thought of the dead bodies during the urban war in Yugoslavia. Of the meaninglessness of the civilian victims killed by "accident." What a shame that the beautiful white walls of the exhibition space are not being used! No, shame comes from the dead who died without reason. Is it a shame that my work does not show its power on the white walls? No, it's a shame to witness Iranian women stoned by their own families.

I wanted all my works to be on the ground, displayed equally. Whether large or small, made of wood, paper, or cardboard, I wanted each work to be considered single and autonomous but also all together. I wanted no arrangement with large, small, wood, paper, carton work. Nor did I want any other *accrochage* [hanging] system. I wanted the visitors to walk around my work, find their way in a space where everything is put on the same level. The works can be considered from a "neutral" standpoint. I simply did not want to make a demonstration by hanging all the works on the wall. It is the first time I didn't hang my work, as an *accrochage* or as a single work, for an exhibition but put it on the floor instead. What is important is my decision to show the works like that. It wasn't a set decision, but the result coming from a process and not from a concept.

I want to add that the decision to put the work on the floor wasn't thought out thoroughly in all its consequences. All my energy was taken up with this specific decision, and every other question—how much space to leave around each work, how to separate the works, how to place the works all over—became minor.

I am not satisfied because this part of the exhibition wasn't good and it could be misunderstood. I wanted to be simple and clear. However, I don't feel that this exhibition isn't right or just, but it lacks the force, the strength, the power that is present in a single work. I didn't want it to be so. I assume that when my work is shown, it can be shown everywhere and in any condition. I believe my work is powerful even when it is packed or stored in the dark. My work doesn't need an attractive presentation. My work simply "exists." I think my work is not bound to a territory. My work can be shown on the wall, on the ceiling, on the ground, or in space. My work can also be carried around in a jacket pocket. This now needs to be proved.

This exhibition shows that everything is possible; that was its purpose. I said to myself: With my work I do what I want. I have no doubt that it's possible, but is it really good? I want my work to be good without any possible misunderstanding (I don't care if it is understood or not). I must look for the mistakes. One mistake is that I didn't take the time to try out different possibilities once I had decided to put the works on the floor. I didn't go to the core of this act. Would it have been better to distribute the works irregularly on the floor? Would it have been better to show the works with larger intervals? Would it have been better to cover the entire exhibition space, including the two other works (*Jeudi 17.1.1991–Jeudi 28.2.1991* and the video *Périphérique*)?[2] I can draw no conclusions because I didn't try it out. Another mistake was that I am the one who chose the space, I even fought for it myself, and I worked it out with a set idea, instead of letting things come from the works. I can say it now because I had originally planned to hang the works, and ultimately I put them on the floor. A reaction instead of action. And finally, the mistake was: I didn't really know before the exhibition how I wanted to do it, yet I was assertive, which created an unnecessary pressure. (I did not stick to what I had asserted, and what I did wasn't good.)

My conclusion: Proceed much more from the work itself. Allow myself much less time for set up. Much less intent. Do it simpler.

April 1992
[Translated from German by Andreas Riehle]

———

3.2 *Fifty-Fifty*, 1991.

REGARDING MY EXHIBITION AT RUEIL-MALMAISON

During the opening, I felt that the people present were desperately looking for the art. I did not see many people looking, really looking, at my *Fifty-Fifty*, which was hanging alone on a wall. They had hardly set eyes on this work before they were already thinking, Is that all? I wanted to create the ideal conditions to see a *Fifty-Fifty* all alone, to see and to judge. And there it was, seen and judged, this bit of wood and tape stuck on top. In any case, I've wanted to show a single work alone for a long time. I'm convinced that a work alone holds (certainly it was made all alone and autonomous). And all the reflections revolve around a single work, which of course is never alone and furthermore can never again be alone. What I wanted at the same time was to choose the work to be looked at myself, not to leave the task of choice to the viewer. I wanted to do the job, me. And when I did it, when the choice was made, I'm sure that what is called the equivalence between all the works made but not exhibited is asserted naturally. It's not a minimalist, conceptual installation; it's a setup in which a single work replaces all the other works. It's a setup that wants to show the importance of a single work replacing others, by taking all the responsibility on itself.

I was under the impression that this was not understood by most people. Many only saw the formal aspect of the installation form. But the *Fifty-Fifty* is not done simply by filling half of a support with collages. No, the *Fifty-Fifty* proposal goes further, also in its setup. It's only half of a made work. My half, the choice of the work, the decision of the setup. (Where? How?) The other half, the half of the viewer who's seeing the *Fifty-Fifty* and who has to think about the "empty" half. Why isn't there anything here? That's what it's about for me. Yes, why is there nothing here? Why are there some people who have things and others who don't? Why are some massacred and others not? In any case, what keeps me working is this human condition, which is unacceptable and against which I revolt, and my artistic engagement is the determination to never accept this fact. I work with anger, I refuse, I want to try to resist, I want to try to disobey, I want to make my work. I want to be understood for this:

that I try to conceive of each exhibition in such a way that my work, without explanation, without a preestablished concept, can be understood.

In Rueil-Malmaison I thought that the viewers would be able to see the *Fifty-Fifty* alone and would understand, from seeing the video *105 Fifty-Fifty*, that the form of the work can be different (wood, cardboard, paper, format, what is on top). But also, and especially, that there could be something shown or hung in its place. Equivalent. Equality. Replacement. Responsibility. Solidarity. In the place of. Sacrifice oneself for. Survivor. Witness. Memory. Shit, all of this is for me, even without extensive writing, very important and obvious in my work, and I suffer if it's not understood. In Rueil-Malmaison I obviously didn't want to be demonstrative; that's why the setup and the video might come across as minimal, conceptual, lazy, mannered. I accept it. And my work can endure it.

November 1992
[Translated from French by Molly Stevens]

99 *Sacs plastiques (Dépôt)*

This is the first time that I've shown the plastic bags. This is new work and *99 Sacs plastiques (Dépôt)* is a new piece. I filled the car with as many bags as possible in order to store them for a period of time in Brussels. They're stored in an inhabited apartment, in the dining room and in the living room, which are two large, juxtaposed rooms. The bags are placed against the wall on the ground one next to the other without moving furniture or other household fixtures. The bags must not disturb anything! They won't hinder normal traffic through the apartment. Each bag is only allowed to touch the floor and the wall simultaneously. I do think it's important that they occupy this "strategic" angle in the room, occupying both the floor in the horizontal and the wall in the vertical.

I say "strategic," but in fact it's a place that plastic bags (in the street) don't occupy because we put them "off in a corner" so that we see them less, so that they are less disturbing. It's a positioning of withdrawal, of force—defensive. It's the "strategy of weakness"! And yet that's where their place is most energetic, dynamic. It's from there that they can move either by pushing against the wall <u>in</u> the room (so on the ground) or by pushing against the ground <u>at the height</u> of the wall. I'm under the impression that the feeling of lightness that these bags emit comes from their potentiality of action. It's simply the most simple way to arrange them while "respecting" them at the same time. Plastic bags are never alone. There has to be at least two. Their number doesn't matter, but a single bag is not possible; it can be shown alone set apart from the others, but always <u>non-isolated</u>. In a herd. They don't appear alone, perhaps in order to resist better. I also think that this being in a group is a way for me to make a "series" without it being a real series that is determined, conceived of. A plastic bag <u>alone</u> is not a plastic bag. Besides, if you look carefully, bags are never alone!

The intervention on the bags is a collage, either with tape, or I've glued something printed on it. These interventions are made according to a *Moins* classification. In other words, <u>less</u> than half of the support surface (in this case

3.3 *99 Sacs plastiques (Dépôt)*, 1994. Barbes-Rochechouart, Paris, France, 1995.

the plastic bag) is occupied by one of my collages or a combination of collages (tape and printed matter). I make the collages from nonfilled, closed bags. All the bags have two sides, recto-verso. I therefore glue something on one side, something else on the other side. Then I fill the bag with nonspecific filling material, newspapers, etc. It's not garbage! This fact of filling is important because it allows the plastic bag to become what it is, because when empty it's only material. But full, it's a bag. It's existential!

It's therefore not a sculpture or a volume. It's just existential for a plastic bag! But I like that you can think about the history of sculpture in looking at a plastic bag. Yet, what's important is that for me the energy doesn't come from sculpture or from art in general. My energy to work comes from the human condition and my revolt against it. That's what makes me work. And I want to make a work that is impure, dirty, unclean, approximate, low. But not low in comparison to high things—low in comparison to other low things. I want to make a work in which nothing is heightened. Everything is equivalent. (It's not that everything is the same, or that everything is equal!) I also want to make a "too much" work: too foolish, too simple, too weak!

I also want my work to always be fighting for its existence, for its raison d'être. I would like the raison d'être of these works to be their charge, their content, the subject. I want to make my work fragile once again. I think that an artist has to be cruel. But he has to be cruel <u>first</u> with his own work. With himself! Protect nothing. Heighten nothing. But take his responsibility and act! I want my work to remain very mobile—simultaneously as a <u>single work</u> and in its context. And in its development. I am not a theorist; I don't have concepts. I want to make my work with what is around me and with what I have. I want to make something for which it was not made. I don't want to be absolutely coherent, but I always want to try to work with the <u>and</u>! This way <u>and</u> that way. (Doing an art depot in Brussels while having the rest collected in Paris by garbage workers, for example.)[3] Valorizing nothing except the affirmation that it is art and that it intends to be judged in comparison with works by Malevich, Beuys, Mondrian, Warhol, Filliou, Schwitters, to only name what I like.

I'm not making readymades! The plastic bags are <u>artificially closed</u> with transparent tape. They no longer have their handles. They are from now on <u>another</u> plastic bag; in my work there's <u>always</u> an intervention. There is no salvaging. This is a work where availability matters; for example, these are my bags that I myself have used to carry things home.

Overdoing is a tactic that can lead to a condition in which the work so overloads the eye, makes it so tired, that the only thing that counts is what no longer lies! The critique that I must formulate with regard to my *Dépôt* is as follows: It has too few bags, far too few!

Amsterdam, 1994
[Translated from French by Molly Stevens]

REGARDING MY EXHIBITION OF *WALL-DISPLAY*, *ROSA TOMBOLA*, *SAISIE*, *LAY-OUT*
(1988–1994) AT THE GALERIE NATIONALE DU JEU DE PAUME

I'm writing these sentences a few hours before the opening of the exhibition. As I've already done several times, I want to write here what I think about my exhibition before receiving critiques, compliments, comments. I've made a dense exhibition, with concentrated strengths. I think that my exhibition holds. It holds; not less, not more. Not less, because I was able to do what I wanted and had planned for a while, that is, show a lot of my work from different periods without it being a retrospective or a visible development. Therefore, I realized what I call the four different planes—*Wall-Display*=vertical, wall; *Rosa Tombola*=vertical, wall, and horizontal, tables; *Saisie*=horizontal, tables; *Lay-Out*=horizontal, floor—which, seen as a whole, offer, I believe, the impression of overload, which I wanted. That overload has to allow the eye to get tired to the point that things do not lie. So I didn't create conditions for contemplation, for concentration; no, I created a "too much" atmosphere. Too many different things, too many levels, too crowded.

What I want is that each work has to fight to earn its place, is just and visible. I also wanted to create with these four levels a very silly movement, simplistic, from floor to wall, and from wall to floor. Something tired once again. Or something obvious, without seeking any tension (aligning the four levels along the biggest wall, and also over a small amount of surface on the ground, widthwise). As if to let myself be dominated by the premises, its architecture, to be economical too, that is, to show a lot without much effort. I think the four levels are the same; there isn't a preeminent level, unless you consider verticality as stronger than horizontality, which I absolutely contest. In my exhibition there's nothing solemn, which I like; there's nothing heightened, which I also wanted. All this semblance of order, all this semblance of concept (horizontality:verticality), the whole dynamic of alignments, is in fact only pure loss, even weariness, weakness. Yes, weakness. But this says: I am weak, you are too; no one has the right to be the strong one, the one who understands, the one who knows. No one. Everything is low; that's how there

3.4 *Wall-Display*, *Rosa Tombola, Saisie, Lay-Out,* 1988–1994. "Invitations," Galerie
Nationale du Jeu de Paume, Paris, France, 1994.

isn't any "high." It is not the strategy of weakness, as Fabrice[4] called it; it's an intuition, an instinct, something stronger than oneself. It's a tendency, it's an attempt, it's an effort toward something. Obviously this totally contradicts my ambitions for my projects, for my approaches. But that's the way it is: what I want is not that weakness triumph over strength. No, I want that sought-after weakness, non-endured, nonimposed; I want that that weakness, perhaps that nihilist tendency, be precisely what conquers nihilism. The sought-after weakness allows the endured, imposed weakness to be conquered. Something like that. I'm losing myself now. But I think something like not putting anything higher, not taking satisfaction, not protecting oneself, not affirming the masterpiece, can be seen in my exhibition. To make an honest exhibition. That's why I feel satisfied, because it holds. I'm not more than satisfied because I still have (I always do) the feeling that it's not radical enough, not clear enough, not beautiful enough. But I don't know how to do better. As consolation, I stick to: you can do better, but it's less good.

March 30, 1994
[Translated from French by Molly Stevens]

BERLINER WASSERFALL MIT ROBERT WALSER TRÄNEN

Berliner Wasserfall mit Robert Walser Tränen [Berlin Waterfall with Robert Walser Tears] is the title of the exhibition I want to do in January 1995 at Künstlerhaus Bethanien. The exhibition gallery is almost eighty square meters. Two walls are over ten meters long and the other two are about seven meters. The height is four-and-a-half meters. I'll only use two walls, a long one and the short one in the back of the room. I'll arrange tables against the ten-meter-long wall, on the right when you enter; I'll put two tables, one on top of the other, and in front, further inside the room, just one table, and this all along the wall. This will make a kind of rudimentary ladder, since the tables measure one meter in height. Or a kind of display or, in a more imaginary leap, a "waterfall" or cascade. From the wall four meters high to the floor sticking out four meters in length, I'll cover the table with aluminum foil, like that used for cooking. This will be the background. After having worked with fabric, I wanted a more "dematerialized" background, more non-existent, where the question of background color isn't raised. Because the material, its quality, its multiple uses of protection and isolation, lets the work on top "come out" better, and makes it less of a composition. Because I will present the work I made here in Berlin on these tables but also on the floor and against the wall, isolated by the aluminum foil. Works on wood, cardboard, paper, with adhesives, printed matter, and marks made with a Bic pen, like scribbles testing a Bic pen. I mean circles, the simplest forms, sometimes more, sometimes less. Like trying out a pen, but more like trying out the world. Furthermore, these works, which I call *Série Nouvelle,* are all wrapped in transparent plastic. To protect them, to mark their definiteness even more—I mean, to assert their existence. To strengthen the varied aspect of the formats I use. And also to exaggerate, because to envelop a piece of used cardboard is exaggerated and unnecessary unless I want to accentuate its existence. The wrapping in plastic also allows several works to be brought together in the same wrapping. So I made packages, not all are multipacks, but there are a few. The others have their own wrapping.

3.5 *Berliner Wasserfall mit Robert Walser Tränen*, 1995. Künstlerhaus Bethanien, Berlin, Germany, 1995.

With this "waterfall" I want to again accentuate the problem of the horizontal and the vertical, because the works are put either flat on the floor or on top of tables covered in aluminum foil. And the other works are placed vertically on the floor, leaning against the legs of the tables and on top of the tables leaning against the wall. I like that you can't see the horizontal works on the tables next to the wall (the height is two meters) because they're there, they occupy their place, but you don't have to see them. In general, this "waterfall" presentation is a very frontal presentation, which forces the viewer to face it; he can be very close to the nearest works on the floor, but he can't get closer. Therefore, he has to develop a general view of things. But I also want you to be able to slide over to the side so that you can realize that this isn't in fact a sculpture or a volume. It's flat against the wall and follows the angles or gravity, down to the ground. And this flatness folds four times, twice inward, twice outward. And behind this thin aluminum foil, like a carrier or an obstacle, there's nothing, so despite its spatial aspect, it's a work that's flat and two-dimensional.

In the back of the room, on the short wall, there will be what I call the *Robert Walser Tränen*. It is a homage to Robert Walser who lived six years in Berlin, from 1906 to 1912. Evoking him in the title of the exhibition and thinking of him is just one possibility. He wrote *The Tanners*, *The Helper*, and *Jakob von Gunten* here, among other things. So these *Robert Walser Tränen* are a reminder. Plastically I want this thing to be something impure, incoherent, a bit silly, a shame. For, in front of *Berliner Wasserfall*, which dominates the room, which is light and clean, and built, on the adjacent wall there's an annex or a cell, which has become autonomous and which doesn't correspond to the rigor of the other wall, nor to its spatial affirmation. There is something that seems to slip out of control. And indeed, out of the two corners of the "waterfall," growing against the adjacent wall are two lines of tears, also made of the aluminum foil material, that connect two or three works each. These works are works from the same series *Série Nouvelle*, like the ones that are part of *Berliner Wasserfall*, but they're autonomous, the representatives, isolated on the adjacent wall, attached. But again they're connected by the string of aluminum foil,

which can be easily shaped, and which ends up in the form of a tear. So, for me, these *Robert Walser Tränen* allow the work to become autonomous, to stand on its own, but they're linked to the others by a form (the string of tears) to the "waterfall." What I liked plastically was using that aluminum foil as background, flat on one hand but also as volume (the string, the tears).

You put chicken in aluminum foil and you decorate discos in aluminum foil. It's all a bit cheap and conveys will more than efficiency. I like that. Obviously these *Robert Walser Tränen* also make me think of decorative banners placed over existing things for a celebration—on top of paintings, clocks, photos, diplomas, furniture, plants, etc. When you connect them in order to make it "festive," you also empty them of their value, and I like that form too. Standing in front of my work, I want there to be a clear and obvious proposal, and I want it to carry within itself a questioning of this clarity and obviousness, but not like an equivalent dialog, more like a tendency or a "weakness" or something uncontrolled or self-producing that can fight against a stronger desire, much stronger, something structured, a concept, formalized. This work could have been made somewhere other than Berlin. That's precisely why it seems important to me to assert its existence from now on as a work from Berlin, in the title and the reference to Walser, who was here after so many others, and before so many, myself included.

1995
[Translated from French by Molly Stevens]

LETTER TO MATTHIAS (REGARDING *VIRUS-AUSSTELLUNG*)

Dear Matthias,[5]

With this letter, I want to introduce you to my exhibition plan, as I envision it at your gallery. I'm starting from the will to make something and not from the potential result. So there's a risk. First, the risk that everything will be different from expected or that the things, once written, won't be clear enough or well understood. In particular, there's the risk that on the day of the opening, my exhibition won't reflect the initial intention at all or only partially. But this doesn't have an effect on the work itself, I'm sure of it. What matters, and this is why it doesn't bother me to present myself in writing, is the will that leads to this work.

With my exhibitions, I always ask: Did I do what I wanted to do? If so, it's OK. It doesn't matter if it's good or not. If you sense the will through the work, I feel fulfilled. Someone once said, with regard to one of my exhibitions: "Even though it's hard for me to understand this work, I feel that you want something." For me, that was a real compliment.

If, through this work, I can express that urgency, that aspiration, that will, it's worth the whole effort. I'm writing this short introduction with regard to what interests me: that is, the birth of forms stemming from a manifest desire for profit, sales, a political message, or in order to impress, explain, be understood, be efficient, be secretive, or any other reason requiring a form. Form follows function, utility. I like all forms stemming from this urgency: buffets, tombolas, polling stations, laboratories, bricolaged devices, stands, local discotheques, etc. All these forms have something in common, namely the provisional, fast, open, and political aspect. But actually I don't think that far ahead; these are simply forms that I like, and, in this sense, I totally disassociate form from context. It lends an artificial aspect that interests me. I want to stay on a formal level; the questions of ethnology, of culture, don't interest me. These are neither provocative nor theoretical. Through this formalist approach, I would like to return to what's important to me, that is, the human

3.6 *Virus-Ausstellung*, 1996. Gallery Arndt, Berlin, Germany, 1996. Collection Fond National d'Art Contemporain, Paris, France.

condition and the power of art: awakening the senses, provoking sadness, asking questions about morality.

At your gallery I'd like to show my most recent work, *Virus*, forms doodled with a ballpoint pen on cardboard or paper. I call them *Virus* because of their forms, their simplicity and their limits, but also because of their infinite diversity, their ability to adapt, their unknown strategy. I don't know their strategy myself. I simply produce them, and I find it very beautiful to be able to make the same movement for years without ever giving the same form. It's like drawing without making a drawing. And doing so where the notion of "virus" again overlaps with reality. So I want to show these *Virus*, sometimes along with other forms (writing, graphics, photographic reproductions), and cover everything in transparent plastic. In addition, [I want to show] a few older works from the series *Les plaintifs, les bêtes, les politiques*, then other works from the series *Fifty-Fifty* and *Moins*, and even a few very old pieces like the sponges. It won't become a retrospective, don't worry; it simply is about reincorporating these works, not to display "old work" on one side and "new work" on the other, but to show that we're lost, to admit to doubting in progress, and to consider it all a huge bricolage, like a rotation without any direction. It's about showing that it's a step backward, despite discussions about strategy and the development of organizational charts: there's unemployment, the death penalty, but also art. My art, first and foremost. I noticed that politicians are using the word "hope" more and more, even though they're in a profession that's really without hope. My exhibition isn't about giving hope or giving references, but about showing my disgust for the dominant discourse and my contempt for the fascination with power. Your gallery becomes a bricolaged workplace, where someone is attempting to find clarity through classification, selection, order, isolation, the establishment of relationships. All this is purely formal because there is nothing to develop or understand. But there will be a lot to see. It's the only thing I believe in.

Concretely: the walls of the gallery will be covered in aluminum foil, not all the way to the ceiling, but to the height of people. Then there are tables, any ones, and there will also be "pinball machines," tables with a wall,

and then "Christmas trees," in other words, pieces of cardboard on top of each other in the shape of a pyramid; there will also be an isolation room, made with transparent plastic. On the floor, a few garbage bags. This display material serves as a support for the *Virus*. These works are placed, alone or in combination, with others, and are all connected by aluminum rope made with crumpled aluminum, as in *Berliner Wasserfall mit Robert Walser Tränen*. What I like about aluminum foil is that very malleability that suggests the form of viruses. At the same time, as a roll, you can't find any other material that's flatter. So I use aluminum both as a support and as a connective element, echoing, because of its transformative potential, the *Virus* works in the exhibition. On the wall, there will be "windows," in other words, surfaces that are not covered with aluminum, but rather with works that are protected by transparent plastic because they are not wrapped separately. With regard to the isolation spaces, I would like to have neon lights, so that you can see even better. Then I'll show two videos. One shows a woman dancing with a dress with a *Virus* attached. The other video shows a man offering an explanation of the *Virus*, without sound. In the first video, however, with the woman dancing, you hear music. The gallery will be rather cluttered, not completely or evenly filled, but simply according to where it will be best to place objects. All the elements are connected to each other as if on a single plane, connected also to the floor—if the situation requires it—except those presented in the isolation spaces. I want it to be a dense exhibition, full but cold.

Paris, January 1996
[Composed in German; translated from French by Molly Stevens]

179

THE BILBAO FAILURE

I want to talk about my experience during my time at Bilbao. I did three things in Bilbao: first, the *Bilbao Catalogue*; second, the work during my stay in Bilbao; third, the *W.U.E., World-Understanding-Engine.*[6] Here I only want to talk about my work <u>during</u> my stay. I asked that during the three weeks I would be able to occupy a premises with a window on the street level and that I be able to work there. I wanted to show people in Bilbao that I was there, that I was working, that I had nothing to hide, that there was no secret. I also wanted, precisely, to not work in relation to this city or to its political and economic situation, because to me it's demagogic to come for a few days and develop a work that takes into consideration the givens of the area. Works like that can only be superficial. So I set myself up in an old haberdashery on a rather well-off street with other businesses. The area had the advantage of being near the Institut Français and also the Salle Rekalde 1 [contemporary art space]. I thought that the fact I had removed the window separating the store from the street would allow passersby to establish a visual dialog. I wanted my approach to be understood only through looking: the approach of an outsider who has come to work among them. Transparent, available, curious.

I quickly understood that this could not work. I understood it would be a failure. I understood that there were three unresolved problems that did not allow this project to achieve a conclusive result. A question is immediately raised about my desire to be "transparent," close to people, to not want to intimidate but rather to exhibit, show the process, and therefore the doubt, the hesitation. I think it's a mistake to want that. Even though I respect my willingness to show weakness, I have to fight against it with all my might. You have to fight against it because the viewer cannot understand that willingness because there is no distance between my willingness and its result. So there's a hesitation, there's awkwardness. I'm neither an exhibitionist nor a masochist. I think I was lacking utopian lucidity about this first problem, that I made the mistake of being a "native" and you don't get anywhere by staying "native." The other problem is a problem regarding the structure of this intervention.

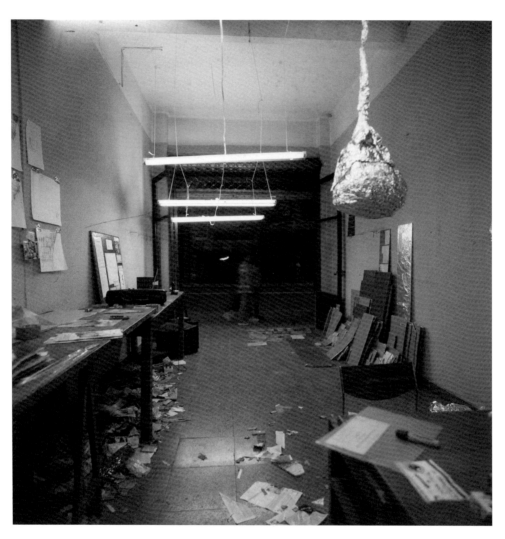

3.7 View of studio in Bilbao, Spain, 1996.

Obviously, it's connected to the first point. But from the moment I felt my project couldn't work, I didn't make the effort to stir up people. I find this artistically and intellectually honest, but it contributed to the failure. For, I'm sure of it, if the effort to communicate were made, my project could have been understood. I mean by including information panels, by approaching people, by circulating information in the street, I could have better circulated my intention. Clearly it's not what I wanted, because I wanted visual dialog, not a dialog-explanation. I was conscious that this project could only be achieved by explaining my intention to people, yet I precisely wanted them to see without my explanation, without my help. So it was impossible to change and, at the same time, impossible to "win." I therefore continued and that was the only satisfaction I got from it. I didn't give up, I worked well, I understood, I took responsibility. The third question is a technical problem. A store with a window is, indeed, not the street. The window, the pane, the entrance door are to be crossed with the "gaze" or by entering into the store. There's still a very significant line between the passerby's passivity and activity. I removed that line by removing the window and by installing neon lights that made it seem that the studio was occupied twenty-four hours a day, seven days a week. (A mesh curtain was drawn only at night, and even when I wasn't there, there was a video screen that showed me working.) So, by removing that essential boundary, I did something that no longer has a code, which cannot be read. Passersby immediately grasped, in a blink of the eye, the nonaccessibility, the incommunicability, of my proposition. I assaulted them as much as I found myself being assaulted. It was a non-dialog. I made the mistake of not establishing that artificial boundary between them and my work. That distance allows one to become active or to remain passive. The only people, and this is moral evidence, that entered into active contact with me were artists (who knew about my project), the mentally ill, alcoholics, and drug addicts (asking for money), foreigners (non-Basques, non-Spanish) wanting to talk!

1996

[Translated from French by Molly Stevens]

LASCAUX III

I want to show my work *Lascaux III* to the people of Bordeaux. I want to do it in different places. I decided to do four very short, day-long exhibitions. People in Bordeaux can see the four places or just one or two. *Lascaux III* doesn't change; the places hosting it change it—in order for the work to be mobile, in order to show that it's not a work "in situ." It also requires quite a bit of effort, because putting together and dismantling the work to be shown in four different places in a limited period of time is a considerable job. With these four exhibitions, which together are one, I also want to prove that my work can be everywhere. My work does not need a specific structure (museum, art center, gallery) to exist. *Lascaux III* has to function everywhere. Inside, outside. In an artistic context, but also without that context. What I've always sought for my work is for it to exist and to have an impact.

For Bordeaux, I thought of four places:

A "convivial" place: a bar, a café, a restaurant, a place where people share a moment of their time together.

A "public" place: I'm thinking of a square, a street, a park, something accessible to everyone all the time.

A "private" place: an inhabited apartment, big enough to host *Lascaux III*.

Finally, a place of "passage": a place where people go to buy something, post a letter, ask for information. It's more a place of obligation.

With these four places, I want to show what's most important to me: that *Lascaux III* be a work outside of time, outside of place, outside of history. *Lascaux III* has no gravity, no hierarchy. A work brought to people's attention. Toward people. Without any pretension of interactivity or encounter, of dialog or provoking a reaction.

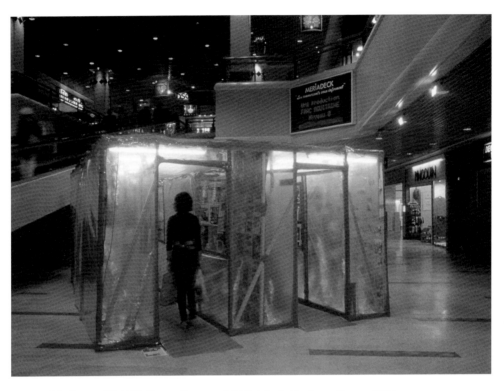

3.8 *Lascaux III*, 1997. Centre Commercial Mériadeck, Bordeaux, France, 1997.
(Photo: Frédéric Delpech). Collection FRAC Aquitaine, Bordeaux, France.

This exhibited work is an action. It is a generous action. But doing a generous action doesn't mean giving a gift. With this exhibition in four different places, I want to fight against cynicism, against the discourse of "context," against the second degree. This exhibition in Bordeaux is a commitment.

April 2, 1997

[Translated from French by Molly Stevens]

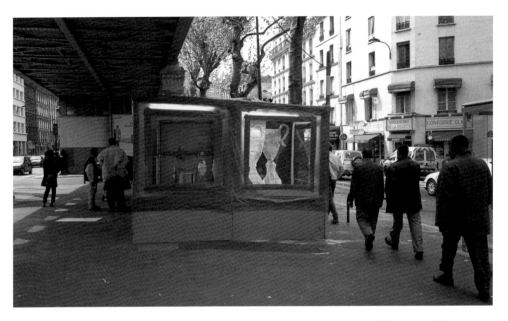

3.9 *Skulptur-Sortier-Station*, 1997. Stalingrad Metro Station, Paris, 2001. Collection MNAM, Centre Georges Pompidou, Paris.

SKULPTUR-SORTIER-STATION

I'm making *Skulptur-Sortier-Station* (1997) for Münster. It's a precarious, free-standing structure made of roofing slats, plastic, timber, Perspex, neon tubes, and cardboard. The neon light is important because I want people to look into the station at any time of day or night, throughout the week. The lighting is also important because it makes this space autonomous, a foreign body, a space without time, a room without hierarchy. Of course the lighting needs to run off electricity from somewhere, and I like that because it shows that there's a connection, gives a sense of being dependent, or belonging: this space is being supplied with energy, being supported. Visitors cannot go inside but will be able to look in from all the way round. The space is divided into eight to twelve different compartments, rather like alcoves, each lined with a different colored fabric: linen, printed or unprinted. The alcoves are not all the same size: they vary as needed. The sculptures—including the videos, which I'll be making specially—are then arranged in the alcoves.

Now, about the sculptures, there's something I definitely intend to do: I'm using fairly large trademarks, cutting them out of cardboard myself, like the Mercedes logo, the VW logo, then the "peace" sign and the Chanel logo. These are all round, flat shapes, covered with aluminum foil. This group of sculptures will go into an alcove that might be lined in red, for example. I should also point out that the alcove does not come right down to the ground, but to about table height, so that it's like a shop window. Then there are the aluminum-cup sculptures, which are similar to the trademarks. Trophy shapes cut out of cardboard like those I know from football matches or other sporting events—like the World Cup, European Cup, Cup Winners' Cup, Intercontinental Cup. Fans wave these oversize homemade cups to encourage their team. These sculptures will be shown in a specific alcove on something that looks like a display case, such as one finds in every clubhouse. Then there's an Otto Freundlich video. I'll go to Pontoise, a suburb of Paris, and film the two bronze sculptures by Otto Freundlich—an artist I admire—that are on display in the garden of the local museum. I will show them in Münster, which also has a

wonderful Otto Freundlich sculpture, but it's shown in an impossible place there. His work is still not given the stature it deserves! Even the Nazis acknowledged the explosive force of Freundlich's sculptures by using a picture of one of them—*Der Neue Mensch* [The New Man]—for the title page of their *Degenerate Art* catalog. This video is a tribute. My next sculpture will be a copy of a sculpture that no longer exists, also by someone I admire. It's based on a small picture in the 1937 *Degenerate Art* Munich catalog of a work by the artist Rudolf Haizmann. It's mentioned in the *Fabelwesen* [Fabulous Creatures] catalog; the only information we have about it is that it was made of marble (dimensions unknown) and acquired by the Museum für Kunst und Gewerbe in Hamburg. This sculpture dates from 1928, and was presumably destroyed. The artist was born in Villingen in 1895 and died in Niebüll in 1963. I've known this picture for some time. I intend to copy the sculpture for Münster in cardboard and wood. I want to draw it to people's attention again in this way—have them look at it again; reconstruct it, a bit like playing a particularly important scene from a film in slow motion over and over again to understand it better. Then there's a video about Marlboro. This too is a video loop, made specially for the *Skulptur-Sortier-Station*. A person is trying to build a monument from empty cigarette packets, and of course it keeps collapsing all the time. Then there will be an alcove with tears, such as the aluminum foil tears I made for the first time at the Künstlerhaus Bethanien in Berlin, called the *Robert Walser Tränen* (1995). The tears are all of different sizes. They're either covered in silver paper or painted with spray-paint—red tears, blue tears. There are also two videos in this alcove. They show a woman slowly moving her head up and down, linked once to red and once to blue tears that hang behind her on the wall. Another alcove shows aluminum foil stalactites and stalagmites hanging in front of a subject panel devoted to "Collectors' Spoons." The stalactites and stalagmites reverse the current fascination with domination theory: something that comes up from down below can get bigger and bigger, and something that comes down from above can get smaller and smaller. That's also why I chose the "Collectors' Spoons" theme. I intend it to show the unprejudiced inner glow of these spoons, and also their limitations. There's no room for kitsch, no

room for cynicism, no room for insinuations! There will be another alcove with sculpture-art-postcards and posters pasted on wood, which gives them volume. They are a personal sculpture collection, not mine, but I'm connected to them in the sense that they don't present sculpture as a volume, as controlling space, but as an image, as something two-dimensional. All my Münster sculptures are based on this two-dimensional quality. It emphasizes the context, the background, the origins, the circumstances.

In my works in public space the context is never the issue. And I'm not trying to provoke any particular reaction, either. I think the question of context and decontextualization, which crops up often these days, is just something to talk about that distracts from the work. This empty theme is just there as a means of avoiding questions of commitment and of the strength or weakness of the work. And with works in public space, there is precisely a lot of weakness. I'm talking about admitting weakness, sculptural weakness. That's what I mean by commitment—not being cunning, clever, ingenious. I don't want to have ideas for public space; I want to show my work everywhere, without making any distinction between important and unimportant places, just as I don't want to distinguish between important and unimportant people. I'm also resisting the virtual. Being on top is being on top. Being on the bottom is being on the bottom. More is more. Less is less. An unemployed banker is just as unemployed as an unemployed taxi driver. My creative work is not driven by aesthetics or art. The human condition, questions about life, give me the energy to work; I want to work from necessity. I keep asking: Is this necessary?

Back to the next alcove. There will be a Robert Walser Prize alcove and an Emmanuel Bove Prize alcove. A double alcove. I'm going to make more trophies in different sizes for these two writers. These will be statues like the "decorative" statues or "Golden Lion" statues that are awarded to prizewinners. And for Münster there is of course the pretext of making a sculpture as a mobile memorial to these writers I'm so fond of. And these statues' lack of format is important as well; they can be larger or smaller. The possibility of reduction or enlargement, or of multiplicity, is an essential part of these

sculptures. A model is displayed in another alcove: an architectural model made of wood, cardboard, polystyrene; an art gallery model, with four of my works shown in it. It's not an exhibition project; it's a proper exhibition: my works are real. They're not to scale, in other words. All that is reduced is the space. It has been so reduced that my works now seem gigantic in this space, because the viewer enlarges them optically. Those are the sculptures in the alcoves or sections of my *Skulptur-Sortier-Station*.

This title comes from my work's location. It's a temporary location. The structure will be dismantled after the exhibition. But it's an unambiguous location—unambiguous because I've been invited to Münster, and I'm not familiar with the town. I know nothing about its history, its inhabitants. But I have come determined to make sculptures and to show them to visitors and to people who live here. I don't want to relate to anything that has to do with the town; I think that would be pretentious. I need a location that makes it possible for my work to be seen day and night, seven days a week, and also a location that could just as well be somewhere else, in another town or another country. I've also looked for a location that's a nonplace. A nonplace is a place I can or must go to, for a reason which has nothing to do with the town's geography or history. And the site for depositing recyclable paper and bottles is that kind of place: the rows of containers that people take their rubbish to, where they go for a particular reason, which certainly isn't art. Of course there are other places like this, like ATMs, phone booths, or cigarette or condom machines. I chose the recycling collection point because that's where one brings the kind of material I work with: cardboard, old magazines, plastic, aluminum. I work with these materials because they're economical. "Economical" doesn't mean cheap. "Economical" means political. I work with these materials because everyone knows and uses them; they're disposable materials; they're there, even if not for making art with. Economy interests me. Economy has nothing to do with rich or poor. Economy needs connections, makes connections. Economy is boundless; economy is active, assertive. Ecology, on the other hand, bores me, and this self-centered, dull, passive, ecological thinking has got on my nerves for a long time. These recycling collection points are an

———

expression of this. Nothing is built up here; no projects are thought out. Easy consciences are collected here, and conformity is examined. If human energy is being used to distinguish between brown and green waste glass, then that energy is being drawn off, burned up, and real distinctions, life decisions, attitudes, are not being made. A person who cleans yogurt containers, collects them and takes them to a recycling point won't have any energy left to fight against injustice, racism, incipient fascism. But I want to do that. I want to make my art political.

1997
[Translated from German by Michael Robinson]

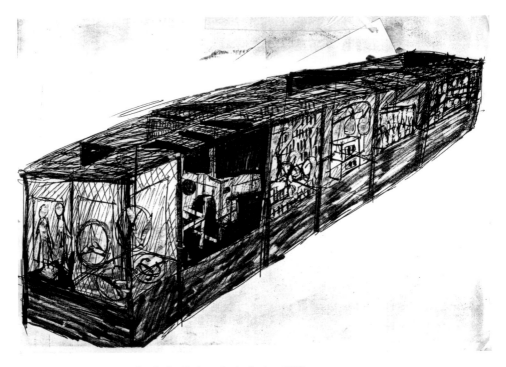

3.10 Preparatory sketch for *Skulptur-Sortier-Station*, 1997.

LETTER TO ALISON (REGARDING *SKULPTUR-SORTIER-STATION*)

Dear Alison,[7]

First, please be patient with the many mistakes. In these few sentences I would like to explain the importance of placement of the *Skulptur-Sortier-Station* 1. with regard to the work itself, 2. with regard to the Centre Pompidou, and 3. with regard to the city.

1. With regard to the work itself: The placement must be a site where people go to do something other than to see art. Throw out garbage, make a call in a booth, wait for the bus, withdraw money. This place has to be a place that is both very local but at the same time universal. (You have to be able to imagine it in Stuttgart or Mexico City.) The *Skulptur-Sortier-Station* was shown in Münster next to a container where household waste was sorted. I thought that someone going to throw out his garbage would discover the art. At the same time, he doesn't have to go there for the art because he's going there to throw out his garbage and he can leave it next to the art. This is an essential point of this work and what I want with this work: to go toward people, to not force them, attract them, or seduce them. Also to show that the telephone or the bus or the garbage can also be important for someone. This place is both precise because explainable and open because transportable in spirit. The choice of place must underline the utility of this work.

2. With regard to the Centre Pompidou: This work belongs to the Centre Pompidou, but *Skulptur-Sortier-Station* is autonomous from the Centre. It is like a little center itself. A station in space. A satellite. With its own energy, its own area of influence. It's like an isolated particle or a virus that has detached itself. Programmed, determined, but also free and detached. That's why this work does not need the material, physical, visual presence of the Centre in order to exist. The significance is precisely creating a connection through the idea, the project, the reflection with the Centre and the art presented there. The farther it is, the stronger this connection will be. With this work I want to implicate people who are not interested at all in art and people who are very interested in art. People who are interested in culture don't

interest me, in that I am proposing a work that is antispectacular, a non-event. The Centre Pompidou will of course be presented alongside *Skulptur-Sortier-Station* as its owner with a text, a map, or other indication. I think it would be right to be able to also think that the connection with the Centre Pompidou can be made <u>via this work</u>, and <u>not</u> that the connection with *Skulptur-Sortier-Station* can be made via the Centre Pompidou. The work was shown in Münster without a connection to the museum either, so a placement on the piazza, next to the museum, or around it, is not possible for these reasons.

3. <u>With regard to the city:</u> The site of *Skulptur-Sortier-Station* must be chosen with the intention of not giving in to facility (of access or <u>of circulation</u>), of not giving in to fear (<u>of destruction, violation</u>) or other "bourgeois" concerns (<u>strategic place, trendy location</u>). With regard to the city—and this work <u>is</u> a work for the city—the location has to be a "nonplace." Without known history, without importance, without interest. This place has to allow for the inclusion of the margin, the periphery. This place cannot answer to the forces of the center, which ruthlessly eject the margins. I want this place <u>to be able to include the margin, the periphery</u>. Noncontrollable, unexpected things. I want this work to resist functionalist urban planning. With *Skulptur-Sortier-Station* I want the viewer to be able to have a universal, utopian thought. That's why a <u>noncharged</u> place—which doesn't mean quiet, or protected—has to be found in the plan of the city. I also think that the question of neighborhood with respect to interventions of vandalism must not in any way play a role in the choice. The work's only possible "defense" is the <u>justness of its very proposal</u>, so <u>without provocation</u>, but also <u>without complacency</u>. This suitable place is to be found, and I am sure there are several that must exist in a city like Paris. I think the three criteria can be found everywhere, in various cities, and therefore can allow this work <u>to travel concretely</u> in the future also, either in Paris itself (in several different places) or through plans for the exhibition to travel elsewhere. I hope that these notes will help solidify this work.

October 3, 2000
[Translated from French by Molly Stevens]

Spinoza Monument

I am back from Amsterdam, where I did the *Spinoza Monument*. Here's a short account. I agreed to do this exhibition project for three reasons:

1. The ["Midnight Walkers & City Sleepers"] exhibition organizers are individuals actually working and living in this neighborhood (the red-light district), who therefore really wanted the artists to get involved in this environment and public space.

2. Amsterdam is one of the very few European cities that still has quite a vibrant center, that is, where the city center hasn't yet turned into a shopping center. (The red-light district is a neighborhood where people live, work, where there are hotels, bars, restaurants, where you'll find pedestrians <u>and</u> cars.)

3. I deliberately wanted to participate in this exhibition, even though it is not a "big name" event. What I mean is that I want to continue to participate in exhibitions in which younger and lesser-known artists take part—which are not just about name-dropping!

These three reasons led me to develop, with much enthusiasm, this new project that might become a series (Spinoza, Gramsci, Deleuze, Bataille, or others). I am now also happy and at peace with my work: I believe it can hold its own. I was surprised how easy it was to put together the project once at the site. I was surprised at how cooperative the owner of the sex shop was—he provided the electricity. During the two-day installation stage, I sensed a certain respect, even if it came from a critical distance, on the part of the people working there, inside and out on the street. I don't mean that they responded enthusiastically, but they <u>were following</u> what was going on, even if judgmentally. I was surprised at how well-known Spinoza is <u>after all</u>. Although it raised questions, the choice of this philosopher was obvious for the viewers. I held discussions with the police, with Martin of the Hell's Angels, and with some of the residents. I believe that such dialog is OK and it's part of the process involved for an artist working in public space. While not always particularly pleasant (as

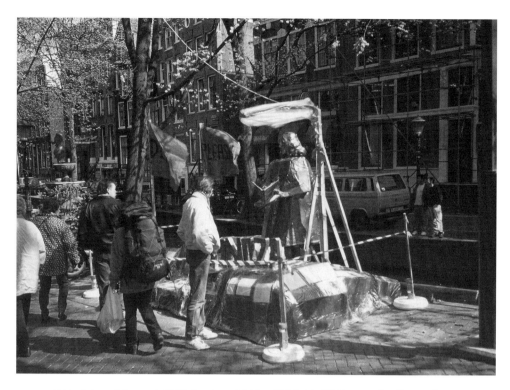

3.11 *Spinoza Monument*, 1999. For the exhibition "Midnight Walkers & City Sleepers,"
W 139, Amsterdam, The Netherlands, 1999.

in the case of groups of men making overbearing comments in passing), it is part of working and has to be tolerated if you, as an artist, assume that you have to <u>give something</u> first. I <u>want</u> that; I <u>can</u> do it; I think that's what artistic commitment is about.

What really disappointed me about the event "Midnight Walkers & City Sleepers," however, was that, with the exception maybe of two or three works (out of twenty total) which I thought were very good in terms of concept and message, but also in terms of their reference to public space and the specific neighborhood, either the exhibits were devoid of interest or their engagement with the neighborhood was so marginal that I could only wonder! If you consider public space as a hotel room in the middle of the neighborhood which, on top of that, is occupied by the artists; if your concept of public space is sticking posters up, or placing photographs inside shop windows around the neighborhood, then I think involvement with the neighborhood and its issues has considerably fallen short. And in the end the whole thing backfires, because, if I really want art to appeal—and I think it has to appeal—to those who are interested and informed and, at the same time, to those who are not interested and not informed, then half-hearted and poor projects such as these will only be exclusive rather than inclusive. They implode rather than explode.

Paris, April 23, 1999
[Translated from German]

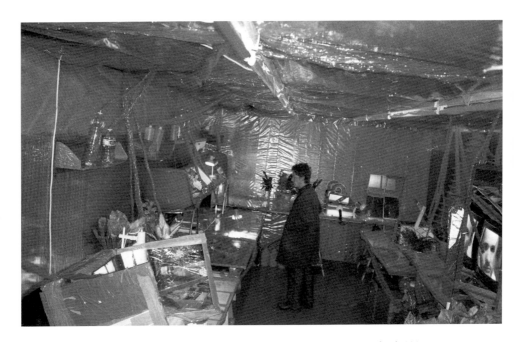

3.12 *Critical Laboratory*, 1999. "Mirror's Edge," Tramway, Glasgow, Scotland, 2001. Collection Fundacion Jumex, Ecatepec, Mexico.

CRITICAL LABORATORY, PROJECT FOR "MIRROR'S EDGE"[8]

For "Mirror's Edge" I want to make a "critical laboratory." It will be a new work. It is a site-specific work but with the possibility of being rebuilt in other places (if the exhibit should be shown elsewhere afterwards, as planned). *Critical Laboratory* is a space aside, a secret space, a peripheral space, because the subject of the research is: How to gain a critical position? How is a critical judgment built up? How can one be critical? This laboratory is utopian and realistic at the same time. For Uméå, I think that the existing storage room would be the appropriate place for this site-specific work: because of its exiguity, because of the placement in the whole show, and because of the visible elements within the space (pipes, lights, shelves). The *Critical Laboratory* is a mentally transportable space. This space is a possible enlargement, a visualized model of a brain section that is interrogating criticality. It is a combination of a clandestine laboratory making Ecstasy and a top-secret laboratory manufacturing biological weapons or pharmaceutical products. I want to find the forms, the connections, the elements that convey what happens at the moment of <u>the creation of criticism.</u> <u>I want to multiply the angles.</u> I want to show this plastically. To be critical, to create resistance, to be disobedient.

Critical Laboratory is a space within a space. It is a hidden space. It is at the same time autonomous and fits exactly the space that receives it (the storage room of Bildmuseet). I want to cover the space (walls and floor) with Scotch tape to three quarters of the height. The remaining quarter and the ceiling will be covered with transparent plastic that will leave the infrastructure of the room (pipes, lights, shelves) apparent. Inside I will add red neon lights in order to give the space its own atmosphere. Along the two walls and in the center, the visual elements I made for critical research will be laid out on tables, chairs, small pieces of furniture. The elements are videos, a diorama, photos, publications, books, photocopies of texts—all of these concerning fashion, luxury, economy, philosophy, culture, war, suburbs, history. Everything will be linked with "red plastic ramifications" that will run over everything on the top. There will also be mirrors to <u>reflect</u> what is being questioned. There will be

"resistances"[9] to prove and to test the questions. There will be lights that shed light on the problems. There will be original texts to compare the contradictions. There will be flowers and plastic flowers, and there will be many jars and jerry cans of different sizes.

I have asked the author Manuel Joseph to write in English free and personal texts, short and longer ones, on the same "critical" problematic. He will reflect upon the phenomenon of the "Stockholm syndrome." These texts will be integrated texts—integrated into my work (enlarged photocopies, hanging, under glass). These texts cannot be taken out, but can be looked at and read on the spot, as can any other element of the exhibition, in excerpts or completely. The space of this *Critical Laboratory* is not very large, about fifty square meters; it is too small and will be overcrowded. I will leave the back wall free for projection spaces. These projection spaces are several large blank fiberboard panels covered with plastic and left on the floor ready to be spread out, filled, and discussed elsewhere. In the corner, four piles of chairs stacked up to the ceiling convey the idea that the message of the projection space should be "confronted" not only in the exhibition, but outside as well. The piles of chairs mean the potential to address more people, to welcome an audience, to create an audience beyond the laboratory space itself.

June 22, 1999
[Translated from French]

WORLD AIRPORT

I want to create a new work for the Venice Biennale. It must be a new work in order to make an impact, like an emergency—for me and for the person who looks at it. I want to make an emergency exhibition, with no way out, no emergency exit. However, creating a new work means remaining faithful to what has been my method up until now, but to give even more, to give clarity and solidity, to be definitive. I want to super-inform and super-detail in order not to inform or detail. I do not want to communicate, I want to work with an excess of pressure. I am not a supporter of chaos—I am an artist-worker-soldier. I want to deal with the world around me and in doing this I want to remain free. I must take a position in confronting the world and do not need to concern myself with whether the battle is won or lost. I do not wish to exclude anyone from my work; it should be clear that I wish to include everyone. I refuse the grand, luxurious environments, with their pure and elegant lines; I want to work against fashion. Beauty needs to be defended against capitalism. Fashion is reaction. Fashion is escape, but not escape into beauty. It is an escape into the personal, the private, the refined, the exquisite, the chosen, into an apparent independence. What does not correspond to reality is a lie. I want to create a dense and complex work, rich with political bite and sculptural force. It contains two opposing themes. On the one hand, it deals with globalization and the forces it is subject to, from the unstoppable whirlpool toward something ever larger, more complex, more dominant. The "world idea" of the community, in the multiplying of networks, communication, and the elimination of distances, the implicated idea of globalization. At the same time, it deals with macroization, the emergence and "discovery" of new populations, the regionalizing of conflicts, the anxiety of the loss of regional, local, even private identity, the fragmentation and the crumbling of companion states. What I want to show in this work is the relentless contrast between thinking in terms of "Number 1," making mergers, making profits, and conforming to determined models, on the one hand, and, on the other, the tendency to break away, to separate, to claim the particular, and to increase

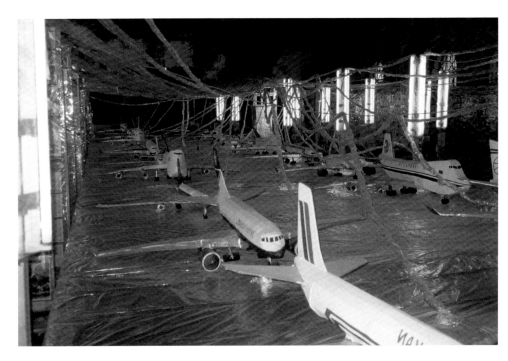

3.13 *World Airport*, 1999. "dAPERTutto," 48th Venice Biennale, Venice, Italy, 1999. Collection Musée d'Art Moderne Grand-Duc Jean, Luxembourg.

ramifications. The forces of globalization unite their energies and meet the united forces of macroization. But rather than a reciprocal reinforcement or a conflict, nothing happens. They meet and that is all. Because the moment in which the two energies meet is removed, the energy is reabsorbed, the head is turned elsewhere, awareness is narcotized, the force is dissipated and distance is suddenly restabilized (the Gulf War). Nothing stirs, nothing moves or is moved. Only consumption receives a new impulse, from the fusion of large regional businesses and from regional wars.

My work is called *World Airport* because everything is part of it and it is connected to everything. It could be an aircraft carrier: a separate place, but so large and apparently autonomous as to underline opposing world energies. The civil, worldly, clean, neutral, efficient, and rational aspects of an airport make it possible to look the other way, to know nothing. In fact, military operations are only carried out in the background in order not to disturb the commerce that envelops the entire world. The airport is calm, and yet in an airport it is possible to understand many things. The airplanes indicate the sovereignty, the force, and the real and simulated power of a state. By plane, one quickly arrives in the crucial areas of today's wars (Kosovo, Iraq, Afghanistan, Sierra Leone). Refugees in search of political asylum and without papers are expulsed and sent back to their countries of origin in these planes. Liberation fighters, terrorists, politicians, and all kinds of import/export businessmen fly on these planes. In airports there are passport controls for some and perfume sales for all. All airports are alike and all the planes are the same: Boeing or Airbus. The central element of my work is a long table, a platform, a runway, or even the deck of an aircraft carrier. On them there are models of planes from all over the world; and all the world is: Air France, British Airways, Swissair, Lufthansa, American Airlines, Air Italia, Kuwait Airways, Air Iraq, Pakistan Airways, Albania Airlines, Croatia Airlines, Air Bosnia, Air Yugoslavia, China Airways, Air Serbia, South African Airlines (with the old insignia and the new), Aeroflot, Virgin Atlantic, United Airlines, Gulf Air, El Al. In the airport, near the runway, there is a control tower. All the threads go to and from this tower. The threads come and go among the elements and informational material that one finds in

the exhibition. They form an enormous, entangled, inextricable ball, intimately united even in conflict. Just like the idea of globalization in the macroized thought and the idea of macroization in the globalized thought. In the exhibition there are mobile walls alongside the platform with the model airplanes and control tower; mobile walls with newspaper cuttings, prints, photographs relating to local and regional conflicts: Kosovo, Yugoslavia, Afghanistan, the Gulf War, the Falklands War, Rwanda, Sierra Leone, Ethiopia. There is an enormous map of the world with a flight timetable. The map of the world is a chaotic list of names of cities from all over the world. The flight timetable is a board containing broken planes, information on the fear of flying, flight connections, charter flights, flow charts on the fusion of individual air companies, logos, information regarding "Swissair Crash," projects for the expansion of airports, anti-noise measures for air traffic. And then it is possible to see photos regarding man's age-old dream: the ability to fly. There are videos of planes taking off and landing, which defy the laws of physics. There is a so-called "model Ford," in which, with the help of model cars, the strategy of business concentration is represented. There are four altars, as in Asian restaurants, as a last opportunity to offer sacrifices to religion, sport, and philosophy. All that remains are Reebok, Adidas, Puma, Nike, Deleuze, Spinoza, Bataille, Gramsci, flowers, candles and the Dalai Lama (who conducts his private struggle for freedom). Enormous spoons are scattered under the platform, recalling Brecht's motto: First food, then morals! There is a quantity of informative material lying around. A large "stain on the conscience" with some flowers is on the floor. The entire work is surrounded by blue plastic taken from bin liners, to create a slightly raised horizon. There are chairs from a waiting room. On them are publications in black and white (eight pages on A4 paper). You can read them on the spot or you can take them away with you. I asked four authors I know to write short pieces. They are Alison Gingeras, Stéphanie Moisdon-Tremblay, Manuel Joseph, and Marcus Steinweg. Their texts are an extension and expansion of the exhibition. They are texts that take a position, free texts. They are not boring descriptive texts one finds in catalogs. They are written in their original language, without translation. In German, French, and English. I want

the visitor to be able to read all these texts, or at least one of them, or just a single line.

1999
[Translated from German]

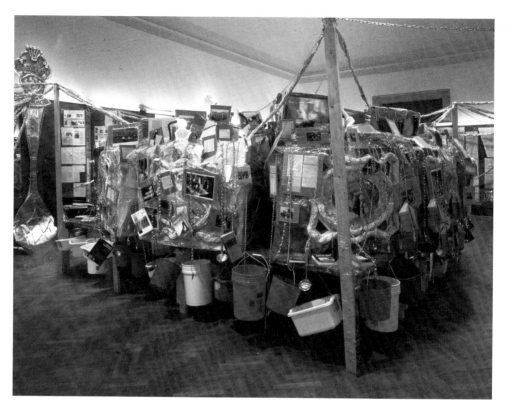

3.14 *Jumbo Spoons and Big Cake*, 2000. The Art Institute of Chicago, Chicago, 2000. Collection Museum of Contemporary Art of Montreal, Canada.

Jumbo Spoons

For the exhibition at the Art Institute of Chicago in January 2000, I want to make a new work about the world condition, the World State. The World State is about the need to eat or the possibility of not eating. The World State is unjust, inconvenient, confused, fucked up, shitty. Everyone has to eat. That is the reason there are "jumbo spoons." The *Jumbo Spoons* are about three meters high, fabricated out of aluminum and cardboard. These spoons are not for eating; they are destined for collectors, gifts, memories ("You were born with a silver spoon in your mouth.") These spoons are handmade, blown-up real gift spoons, which are always stored away in a drawer. There are twelve *Jumbo Spoons*: the Fashion spoon, the Mies van der Rohe spoon, the Rosa Luxembourg spoon, the Degenerate Art spoon, the Malevich spoon, the Rolex spoon, the Venice spoon, the Gun spoon, the Nietzsche spoon, the China spoon, the Chicago Bulls spoon, the Moon spoon. In addition to the spoons there will be mirrors; they reflect the space and the public. The *Jumbo Spoons* are not quite clean. There are drops of red color on the floor. Every spoon has documentation about its specific theme (for example, extracts of Nietzsche's books). There is an engraving at the ends of all the spoons; this is also where they are attached to the wall. The engraving of the spoon is repro- duced by a tag. There are twelve little tables with books on each theme. Every book is tied up with a chain to the table. Under the table is a bucket collecting "the rest." The twelve *Jumbo Spoons* are fixed on the wall covered with blue plastic, two-and-a-half meters in height. On top of the plastic there are cold blue neon lights. In the center of the hall there is the "world cake" on a big table. This big pyramidal cake is about five meters in diameter, two meters in height, covered with aluminum and spray-paint. This "world cake" will be divided, stolen, conquered, cheated, protected. It is decorated with world problems: famine, wars, undivided wealth, the war men, the lack of water. The spotlights are like local explosions. The *Big Cake* looks like a cake after dinner—used. Real spoons will be affixed to the cake. The *Big Cake* is rich with photographs, information extracts, and with four integrated videos

(pictures from reality). Under the *Big Cake* there are buckets collecting the leftovers of the world. The *Big Cake* is connected on the top with the spoons and with every element of the work like an electrical network.

Paris, October 1, 1999
[Composed in English]

The Matter of Location (Regarding the *Deleuze Monument*)

Open Letter to the Renters and Residents Association and to All Renters and Residents of the Louis Gros Housing Project[10]

Dear Sir, Dear Madam,

Owing to the notice posted in the Cité Louis Gros, I permit myself to write you in order to clarify certain points regarding the *Deleuze Monument*. I am an artist, I have a project, I have a mission. It is an artistic mission. I must work in accordance with my projects, in accordance with this mission. As an artist, I cannot imagine not realizing one of my projects, falling short of my mission. Abandoning it is not an option. I can make a mistake or propose a bad project, I can modify it, I can shift it, but I cannot give it up. In your notice you speak of a rejection of this project. Yet this rejection, which is perhaps not everyone's rejection, is part of such a project. Failure is part of every project. I do not work to succeed. I have to do my work.

When I was invited to participate in the exhibition "La Beauté" in Avignon, I did so with the intention of proposing a new and demanding work, which I attempted to explain to you in my first letter. I aim to shift the notion of "beauty" in an aesthetic conception toward a thought, toward ideas, toward projects. But also to make a project outside city walls, far from the *belle ville*, in "Greater Avignon." This is an essential point for me. I am well aware that this might provoke questions, rejection, and criticism. But my will as an artist is precisely to seek a dialog, a confrontation. I know there will be difficulties. I do not seek out difficulty for difficulty's sake, but because difficulty seems to me to be the mirror of reality. I want to face reality. My work has to face reality. It is an ambitious project, the realization of which interests me greatly. I've exhibited in museums, in commercial and noncommercial galleries, in alternative exhibition spaces, in public spaces in France and elsewhere. I've wanted to show that my work does not have an exclusive site, that it can be presented in different places. For the *Deleuze Monument*, not knowing Avignon and having

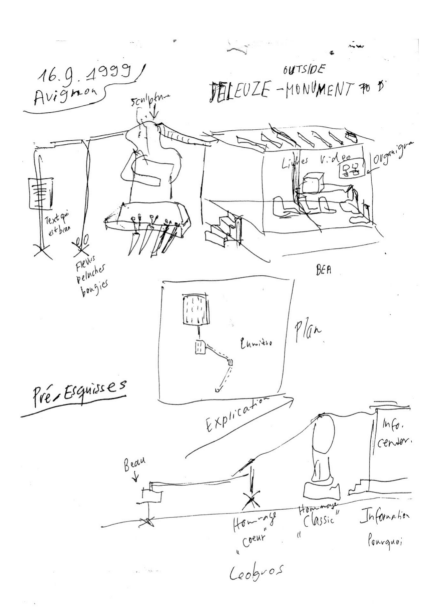

3.15 Preparatory sketch for *Deleuze Monument*, 1999.

made the choice to do a project in a public space, my choice settled on the Cité Louis Gros for its architecture, for its proximity to the station, for its size, and for its green space in the middle. After gathering information about the housing project, I learned who Louis Gros was. Louis Gros, mayor of Avignon in the 1930s and 1940s, was at the root of the first housing projects in Avignon, to which he gave his name. Louis Gros remained mayor of the city until he was deposed in 1940 because he was one of the rare deputies to reject an alliance with Marshal Pétain. He is a hero, and I was happy to have chosen this housing project without knowing this fact. It is also for this reason that I must maintain my project in your housing project. Furthermore, with respect to recent events—especially in Austria—I feel encouraged to do so. But this is not the only reason. During my four visits, I was able to meet residents. Moreover, my first encounters in the housing project were with members of the Association and they were not negative. I also wanted to meet youth from the projects in order to involve them in my *Deleuze Monument*. I therefore met, several times, more than a dozen young people or not-so-young people from the projects and from its surrounding area without feeling any hostility toward my endeavor. I am not asking anyone to sign my project. I take full responsibility for it. I have nothing to "sell" and I am not campaigning for political, religious, or any other causes. I am proposing, however, to be helped—in return for remuneration, of course—by the residents of the housing project. No one is excluded from helping, no one. In this regard, everything will function completely transparently under the patronage of Mission 2000.[11] Moreover, I understand that this project might not be appreciated by or suit some, though I truly think the *Deleuze Monument* is not likely to bring instability to the neighborhood. Instead, I think it could shed light, light on ideas, a reflection, a vision of the world. I do not think this project can be seen as an aggression. I don't think this project provokes violence. I am not naïve. I am an artist-worker-soldier. I believe I also know there are people—residents of the project or its surrounding areas—that agree with my project and would like to support it. The people already contacted for maintenance and construction work cannot be disappointed. They cannot think that I don't stand by my

commitments. Moreover, I have a hard time thinking that the local authorities could be hostile toward such a project. I have always stated that this is a project inspired by the base. All my work as an artist is inspired by the base. I will not dodge your judgment. However, the project must be realized in order to then be judged. I find it normal that my work be judged and critiqued, but the work must be made. I MUST DO IT. I am ready to explain myself and explain again, to come and return to Avignon, to review the possible location while avoiding any misunderstandings, while avoiding any gaps in good communication. I want to resolve the misunderstandings. I want to do my work as an artist. I have a project.

March 14, 2000
[Translated from French by Molly Stevens]

LETTER TO HERVÉ LAURENT AND NATHALIE WETZEL
(REGARDING THE *DELEUZE MONUMENT*)[12]

Dear Hervé Laurent, Dear Nathalie Wetzel,

I'm coming back from vacation and I found your letter, to which I will respond, if I may. I'm also coming back from Avignon. I'm in the train to Paris and I, as well as the *Deleuze Monument* team, to whom I read your letter, extend our sympathy; we are distressed knowing you are traumatized. We hugely regret what happened to you, and we all wish it hadn't happened. We offer our apologies. I offer my apologies, and I would like to answer your letter in greater depth. I spoke to my team, and it is clear that you were attacked by individuals who do not belong to the Champfleury housing project. There has been no other known case of hostility near the *Deleuze Monument* aside from a few verbal punches. That doesn't make anything better; it doesn't explain anything.

I don't agree with you when you state that the *Deleuze Monument* functioned as a trap or that you served as prey. I think these animal comparisons won't help you overcome your trauma, which I very much understand, for I myself was attacked a few years ago (also in an art context). I felt the same fear, the same physical and human fragility, you describe concerning you and your friend. What helped me was talking about this event with those around me, and I learned, to my surprise, that there are other people, many other people, to whom something similar happened—worse even, and also not as bad. These things happen. I'm not relativizing it. But knowing that these things happen helped me, after some time, to live with this attack as something that can happen to a human being in his <u>life as a human being</u>. This raises <u>a human question</u> and not a question about victim or torturer. There's no use thinking about: Why me? Why did this happen to us? Why did they send us there? What happened must not be accepted, but it must not be charged, either, or given a meaning. You weren't imprudent or weak, you didn't do anything wrong.

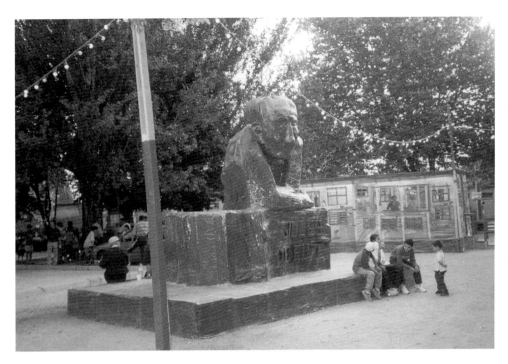

3.16 *Deleuze Monument*, 2000. "La Beauté," Avignon, France. Courtesy DRAC Provence-Alpes-Côte d'Azur, France.

To accuse me of naïveté or even innocence is something I cannot accept now. To accuse me of completely ignoring an explosive social situation, to accuse me of having wanted to assess the gravity of the social fracture that society generates, is something I cannot accept. For, I have a utopia; that utopia is called <u>the context is the world</u>! In my artistic project, I want to work on demonstrating this. Champfleury is the world! There's nothing to do about it. You may not agree, I can understand that well, but it's not about what happened to you personally, because in that case you would immediately find people around you to whom such things have happened, especially in Avignon but also elsewhere, and I don't think this would reassure you. Resentment is not what provides energy, the strength to act. I want to make a work that is on the offensive. I want to make a work that can be destabilized. I don't want to work with vigilantes and their dogs. I'm not for everything safe. <u>I don't want something to happen to anyone that couldn't happen to me.</u> Do you understand? One man equals one man. I cannot accept that it not be so. This is the very motor of my work. With all the incoherence, the misunderstandings, and even the contradictions. I don't think we can talk about inconsequence with regard to the *Deleuze Monument*. You have to manage all the consequences of this project. I agree that talking about the failure or success of the *Deleuze Monument* is of no interest to anyone. But one must say: Here is a project, here is its realization, here is what happened with the people. That is what interests me. The implication of people (residents), the appropriation that they've made of the work. <u>The question of the audience of art today.</u> That is what this work raises.

Perhaps you won't understand me, but I find it naïve to do a contemporary art exhibition in a Pope's Palace! I find it innocent to decorate buses, TGV, the entire city! I find all that quite simplistic! This is only talking about what happened in Avignon this summer! Rarely have I done a project that was so difficult, so demanding, but also so interesting! I had to face difficulties I could not have imagined I would have to face <u>as an invited artist</u>. I feel no pride about having endured quite a bit of difficulty. But this project is not just one more exhibition. I think I really tried to do <u>my work as an artist: connecting the world</u>. Working with other people, implicating them. Not reassuring myself. Exposing myself.

———

I'm coming back from Avignon where today I made the decision that the *Deleuze Monument* has reached its time limit. We are going to dismantle it in the upcoming days! The *Deleuze Monument* existed for sixty-one days. The damage and the nonnatural interventions have become too great to continue to give room for reflection, information. We decided to proceed with the dismantling. This too is an element we must learn from. The precariousness of such a project is declared right off by the use of the chosen materials, but also by the importance given to its content. For, <u>it has to stay in one's thoughts and spirit</u>.

P.S. The *Deleuze Monument* was, quite opposite to what you thought, presented during your visit and until its end with all its four parts. The video cassettes were indeed damaged but were replaced later.

July 24, 2000
[Translated from French by Molly Stevens]

REGARDING THE END OF THE *DELEUZE MONUMENT*

The *Deleuze Monument* was dismantled from July 25 to July 28, 2000, in agreement with the team of residents from the Champfleury housing project. I did note during my visit to Avignon on July 11 that the *Deleuze Monument* experience was coming to an end, that's to say, the television monitors and the VCR players were missing in the library, which moreover had stopped being maintained a few days earlier. In fact, what happened is that, during the first week of July, one VCR was stolen by people who don't live in the neighborhood. The Champfleury team therefore decided to keep the rest of the equipment safe (the four monitors, the three remaining VCRs), and they de-installed them to store them within our area. Of course, without the videos, the library portion of the *Deleuze Monument* lost its meaning and was quickly abandoned. (There was nothing else to keep in there.) The electricity in the library was no longer necessary either, and at night, without its light, there was no more life, and no protection any more. I noticed this too late, which is my fault, because I was not in Avignon.

You do have to clearly set forth several things for misinformed, well-intentioned people or for people only interested in success or failure: the duration of a *Deleuze Monument* experience depends on several factors, but it is above all a part of the precarious work itself. So it depends on the choices of one or several people; that's what makes the work precarious! The factors are the life of the neighborhood, the involvement and acceptance of its population, the artist's preparation and follow-up, and the means made available. I think these factors together determine the lifespan of a work like the *Deleuze Monument* outside the artist's decision to give an end to the experience. For my part, it must be said that despite the difficulties encountered, the preparation, in Avignon and with the Mission 2000, was just. It was an encounter with the residents of the real neighborhood. The mounting of the *Deleuze Monument* was dense, strong, and I think it was an artistic experience with an intensity that went to the limit of what I can do. It enriched me with questions and doubts but also with confidence and a fighting spirit. I think we were able to

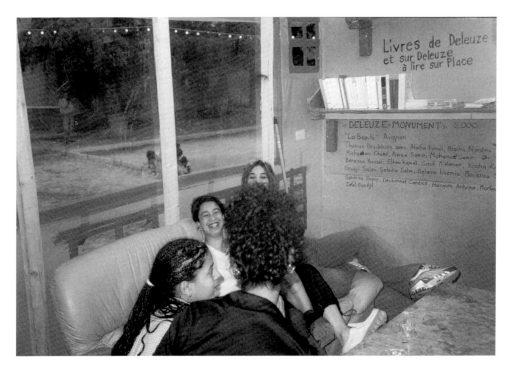

3.17 *Deleuze Monument*, 2000. "La Beauté," Avignon, France. Courtesy DRAC Provence-Alpes-Côte d'Azur, France.

demonstrate this during the three days inaugurating the *Deleuze Monument*. However, what I underestimated, from the start, was the follow-up, the stage (in fact the most important one) of the exhibition of the *Deleuze Monument*. I was not present enough. (One visit per week was not nearly sufficient.) Also, I underestimated the fatigue, the workload, and the importance of the "on call," "surveillance," and "guard" work that this kind of proposition requires. For a future monument, I must absolutely incorporate this question at the beginning of the project, by including the necessary means in the budget from the start. I didn't do that (or not enough) for the *Deleuze Monument*. I was forced to invent a "system of presence" in or around the monument, which was not, because of a lack of money, consistent with what was asked of the team of residents. What's more, they were lucid about the question and were always noting the lack of means for what they call "surveillance"—a term I don't like, but one that was certainly appropriate at the Champfleury projects. I therefore tried, in a mad rush, to find more money to extend the duration of the work, which was met with growing interest, but this interest was not met with action; in other words, unfreezing the amount of money necessary to better pay "the guards," who were people from the neighborhood and not vigilantes, never happened. This is one of the realities I have to take into consideration much more seriously from the start of a project of this breadth and ambition. Finally, I have to plan for my presence, the artist's presence, to be practically continuous during the entire duration of the exhibition.

December 2000
[Translated from French by Molly Stevens]

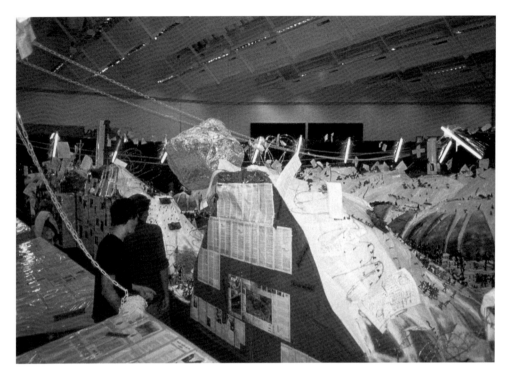

3.18 *Wirtschaftslandschaft Davos*, 2001. Kunsthaus Zürich, Switzerland, 2001. Collection Kunsthaus Aarau, Switzerland.

LETTER TO BICE (REGARDING *WIRTSCHAFTSLANDSCHAFT DAVOS*)

Dear Bice,[13]

Here are just a few sentences about my plan for our exhibit on the occasion of the art prize at the Kunsthaus.[14] The title will be *Wirtschaftslandschaft Davos* [Economic Landscape Davos] or something similar. A temporary exhibit will be set up in the Hall of German Painters to explain the economic landscape of Davos, that is, it is to be a didactic parish-hall exhibit. Based on a large number of documents, the exhibit will attempt to "explain" exactly what has happened to the Davos landscape ever since it was taken hostage by the World Economic Forum. That is, the completely absurd spectacle that now takes place each winter when this tourist town, in the most beautiful natural setting and in the deepest snow, the Davos landscape, is transformed into a police-and-war zone that is networked and transmitted globally. Where "peaceful" citizens are afraid to walk the streets, and lock their doors day and night; where paranoia reigns because of purported "thugs" and "rowdies"; where for years citizens dutifully approved conference center expansions, worrying about the well-being of the landscape; and where, in February, the same good citizens prefer to flee to the lowlands because of the emergency conditions that pertain. I want to show that Davos is no longer known for the sun, the snow, for Parsenn, Pischa, and Jakobshorn, or for Kirchner and his museum, for Thomas Mann, or even for Wilhelm Gustloff and his just end in the blue houses.[15] Davos is now known globally only as the late-capitalist meeting place of the super powerful and the stinking rich. I want to show all this shit, the links between the sled runs, the Davos hockey club, between Bill Gates and the local historical museum, between Laurent Fabius and the village police, who now hunt terrorists instead of jamming parking tickets under the windshield wipers of illegally parked limousines from Germany. The marvelous winter landscape, blue sky, sunshine, and undisturbed snow <u>and</u> black-uniformed special police armed to the teeth who encircle and fortify the landscape. The little red RhB train that wends its way through the winter forest and the guests flown in by helicopter in their winter suits or [sitting] in casual wear next to

the fireplace. All of these impenetrable combinations of things that do not belong together and are therefore linked from now on; these need to be "explained." And then the role of Switzerland's direct democracy, which, on the one hand, made the perverse possible (referendum on communal infra-structure) and, on the other, equally perversely institutes bans (demonstrations against the Forum).

Concretely, I intend to set up a large table in the middle of the space; on the table is a "model of the Davos landscape in winter," done quick and dirty. With a red Märklin RhB train, with mountains and houses, with the Hotel Schatzalp and the Kirchner Museum, convention center, and other strategic locations in this Alpine town. With models of mountain trains and ski trails. Distributed across the landscape are miniature policemen and soldiers with tanks and helicopters and military aircraft, completely exaggerated, who secure the place and fortify it with barbed wire and machine-gun positions. A war landscape in a most lovely tourist-miniature. Two televisions broadcast con-stant weather updates as if nothing were happening, while on the information console opposite the model table, information of all kinds can be read about the Kirchner Museum and the Hotel Schatzalp. The information consoles have the elongated shape of the landscape orientation tables in natural settings, where one can spot the names of the mountains. They are covered with trans-parent plastic. The entire exhibit is surrounded by free-standing panels of blue plastic, approximately two-and-a-half meters high. Neon tubes or spotlights at regular intervals illuminate the model from above—very garish and disturbing. The entrance is made of plastic that has to be pushed open, as in a circus tent. On the one hand, the blue plastic represents the sky; on the other, it forms a boundary with the work of the German artists that can, however, still be seen behind it. The sculptures should also remain in the space; they can be moved to the side, but I think that they are already pretty much located at the perim-eter. The explanation panel stands at the entrance on the left and "explains" the model; farther toward the back of the space is the Kirchner platform. This is a platform covered with red plastic on which original paintings and sculp-tures by Kirchner are exhibited. The original works are displayed like prizes at

the county fair shooting gallery. The original works are set up on steps. The exhibition should have something "studenty" about it, that is, done with the energy, with the utopian power that people have when the information, the exhibiting, and the desire to explain and to appear in public are more important than the design of the exhibition itself. The whole thing should be dense and bright, inexplicable and illogical. The *Wirtschaftslandschaft Davos* is irreparably INCURABLE.

Siegfried Kracauer:[16] *"The more incorrectly they present the surface of things, the more correct they become and the more clearly they mirror the secret mechanism of society."*

Paris, April 27, 2001
[Translated from German by Kenneth Kronenberg]

3.19 *Bataille Monument* (Snack Bar), 2002. Documenta 11, Kassel, Germany, 2002.
(Photo: Werner Maschmann). Courtesy Gladstone Gallery, New York.

LETTER TO THE RESIDENTS OF THE FRIEDRICH WÖHLER HOUSING COMPLEX (REGARDING THE *BATAILLE MONUMENT*)[17]

As an artist with a project in a public space, I ask myself the following questions: Am I able to initiate encounters through my work? And, if so, am I able to create events through my work?

The *Bataille Monument* is a precarious art project of limited duration in a public space built and maintained by the young people and other residents of a neighborhood. Through its location, its materials, and the duration of its exhibition, the *Bataille Monument* seeks to raise questions and to create the space and time for discussion and ideas. The *Bataille Monument* comes from below; it does not seek to intimidate anyone; it is not indestructible; and it is not intended for eternity.

The *Bataille Monument* is dedicated to the French writer Georges Bataille (1897–1962). I take responsibility for this choice; it is a form of artistic engagement. I am a fan of Georges Bataille; he is at once a role model and pretext. Bataille explored and developed the principles of loss, of overexertion, of the gift, and of excess. I admire him for his book *La part maudite* and his text "La notion de dépense." Choosing Bataille means opening up a broad and complex force field between economy, politics, literature, art, erotica, and archaeology. There is a great deal of explosive pictorial and textual material. Bataille has nothing to do with Kassel. The *Bataille Monument* is not a contextual work; rather, the monument could as easily be shown in another neighborhood, in another city, in another country, or on another continent.

The *Bataille Monument* has eight interconnected elements. There is no hierarchy among the elements. The individual elements should form different doors onto the monument, and it is also possible to understand each individual element as its own monument. The eight elements are:

• a sculpture of wood, cardboard, tape, and plastic

• a Georges Bataille Library, with books that refer to Bataille's oeuvre, arranged according to the categories word, image, art, sports, and sex (a collaboration with Uwe Fleckner[18])

• a Bataille exhibition with a topography of his oeuvre, a map, and books on and by Georges Bataille (a collaboration with Christophe Fiat[19])

• various workshops through the duration of the exhibition, from June 8 to September 15, 2002 (a collaboration with Manuel Joseph, Jean-Charles Masséra, and Marcus Steinweg)

• a television studio that broadcasts daily a brief show from the *Bataille Monument* on the Kassel public-access channel

• a stand with food and drinks

• a shuttle service of personal cars and drivers to bring the visitors from Documenta 11 to the *Bataille Monument* (and back) and to bring the residents of the neighborhood to Documenta 11 (and back)

• a website with photographs from web cameras installed at the *Bataille Monument* (twenty-four hours a day, seven days a week)

I cannot produce the *Bataille Monument* alone. I am an artist; I have a project. I want to realize the project. I know that realizing the *Bataille Monument* requires the help, support, and tolerance of the residents, including the younger ones. So I don't say: Do it as I do; but rather: Do it together with me.

The site for the *Bataille Monument* is the Nordstadt neighborhood of Kassel, specifically in the Friedrich Wöhler housing complex. It is a site that assumes the reality that the construction and maintenance can be achieved, that friction and engagement are possible. No special site is required for the *Bataille Monument*. The sites of individual elements are determined after consulting the residents of the housing complex and are connected to one another. The construction and maintenance are carried out by (among others) the young people of the Philippinenhof Boxing Camp; everyone is paid for his or her work.

I am not a social worker; I am not trying to revive this neighborhood. For me, art is a tool to get to know the world. Art is a tool to make me confront reality; art is a tool to experience the time in which I am living.

The *Bataille Monument* is intended to communicate knowledge and information; the *Bataille Monument* should permit connections and establish references; the *Bataille Monument* should include people; it is made for a non-exclusive audience.

The *Bataille Monument* is the third in a series of four monuments. I realized the *Spinoza Monument* in Amsterdam in 1999 and the *Deleuze Monument* in Avignon in 2000. I want to make the fourth and last monument in this series for Antonio Gramsci.

Paris, February 2002
[Translated from German]

3.20 *Bataille Monument* (Shuttle Service), 2002. Documenta 11, Kassel, Germany, 2002. (Photo: Werner Maschmann). Courtesy Gladstone Gallery, New York.

LETTER TO LOTHAR KANNENBERG (REGARDING THE *BATAILLE MONUMENT*)

Dear Lothar Kannenberg,[20]

I just want to convey in a few sentences why I think that a collaboration with the Philippinenhof Boxing Camp at the *Bataille Monument* is so important. The *Bataille Monument* needs to come from below. That is, it is not a memorial that seeks to intimidate or instruct. Rather, it seeks to convey information and promote friendship and a sense of community. It seems to me that the Philippinenhof Boxing Camp, which was self-initiated, has similar goals. I read, "Get up when you're down!" The point is not to use the Philippinenhof Boxing Camp to exploit your previous work, or to profit from what already exists. The point for me is to say, What is new in this project is not the idea. What is new, what is important, what remains is: It was made together with what already exists. Because my guiding principle for Documenta 11 is not to create something new by myself, but rather to make something together that's new! The Philippinenhof Boxing Camp is also especially important because, as a self-initiative, it comes so close to being an art project. It suggests the notion that something can be connected there that cannot actually be connected!

The library of the *Bataille Monument* includes books about sports, which is one of the five themes by which I attempt to come to terms with the work of Georges Bataille. What I'm thinking is that small regional sporting events could take place there. We talked about this: boxing matches, track events, capoeira demonstrations. I want my work to be an open encounter that seeks exchange. I'm not interested a priori in attracting a particular target audience. I want to try to achieve utopia. I'm not looking for "ideal" collaborators! I'm not looking for a "suitable" venue! I want to create my work where I can, where I find tolerance (not acceptance). In terms of content, I want to do my work without compromises. I believe that it is only possible to be respected when I myself first show respect. Respect for what is important to me. The Boxing Camp is very important to me! In addition, the Philippinenhof Boxing Camp is also very important because of its location. I've decided to create my *Bataille Monument* at the Friedrich Wöhler housing complex because a

relationship exists with the young people who box at the Boxing Camp. Therefore, at our last meeting, which was about settling on the location, I perceived the desire to have it take place in the Friedrich Wöhler housing complex (two or three young people said so). Finally, I simply think that the young people can understand their own importance, and that this collaboration can move from an encounter to an experience. This experience would be, for the Philippinenhof Boxing Camp, one among its increasingly numerous experiences. And for me and the *Bataille Monument*, it could lead to an attempt to make an artwork that really confronts reality, that really wants to encounter the world, and that really happens during the time in which we are living! All that, dear Lothar Kannenberg, interests me as an artist-worker-soldier. I look forward to a beautiful, difficult, thorny, and wonderful collaboration!

Kassel, February 21, 2002
[Translated from German by Kenneth Kronenberg]

LETTER TO IRIS (REFLECTIONS ON THE *BATAILLE MONUMENT*)

Dear Iris,[21]

1. *Preparations for the* Bataille Monument *in Paris and in Kassel*

From my experience with projects in public space—and so far I have worked on forty-three projects, both large and small—I know that the preparation phase is extraordinarily important. For this project, two aspects had to be prepared at the same time: on the one hand, preparation on the ground in Kassel, which encompassed the selection of a site for the project, looking for potential partners, grants, on-site organization, and generally getting to know the city of Kassel; on the other hand, preparation in Paris, including the substantive discussion on Georges Bataille, the people who did the workshops, preparing the "software," that is, materials needed independent of site selection and other local aspects. I tried to use the time available as efficiently as possible. Together with Okwui Enwezor [artistic director of Documenta 11], I set the basic features of the project early on: It would be a project in public space, as part of the monuments series; it was about Georges Bataille, the third in a total of four philosophers who had been previously selected. Owing to the experience I had had with the monuments, I wanted to further develop the *Bataille Monument.* That is why, even before I visited Kassel for the first time, I had already decided in November 2000 that I wanted to make a monument with a number of elements. I wanted to make it right where people live, in other words, in a housing complex. I wanted to do it with the residents; especially because of what I learned from the *Deleuze Monument,* I wanted to supervise and follow the project myself for the duration of the exhibition. I also wanted to be there when it was dismantled. That much had been discussed with Okwui and was clear in my head.

All in all I made ten short trips to Kassel in the period from November 2000 to April 2002. I knew I wanted to devote as much personal energy as possible to this project; that is, to travel there without any assistants. That is

3.21 *Bataille Monument* (Library), 2002. Documenta 11, Kassel, Germany, 2002.
(Photo: Werner Maschmann). Courtesy Gladstone Gallery, New York.

always difficult, since different laws prevail in public space than in a museum or gallery. So it was imperative, for example, to be able to speak the language spoken at the site. Through an acquaintance I contacted Robin Dannenberg, a social worker in Kassel, who was supposed to help out in the various phases of the project. More important for me than his qualifications as a social worker was the fact that he knew the city very well and could help me clarify the site issue during the preparation phase. I knew that the site question was extremely important, and that precisely because it is so decisive, it <u>can only be resolved instinctively, in a kind of emergency situation</u>. This is because, though I spent all in all more than two months in Kassel, I don't really know the city, so I needed information obtained from residents, acquaintances, informational material from the city, and of course by visiting the locations that were being considered. Since I wanted it to be possible to <u>mentally</u> transplant the location to another district in the city or to another city or to another country, the site had to allow for that. The selected site thus had to possess this element of asserting its ability to be transplanted. Yet, it also had to be a place that satisfied the criteria I introduced earlier. Only instinct can help in such a case! The most important thing in selecting a location in Kassel was finding potential helpers, the residents, the supporting contact people. Getting to know Lothar Kannenberg, the independent initiator of the Philippinenhof Boxing Camp, was of prime importance. After visiting and talking with him and the young people he boxes with on several occasions, I was certain that the Philippinenhof Boxing Camp and the charismatic and exemplary position of Lothar Kannenberg had to be an important fixed point for my project in the housing complex. It was up to me to convince him and the young people of the seriousness of my project. I succeeded in doing that because, for one thing, I admire him. For the fight that he is fighting with himself. <u>He has become a true friend.</u> The dynamic of the boxing camp was therefore one of many deciding factors in selecting a site, and getting to know Lothar Kannenberg was important for the project. This alone explains the long preparation phase.

Preparations in Paris, including working with Christophe Fiat, who explained the work of Georges Bataille to me from his personal perspective

and in context, was quite an enrichment for me. In dialog with Christophe, I explored the work of Bataille. This was new for him as well as for me. He explained Georges Bataille to me. I encouraged him to map out Bataille's work for me visually. Together with Christophe I made four trips to stations in Bataille's life. This was one of the best parts of the work on Georges Bataille. The four trips were to St. Germain en Laye, Vézelay, Lacoste, and the caves of Lascaux. As short as they were, these trips were important experiences for my understanding the work of Bataille as well as for dealing with it freely. Christophe Fiat always made succinct, precise statements that helped me understand the contexts in the life and work of Bataille. These trips had a significance that went beyond the status of implementing the *Bataille Monument*. They were moments of insight.

2. *Construction*

It took two months to set up the *Bataille Monument*. There were between 20 and 30 young people and other residents of the housing complex working on it. My plan was to seek no experts, art students, or other art connoisseurs to help build it. Instead, I wanted to build my project together with the residents. It was no problem to find young people and other residents wanting to work on the project. The incentive was the eight euros that I paid as an hourly wage. I will come back to the problem regarding payment later on. One thing that was certain for me was that everyone would be paid for his or her work. I hate volunteerism for the sake of art! I refuse to appeal to volunteers, that is, unpaid workers, in order to implement my work of art.

Constructing the *Bataille Monument* was the hardest project I have ever undertaken. I went beyond my limits; I was worn out. I really had to activate strength I did not have. The construction was overtaxing, in terms of technical efforts, organization, group dynamics. It was one big mess. I never had as many doubts about the *Bataille Monument* as I did during the setup phase. I wanted to create my project with young people and residents from the housing complex. I did not want to exclude anyone. No one and never! I said, "If

you live here, you can work on the project!" The group that came together was very diverse, with respect to age, cultural and social background, attitude toward work. When despite all the problems we made it through the first week, I went home—I had moved into an apartment in the complex—to discover that my apartment had been broken into and my personal hi-fi, camera, and video equipment had been stolen. I knew that it was one of us and I knew that the continuation of the project was thus uncertain. I had serious doubts about my project. <u>I knew I would have to provoke a solution since this was a test of my project's contact with reality. In other words, was my project too out of touch with reality?</u> I also had to take responsibility for what happened. I didn't have any choice. Either this was a test I would pass, or it would be the end of my project. I could pass the test only if I got back all of the stolen property without having to look for the culprit or culprits and without calling in the police. I passed the test. I was only able to pass it because I always focused on my art project. <u>I knew when everything was returned that my project was difficult and complex, but it was not out of touch with reality.</u> I had doubted my work, but it helped me eliminate all other choices. It put me in an emergency situation in order to make the right decision. I was doing the project because at that moment I was confronted with the <u>fundamental question that was posed: What do I want?</u> I could not answer this question hypothetically. I had to be active; I had to act and use a certain degree of authority and also force. I had to counter theory with practice. This experience and the happy outcome of this test strengthened me in my goal of not wanting to exclude anyone from working on the project. Despite pressure from the group of workers toward the suspected thieves, I thought if art is not capable of resisting this normative pressure to exclude, then nothing and no one will be able to!

The construction, with its daily, not irresolvable <u>but often simultaneously appearing problems,</u> was an act of strength. I had a hard time assessing the extent to which it was an act of strength because I, Thomas Hirschhorn, was the initiator, the organizer, the employer. Paying attention only to the time, I too often lost contact with the experience of building it together. It is

———

also impossible for me to say with certainty that it could be done differently! One thing that I *can* say certainly occurred, and which is not a new, that is, unknown, phenomenon for me, is <u>the satellite status of my work</u>. A negative experience I have had more than once, which I also could not prevent on this project, is that of isolating myself, of cutting myself off from the group project of Documenta 11. Despite the excellent starting conditions, and by that I mean the relationship to the Documenta 11 team, I was not able to avoid all conflicts. Not that I was afraid of conflict or that I tried to avoid it, but Platform 5 is <u>a group exhibition</u>. On the one hand, there were objective reasons for this satellite formation: the geographical distance between my project and the main venues of the exhibition, the increasing stress as opening date approached, and the growing, clear-cut hierarchies that were forming, which had a negative effect as regards technical help since we were further away. <u>But I also think I myself participated in creating a conflict and building up negative energy, since I didn't resist this urge to be a lone fighter.</u> It was not the first time this happened, and I think it was absolutely unnecessary, especially since I was not agitating myself only, but this time it also involved the people working with me. From the setup phase I remember the wonderful answer that Marco, one of the workers, gave to a passerby who asked, "Is that supposed to be art?" He responded, "Yes, because we did it together!" In spite of everything, construction was completed on June 5, 2002, right on schedule, and all the elements of the *Bataille Monument* were finished!

3. Opening of the Bataille Monument

The opening of the *Bataille Monument*, like the rest of the Documenta 11 exhibition, took place over the course of three days. I decided we would celebrate it in the housing complex for three days. Every day, that is, on the 6th, 7th, and 8th of June, there were free drinks and food at the snack bar starting at 6 p.m. On the one hand, I wanted to thank the residents of the complex, who accepted the project in spite of the noise and the space we used. On the other hand, <u>I wanted to have our own opening celebration here in the</u>

housing complex. This went well, although the Kaban family, who ran the snack bar, was totally overrun by the storm of kids. Most importantly, the opening celebration in the complex served to create a mixed audience. I must admit that I organized that deliberately. I had assumed that the visitors who came to the opening of Documenta 11 would not correspond to the regular visitors, so that on these three days the invitation to the locals encouraged a mixing of residents and Documenta 11 visitors. I was surprised by how many Documenta 11 visitors came to the Friedrich Wöhler housing complex. Although it definitely took a lot of time and the program schedule was very full, I noticed the seriousness and genuine curiosity of many visitors. Was that the Documenta mythos? That is why I was also surprised by how fast many people voiced opinions of my work—already on the first evening! I posted a quotation by David Hammons on the freestanding panels set up at the two shuttle stops, in the Friedrich Wöhler housing complex and in front of the entrance to the Binding Brewery:

> The art audience is the worst audience in the world. It's overly educated, it's conservative, it's out to criticize, not to understand and it never has any fun. Why should I spend my time playing to that audience? That's like going into a lion's den. So I refuse to deal with that audience, and I'll play with the street audience. That audience is much more human and their opinion is from the heart. They don't have any reason to play games; there's nothing gained or lost.

I read this quotation in London at the "Protest and Survive" exhibition I participated in.[22] This quotation is both problematic and contradictory, but it strikes at the core of the complexity of work in public space and the audience of public space. David Hammons is part of the art world and his work is part of the art market. Nonetheless, these sentences also defiantly assert the autonomy of a work of art. I wanted to honor that and at the same time propose it as an appeal for reflection and as a link between the two stops of the "shuttle

service." It is also a homage to the artist David Hammons, whose work I value very much. What I see in this quote that applies entirely to my *Bataille Monument* project is that it also has nothing to win or lose. Work in public space can be neither a success nor a failure. Instead, it is about the experience, about exposing oneself, about enduring and working out an experience. A project in public space is never a total success or a total failure. I think working in public space does not need these criteria. Am I capable of making contact with people? Am I capable of creating events? Am I acting in earnest?

Right on opening day I realized that earlier—during planning, preparations, and setup—I had never thought the *Bataille Monument* could be discussed and criticized as a social art project. I think it is totally proper that social issues are raised through an art project. It is a question as to the surroundings, the environment, the world in its broadest sense. That is a goal of my work. I am not afraid of false interpretations or over-interpretations or misunderstandings. But one thing was and has always been clear to me: I am an artist and not a social worker. My project is an art project that aims to assert its autonomy as an art project! This was the starting point and cornerstone of all the discussions I had with the people working on the project as well as with the visitors. Precisely because the *Bataille Monument* is an art project it is possible to refuse to exclude anyone from working on it; and because the *Bataille Monument* is an art project, it is also imperative that it not be influenced by the wishes of the residents as regards content. The guideline was: As the artist, I am not helping you; I don't want to help you or ask you how I can help. Instead, as the artist I am asking, Can you and do you want to help me complete my project? I think this was acknowledged and accepted by the residents and the workers. I wanted to make it clear to the residents of the housing complex why I wanted to create my work of art right there with them. I wanted to create my work of art in a housing complex that is itself a piece of reality. Without illusions; without fantasies. I wanted to act; I wanted to act with and through art. Hope not as dream or escape. Hope as discussion and confrontation, hope as the principle of taking action. You take action only because you have hope. And if the *Bataille Monument* is supposed to be set up, supervised, and taken down,

together with the artist, what is more natural, more logical, than asking the residents for help? Why should this project be set up and supervised by specialists if there are enough people in this housing complex who are available to do the work? What is the more obvious choice and more understandable? And what makes more sense than to say, "The assistance by especially talented, fast, or specialized technicians is not needed; assistance by the residents is needed!" For the simple reason that the project is being done here! To that extent the workers were never "materials." Instead, I could not complete my project on my own, and that is why I posed the question and demand: Don't do it my way! Let's do it together!

October 19–22, 2002
[Translated from German]

3.22 *Doppelgarage*, 2002. Gallery Arndt, Berlin, Germany, 2002. Collection Neue Pinakothek, Munich, Germany.

DOPPELGARAGE

I want to make a *Doppelgarage* [Double Garage]. There are no vehicles in this garage. The garage space is used as a workshop or storeroom, as a morality-free space in which observations can be made that cannot be made in the living room, bedroom, or kitchen. September 11 will be worked through in the *Doppelgarage*. September 11 will be worked through without any attempts at publicness. The *Doppelgarage* will focus on a work, an engagement, a bricolage, a philosophy, or a paranoid amateurish psychology. It is not meant for a public. We stumble onto the *Doppelgarage* just by chance and witness this private engagement with September 11. This engagement is art. That is, forms are sought and worked on. Something is given form. Something is given form, or an attempt is made to give form: to the hostility, the vengeance. September 11 as an act of vengeance. As I was watching the Twin Towers collapse on television on the afternoon of September 11, I remembered the first Gulf War. I recalled the few, very sparse images of the column of cars that stretched for kilometers carrying Iraqis fleeing from Kuwait. They were torched as they were stuck in a traffic jam. There were thousands of dead. The highway was transformed by the American Air Force into a river of flames because it was an easy, inescapable target. Close-up shots showed that no one could have escaped. Most of those fleeing simply burned in their vehicles; a few were able to make it to the roadway, only to be burned up there. I recalled these images on the afternoon of September 11, and I thought: this is revenge for that. This is retribution. This is the counterstrike years later for this massacre in this lost war. I thought about war. I tried to understand what happened:

For me, this act was an act of revenge. This will be shown, or an attempt will be made to show this, in the *Doppelgarage*, without moral indignation, without a know-it-all attitude. Marcus Steinweg will write the texts. These texts will be short texts that can be read independently of each other, even though they belong to the same project. They will be enlarged or scaled down as text material. It is material. The texts are not to be taken along. They hang on the wall. They are on tables. Integrated into the models. In the garage,

there are also train models, house models, models of ruins. The garage has fake cardboard walls and its own "garage light."

I want to assume responsibility for something for which no responsibility can be assumed, for something that is too much, too big for me. "Responsibility is only conceivable as an excessive demand, as the possible impossible, and as excess," writes Marcus Steinweg. Work will be done in the garage through sleepless nights. The *Doppelgarage* has a special floor, and the garage is a machine that produces multiplicities. Nothing can be put in order. It's an attempt to give form to that which has no form, to what can have no form and what cannot give form. I want to give form to it. It is only possible if I make something that is impossible and that has no guarantee of recognition or understanding, or even respect. That is what I want and I can do it. I do it for myself.

Kassel, July 29, 2002
[Translated from German by Kenneth Kronenberg]

The project *Chalet Lost History* is the second "Lieux d'un autre" [Places of an other] exhibition proposal. It's not me, the artist, who conceived of the place, it's an other. It's another me. A <u>possible</u> other me. I'm actually thinking of an other, of the other in general, in conceiving of this exhibition. The first "Lieux d'un autre" was *Doppelgarage*, which I made a year ago in Berlin. *Chalet Lost History* and *Doppelgarage* share the ambition of completely enveloping the gallery by making another space, not through its architecture, but through its envelope. The floor and the walls have to change the gallery into a chalet. *Chalet Lost History* and *Doppelgarage* also share the fact that there are integrated texts in the work—not integrated in the exhibition but into the work itself. So the integrated texts (by Manuel Joseph) will be enlarged, cut, reduced, transformed, glued in such a way that the work is one with the integrated texts. I want to go farther, especially by reducing the texts and by gluing more than I did in Berlin.

The Chalet

The chalet gives another tone upon entering the gallery: the tone of the other, the "Lieux d'un autre." The chalet is the river that carries you to the banks of the other world. The floor, the walls, and the light (not the ceiling!) allow you to understand that you are <u>in another world</u>! The chalet is a typical vacation spot, wealthy, warm, healthy, with know-how, etc. It's also a secret place but banal, unknown, and familiar.

"Lost History" is the name of this chalet. Like "Bellevue" or "Beausoleil" chalet. The title, however, is the true program, the plan, and the driving force of this "other," of the one who lives in or uses this chalet. It exposes the theme essential to him: History is lost. History was stolen, looted, sacked. History <u>has always</u> been stolen, looted, sacked. History <u>was always lost</u>! I'm picturing images of "pillages" in Baghdad. The people who were leaving the Iraq Museum of Archaeology with refrigerators, air conditioners, furniture, plants, and with old,

3.23 *Chalet Lost History*, 2003. Galerie Chantal Crousel, Paris, France, 2003. Courtesy Galerie Chantal Crousel, Paris, France.

historic, archaeological objects. The people stealing a refrigerator are running alongside people stealing a Mesopotamian vase. The people stealing Sumerian statues pass alongside people stealing a chair. History is lost, History has always been lost. Mr. François Pinault bought an Egyptian statue. History is pillaged. The Egyptian statue was only a copy. It doesn't matter. History is lost. <u>Values no longer exist!</u> There is no hierarchy. There are no values. It's chaos and also paradise. It's what I want with my *Chalet Lost History*.

I want this exhibition to bring the viewer, the visitor, <u>to the banks of the other world</u>. I also want to make a connection between the "looting" of Iraqis in Bagdad and the pillaging of the English, French, and Germans in the past. I want to draw a parallel between what is pillaged and exhibited at the Louvre, at the British Museum, and at the Pergamon Museum and what rich art lovers own all around the world. History was lost long ago. History is lost. But <u>history was History</u>!

The Integrated Texts of Manuel Joseph

The integrated texts are very important. They are important for what they are: texts by an author, a writer. They're lost texts, looted, stolen, sacked. They're <u>free</u> texts that agree to be looted, stolen, sacked, lost because they exist. They have existed. They are history. They were texts. They were! Manuel Joseph's texts are parallel texts, with his themes, his history. Manuel Joseph also works to bring the visitor, the reader to the banks of the other world. Our two approaches are parallel. Like the refrigerator thief and the thief of the statuettes. We advance in parallel toward another world. Toward paradise and toward chaos. <u>I believe in the texts</u> of Manual Joseph because they are free and they <u>resist</u>. There are very, very few things that resist. These texts by Manuel resist and, in general, texts, writing, resists. That's why I want there to be a lot to read in *Chalet Lost History*. I want there to be isolated words, amputated phrases, pieces of scattered texts. I want that the texts not be there for the taking. But the texts are to be read in the chalet. In bits, in pieces, fully. But the reader cannot take them away. Only in his mind. Only in pieces. Like the

looter. I want visitors to stay a long time, read a lot, not understand, in the *Chalet Lost History*. <u>I want a lot of people to come see</u> *Chalet Lost History* on view at Galerie Chantal Crousel!

September 2003
[Translated from French by Molly Stevens]

LETTER TO CLARE (REGARDING *CHALET LOST HISTORY*)[23]

Dear Clare,[24]

I am, of course, not happy about your "consensus" decision, and I could never have agreed with your initial proposal, which, of course, made no sense to me! I could not believe it! It was such a shock to me! Never, ever did I expect such a thing! (In Chicago I agreed to have informational texts—but no restrictions! I can agree with information for the public but not with a public restriction!)

This restriction made me crazy: I have been working and fighting with my artwork for many years to include people, to exclude no one, with and through my artwork. I have been asserting for years that I want to work for a non-exclusive audience—and the Hayward Gallery imagined it possible to restrict the audience!

I am sorry that this point was never discussed with me, and I was about to have you remove my work from the "Universal Experience" exhibition, I am so sorry to say, because this was really not OK with me!

People are so afraid today, it is really unbelievable. Even you, people from the art world, are so afraid! People suspect my artwork, people are suspicious of art, people are suspicious of everything! My artwork is but a slight turmoil at a time when looting takes place, when there is tourism, when there is war, when there is economic piracy!

But you at the Hayward Gallery are afraid of some pictures of sexual penetration! In every bad sex magazine there are thousands of pictures like this!

I think it is stupid, because to make such restrictions puts people directly in a situation where something "forbidden" and "scandalous" will happen. It's so ridiculous!

Chalet Lost History is an artwork. *Chalet Lost History* is the intimate place of the nightmare of lost common history, of lost common values, and of lost things shared because they are universal and belong to everybody. The Hayward is an art gallery; you are working with art. Art is not something

3.24 *Chalet Lost History*, 2003. Galerie Chantal Crousel, Paris, France, 2003. (Photo: Florian Kleinefenn.) Courtesy Galerie Chantal Crousel, Paris, France.

controllable. Art has the power and the force to go out of control at any instant! Art is not something to which you can put limits. I think there was a profound misunderstanding about your mission within the gallery, and about the power of art and the possibility of art, when you asked me for justification regarding the penetration pictures in my artwork, about shock, about the juxtaposition of sexual imagery and war imagery, and about hard-core images. The recent accounts of Hurricane Katrina made it possible to imagine and to think out the absolute nightmare! *Chalet Lost History* is a tender work regarding what happened recently. For a long time pornography has not been limited to sex shops! The obscenity is not in pornography; the obscenity is in the looting, in the historical looting, the cultural looting, the touristic looting, the economic looting, the religious looting, and the nature looting! Do I have to justify the juxtaposition of sex pictures with war pictures? I am dreaming! I ask you: Did you watch television last month and see the armed American soldiers and the helpless and homeless abandoned citizens? Did you see pictures from New Orleans? Were you shocked by the pictures of the burning British soldier trying to escape from his tank in Iraq these past days? Did you see the picture of the armed guard in the New Orleans art museum in front of a Degas sculpture? All this is more than justification for an artwork made two years before the fall of Bagdad!

I have to fight for the autonomy of my artwork and the integrity of it! I love art, I love all art, I also love bad art! And I do believe in art—in all art— and I do believe also in bad art, and I really try to work with and in the chaotic world I am living in. I do not want the chaos, I do not want the provocation, and I do not want to shock—but I am living in a shocking, provoking, and chaotic world. My mission is to work in this world—to face it, to struggle with it, to fight with it. My work does not want to bring peace or comfort or quietude in this world. My work wants to be a contribution to the confrontation with this world in trying to establish the conditions for a dialog today with the spectator, with a sovereign and universal spectator!

I am very disappointed. I am not complaining, but I am angry—because again and again I have to fight—even when things seem clear to me!—but I

will continue to fight for my artwork, for its existence as artwork and not as "hidden spectacle," and I want to fight against stupidity! I want to continue to try to be courageous! To assert art as absolute freedom! To be headless and to give form to this headlessness! I want to be true to a non-analyzing artwork, to a non-narcissistic artwork, and to a non-cynical artwork. I am not for censorship, I am not for self-censorship. I would have made the sacrifice not to exhibit my work under the restrictions of the Hayward Gallery!

Finally, I hope we can solve the problem as in Chicago.

September 30, 2005
[Composed in English]

REGARDING *HOTEL DEMOCRACY* AND *U-LOUNGE*

I do not want to provoke anybody or anything, but I am also not afraid to give titles to my work. I think it gives more surface to attack the work, to confront the work. The title never explains or completes my work; I just like to fix and to assert.

Hotel Democracy and *U-Lounge* are two new works I want to do. *Hotel Democracy* will be a sculpture of an uncertain building embodying different concepts, realizations, misunderstandings, perversions, hopes, dreams, disasters of democracy. In every room, or model room, of this hotel, I will interpret the common meaning of "democracy" in a different way, in a contradictory way. Everybody wants democracy, nobody is against democracy, but there is not one universal model of democracy. So I want to present this confusion without judgment, without hierarchy. The picture of a hotel seems to me a possible and appropriate form because a lot of unexpected and incoherent events happen in hotels all the time. A hotel is not really a place to remain; a hotel is neutral space. Its owners close their eyes to everything; you just have to pay for your room.

U-Lounge is the second new work I will do for "Common Wealth." It is a space for poetry, philosophy, and art; it is a space with books, with an integrated video, and with integrated philosophical texts by Marcus Steinweg; it is a space to sit down and read a book. The title *U-Lounge* stands for "utopian lounge," but before "utopia" gets fashionable, I prefer to begin only with its first letter, U. In fact, I think utopia is inside art, philosophy, and poetry; utopia has nothing to do with politics. That's why, beside *Hotel Democracy*, I will do another work. The term "democracy" is common to us, or used as if common. The term "utopia" is the real wealth; wealth is art, philosophy, and poetry.

U-Lounge and *Hotel Democracy* are separate works in separate spaces; though close to each other, they are separated for Tate Modern security reasons.[25] In the beginning I planned to have them linked with a strong physical connection through the doorway, but it was not possible to do this. Security will kill us all. First security will kill our mind and then security will kill our

3.25 *Hotel Democracy*, 2003. "Common Wealth," Tate Modern, London, U.K., 2003.
Courtesy Stephen Friedman Gallery, London, U.K.

body. Because I did not want to make a small or clever connection, I decided instead to make a mental connection; this connection will be worked out visually. I want to assert this visual connection between *Hotel Democracy* and *U-Lounge*, in order to be the first killed, as the artist, for security reasons.

2003
[Composed in English]

3.26 *Swiss-Swiss Democracy* (*William Tell*, play by Gwenaël Morin), 2004. Centre Culturel Suisse, Paris, France, 2004. (Photo: Romain Lopez.)

SWISS-SWISS DEMOCRACY[26]

I propose an exhibition at the Centre Culturel Suisse as a form of *tenir un siège*.[27] This exhibition will be open every day except Monday from December 1, 2004, until January 30, 2005. That makes eight weeks: fifty days from 11:00 a.m. to 9:00 p.m. without interruption. *Tenir un siège* is not the theme of this exhibition, but it is its engagement, its mission. Marcus Steinweg, Gwenaël Morin,[28] whom I invited, and I will be present at the Centre Culturel Suisse all the time (with rare exceptions) during the exhibition, during the announced hours. The exhibition takes place throughout the Centre Culturel Suisse, including the projection room. And so a specific "decoration" of the walls with cardboard painted in "neutral" colors (pale blue, pale yellow, and pale red) will cover the spaces. I want you to be completely in a separate universe. In this pale blue, pale red, pale yellow universe, actually in a universe of democratized colors. *Swiss-Swiss Democracy* aims to reach the boundary of democracy. With this exhibition, I want to de-idealize democracy! For a long time (I did a work in 1997 titled *Pilatus Transformator*), I've been revolting against democracy, direct democracy. I've been revolting against the use of democracy. With *Swiss-Swiss Democracy* I want to show that there is no ideal "democracy." I want to show that existing democracy, Switzerland, is still just as antidemocratic. I want to express my revolt, not against democracy, but against the use of democracy for personal interest, for good conscience, in order to assuage criticism, to assuage opinion. I want this revolt to be visually visible. With density, charged with complexity, I want to give form to the end of the Idealization of Democracy.

Swiss-Swiss Democracy will have eight elements:

1. A Showroom. I call it "showroom" because all the eight elements are the exhibition. The "showroom" is only one part of the exhibition. In the "showroom" there are the fifteen integrated texts by Marcus Steinweg. There will be a lot of material on democracy; there will be models of democracy. There will be integrated videos.

2. <u>An Auditorium.</u> There will be a space with chairs, and a microphone on a table for the regular and daily interventions of Marcus Steinweg. He will read his statements about democracy. These readings will be in this auditorium.

3. <u>A Library.</u> There will be a place with books, newspapers, texts, so that one can be confronted with writings about Swiss democracy, but also about current politics in Switzerland and elsewhere. There will be furniture for sitting and staying, for discussing or just being there.

4. <u>A Bar.</u> There will be a bar to allow people to stay, come back, spend time. The bar will be open, like the rest of the exhibition, all the time.

5. <u>A Theater.</u> Every day Gwenaël Morin will perform *William Tell*. Every day at the same time in the projection room. This play staged by Gwenaël Morin will confront the audience coming for this only or passing through by chance. The play will confront the audience with William Tell, with the question of democracy today, with myth, with "democratic kitsch," and with history. The set of the Theater, the theater space, will be integrated into *Swiss-Swiss Democracy* as a whole.

6. <u>A Swiss TV lounge.</u> The lounge will have three to four televisions broadcasting Swiss TV live—all the time—to include a "live example" of democratic expression on television. This space will allow viewers to be confronted with "cultures" of democratic expression.

7. <u>A Newspaper.</u> Marcus Steinweg and I want to produce something on site. Every day a newspaper will be self-produced as photocopies on site. It will be distributed for free and made anew every day, so fifty issues. Marcus's texts, Marcus's readings, contributions from myself, and other possible contributions will provide the elements for the newspaper. The newspaper will be distributed on site. It is an immediate production. It is an activity.

8. In a part of *Swiss-Swiss Democracy* there will be explanations about my refusal to show my work in Switzerland, about my statement, about the Federal Councilor Christoph Blocher.[29] This will be the "citizen" moment of the exhibition. *Swiss-*

Swiss Democracy aims to produce space, time, urgency, and an attentive ear for the confrontation with democracy.

Aubervilliers, July 2004
[Translated from French by Molly Stevens]

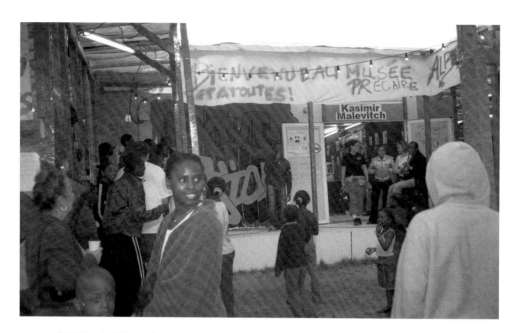

3.27 *Musée Précaire Albinet*, 2004 (Opening, Kazimir Malevich Week). Cité Albinet, Aubervilliers, France, 2004. Courtesy: the artist and Les Laboratoires d'Aubervilliers, Aubervilliers, France.

THE *MUSÉE PRÉCAIRE ALBINET*

The *Musée Précaire Albinet* is called "museum" because it is a museum, and "precarious" because it is limited. This project was a project about excess and the unreasonable. It was a project that wanted to be a concrete manifesto on what an artist can do in public space. The *Musée Précaire Albinet* wanted to be a breakthrough.

The Openings

Every week we organized openings. Through these openings I wanted people to realize the importance of art and the importance of the moment in which we are experiencing it. The *Musée Précaire Albinet* asserted and defended its autonomy as a work of art at every moment. That's why it was able to bring the experience through to its end, because it was a work of art. However, the *Musée Précaire Albinet* had to be built at every moment in my head and also, I think, in the heads of the people of the housing project [Cité Albinet].

The Exhibitions

The exhibitions were the heart of the *Musée Précaire Albinet*. I wanted not only to exhibit work but also to give information about the works exhibited and about the other works realized by the artist. The eight artists that I chose (Duchamp, Malevich, Mondrian, Dali, Beuys, Le Corbusier, Warhol, and Léger) are artists that I love and that, through their works, wanted to change life and were able to change life.

I think that only art does not exclude the other and that only a work of art possesses the universal ability to initiate a dialog one to one. As an artist, this is what I want: to create the conditions to initiate a dialog one to one.

The Children's Workshops

Every Wednesday there were children's workshops. Beforehand I had met two women who had created an association called *La part de l'art*. They had already worked with youth in a housing project also in Aubervilliers: the Cochennec housing project. I invited them every Wednesday to lead a workshop for the children of the projects based on the exhibited works.

For me, the *Musée Précaire Albinet* was the most demanding, the most complex, the most difficult, but also the most radical project that I've been able to do in public space because it was only conceived of for the people of the projects and because it was conceived outside an art event, a national or international exhibition.

The Writing Workshops

Every week I invited two friends, Manuel Joseph and Christophe Fiat, writer-poets with whom I had already worked; they in turn invited eight women artists and writers. These women came every Thursday afternoon to lead a writing workshop. The writing workshop was somehow the most difficult workshop to lead because people in the projects, our audience, are the hardest to get to write.

The Discussions

Manuel Joseph and Christophe Fiat not only led the writing workshops, but also organized a debate every week, debates that were conducted clearly and had very simple titles, such as "Jews/Arabs," "Europe/United States," "Communism/Capitalism," etc.

With the *Musée Précaire Albinet*, I wanted to justify nothing. I wanted the project to assert itself more and more every day, every week. And that this claim would be more and more demanding, both for those receiving it and for those giving it.

The Art History Conferences

I also wanted to inform the people of the projects about the works exhibited among them. Every week an art historian, a specialist, came and showed slides of the work of the exhibited artist.

The *Musée Précaire Albinet* was based not on respect but on love, because asserting something doesn't mean respecting it; asserting means loving.

Communal Meals

At the end of the exhibition week we organized shared meals. The idea was that a family from the projects, or friends from the projects, would organize a big meal that somehow celebrated the end of the exhibition and punctuated the weeks.

This project was a project about excess and the unreasonable, and I had to convince myself at every moment that I had made the right decision, I had to encourage myself every day to continue. The *Musée Précaire Albinet* was not possible without agreeing with the housing projects. Agreeing doesn't necessarily mean approving, but agreeing is necessary if you're going to change reality: that is the lesson I learned from this experience. If you carry out a project in public space, with the residents of a housing project, the artist absolutely has to agree with everything going on in the projects.

Outings

We organized outings every week. Eight or ten people took a small trip with regard to the work, the artist exhibited. For example, for Duchamp, we went to visit the BHV department store; for Le Corbusier, the Cité Radieuse in Rezé, near Nantes; for Andy Warhol, an advertising agency. The project consisted not only in bringing works of art from the Centre Pompidou and exhibiting them in the project park, but also in showing that there were other trips to be made—that's why we organized these outings.

Dismantling

Dismantling the *Musée Précaire Albinet* was the final stage of the project. Every stage was equally important. The dismantling happened very quickly, in a week. It was not the end of the *Musée Précaire Albinet*, but it was one of its stages.

I won't ever say that this project was mission impossible—it taught me that, too. I think with art every mission is possible. This project, I think it's important to say, did not work for justice or democracy. This project also didn't want to improve, or appease, or calm the neighborhood. It wanted to touch what you can't touch, the other.

The Raffle

After dismantling, we organized a free raffle in the projects so as to distribute what I call the "software," in other words, all the tools and technical equipment that were part of the *Musée Précaire Albinet*. Through this act of redistribution and re-attribution, I wanted to make a gesture of memory in the projects.

Never will I say that the *Musée Précaire Albinet*, like every other project in public space, was a success. But nor will I ever say that it was a failure, because I know that if you work as an artist in public space, there's never total success, just as there's never total failure.

Aubervilliers, 2004
[Translated from French by Molly Stevens]

Utopia, Utopia = One World, One War, One Army, One Dress[30]

Utopia, Utopia = One World, One War, One Army, One Dress is an exhibition.
Making an exhibition means to exhibit something, to exhibit a project, an
idea, a problem, a plan, a will. Making an exhibition means to work in necessity, emergency, and complexity. I like making exhibitions. I understand art as
assertion of forms. As an artist, I have to make theory confront practice and
transform a two-dimensional thought into the third dimension. I want to work
out my brain map directly in a three-dimensional form without thinking about
volume. I want to make space for time—time for dialog, confrontation, and
involvement. I want to do "sculpture." I do not make "installations." My
exhibitions are never site-specific or contextual; they're works that must be
transplanted mentally, and they're works that can be transplanted physically to
other locations. My exhibitions can travel and be adapted to different locations. I do not want to work with architecture; I do not want to work against
architecture; I want to ignore architecture.

The exhibition *Utopia, Utopia = One World, One War, One Army, One
Dress* is about the incredibly fashionable tendency to wear camouflage clothing.
I want to work out this fact strongly, offensively, and aggressively, blindly. I
want to show that anyone wearing camouflage clothing, just an item of camouflage clothing, puts himself in the position of a soldier at risk of being killed.
Objectively, it means that he or she accepts being part of an army and is ready
to kill and ready to die—the absolute nightmare. Unlike real soldiers, camouflage-dressed people wear camouflage clothing to be noticed, to attract attention, to signal themselves. There are many different motivations for wearing
camouflage: to be sexy; to be a "street-fighter"; to be cool; to express political
opinions; to dress cheaply with second-hand clothing; to dress practically, with
many pockets, warm and waterproof. Real soldiers wear camouflage outfits for
protection, for camouflage, to be unnoticed, to hide themselves, or to become
invisible. The idea of camouflage does not come from nature. I refuse this
simplification and this kind of legitimation, because animal camouflage (for
insects, fish, predators) is a natural protection to avoid being eaten or to get

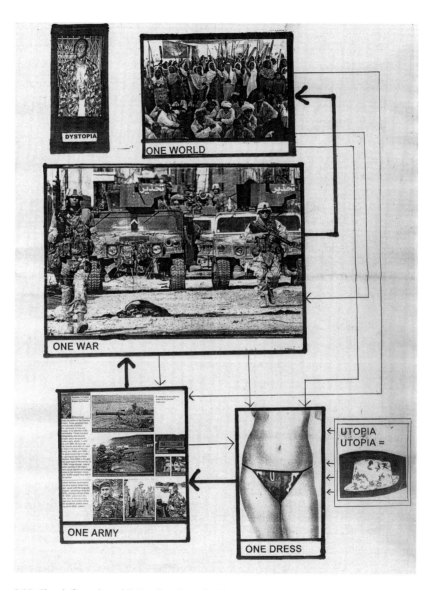

3.28 Sketch from the exhibition brochure for *Utopia, Utopia = One World, One War, One Army, One Dress* at the Institute of Contemporary Art, Boston, Massachusetts, 2005.

food. There is no natural human camouflage. Camouflage has nothing to do with the human; it doesn't belong to human nature; a human being doesn't need to use camouflage in order to feed himself or to avoid being eaten. So the reasons for wearing camouflage do not come from nature; they are to be found elsewhere in motivations about appearance. The reasons come from the human condition. I know the fashionableness of wearing camouflage clothing and military items: the chic feeling of being fashionable and being a "fighter." I wore camouflage when I was in the Swiss Army, first as private, then as corporal, and finally as lieutenant. [. . .]

I want to shoot at fashion; I want to shoot at glamour; I want to shoot at the military and the camouflage look. I want to shoot at myself. This shooting, this outcry, wants to give form to a nightmare exhibition. I want to make a nightmare exhibition with a dark side, with things that run wild, with the totalitarian side that goes wrong. I want to work this out in a dense, plastic, explosive, headless way. With *Utopia, Utopia = One World, One War, One Army, One Dress*, I want to do a dystopian exhibition. I want to make clear that it is dystopia, it is nightmare, it is chaos. Here there is no basis for thinking, no place for ideological critical thinking. My exhibition refuses sentimentality and good conscience. I am against the pretension of narcissistic self-fulfillment. I want to fight resentment, cynicism, and narcissism. And I want my work to fight the dictatorship of morality, nonpleasure, indifference, and nihilism. Utopia doesn't exist; this is why it cannot disappear. I want to do a work with enthusiasm and joy. This joy comes from an amoral dream, my dystopia–utopia dream. It is the joy of an unpessimistic action, of self-assertive action, beyond the question of good or bad. This is the art project *Utopia, Utopia = One World, One War, One Army, One Dress.*

Coming out from dystopia, from nightmare, from darkness, from absolute catastrophe, there is a way, an incredible, impossible, utopian way. From the youngest to the oldest—from the Palestinian baby dressed in camouflage to the Russian Volga fisherman wearing military dress; from the antiglobalization, *altermondialiste*, anarchist "street-fighter" to the glamorous female pop-star singer—everyone wears the same camouflage look. Everyone becomes

fashionable, glamorous; everyone goes crazy about this chic clothing, and everyone wants to be a street-fighter, a street-warrior. To wear the same clothing is the dystopian act of accomplishing utopia: because everyone dresses the same way and everybody wears the same dress, the ONE DRESS. Utopia is accomplished not because everyone is sharing the same ideas, ideals, dynamics, love and peace, but because everyone is dressing the same way. From ONE DRESS to ONE ARMY to ONE WAR to ONE WORLD. These are the dystopian steps to utopia. Utopia coming from an incredible, headless, and fashionable logic! Utopia not coming from reflection on society and theoretical thinking. Utopia from headlessness. Utopia from practice. Utopia from assertion. Utopia from Art! This is my consistent project.

I am interested in ethical questions; I am interested in full-time thinking; I am interested in pure philosophy; I am interested in philosophy as art; I am interested in philosophy and art as assertions. That's why I don't need philosophy in order to do my artwork. I need philosophy as a human being, as a man! I need philosophy for my everyday life! Philosophy and art work together. They act! They are free. Philosophy and art are not afraid! I like the philosophy of Marcus Steinweg. I have asked him to write "integrated texts." He wrote twenty-nine short texts about the world, about ONE WORLD. The title of his texts is *Worldplay*. These "integrated texts" will only be readable in their complete form in the free publication that is an element of the exhibition. The twenty-nine texts will be cut, transformed, integrated in bits, enlarged, reduced, worked out into a big layout without sense, with non-sense. There will be a lot of letters, words, sentences, text as weapons, text as tools, text as blind text. Text as resistance. A conflict in the conflict. For the past few years I have been using "integrated texts" by different authors as material in my exhibitions, like tape, cardboard, printed matter, electrical wire. My use of the "integrated texts" treats text as a material of resistance but at the same time asserts its autonomy as text. Marcus Steinweg remains the author of *Worldplay*, free to use it as he wants; he gave it to me as a tool I can use as I want too.

Utopia, Utopia = One World, One War, One Army, One Dress has to be big, exhaustive, and exaggerated. It will be a large exhibition with reduced

elements and enlarged elements. Making something big, enlarging it by hand, does not mean it is important. But it does express a commitment to something—that is why it is enlarged—and, simultaneously, an enlargement makes it empty. The commitment and the emptiness remove the meaning. They suggest another meaning, a different meaning! The exhibition will include a lot of various elements: display-panels, models, mannequins, printed matter, topographies, "integrated texts," explanations, photographs, sculptures, and video films. There will be different links possible: from camouflage to fashion, from camouflage to art, from camouflage to weapons, camouflage and fashion for kids, different types of camouflage material, desert camouflage, air camouflage, water camouflage, techniques of camouflage, history of camouflage, history of uniforms, history of the military look, camouflage versus uniform. This exhibition is not another exhibition about camouflage and its fashionableness. It will look like some local community exhibition, about the World War II Normandy landing of American and Canadian soldiers, for example—the kind of historical exhibition made with love but with no aesthetic ambition or sense of design, of museum design or architecture. The only thing that counts is the will to make an exhibition!

With *Utopia, Utopia = One World, One War, One Army, One Dress*, I want to confront camouflage and the military look with hope, hope as the principle of activity, of action, in order to go through the tunnel of camouflage, this nightmare. In this dystopian tunnel UTOPIA again makes sense today. I want to do too much, I always want to work in excess, and I want to be precise in this excess. I want to make my artwork without illusions. I want to hope. Hope not as dream or as escape. Hope as dialog and confrontation. Hope as the principle of taking action.

Aubervilliers, Spring 2005
[Composed in English]

3.29 "Anschool," 2005. Bonnefanten Museum, Maastricht, The Netherlands, 2005. (Photo: Romain Lopez.)

"ANSCHOOL"[31]

To make art politically, not to make political art, means the <u>making</u> is political, not the art or the "conscience" of the art! Making art politically means to assert the existence of art as absolute art and with absolute freedom. "Anschool" will work out this statement in keeping with other statements of mine, such as "Energy = Yes! Quality = No!" and "Better is always less good!" The exhibition "Anschool" takes the form of different classrooms of a school, a college, or a university: the same color, the same furniture, the same lighting. In the different rooms there are different works of mine, sometimes alone, sometimes together with other works. The furniture includes chairs, lecture stands, showcases, boxes, benches, panels, mannequins, "world" globes, "world" maps, shelves and closets, TV screens, screens with slide projectors. All this material I call "the hardware." "The software" will be my exhibited work. But I will also mix in, in a headless, confused, unbalanced way, texts and documentation about my work: videos, photos, slide projections, printed matter (press reviews, my own writings about my work, writings for preparation of my work). This will be an important part of the exhibition: I call this "the pedagogical material." So there will be hardware, software, and pedagogical material. Everything will be completely mixed up and follow only my own inner logic. It's not about communication; it's about codification and precariousness and wanting the visitor to be implicated. To implicate the visitor means to give so many of my own forms that the visitor can only become active. Not interactive. The activity of the visitor is his thoughts about the artistic position I assert and I defend. The activity of the visitor is his own thinking, his own judgment, and it is not, in any case, a "school-making" way of thinking. This is the aim of "Anschool."

February 14, 2005
[Composed in English]

3.30 *Superficial Engagement*, 2006. Gladstone Gallery, New York, 2006. Courtesy Gladstone Gallery, New York.

SUPERFICIAL ENGAGEMENT

Superficial Engagement is the title of my new exhibition at Gladstone Gallery in New York. The title asserts a position. This position wants to be an artistic, political, ethical, and aesthetic position. This title, in its wording, is an engagement and at the same time a challenge. It is an engagement because I do believe that an engagement is a superficial thing, needs superficiality, is always superficial. Superficiality is not negative; superficiality is the condition for a real engagement because if there is no engagement on the surface, there cannot be a profound engagement. To go deeply into something, I must at first begin with its surface. The truth and logic of things are reflected on their own surface. Superficially engaged people are unjustly considered with suspicion; what is important is not the superficiality but the engagement. Superficial engagement is not non-engagement! Let's keep things on the surface, let's take the surface seriously!

I was always interested by surfaces, by contact with surfaces. The impact is always on the surface. The impact has to touch the surface. Through the impact, the surface has to be perforated. It doesn't help to be deeply engaged if there is no will to break through the surface. I want to have impact with my artwork; that's why I have to stay on the surface. The challenge for me is to try to give form to this affirmation without falling into facility. The challenge is to avoid non-engagement. Searching for the impact and staying on the surface is the problem. And to do so means to include the other and to refuse all exclusion. I try to implicate the other without neutralizing him. As always for me, the challenge is to create a new form with a multitude of existing forms—to do an artwork where superficiality and engagement are confronted together in order to change the meaning and to give a new meaning. If someone qualifies my work as superficially engaged, I am not offended. It is a misunderstanding I must acknowledge. I am not complaining.

Superficial Engagement is the title of my artwork, which is divided into four independent platforms. Each platform is a different attempt to confront art and war, to heal war and violence through art. Art is healing war. This is the

hidden strategy of *Superficial Engagement*. The subtitles of the four platforms are *Concrete Shock*, *Spatial Front*, *Chromatic Fire*, and *Abstract Resistance*. These subtitles are mentally interchangeable; they are permutations; they are intended not as explanations but as designations for the four different displays on the platforms. The four displays are built according to the logic: War/War, War/Art, Art/War, and Art/Art. Each one has a different dominant term, different stages of healing from war, that range from War/War to Art/Art. This is the logic; it's my own, my inner logic; it's the artistic logic; it's not a communicable logic. To me, as an artist, the problem is: How can I take a position, and how can I give form to this position beyond political, ethical, and aesthetic particularities? How can I create a universal form that goes beyond history and that resists historical facts?

I have recently been working on the *Nail & Wire* series. These works are inspired by the decorative "nail and wire" craft. I like this pure, formalistic pastime. Without intending to, people who do this kind of craft are resisting the historical time we are living in. This craftwork is also a link to art for me.

I will use the artwork of the Swiss artist Emma Kunz (1892–1963), not as a homage but in a friendly act of piracy that could also turn against me. The act of piracy consists of using her beautiful images as healing images against war, terrorism, violence, resentment, fear, and ignorance. I want to take the beauty of her work superficially to make use of it as pictorial energy in a three-dimensional display where questions of decoration, formalism, and superficiality confront pictures of war, human violence, and wounds.

Concerning the platforms, these are obviously displays that are not physically accessible to the public. Each platform is colorful, with a number of various elements—*Nail & Wire* sculptures, some very different sculptures, others similar, nailed mannequins, mobiles, soldier silhouettes, printed matter, banners, coffins—all made according to a will to autonomy and universal coherence. The amount, specific thematic, and plastic form of all these elements are intended to create the artistic evidence working out universality in opposition to (in conflict with) a particular historical fact (Afghanistan war, Iraq war, 9/11, London suicide bombers, etc.). The artistic evidence I want to create requires

working in our historical field, the one we are living in, with the will to build, to give forms to a mega-historical viewpoint. I want to do an artwork beyond history. Not against history. I want to work out the evidence that art can heal the desire for revenge. I want, with my work, to go beyond the immediate history in which I live, without leaving aside, avoiding, or correcting my own inclination and admiration for decoration, formalism, abstraction, op-art, nail and wire, kinetics, and oscillations—without denying my own superficiality.

Aubervilliers, October 11, 2005
[Composed in English]

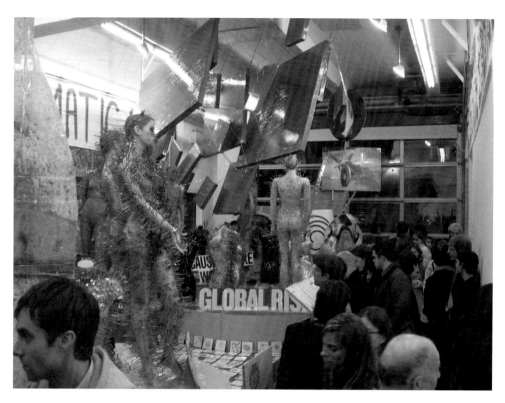

3.31 *Superficial Engagement*, 2006. Gladstone Gallery, New York, 2006. Courtesy Gladstone Gallery, New York.

LETTER TO SABINE (REGARDING *SUPERFICIAL ENGAGEMENT*)

Dear Sabine,[32]

I want to try here to record in just a few sentences what happened in New York concerning my exhibition *Superficial Engagement*. The exhibition has now ended after five weeks and will be disassembled today, Monday. I am, once again, surprised by the reactions to my work. The visitors were partly shocked and above all <u>disturbed</u>. They were disturbed because in my work I show photos—some enlarged by photocopying—of exploded, dismembered, destroyed human bodies. My concern was not to show dead people but to show the absurd destruction of human bodies from Afghanistan, Iraq, 9/11, London suicide bombers, Bali, Israel, etc. We do know what that looks like! On websites we can see the latest images every day. It is no longer about killing, about death; it is about destruction. For me, the image of a mangled victim of a bomb attack or the image of a suicide bomber reaches a degree of abstraction way beyond what we can conceive with our imagination. I wanted to confront this degree of abstraction with the degree of abstraction of art, <u>of abstract art</u>. I wanted the different connections on the surface to confront one another. Therefore the title of the exhibition, *Superficial Engagement*.

I wanted to make an exhibition that reaches beyond facts, with images from the world around me today. For me, it is not a matter of: Who is the victim? Who is the culprit? Who is the subjugated? Who is the oppressor? Who is the oppressed or the subjugated? Who is in the "right"? Who is in the "wrong"? Who is the winner? Who is the loser? For me, it is a matter of showing, by using images from the world in which I live—because there is only one world—what my position is, where I stand, what I want to achieve as an artist! I think that art, as art, has the power to heal! Art possesses this absoluteness that can break through the everyday frame of thought and factual information. Art possesses the energy to go beyond that which, in the political, cultural, economic, religious, and social belief in facts, tries to control us, to intimidate us, and ultimately to make us lose hope! I think there are forces and strengths that have an explosive power that goes beyond the "realistic." In

order to disrupt this "realistic thinking," I must, however, through my work, measure myself with this reality and confront it. I must risk confronting reality myself—yes, indeed—and even cooperate with it in order to change something! I must risk touching the other without neutralizing him or her. That is what I have tried to do. I have achieved this, at least in part, and of course it is not the first time there has been "resistance." These misunderstandings, this feeling many people had that I wanted to provoke and shock—these are reactions revealing a total helplessness and lack of orientation. Indeed, in art the point is certainly not about supporting or promoting indifference! But I am not concerned with "problematizing" anything!

Rather, I want to make something beautiful, something that—in its assertion, in its absolute detailed formulation—achieves beauty! That is my aim because I think beauty can change something through the <u>impact</u> it attains. This impact is possible only if I am prepared to touch the surface, if I succeed in giving a form to this touching of the surface, a form that is appropriate to <u>the force of the impact</u>. What amazed me was how many visitors wanted to go quickly into the "depths." I was also surprised by the degree of <u>hypersensitivity</u>, by the absolute readiness to consider one's own sensibilities as so important, to the point of self-protection and narcissism. Such an overly refined sensibility is ultimately open to being corrupted by politics. Why, then, should we not want to see any images of dismembered, exploded, destroyed bodies of human beings? This hypersensitivity can be controlled and abused politically as a protective shield for those who want us not <u>to live in the one world</u>, despite all differences. I am interested in the idea of universality. Art and philosophy are the only tools that can be used to work concretely on the idea of universality. My concern is not globalization, not antiglobalization, not alternative globalization, but rather to make, with and through my work, a manifesto <u>for universality</u>. In order to do this, I try to employ the materials, means, connections, elements that give this thought a form. Each of my individual works, each of my thoughts, follows this direction and wants to live up to this ambition.

The nice thing in New York, despite everything, was that thousands of people saw my exhibition! The belief, which I always have in mind, that art has the force, because it is art, to create a one-to-one dialog was here confirmed. Apart from the reactions, the exaggerated reactions—Is he a genius or a charlatan?—the nice thing was that a <u>critical, engaged discussion</u> could take place in a commercial gallery space. As I was working, the beautiful works and the wonderful life of Emma Kunz constantly encouraged me. She was my "guiding star." With her work she achieved something exemplary that, as a guiding thought and despite all my own headlessness and refractoriness, demanded to be taken seriously! It means to take seriously what I do as an artist, <u>not to take myself</u> seriously, but to take my work seriously and be prepared, without losing my sense of humor, to pay the price for it! Therefore I won't complain about all I read and heard about *Superficial Engagement*. Of course, I am the first one to deal with justified and unjustified criticism. I am, however, also the first one who knows I have really tried to make a work that overpowers me, that escapes my own control, that surprises me, <u>but also</u> a work that <u>disappoints</u> me! For I, the artist, I am the first one who has to be disappointed by my work! Do you understand that, Sabine?

Emma Kunz (1892–1963) said, "The time will come when people will understand my paintings."

Aubervilliers, February 13, 2006
[Translated from German by Michael Eldred]

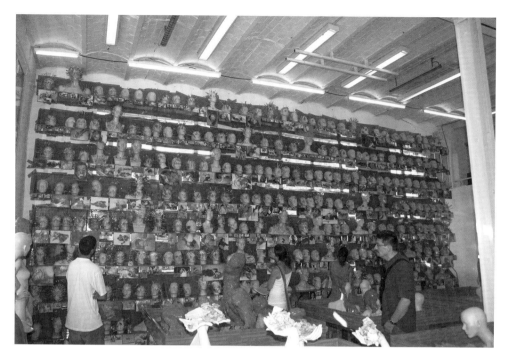

3.32 "Concretion," 2006. Le Creux de l'Enfer, Thiers, France, 2006. (Photo: Romain Lopez.) Courtesy Galerie Chantal Crousel, Paris, France.

LETTER TO FRÉDÉRIC (REGARDING "CONCRETION")

Dear Frédéric,[33]

I'm writing to tell you with these few sentences what I want to do at your place, at Le Creux de l'Enfer. I mean what I intend to do; I'm not saying that I will be able to do it or that the result will reflect my will. I want to make "Concretion." I want to make an exhibition with several works, about twenty altogether, either individual works or series of works, which all follow the same theme: "Concretion."

I will name these works or series of works here: 1. "A Swarm of Images," 2. "4 Candelabras," 3. "Jumbo Resonance Chamber," 4. "4 Resonance Chambers," 5. "Embedded Fetish," 6. "Pile of Stones with Images," 7. "Wood Connected Heads," 8. "Wood Connected Mannequins," 9. "Head-shot Heads," 10. "Mannequins with Nails and Screws," 11. "Tables with Nails," 12. "Table with Hands Filled with Stones," 13. "The Stoning Table," 14. "Heads with Outgrowths," 15. "Mannequins with Outgrowths," 16. "Mannequin with Very Large Outgrowth," 17. "Table with Stones with Out-growths," 18. "Pendulums with Outgrowths," 19. "Outgrowths on 2 Stair-cases," 20. "Real Outgrowths."

I want to give form to the medical or geological expression "Concretion"; I want to give form to what interests me in this term today: hardening. The hardening of the world in which I live. This hardening of the world comes from the hardening of each one among us. This hardening comes from the interior, it comes from me, I harden, I am hardening. Hardening is self-produced. Hardening is a problem, a tumor, a cancer, an uncontrollable disease. Hardening nourishes itself. And hardening is sufficient to itself. This hardening creates shapes, knots, and deposits. These forms interest me. What also interests me is that these forms exist in nature, in geology, in medicine. These forms are to some extent "natural," as the human condition is "natural." But this "nature" does not mean coming from nature but having its own law, following its own logic, being autonomous. It is in the nature of the things themselves. Good or bad, positive or negative, but autonomous and self-produced. I want to use the

natural pretext in the very theme of "Concretion" to give shape to what seems to be human: the need to clash with the other, to make an enemy, to fight against the other. But that is only the pretext of "Concretion" because the battle that should be carried out is the battle against oneself. To fight against oneself and to fight oneself. This is "Concretion." This is what I strive to give form to through the work "Concretion." I am the problem; it is inside of myself, inside of each of us. It is not the world surrounding us that poses a problem: I am the one who poses a problem, who is problematic. I am the one who is uncontrollable, I am the one who is hardening, and it is I who makes deposits and knots. Through the score of works of the exhibition "Concretion" I want to confront this vision as directly and firmly as possible. "Concretion" is an illustration neither of a "medical concretion," nor of a "geological concretion," nor of a "human concretion" (Jean Arp). I want to make a harsh, real "Concretion." I want to make "Concretion" with all its plastic, visual power, practical, uncontrollable, inevitable, and disturbing power. It is a "Concretion" that is aimed at me, against me, and inside me.

I will now describe the principal formal elements that I will use as "lines of force" to give form to the twenty different works or series of works.

Images of Wounds: These images, more than showing the horror of current affairs, are the images of one's own wounds. There is no victim and there is no torturer. Each wound is also mine; each wound is that of whoever looks at it. There is no escape, there is no reason, and there is no excuse. They are wounds of each one of us. They should be borne, they should be carried, and they should be looked at.

Outgrowths: These forms, simple and ignorant, are forms that grow from something else. On skin but also on stone. Outgrowths cannot create, grow, or increase without home ground, space, or foundation. Outgrowths "grow" on something. Like a concretion in nature, the form in my idea of "Concretion" requires a ground base or a nesting space "to grow," but its existence is not natural; it is both resistance and assertion.

Nails and Screws: In the mannequins and the mannequin heads, the "nails" don't "grow" on something; they penetrate something. The nails and

screws that I put in are not only fetishes to ward off evil or nails and screws marking a passage. Nails and screws are not only nails such as healing acupuncture needles or nails of a diabolical bomb explosion blasted in a body. Nails and screws are themselves "Concretion," the hardening that is in me—and that comes from me against me.

The Swarm of Images renders hardening present in space, in the spirit, and in time. For "Concretion," it is a swarm of images of wounds. The images resulting from the swarm are omnipresent in the exhibition, without hierarchy, message, or dynamics other than that according to the law inside of the swarm itself. A swarm changes direction as an entity and not while following one isolated element. The swarm follows its own logic of a law based on itself.

The Mannequins are a "headless" form of my neighbor, a form I use to give shape to the other. A mannequin represents the smallest distance between me and the image of another. A mannequin is another form of me. It is a surface of projection.

Resonance Chambers are rooms of resonance to amplify. Their shape is similar to that of an outgrowth but, contrary to the outgrowths, they possess an opening. I want to give form; I want to give importance and depth to something—to a wound. I want to give another dimension, to break the scale, by making reference to another thing than the wound itself.

The Candlesticks are the forms of nonreligious worship of one's own wounds. A way to contemplate that which escapes me, and an attempt to tame it through celebration.

The Stones of "Concretion" are an explicit form. I use them for their hardness. But I also want to use their rich capacity of evocation (from construction material to stoning as punishment). I also want to use the stones to anchor my work "Concretion" in this place of stones, of the Creux de l'Enfer (the cliff, the river). I use stone as an "elemental matter," and at the same time I want to insist on the universality of this matter, the universality of all stones. The stone, neither passive nor active, bears the capacity of "Concretion." The stone is the universal element of this exhibition. It is this universal "lay-down" that will be the element of hope in the exhibition "Concretion."

Here, in a few words, are my "lines of force" for this project. I have written these sentences to communicate my exhibition to you, but I began working a while ago, and the forms have been in my mind for some time. The process of my work in general appears to me as a concretion, something I don't control, which follows its own intentions, that I cannot describe, and which is not a theory either. I only know that it is something to which I must give form.

April 14, 2006
[Translated from French by Matt Hill]

THE PROCESSION

It can never be about perceiving and understanding my work as art. It is certainly not about making art or making a work of art. My work is art, and that should clarify the matter once and for all. If a person says about my work, "That's not art," or "I could do that myself," that's not a bad sign because it shows that this person hasn't been excluded from my work or intimidated by it. Furthermore, it's a first step toward my work, the first step and the most important step, the one that art makes possible—without mediators, without consultants, without communication or information. Because art possesses the power—as art—to create the conditions for <u>confrontation</u> or for <u>dialog</u>, from one to one—by a direct contact. I want to make a work that dares to touch non-art. Only by this <u>touch</u> does art prove itself as art, because within this touch is the possibility of involving <u>the other</u>, of not excluding or neutralizing him. *The Procession* is a sculpture in which the viewer can wander. It is a "protest" that is laid out and spread out—a three-dimensional manifesto. I love <u>the sculptures</u> that people carry at protest marches or demonstrations. They are quickly made objects with an unambiguous mission: to give form to a grievance! I love these objects because they are <u>universal</u>. They possess the utopian power of a universal visual language! The ritualized bearing of coffins is the same all over the world. It is a manifesto of mourning. It doesn't matter whether it is the coffin of a deceased statesman, the coffin of a revolutionary, the coffin of a martyr, or the false—or empty—coffin of Arafat "carried to his grave" by his compatriots in the Gaza Strip at the same time that his "real" coffin was buried in the West Bank. A coffin that is carried always has the same meaning—it conjures up the future dead by means of the coffin of actual dead soldiers! The coffin that is carried during a demonstration against a factory shutdown is as important as the "coffin" of actual unemployment. The coffin becomes a symbol of <u>sadness</u>. A sadness without hierarchy.

A coffin is carried along. A coffin, which is a passive sculpture symbolizing death and dying, is <u>activated</u> by the hands that bear it. It is active. The absurd "activity" of the coffin—what it always means, whether empty or not—is the

283

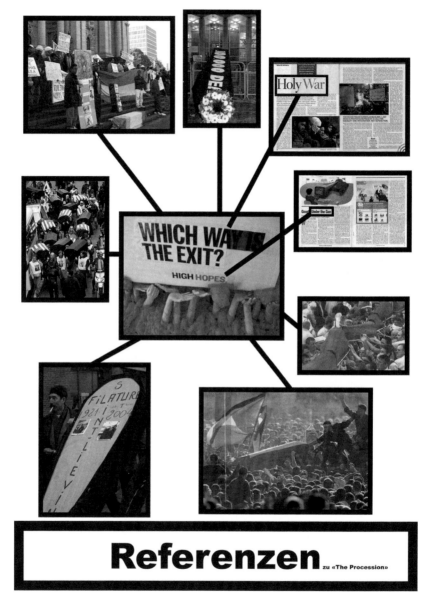

3.33 Excerpt from the exhibition catalog for *The Procession* at Kestnergesellschaft, Hanover, Germany, 2006.

reference and inspiration for my work *The Procession*. The urgency, the necessity, the conjuring collective ritual of coffin-bearing and the <u>resistance</u> that develops as a result are what interest me—the resistance between the passive object and the hands that set it in motion. It is not about honor or religion. <u>It is not about consolation.</u>

Borne by thousands of hands, touched by thousands of hands, Arafat's coffin was <u>driven off</u> from its intended place of rest by an irresistible force. This force is the guiding idea behind this work. I wanted to <u>give it a form</u>: a form bearing handmade decorations, lettering, and messages with and without context, which nonetheless make <u>sense</u> on the coffin they accompany and which actually turn the coffins into message bearers. It is as if loss itself is transformed into a megaphone. I want to bring these surreptitious connections to the surface—and give them a form. As always, *The Procession* is not about current facts. It is about transcending actuality <u>through the reality of a fact</u>. That is what I am engaged in; that is what I want as an artist.

This does not preclude misunderstandings or misinterpretation. It is a necessity for me to try to break open the limits of theory—and the limits of praxis <u>as well</u>, my own artistic praxis included. It is necessary that I work <u>head-less</u>, disobedient, independent, obstinate, and <u>without any sort of protection</u>. I must always <u>put everything on the line</u>. I must always be daring, I must always risk everything. Only by doing that, and only by proceeding from my inner self, from what <u>only I see</u>, from what only I see <u>like that</u>—is there a chance that my work will implicate the other! And it is clear that "to implicate someone" does not mean that my work is "understood" or that my work "functions." It means that I am making something <u>that cannot function</u>! It means that my work can endure incomprehension, and that my work dares to confront reality and work with it, without argumentation, in order to create an impact and to have real force. I want to make a work that appeals to the <u>sovereignty</u> of the viewer: to <u>precipitate a judgment</u> from his sovereignty. <u>I also want to try</u> to be sovereign myself, and to make a work that is free, that comes from within myself and only from me! I want to bear responsibility for my work, and I want to be responsible for my work without <u>neutralizing myself</u>!

Aubervilliers, February 20, 2006
[Translated from German by Kenneth Kronenberg]

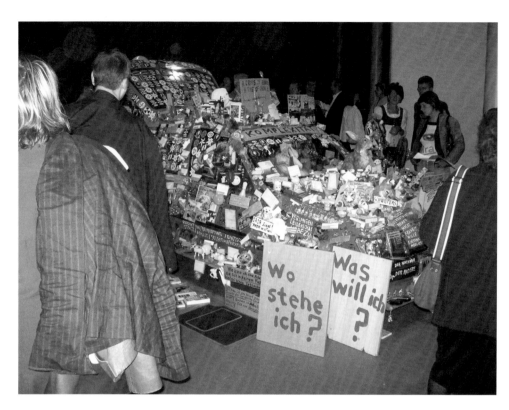

3.34 *Concept Car*, 2007. "Volksgarten: Politics of Belonging," Kunsthaus Graz, Austria, 2007. Collection Centro de Arte Contemporânea Inhotim (Collection Bernardo Paz), Brumadinho, Minas Gerais, Brazil.

CONCEPT CAR

Once again I failed to understand—or even worse—I misunderstood. "Politics of Belonging" is the subtitle of the exhibition,[34] and before my eyes I saw people stashing and retrieving suitcases, sacks, bags, and items of clothing from the compartments above their seats in an airplane. I translated "belonging" as *Habseligkeit*. I like the word *Habseligkeit* because of its meagerness, because a *Habseligkeit* is the last thing that I have, but also the most important. I carry it around with me; I wear it on my person and in me. That's how I view the word "belonging," though I just learned that "belonging" actually has to do with affiliation or membership [*Zugehörigkeit*], and now I know that the "Politics of Belonging" means the *Politik der Zugehörigkeit*.

What should I—the artist—make of this misunderstanding? Correct it? Repeat the stupid saying, "I have the right to be wrong"? Or pretend that I understood it correctly? Did I misunderstand the word because my English is limited? Because I simply understand too little? The answer for me is clear: I misunderstood it because for me the word "belonging" is an image. "Belonging" is a form. It is the form of apparently indispensable things that one drags around in the airplane, on the train, in the car, as a pedestrian. It is the image of things I keep close at hand, and it is the form of those things which even in emergencies—for example, emergency landings—one tries to salvage in spite of sharply worded instructions from the flight attendants. That is how important our possessions are to us. I see this form everywhere; it is a loaded, dense form.

As an artist, I want to and must work on this form, this image, because making art means giving form. Making art means asserting this form, defending this form, and being absolutely truthful to it. That is why I have to live with this "having misunderstood" and must—if I'm serious about it—work with this "having misunderstood." I must insist on it; I must stick to it. I must not give in now and "see it correctly." I must not deny that I saw it "incorrectly." And I must endure looking stupid. I must have the courage not to play the "smarter one" or the "more intelligent one."

I want to make a work that goes beyond misunderstanding, beyond mistakes, beyond faults. I want to make a work in which it is unimportant that I "have misunderstood." That is my problem as an artist; for me, that's what it's about: my view, my form, my work, my position. Not as an egomaniacal, narcissistic adventure, but as the assertion that this is precisely how to create the conditions for a direct dialog through the work. The absolute that comes from me is what is directed at the other. Only in this way can I take the other and my mission—to work for a non-exclusive audience—really seriously.

As an artist, I have at my disposal the tool to fulfill my mission—and it is immensely important that I understand it (first). My tool is my form field and my force field. It is my artistic logic, and it is my faith, my fundamental faith in grace when making art. Because—as an artist—I've never won, but also never, never have I lost—as an artist—when really working with what comes "from my own." When I proceed from what comes "from my own," I approach grace. To determine what is "my own," and to have absolute faith in it, makes it possible for grace to touch my work; grace is what cuts openings into my work—despite all misunderstanding and error. Perhaps these openings into my work enable words like *Habseligkeit* and *Zugehörigkeit* to take on a new meaning. It's such openings that make it possible for the observer to implicate himself through the work and with the work. Implication by grace! The meaning of implication is clear: it is about intellectual inclusion. Activating the brain is activity, that is the work, that is the problem as an artist. "Interactivity" is too cheap.

Concept Car seeks to give that form. It is my past and my future simultaneously. As with other of my works ("altars," "monuments," "kiosks"), I proceed from something that exists. Concept cars do exist—but I want to make my own concept car! *Concept Car* is a form for what is carried, what I carry on me, and what I carry in me. There is no hierarchy between what is important and what is unimportant because it's all *Habseligkeit*. On the one hand, *Concept Car* is the form from which I draw and from which I create, and, on the other hand, it is the bearer of this form; it is the bearer of my force field and form field. My force field and form field is between love, politics, philosophy, and aesthetics. *Concept Car* gives form to everything that really matters to me and

that I think is really important. Because I think that everything can be important, nothing is unimportant. No one can determine for another what is important for them. I want to give this assertion form with my new work *Concept Car* for "The Politics of Belonging." *Concept Car* is my entire *Habseligkeit*.

Aubervilliers, July 2007
[Translated from German by Kenneth Kronenberg]

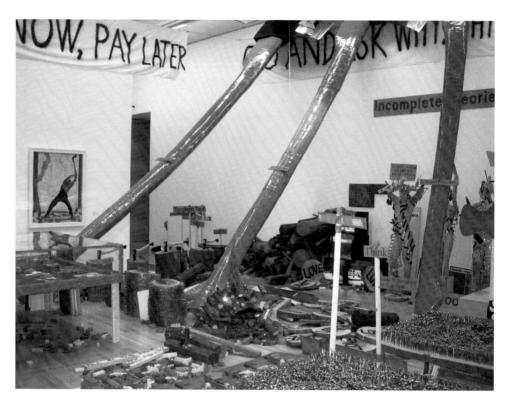

3.35 *Power Tools*, 2007. "Swiss Made+ 2, Präzision und Wahnsinn," Kunstmuseum, Wolfsburg, Germany, 2007. Collection Centro de las Artes Visuales, Fundación Helga de Alvear, Cáceres, Spain.

POWER TOOLS

I am "at peace" with my new work *Power Tools* at the Kunstmuseum Wolfs-
burg. "At peace": not satisfied, but not dissatisfied either; rather, it's about
being OK with what I can't change. I did what I wanted to do: to display all
of the elements I brought—which were produced in my studio—and not, for
reasons of time or space or especially "content," to show individual or several
elements. That is what I would call unalterable.

After months of preliminary work in the studio it is too late now—on-
site—to evaluate and arrive at some sort of self-criticism. It is really too late to
backtrack, doubt, and find fault—though there certainly are grounds for that! If
I were going to, I should have considered it earlier and not during the three
days of installation. This principle—as headless as it seems—is the only appli-
cable one in a situation that is an emergency situation, the emergency situation
of installing an exhibition. And "panic is not the solution" transformed into
"panic is the solution" has been my installation logic for some time now.

I love and fear the installation phase. It's about providing each element a
place in a given space—a space that is always too small. It's about decisions that
I make on the fly. But these decisions—once made—are then definitive and
comprise the form, as is the case here with *Power Tools*. Perhaps it's what
Marcus Steinweg describes—that it's about approaching catastrophe, about
immobilizing it without sacrificing oneself to it pathetically or, in the conven-
tional sense, letting oneself go. This is the problem I face when installing an
exhibition. The problem is creating something definitive with complete head-
lessness. The more headless, the more definitive. Leave no room for arbitrari-
ness, not a centimeter, not a second. There's something intoxicating about
installing an exhibition—there are the intoxicating moments where innumera-
ble decisions need to be made—and then the knowledge of assuming responsi-
bility for these decisions and standing by them.

There's something sensuous about installing an exhibition, but at the
same time it is connected to fear: the fear that I won't face the problem, but
evade it, change it, vary it, not put everything on the line, shrink back from the

risk involved. It is this fear of withholding myself from the problem, and it is the fear of not simply throwing myself into the problem. The questions that always confront me are: Am I imaginative enough, awake enough? Do I have enough concentrated energy to withstand what I already know I'm capable of, on the one hand, and, on the other, to resist art history and reception? Resisting myself in the process is even more difficult and demanding. Given my projects—both past and future—can I continue to muster the energy for a liminal experience? Will I continue to be able to confront the moment where I "can't see anymore"? Or will I shrink before it comes to that, before I have reached the critical point? Those are my questions, always and forever.

The *Power Tools* workshop is a mental workshop. I'm not doing interactive art because work is actually being done here. Anyone engaged with tools thinks toolbox, thinks workshop, and thinks work. Work means activating the brain. That's what I want to do—that's what *Power Tools* is about. What I'm asking myself here is: Have I worked at the level and with the energy and the power of the tool? Was I able to give my work a universal dimension? Was I able to render precisely the chaos of the world with these "power tools"? Rendering chaos precisely means to work amid the chaos. Rendering the chaos precisely means not evading it. I want to be precise and excessive at the same time. Rendering chaos precisely does not mean making a "spectacular" piece of work; it means getting carried away by the force of one's own work. I must be the first slain victim, drowning victim, of my work. To me, rendering chaos precisely also means—and this is the beauty, the wonder, the genuine—making my work in the certainty that my logic—the logic to which I have given form—will save me from chaos.

With *Power Tools* I do not intend to describe the tools of the powerful or to denounce the powers that use tools (or weapons). I intend to show with *Power Tools* that the tool is itself power, that the tool is the power to achieve form, and to achieve autonomy, to desire, to resist, to achieve universality, to have courage and hope, to assert. The tool is simply art itself. Art as art. I want to give form to the assertion that art is in itself a tool, and that art is my tool. Art as tool is power, not power for or against something, but power in terms of

itself. The incrementally enlarged cardboard axes aren't functional as actual axes. They embody engagement and dedication. As "artificially" enlarged axes, they are power.

The "Eternal Flame"[35] of art stands at the center of the *Power Tools* workshop; the "Eternal Flame" of art is the love of form-giving and the passion for making art. It is not important how large, how hot, or how substantial the fire is. But it is necessary for the "Eternal Flame" to burn eternally. I must not allow the "Eternal Flame" of art to go out. Because of this, everything that burns, everything that lies around the workshop may be used as fuel to nourish the fire. Everything (love, politics, philosophy, aesthetics) can be used as fuel and ensure that the "Eternal Flame" is not extinguished.

Power Tools in Wolfsburg, in the exhibition "Swiss Made II," is a work in dialog with Ferdinand Hodler's *Der Holzfäller* [The Woodcutter]. But in fact my *Power Tools* seeks to and must exist even without this painting; that is how I have developed the work. I didn't want to shy away from closeness to this marvelous and powerful work of art, and I consciously sought contact, dialog, or confrontation. I love Ferdinand Hodler's art. I love what is excessive in his art. I remember the art actions that I did—together with Christian Tobler—in the Hodler Room at the Kunsthaus Zürich during my student days at the Kunstgewerbeschule Zürich. What we wanted to do was to galvanize Hodler's "parallelism" and make his art more "dynamic." The fact that Hodler's art has recently been used in Switzerland for political propaganda purposes is a stupidity that I refuse to accept. I want to clarify that neither his art nor any art may be used for populism from the right or from the left. Hodler's art belongs to those who dare to enter into dialog with it rather than misappropriate it. Art does not permit itself to be misappropriated. The presence of Hodler's oil painting *Der Holzfäller* (circa 1910) in my exhibition space in the Kunstmuseum Wolfsburg is a statement about taking back his art. The point is to take back for art that which the right-wing populists in Switzerland are attempting to misappropriate. Hodler's work is sovereign in the same way that anyone is sovereign who has the courage to look out upon what is seemingly healthy and vigorous without denying it.

Power Tools consists of twenty-four elements, each of which has a place in the exhibition space. They include eight incrementally enlarged axes; the "Swiss Army Knife" display case; the table with the ten "thematic" cardboard tools (desire, autonomy, headlessness, hope, war, assertion, universality, courage, form, resistance); two nail tables; two nail tree stumps; the "Eternal Flame"; four tree stumps with axes embedded; eighteen containers with "nail protectors"; the wooden "love" slices; the pieces of wood written on with nails; the four piles of "deconstructed" cabinets; the blanket with the fifteen pistols and guns made of Lego blocks; the heap of Lego blocks; four "tool mannequins" with cardboard signs; four woodcutter contest videos; the stack of books with twenty-eight enlarged Reclam books [German publisher specializing in affordable books] and the toolbox with the books and book list; the stack with imitation wood made of cardboard and aluminum foil; the "lianas"; the real tools hung on the wall; the "primitive" tools; the enlarged blue tools and weapons; the four "banners" as room labeling; the "fake" burnt pieces of wood; and the "ax in the head" picture from the Internet.

Six of these elements—the heap of Lego blocks, the "fake" burnt pieces of wood, the imitation wood made of cardboard and aluminum foil, the "deconstructed" cabinets, the wooden "love" slices, and the pieces of wood written on with nails—are also distributed all over the space as "transgressions." The eighteen containers with "nail protectors" are distributed at the *Power Tools* entrances (for protection).

Wolfsburg/Aubervilliers, July 2007
[Translated from German by Kenneth Kronenberg]

UR-COLLAGE

An *Ur-Collage* is a simple, primitive, prehistoric collage. I want to make collages that are evidence in themselves. I want to give form to the origin of a collage. They are called *Ur-Collage* because they are original collages; I would like not to be able to make any simpler collage. The obvious feature of an *Ur-Collage* consists in its creating a new world from only two elements of the existing world. These two elements or images are printed matter, and it is that which associates the two images. One of the elements of printed matter is a double-page advertisement, and the other element is an image printed out on a home printer. I don't say that this latter image, the picture of a dead, destroyed person, comes from the Internet as if it came from another world, because this image is also of this world. The one image is not accused, and the other is not accusing; rather, I want to connect the two images with one another, to bring them together; I want to glue them together into a new worldview. What connects the two elements before I have glued them together is that they are both images of the existing world surrounding me. They are elements, images of our undivided world, of our only world.

I live in this complex, chaotic, cruel, beautiful, and wonderful world. I want to be happy in it and I want my work to reflect that. The *Ur-Collage* is a basis for this. I affirm the world in which I live, and I want also to affirm the negative side of this world. I affirm the world in which negativity is shown and in which the hard core of reality, of negativity, is not bracketed off. I want to show this hard core. I want to turn toward the negative; I do not want to be a cynic or a cunning devil. I do not want to look away, I do not want to turn away, and I do not want to be overly sensitive. I want to be attentive and I want to create a new world alongside and in the existing world. I want to do this with *Ur-Collage*. It shows that, it asserts that, and it defends that. The *Ur-Collage* is the form of this newly created world. To make an *Ur-Collage* means to be in agreement with the world. To be in agreement does not mean to approve. To be in agreement means to look. To be in agreement means to not turn away. To be in agreement means to resist, to resist the facts.

3.36 *Ur-Collage (A8)*, 2008. Courtesy Galerie Susanna Kulli, Zurich, Switzerland.

An *Ur-Collage* is not information, not journalism, not commentary. An *Ur-Collage* creates a truth, and I am concerned with giving a form to this truth. The *Ur-Collage* wants to create a new truth. I love making collages. It is something fundamental for me, something essential. I love the collages of John Heartfield, Hannah Höch, Kurt Schwitters, and, more than anything, the three-dimensional *Das grosse Plasto-Dio-Dada-Drama* by Johannes Baader. I make two-dimensional, and also three-dimensional, collages. I always proceed from two dimensions. What is important is that I always proceed from the two dimensions of a collage, even when the work is spatial. I never proceed from the space or the architecture.

It is simple to make a collage, and it can be done quickly. It is fun to make a collage, and at the same time it arouses suspicion: it is too simple, too fast. For many it is not respectable enough, and many label it as immature. And so collages are mostly done during youth. But a collage is resistant; it escapes control, even the control of the one who made it. That is its resistant character. To make a collage always has something to do with headlessness. Precisely that is what interests me because there is no other means of expression with such explosive power. A collage is charged, and it always remains explosive. In the case of a collage it holds true that I—as an artist—often stand dumbstruck before it, but it is precisely a matter of enduring this "looking dumb." There is no technique more common throughout the world than the collage—almost everybody has made a collage sometime in their lives. That is the associative element of a collage—that almost everybody, sometime in their lives, has tried to make an image of this world. A collage is something universal, and it is an opening toward a non-exclusive public.

Aubervilliers, Fall 2008
[Translated from German by Michael Eldred]

3.37 *The Bijlmer Spinoza-Festival*, 2009. "Streets of Sculptures," Amsterdam, The Netherlands, 2009. (Photo: Vittoria Martini.)

THE BIJLMER SPINOZA-FESTIVAL

Bijlmer: The Bijlmer is a neighborhood southeast of Amsterdam. Because it is the location for the setup of *The Bijlmer Spinoza-Festival*, this neighborhood is both the place that <u>hosts</u> and the place for which *The Bijlmer Spinoza-Festival* is <u>destined</u>. That is why the Bijlmer has given its name.

Spinoza: I am a fan of Spinoza. His book *Ethics* still remains sharp and necessary in the fight against philosophical obscurantism and idealism. To read Spinoza means to agree to insist on receptivity and sensuality, without giving up the idea of a certain infinity. To get started in philosophy—Deleuze would say— read Spinoza's *Ethics*. I myself open this book very often. Spinoza presents a concept without transcendence and without immanence. It is the concept of the "here and now" as shown by Deleuze. It is the concept of life, the concept of the life of a subject without God. This subject is an active subject, a subject of delight and leisure. It is a responsible subject, joyful and affirmative. I like the fact that I do not understand everything when reading Spinoza, and I like the fact that there is always much more to understand when reading Spinoza.

Festival: *The Bijlmer Spinoza-Festival* is an artwork; it is a sculpture. The title includes the term "festival" so it can state clearly its character as <u>event</u>, its vocation as <u>encounter</u>, its <u>time limitation</u>, its <u>transplantability</u>—first of all in the mind, but then physically, elsewhere, at some other time. I assert that a festival <u>is also</u> a sculpture and that a festival <u>can be</u> a sculpture.

Presence and Production: *The Bijlmer Spinoza-Festival* follows the "Presence and Production" guideline, which means: my presence (the artist's presence) and my production (the artist's production) first of all, because that's the condition that makes participation possible for the inhabitants of the Bijlmer neighborhood of Amsterdam. Therefore, "participation" is not the aim of this work; "participation" can only be a consequence of my presence and my production. I am the one who must give something of myself first, in order to invite <u>the other</u> (the inhabitant) to give something in turn.

———

The Other: The question of the public, the question of public space, the question of the other, the question of a "non-exclusive audience" are—more than ever—set forth. *The Bijlmer Spinoza-Festival* is the affirmation that art must be a tool to create this public space. *The Bijlmer Spinoza-Festival* addresses the other. The form of this artwork will enable the other to be included; the form does not want to exclude anyone; that is its will, its breakthrough, its destiny, and its grace.

Coexistence and Cooperation: This project can be done only in coexistence— coexistence with the inhabitants of the Bijlmer neighborhood. Coexistence because it is their place; coexistence because it is with them; it is resolutely with and for the Bijlmer inhabitants. It is with and for the local inhabitants first—without exclusion of others. But it is my work. It is I—the artist—who assumes fully the responsibility, who takes the responsibility for this work, for the entire work, in all of its aspects. The work must consequently be made in cooperation. *The Bijlmer Spinoza-Festival* cannot be done without the help of the inhabitants. This work cannot be done without the help of the inhabitants because I—the artist—am not the one who claims to be helping, who wants to "help" or furthermore who "knows" how to help; on the contrary, the inhabitants are the ones helping the work. The inhabitants are the ones who are helping *The Bijlmer Spinoza-Festival* to be completed.

Precariousness: *The Bijlmer Spinoza-Festival* is a project that is limited in time— for a duration of two months. Precariousness is the dynamics, the emergency, the necessity of this work. All moments are important for the duration of *The Bijlmer Spinoza-Festival*; all moments are unique, all moments are equal in their capacity to reach out. This is how *The Bijlmer Spinoza-Festival* claims to be universal. This work is not "site-specific." This work wants to prove its universality as artwork in the Bijlmer neighborhood and with its inhabitants. Precariousness is a means of asserting the importance of the moment and of the place, of asserting that the here and now touch eternity and universality.

Beam: *The Bijlmer Spinoza-Festival* is conceived as a beam of energy—a beam that both concentrates the energy and gives multiple openings. It concentrates

energy <u>for</u> Spinoza and creates multiple energies <u>to</u> become public, to have an impact, to create a public. The expression of this beam is a very large book (*Ethics*) built on the lawn between the Kruitberg and Kleiburg buildings, next to the training field of the Parels of the Bijlmer. This beam—which is *The Bijlmer Spinoza-Festival*—consists of sixteen elements: 1. Daily Newspaper, 2. "The Bijlmer Documentation Center," 3. "Spinoza Car," 4. Snack Bar, 5. "Spinoza Library," 6. "Running Events," 7. Internet Café, 8. "Child's Play," 9. Webcam/Website, 10. "Spinoza Exhibition," 11. Lectures/Seminars/"Master classes," 12. "Spinoza Theater," 13. Workshop, 14. "Ambassador," 15. TV/Radio Connection, 16. "Tank TV" Connection.

<u>Dates:</u> *The Bijlmer Spinoza-Festival* will be set up from April 2 to May 1, 2009. It opens on May 2, 2009, and lasts until June 28, 2009. The dismantling of the work will take place from June 29 to July 4, 2009.

2009
[Translated from French]

3.38 *The Bijlmer Spinoza-Festival* ("Spinoza Theater"), 2009. "Streets of Sculptures," Amsterdam, The Netherlands, 2009. (Photo: Vittoria Martini.)

"PRECARIOUS THEATER"

Now, after my "Spinoza Theater" experience, I understand why, before per-
forming, actresses and actors in France say *merde* to encourage each other.

I consider the "Spinoza Theater," which I integrated in *The Bijlmer Spi-
noza-Festival* and directed, a disaster. It is a disaster concerning what one would
call the staging; it is a disaster on a human level; it is a disaster in terms of tech-
nique and material; lastly, it is a disaster in terms of acting. But it is not an
artistic disaster because I have done it, we are performing every day, and I am
learning a tremendous amount from it. I exposed myself to an incredibly big
challenge without foreseeing or measuring the difficulties. Very soon I realized
I would not succeed in doing the "Spinoza Theater" as I had first planned; I
was too tired—after a full day's work on the construction of *The Bijlmer Spi-
noza-Festival*—to concentrate, to be awake, present, and lucid enough to
engage in such a demanding task as this one. Headless, I thought that the
actresses and actors, who are all inhabitants of the Bijlmer, should know their
lines by heart, but it was not the case and some of them won't know them
ever. So I finally had to accept the fact that sheets of paper would always be
there on stage, with the consequence of the relative immobility of the actors
obliged to read their lines. That's how the use of microphones, which were
necessary for me since the "Spinoza Theater" was to be performed outdoors
with the surrounding noise of children playing, cars, the subway, people talk-
ing at the food-bar, imposed itself as the condition to read and speak out the
text while also being a fixed point in space.

To be clear and without self-indulgence, I am really a bad theater direc-
tor. Nevertheless, facing this unavoidable fact, and though I am astonished by
the disaster and my incapacity to avoid it, the "Spinoza Theater" makes me
happy—yes, happy.

What makes me happy is that, despite my complete insufficiency, despite
the extremely difficult conditions, I fulfilled the mission I set myself to perform
every day, and maintained this mission and stuck to it at whatever cost.

What makes me happy is to have kept my engagement and my truthfulness toward the beautiful new text by Marcus Steinweg, which, through daily performance, is gradually entering people's minds word by word, sentence by sentence, assertion by assertion.

What makes me happy is to have stood up to the actresses and actors of the neighborhood, who resisted with force and made me pay a high price for my lack of preparation and *savoir faire* with "people." But that's how a conflict rapport was established—which I believe is healthy—since it comes from the permanent frustration that an actor cannot do what I myself cannot do either.

What makes me happy is that I maintained the egalitarian (everyone in the play is of the same importance) and totalitarian direction (no discussion) which I imposed upon my actors.

What makes me happy is that, out of aggravation, I finally found a way to do the "Spinoza Theater" with the lack of discipline (to come and perform every day) of my actors. This turned out to be completely coherent with my position vis-à-vis the neighborhood: I cannot do it alone, I need support. It happened sometimes that the "Spinoza Theater" was performed by only three, two, or even a single actor, but never was I left helpless and alone.

What makes me happy is that, without control, out of urgency, completely overwhelmed in doing something impossible, we achieved, in every performance, some very short, rare, and furtive moments that had beauty, precariousness, and grace. For these very few and exceptional moments it was worth going through such a disastrous experience.

What makes me happy is to have found a sort of cease-fire between my hopes and demands, my inability and limits, to have taken responsibility for this huge gap, and by assuming this gap to think ahead toward future projects. This cease-fire gives me the drive to start defining what theater integrated in a work of art should be. Doing the "Spinoza Theater"—even with its disastrous outcome—has made me, during these three months in Amsterdam, develop and imagine new possibilities for future work which I want to call "Precarious Theater."

"Precarious Theater" is never a play; it's a piece of art always integrated within a whole work. Following this precept, the stage set, the decor, the accessories, and the space for the audience of "Precarious Theater" are always elements of an entire work. "Precarious Theater" happens in the unstable instant and the precariousness of the moment. "Precarious Theater" is made of the extreme difficulty of doing things. "Precarious Theater" is made with "low control."

The guidelines for making "Precarious Theater" follow definitions and conditions.

The definitions of "Precarious Theater" are as follows:

1. Use only new texts written specifically for the occasion (no classics, no repertoire, no references).

2. Use text as blind text.

3. Performances take place in one spot during a set period of time. A "Precarious Theater" piece cannot be played without the artwork in which it is integrated.

4. Actors must memorize and know their lines.

5. No rehearsals: "Precarious Theater" starts directly with the first performance.

The conditions of "Precarious Theater" are as follows:

1. "Precarious Theater" must be performed daily.

2. At least one actor (person) says nothing.

3. There is a short briefing and debriefing with the actors before and after every performance.

4. There are no costumes, no light effects, and no sound effects.

5. Microphones are used as fixed points in space for speech.

Amsterdam, June 18, 2009
[Translated from French]

3.39 *Théâtre Précaire*, 2010. Les Ateliers de Rennes—Biennale d'Art Contemporain, Rennes, France, 2010.

THÉÂTRE PRÉCAIRE FOR "CE QUI VIENT"[36]

For "Ce qui vient" I want to make *Théâtre Précaire*. *Théâtre Précaire* will be both the title of my work and what I want to do. *Théâtre Précaire* is the form of this work, an exhibition platform with numerous elements, and at the same time a theater platform on which, from time to time, *Théâtre Précaire* is performed.

"Ce qui vient" [What comes]: The general title of the event in Rennes in 2010 finds its meaning in my proposal. It's the situation of the theater stage before a play is performed, with elements that indicate "information" about what will happen. It's the situation of imagining something to come, "the dream and the projection" of something to come. "Ce qui vient" furthermore makes sense because it is what will come. It is a new work—never made, never outlined—conceiving of an exhibition as a theater platform. "Ce qui vient" will be my first work with *Théâtre Précaire* that is not a theater but a play performed inside and integrated into one of my works. So, "Ce qui vient" also includes my own work. "Ce qui vient" can also be what has happened and what will happen again.

Precarious: With *Théâtre Précaire* I want to make a formal manifesto—give a form—to the precarious. And to what's wonderful, important, the grace, the treasure, of the precarious: the precious value, the importance of the instant, the importance of the moment, the awakened presence of someone who dares to confront the precarious and its fragile, cruel, wild but free force. For, what is precarious is free. I want *Théâtre Précaire* to be a manifesto for freedom, instants of precarious liberty that supersede—through their fragility, the fragility of making things, the difficulty of making things—the term "precarious," which is only used demagogically, negatively, today. To me, "precarious" is a positive term, for it demands that I be awake, that I be present, attentive, open; it demands that I be active. That is why I absolutely insist on the "precarious" as opposed to the "ephemeral," the biological logic of which is always death. The logic of the precarious, on the contrary, is the precious value of the fragility of life and also its universality; and precariousness is the very form of the

unique life, of the unique world in which we all live. Our only, unique, and indivisible world.

Theater: I don't want to do theater. What I want is to use a dimension that encompasses theater—the dimension of the presence of a human being. I want to use this presence so as to integrate text in my work. This involves extending the field of collage. The actor in *Théâtre Précaire* will—by reading or declaring the text—integrate it in my work. The text is, moreover, already integrated into my work on supports and in various elements. There is another dimension of the theater that I want to use in *Théâtre Précaire*. It is the instant in which the play is performed—that precise moment in which the action is crystallized. I want to repeat those moments during the exhibition. They are events within an event, which is the exhibition itself. These events are not essential for the work, but these events are "becoming" the event; it is neither a finality nor a "foreshadowing." The moments, the instants of theater in the *Théâtre Précaire* are instants in which *ce qui vient* becomes.

Concretely: exhibition, theater, the play's text, the site of the exhibition. I want to make an exhibition with several elements, with the title *Théâtre Précaire*. In this exhibition I want to give form to what is important in the term "precarious" as I've described above. In the exhibition there will be a text and extracts of the text *Théâtre Précaire* that Manuel Joseph will write. In fact, Manuel Joseph will write a play titled *Théâtre Précaire*. This play will be performed once every week in the exhibition. I asked Manuel Joseph to write a play about thirty-minutes long, for between six to nine actors/actresses. The text and extracts of this text will be integrated into the exhibition. The site of the exhibition must be around two- to three-hundred square meters. It must be a place in a residential neighborhood because I intend to ask the residents nearest to the site of the exhibition *Théâtre Précaire* to be the actors and actresses in *Théâtre Précaire*. So it is the site of the exhibition that is defined by the residents, its actors/actresses, its spectators too. It is the very site that is becoming, that becomes. That's why it makes sense to do this event in a residential neigh-

borhood in Rennes—a neighborhood like any other, a place like any other, a universal place.

What I want is for there to be a dynamic between the Subjecters (the mannequins—one of the elements of the *Théâtre Précaire* exhibition), the visitors (or spectators) of *Théâtre Précaire*, and the actors/actresses of *Théâtre Précaire* when it is performed. I want there to be for a very brief instant—precarious—the doubt, question, dream, the project that enters one's head because of the questions that are posed: Who is actor? Who is spectator? Who is playing a role? Who is someone? These questions interest me not because of the sensation of not knowing who is who, but because they interrogate our consciousness of our own reality and of the reality of others.

Aubervilliers, November 2009
[Translated from French by Molly Stevens]

3.40 Picture taken after the destruction of *Théâtre Précaire*, 2010. Les Ateliers de Rennes—
Biennale d'Art Contemporain, Rennes, France, 2010.

3.41 *Théâtre Précaire 2*, 2010. Les Ateliers de Rennes—Biennale d'Art Contemporain, Rennes, France, 2010.

REGARDING *THÉÂTRE PRÉCAIRE* AND *THÉÂTRE PRÉCAIRE 2*

Dear Resident,

I am writing to let you know my thoughts following the fact that part of my exhibition *Théâtre Précaire* caught fire during the night of May 1, 2010. Given the extent of the damage, I have decided to dismantle my exhibition.[37]

I was obviously saddened and discouraged by what happened—for a moment. But that moment has passed. That moment of sadness and discouragement passed rather quickly, because I, as an artist having a project in a public space, a project involving inhabitants and residents, am convinced that what I did is what had to be done: to confront my artwork with reality, to have tried to do an artwork, certainly daring and risky, that wanted to touch the "hard core" of reality. I don't feel my work was obscure or vague. I wanted to resist the temptation of defeatism. I also resisted the temptation of hypersensitivity and "safety at all costs." What counts is that I made an attempt, I tried, and I had a real experience: an experience that was cruel but also magnificent. I did something that went beyond success and beyond failure. In any case, that's what an artist's work in public space today is about: making a form that withstands the notion of success but also of failure. That is why the time of sadness and discouragement is gone, to make way for the memory of the few precarious—actually, very precarious—moments of stupefaction, quiet contemplation, and enlightenment. That's also what counts: the magnificent experience of the two days of the *Théâtre Précaire* with those two performances of "theater" in the exhibition area. Aside from my pride at having found six actors and local residents who gave body and voice to the beautiful text of Manuel Joseph, making that text exist in space and time, I was myself dazzled by the grace of *Théâtre Précaire* as a form. What I hoped for—a new form created by the actors' performance in an exhibition space—really did happen. It was quite overwhelming to observe to what extent the confusion between actor, Subjecter-mannequin, and spectator led those present to question their own roles.

Encouraged by all six actors, I want to persist and continue with this form, and I want to remake what seems essential to me: *Théâtre Précaire* is an exhibition where a new dimension of art is at stake. That's why I now propose to reinstall the exhibition in a smaller place, L'Atelier Culturel de Maurepas,[38] but, most important, to perform the play *Théâtre Précaire* ten times—as initially planned. We are going to exhibit *Théâtre Précaire 2* for ten days and play there daily (at 18:30 every day from June 28 to July 7, 2010). This spot will have the advantage of being located just beside the first exhibition site, and a link can therefore be made by everyone between these two events. The Atelier Culturel will be closed at night, so there will no longer be the risk of fire or vandalism (as was the case twice during the *Théâtre Précaire* setup, before the fire damage).[39] It's I, and I alone, who bears the responsibility for not having taken those two warnings seriously, and who made the decision to leave my exhibition unprotected, even during nighttime. Therefore I have no reason—now—to complain or put the blame on I don't know whom. Certainly not on the residents. I never felt I was unwelcome with my proposal or my work, *Théâtre Précaire*. Misunderstood, to be sure, and not understood also—but that's true of my work elsewhere too (in a gallery or in a museum)! Therefore it's up to me in turn not to misinterpret the fire that destroyed part of my work. And it's up to me not to yield to suppositions as to why my work was damaged. I have to agree with the reality of the neighborhood, the reality of the Gros Chêne, and I do—completely. That's why *Théâtre Précaire 2* will resume its form—differently—but with the essentials preserved. Moreover, this different form (indoors and shorter) allows me to turn it into a "Presence and Production" project, for I will be present myself, every day, throughout the whole time of exhibition (ten days).[40]

I hope we will have the opportunity to discuss further and even organize a debate focusing on the questions already raised on the day of the opening: Why should the negative in art have its place? This way I hope to contribute to and prolong the contact, or even the confrontation, with your ideas and thoughts. Who knows, perhaps this presence and this production will allow my work to create the conditions for a one-to-one dialog!

In any case, I would like you to know that the experience of *Théâtre Précaire* and *Théâtre Précaire 2* makes sense to me, the artist, with my ambition to involve a "non-exclusive audience" to which you belong too!

May 2010
[Translated from French]

Untere Kontrolle

Untere Kontrolle [Low Control] is the name of my new work in the Sprengel Museum, Hanover. *Untere Kontrolle* wants to be a form that enables a new view. A form that projects a new light. A form that emerges from a <u>new perspective</u>: the perspective from below, from the ground, from the "dirt," and from destruction. *Untere Kontrolle* does not mean "under control." On the contrary, <u>there can be no control from below</u>. But I am creating a new perspective from below, from the ground, <u>from the earth</u>. It is the view from the perspective of the person <u>who lies flat</u>. It is <u>not a view that seeks to exercise control</u>; nonetheless, it is not a powerless view. It is a view from the depths, from a place lying way below. A view determines a position. Therefore, *Untere Kontrolle* could also be <u>a place name</u>. The perspective or view from below is sharp and penetrating. The view from below is not directed at existing values or existing standards. <u>It is a new view</u>. Because it is a new view, *Untere Kontrolle* affirms <u>assertion and production</u>. *Untere Kontrolle* stands <u>for assertion rather than skepticism,</u> and <u>for production rather than criticism</u>. This is what makes *Untere Kontrolle* possible, because it is active without placing any value on control. Therefore, *Untere Kontrolle* is a <u>new experience</u>.

With *Untere Kontrolle* I want to capture everything that is beyond control. Capturing something that supersedes the idea or reflex of control: that is the mission of this work. Concretely, I want my work to look as if someone had inadvertently left the door of the museum unlocked at night, and some <u>unknown persons</u> had spread out and taken over in the exhibition hall. With their elements, materials, and aesthetic, these unknown persons appropriated the room as their own. They appropriated the space in order to confront the world within it, the reality, and the time in which we all live. The next day, when the museum door opens, every visitor immediately knows: Here I must confront a <u>new form</u>, a <u>new urgency</u>, a <u>new necessity</u>, and a <u>new conflict</u>. <u>It is the conflict of aesthetics leading to a new form</u>! The visitor knows: There is nothing to evaluate here, nothing to control, nothing to exchange or negotiate. The visitor knows: I myself must lower the "level" in order to perceive <u>the</u>

3.42 *Untere Kontrolle*, 2011. Sprengel Museum, Hanover, Germany, 2011.

new perspective, the new way of seeing. It's not the elements, the materials, or the aesthetic that are new; rather, the enlightenment they irradiate is new. The visitor must seek a new perspective and be creative in the process! Creative like the unknown persons! *Untere Kontrolle* is a homage to this creativity, with which I seek to establish contact. In order to make contact with this creativity, I must set the "level" low. With *Untere Kontrolle*, I want to challenge the visitors to reveal themselves. I want no control of communication to take place. I want *Untere Kontrolle* to make emotions possible, and to make it impossible for visitors to profile themselves! *Untere Kontrolle* is a new "low-lying" form. It is independent, it is resistant, and above all it is form in itself!

2011
[Translated from German by Kenneth Kronenberg]

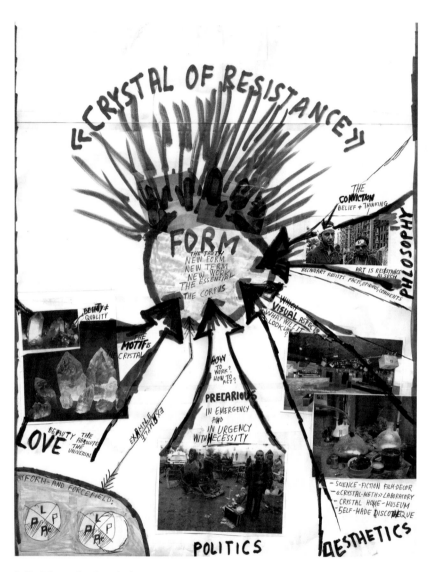

3.43 Schema for *Crystal of Resistance*, 2011.

Crystal of Resistance is the title of my work for the Swiss Pavilion at the 2011 Venice Biennale. Through *Crystal of Resistance* I want to ask questions. First: Can my work create a new term of art? Second: Can my work develop a "critical corpus"? Third: Can my work engage—beyond the art audience—a "non-exclusive public"? I want to answer each of these questions, these goals, and these self-demanding ambitions, with my work and in my work.

I believe that art is universal; I believe that art is autonomous; I believe that art can provoke a dialog or a confrontation—one-to-one—and I believe that art can include every human being. When I write "believe," I'm doing it not because I think or know it, not because I can prove it, but because—in art—it's a matter of believing.

With *Crystal of Resistance* I want to produce a work that is irresistible. This can only happen if I succeed in creating a work out of my innermost self, without confusing—as is usually done—the inner self and "the personal." I can only reach the universal if I risk conflict with my inner self. "The personal" doesn't interest me because it's not resistant in itself; it is always an explanation, if not an excuse. My work can only have an effect if it has the capacity of transgressing the boundaries of "the personal," the academic, the imaginary, the circumstantial, the contextual, and the contemplative. With *Crystal of Resistance* I want to cut a window, a door, an opening, or simply a hole, into reality. That is the breakthrough that leads and carries everything along.

Children at the Rhone Glacier

What prompted me to work with crystals was an experience I had fifteen years ago. It was in the Furkapass Road car park, below the Rhone glacier. I saw some children who had spread out some crystals on a piece of cardboard—most likely crystals they found themselves—and were selling them. It was a simple, wonderful, and universal picture, which impressed me. The same thing could have been done by children in China, Russia, Mexico, or anywhere in the world. Since then I've wanted to do something with crystals.

———

Crystal as a Motif

With *Crystal of Resistance* I want to give a form that creates the conditions for thinking something new. It must be a form that enables "thinking." That's how I see the mission of art: To give a form that can create the conditions for thinking something that has not yet existed. With this form I want to create a truth, a truth that resists facts, opinions, and commentaries. It is not about "my truth," but about truth in itself. In order to make contact with truth, to confront truth, and to be in conflict with it—conflict in art means creating something—I need a motif. That motif is "crystal" in *Crystal of Resistance*.

Crystal is the motif—but the motif only—of the form of *Crystal of Resistance*. Crystal is not the theme or the concept or the idea of *Crystal of Resistance*. The motif is an assertion, a "setting," and the motif is love. As a motif, crystal is the dynamic which links and which puts light—a new light—on everything. It sheds light on its own meaning, its own time, and its own raison d'être. The crystal motif helps me point out one or several facets, because it's only as facets—as a partial vision—that truth can be touched. Crystal is the motif I decided on, out of love for its beauty, for its rigor, for its power, and for its openness. I myself must be open to its grace and its universality. I will consolidate and fix my form with the crystal motif; I will strengthen and determine my form with the crystal motif.

Resistance

Art resists political, cultural, and aesthetic habits. Art resists morality and topicality. Art—because it is art—is resistance. But art is not resistance to something; art is resistance as such. Art is resistant because it resists everything that has already existed and been known. Art, as resistance, is assertion, movement, belief, and intensity; art is "positive." Art resists tradition, morality, and the factual world. Art resists every argument, every explanation, and every discussion.

I am not afraid of resistance, conflict, contradiction, or complexity. Resistance is always connected with friction, confrontation, even destruction—but always with creativity also. Resistance is conflict between creativity and destruction. I want to confront this conflict in *Crystal of Resistance*. I am myself the "conflict," and I want my work to stand in the conflict zone; I want my work to stand erect in the conflict and be resistant within it.

The Four Parts of the Form and Force Field: Love, Philosophy, Politics, Aesthetics

I decided—from the very beginning—to put my work in a form and force field consisting of four parts: Love, Philosophy, Politics, Aesthetics. I decided that my work doesn't have to cover all four parts equally, but every part will always be covered to some extent. Love, Philosophy, Politics, Aesthetics are the parts of the field in which my work asserts itself and is moving.

When I decided about the two "light" parts—Love and Philosophy—I also decided to include in my work the two "shadow" parts—Politics and Aesthetics. I made this simultaneous decision about "light" and "shadow" parts because I live in a world that I understand as "one," as an undivided and unique world, as a world with light and shadow, with the negative and the positive, but also with the "not-only-positive" and the "not-only-negative." That's why there are "light" parts and "shadow" parts and why I set my work in the form and force field of Love, Philosophy, Politics, Aesthetics.

Love

In *Crystal of Resistance* the crystal is the Love part of my form and force field. The crystal stands for the universal, the ultimate, and the absolute. The crystal stands for beauty itself. I am thinking of someone. I am thinking of a child, a girl who finds her own crystal, perhaps her first; she finds it herself or receives it as a gift, and—for this girl—it's the most beautiful crystal, and to her it will always remain the most beautiful! That's why each crystal is for me "the most beautiful." This is the Love part in my form and force field. I know that there

are different qualities and that these differences can be explained. I am interested in the beauty, not in the quality, of the crystal. Quality has never interested me; to me it's an exclusive and empty word, and I decided years ago to always follow this guideline in my work: "Energy = Yes! Quality = No!" Because clearly beauty is not subjective—beauty is absolute and universal.

Philosophy

The Philosophy part in *Crystal of Resistance* stands for the conviction that art is resistance, resistance as such. Other concepts for resistance are headlessness, hope, will, madness, courage, risk, fight. These terms belong to the Philosophy part of my form and force field and are what I want to give form to. A form that only I can give, a form that only I see in that way and that only I understand, a form that only I know, and a form that only I can defend. *Crystal of Resistance* wants to be a form that—in itself—is resistance.

The most important thing in art is the question of form. To recognize this is the Philosophy part of my form and force field. Therefore, in *Crystal of Resistance* the question of form is the central concern. Form is the essence and the "setting" of this work. *Crystal of Resistance* in itself will be form in itself, the truth in itself, the real. I want *Crystal of Resistance* to be "the new"—something that has created its own body.

I ask myself: How can I give a form that resists historical facts? How can I give a form that goes beyond the here and the now? And how can I make a transhistorical work, in my time, in my history, today? My problem—as an artist—is: How can I take up a position and give that position a form? How can that form—beyond conventions—create a truth? How can that form, my form, create a universal truth?

Politics

In *Crystal of Resistance* the Politics part questions: How to act? How to work? With and under what conditions? I want to work in necessity, in urgency, and

in panic. This should be understood as: Panic is the solution! That's the political. Art reaches beyond solutions; art can confront problems; art is the problem, and art can give form to the problem. There's no solution to figure out; on the contrary, the problem must be confronted. And this is only possible in panic. Panic is what gives form, and this form is art. Therefore, panic is a necessity in art.

I want to work in over-haste, I want to work in headlessness, and I want to work in panic. I want to work with the precarious and in the precarious. This is to be understood as the political. The political is to understand the precarious not as a concept, but to understand it as a condition: a condition that is a matter of accepting—frenetically but with awareness. The precarious must be affirmed, and it is necessary to enter the camp of the precarious. The change, the new, and the revolutionary lie in this affirmation—this is the political. The precarious is the dynamic, the path, the possibility, and the movement that is offered to human beings. The future consists in the affirmation of this precariousness—this precariousness that is also the nonassured, the nonguaranteed, the nonstabilized, and the nonestablished. It will be the future because the precarious is always creative, because the precarious is always inventive, because the precarious is in motion, because the precarious leads to new forms, because the precarious shapes a new geography, because the precarious starts with a new exchange between human beings, and because the precarious creates new values.

Instead of wanting to shield ourselves from the precarious, instead of wanting to deny the precarious, instead of wanting to turn away from the precarious, is it possible that the opposite—its affirmation—might be the universal? Is it possible that justice, equality, and the truth are constitutive of the precarious, shared as it is by so many today?

Aesthetics

The Aesthetics part consists of the questions: How does the work look? What visual appearance does it have? What materials and what colors come out? I want *Crystal of Resistance* to be an indestructible earthly dwelling of the

gods—like the cave of the giant crystals of the Naica Mine in Mexico. I want to create a place that is so strange, so entirely of myself—only of myself—and so distinct that it becomes universal. I want to make a large, dense, highly charged, luminous, and meaningful work. There will be many elements to see; there will be "too much." It has to be "too much" not because it is important to get to see everything or spend a lot of time looking, but because with "too much" things do not lie. I want to give form to the thought that truth can be shaped out of facets and that truth can be touched only in a non-unified scale.

With the Aesthetics part of my form and force field I can create a frontal and two-dimensional work in the available space, a work that doesn't allow one to "step back." My aesthetic decision is that there should be no possible overview, no distance, and no illusion of detachment. This is what aesthetics can do. This is what I—in full blindness and full speed—want to assert and "hold high." It's this aesthetics I want to insist on.

I want to produce a work that is reminiscent of the aesthetics of a science-fiction B-movie film set, that derives from the aesthetics of a self-made rock-crystal museum or the aesthetics of a crystal-meth laboratory, and that resembles the aesthetics of a cheaply decorated provincial disco.

Swiss Pavilion

I want *Crystal of Resistance* to be experienced as something autonomous. It therefore has to be inside an envelope in order to make clear that this is a time-limited work. I'm thinking of a skin, a shell, or a geode. I'm not thinking about altering the given exhibition space. I'm not interested in working "against" or "for" the existing architecture of the Swiss Pavilion. I work with the space that exists. It's not about "negating" an exhibition space; it's always about how the work asserts itself in the space as something autonomous. What is important to me is to use the available exhibition space as a container for my work. I want to create the conditions that will make it clear that the space is the shell that contains my work.

I want it to be explicit that *Crystal of Resistance* can also be shown at a different location, in a different city, in a different country, or on a different continent. I am for universality and for autonomy; I am never concerned with context. The envelope or container I will make is the assertion of my work's autonomy. I believe that art is autonomous, and I love art for its autonomy— the autonomy that gives the work its beauty and the autonomy that makes the work absolute.

Reference Books

My reference books are the books and texts I have read while working on *Crystal of Resistance*. They are my references and constitute a booklist. These books aren't the inspiration or the explanation for *Crystal of Resistance* and have no hierarchical order; all books and texts are equally important for me. All these books and texts can be significant to me; no book and no text is unimportant.

Reading these books was a pleasure. But it's not by reading them that my work can be understood, because I read these books by luck and grace—I can even say: by chance. These books and texts accompanied me as I worked. I bought some books myself; others were given to me or brought to me by friends who knew that I wanted to do the work *Crystal of Resistance*. These books and texts are my companions.

These books or texts are Fernando Pessoa, *Message*; Édouard Glissant, *Poétique de la relation* and *Le discours antillais*; Celia M. Britton, *Édouard Glissant and Postcolonial Theory*; Michel Foucault, *Leçons sur la volonté de savoir*; J. G. Ballard, *The Crystal World*; George Sand, *Laura, Voyage dans le cristal*; Elias Canetti, *Masse et puissance*; Gaston Bachelard, *Le droit de rêver*; Marcus Steinweg, *Aporien der Liebe*; Manuel Joseph, *La restitution* and *La sécurité des personnes et des biens*; Giorgio Agamben, *Profanations*, *Moyens sans fins*, and *La puissance de la pensée*; Louis Ucciani, *Distance irréparable*; Alain Badiou, *La relation énigmatique entre philosophie et politique*, *Rhapsodie pour le théâtre*, and *De l'idéologie* (with François Balmès); Comité invisible, *L'insurrection qui vient*; Tiqqun, *Théorie du Bloom*;

Adalbert Stifter, *Bunte Steine* and *Bergkristall*; Stendhal, *De l'amour*; Stéphane Crussol, *Les pouvoirs magiques des crânes de cristal*; Philip Permutt, *Ces pierres qui guérissent: Guide pratique de lithothérapie*; Editions La Boétie, *Le livre des minéraux* and *Le guide familier des roches et minéraux*; Gründ, *Encyclopédie des minéraux*; Nature et Vie, *Les minéraux, une géométrie en couleurs*; Victor R. Belot, *Les minéraux, où les trouver, comment les collectionner*; Rüdiger Borchardt and Siegfried Turowski, *Kristallmodelle*; Clémence Lefèvre, *Guide d'utilisation des lampes en cristal de sel*; Judy Hall, *Nouveaux cristaux et pierres thérapeutiques*.

Aubervilliers, 2011
[Translated from German]

———

INTERVIEWS

BENJAMIN H. D. BUCHLOH: AN INTERVIEW WITH THOMAS HIRSCHHORN[1]

Benjamin Buchloh: Whenever I see a work of yours, a typical art historian's question comes to mind: Who was more important for you, Warhol or Beuys?

Thomas Hirschhorn: Those were the two artists I discovered for myself in the late 1970s. From 1978 to about 1983 I attended the School of Applied Arts in Zurich, and in 1978-79, each had a one-man show, Beuys at the Kunstmuseum and Warhol at the Kunsthaus Zurich. They were equally important; I could say that both were in fact my teachers, though I never studied under them.

Buchloh: What you learned from them was to resolve the apparent contradiction between Warhol's insistence on an aesthetic of technical reproduction and Beuys's continuous evocation of an individual and intense materiality, a kind of secularized magic?

Hirschhorn: Absolutely. What I like tremendously about the work of Beuys— beyond his social engagement, of course, which led to defeats, as we know—is the fact that he revolutionized the idea of sculpture by introducing materials like felt, fat, and conducting materials such as copper that had never been used

before. And he did all of that together with his shamanism, which I take seriously as a form of artistic expression.

Buchloh: But you don't adopt the role of the artist as shaman for yourself?

Hirschhorn: Not at all. Quite the contrary. But I find it highly interesting as an artistic tactic. Both Beuys and Warhol outed themselves as artists at a relatively late age, or at least didn't do so in their earliest years. Warhol is for me by no means the apparent opposite of Beuys. Having myself come out of a school for applied arts, and initially having planned to become a graphic designer, I see Warhol's work as something impossible to surpass. He continued to be an illustrator and a designer, and although he conformed to the time in which he lived, his expression was highly critical.

Buchloh: Is that what Europeans still think? Do you really see his work as critical?

Hirschhorn: Fine. *You* live in America. I believe it is. And, of course, what impresses me about both of these figures—as human beings—is their extreme engagement with their art.

Buchloh: If one would describe the contrast a bit schematically, one could say that in Warhol, we have glamour and design as seduction. And on the other side, in Beuys, we have magic and transubstantiation in the shamanistic tradition. In your work, these two opposing strategies find a quite remarkable synthesis: you perform the travesty of glamour and seduction, and instead of relying on magic and suggesting mystical transformation, articulate a continuous criticism of reification, a transformation of a different kind.

Hirschhorn: Warhol's production is perfectly simple, clear, American: he gave forms to things and shoved them in the public's face. With Beuys it is not primarily the mysticism that intrigues me; what moves me is his continuous appeal to the public, the fact that he was constantly talking, approaching people, carrying on conversations. He didn't see art as something sacred but as a contribution to the ongoing discussion. I learned that from Joseph Beuys.

Buchloh: Then one can say that you have changed their specific positions radically. On the one hand, your work emphatically affirms the need for industrial production as a model for artistic production. And on the other, it affirms the need for communicative structures that appeal to as many participants as possible.

Hirschhorn: That is what I have tried to learn from Warhol and Beuys.

Buchloh: Both artists were originally engaged in a form of radical democratization. Obviously, Beuys's model originated in the aftermath of trauma and some forms of religious substitution, if not attempts at redemption. Warhol's, by contrast—clearly more American—took its point of departure in the populist utopianism that had been delivered in America by commercial design and consumer culture. These are two very contradictory approaches, yet after all they concretize the very structures in which most of us have experienced secularization, democratization, and the semblance of equality in the last few decades. I would say that this dialectic of cult and consumption is one of the foundations of your work as well, yet it is further radicalized and still more secularized. Warhol ended up where he began, as a producer of advertising. Fetishism and seduction, advertising and design (which in the end became merely a new style in Warhol) are again deployed in your work, yet with a newly invigorated critical radicality. As for Beuys, I would say that his promises of "art by all" were increasingly undermined precisely by his cultic stance. It was essentially a total deification of a single artist, and no longer had anything at all to do with the radically democratic intent with which he started out.

Hirschhorn: Correct, but I also admire these artists precisely because they were so radical and so fully engaged in their work, if perhaps wrongly so. Now, after a few years have passed, one responds to their work critically. That is why I can say, "I love Joseph Beuys and I love Andy Warhol."

Buchloh: That brings me to the next question: How do you relate to the generation that preceded you, namely, the conceptual artists? I have frequently wondered whether their project of institutional critique was important to you.

For example, Daniel Buren's work at some point performed the most radical critique of existing institutions, especially the museum, and Lawrence Weiner's work engaged in the most precise contestation of traditional materializations of art. How did you reverse their positions and return to a position that is very much concerned with material production?

Hirschhorn: I could now simply lean back and somewhat high-handedly produce an answer to your question. I could criticize these approaches to institutional critique on the part of Daniel Buren. I don't wish to do this, and cannot, since I have to say in all honesty that I totally blocked out the generation that preceded me. Not because I knew nothing about them, but because I was so caught up in the very idea of being an artist, or not being an artist, that I never even considered this question of institutional critique at all. And it would be highly inappropriate now if I were to look back and say that my art was a reaction to, or a critical rejection of, theirs. But I would say that because of the minimalist design quality of their work, I had to turn away from it.

Buchloh: I suppose you refer to the highly stylized, reductivist, and not to say purist, design qualities that eventually became evident in conceptual art? Would those not have provoked you, and determined your response to be one of chaotic, polymorphic materials and impure structures?

Hirschhorn: Of course. Naturally I had a problem with the excesses of design, because I know what corporate identity is, and I know what advertising is. That is obvious. But, most important, I never shared the notion of a critique of institutions. That was not a problem for me. And I found that conflict in the work of Buren; I speak only of him because he is the most radical. Because his work is so totally designed, it suddenly raises utterly strange questions: Where does the design end, for example? Or does it?

Buchloh: Where does the radicality end and where does the design begin?

Hirschhorn: Precisely. And, of course, where one sees the limits of the work, one sees that he is in a conflict, and I noticed them fairly early. In the work in

which he makes museum guards wear striped vests, for example: on the one hand, that project is a logical continuation of his ideas. On the other, people come into the picture, and they can only go along with it because they work in that museum and are obliged to wear these vests. Here we must confront the question of the individual and of free choice.

Buchloh: So one could argue that you turned away from the critique of institutions because it seemed more important to you to focus on other elements of discourse, such as advertising, design, and commodity culture. To bring those elements into critical focus struck you as much more pressing and urgent than the critique of museums?

Hirschhorn: That is totally correct. As I said, the museum was important to me. Naturally, I want to change the museum. I would like to see museums open twenty-four hours with free admission all the time. I like going to museums—archaeological, local history, natural history museums. I also go to museums for a formal reason, or for an artistic, sculptural reason. I am interested in how things are displayed because I actually find that display is a form of physical experience. One needs time and space to present and display, and that has always been highly interesting to me. And museums make very important contributions. For example, after the Berlin Wall came down, I remember visiting the museums in the eastern sector two or three times. I recall one exhibition, how monuments were designed during the DDR period. It was incredible; those were the most beautiful exhibitions I've seen. Because you want to display something and make something clear, you want to give space and time to that experience of the display. I find that definition and usage of space very important.

Buchloh: Let's move to the question of a criticism of sculptural, instead of institutional, conventions. Your work, as sculpture, transcends even the most radical changes that occurred on the level of materials and morphologies in pop and post-minimalist sculpture. No one knew at first what your work actually was. Was it a painting or a relief? Was it a collage or an object? Was it an

installation? Can you take it with you? Can you dismantle it? Can you throw it away? Do you have to collect it? This was an incredibly radical attack on what, at that point in the late 1970s, was the most advanced sculptural ortho-doxy, namely, site-specificity. Suddenly you came along and undermined all of that by using materials that were seemingly interchangeable, that did not nec-essarily have to be preserved. You opened the production of sculpture to other realms of experience that post-minimalist sculpture had totally shut out, namely, the realm of the everyday and the memory of history.

Furthermore, you repositioned sculpture at a level of crude banality and tawdry cheapness that would have scared most of the artists of the preceding generation, much as they might have wished to orient themselves around pop art conventions (for example, Dan Graham). That was one of the first shocks that your work triggered in me when I saw your *Skulptur-Sortier-Station* pavil-ion in Münster in 1997.[2] For me, that was one of your most important works, in which all of these questions were approached in a wholly new way: What makes sculpture public? What could nowadays be called "specific" about the site of sculpture? What are the proper materials for sculpture? What are the different discourses that can be addressed by the experience of sculpture? And perhaps most important, can historical reflection be one of them?

Hirschhorn: Just so that we keep everything in mind: I said earlier that Beuys opened up for me this issue of materials in his attack on the rigidity of tradi-tional sculptural materials. Furthermore, he opened the question of sculptural function with his idea of social sculpture. By contrast, I didn't remotely want to enter a dimension that had anything to do with either nature or with the esoteric, with the spirit, with mystical processes. Rather, my idea was that I wanted to make sculpture out of a *plan*, out of the second dimension. I said to myself, "I want to make sculpture, but I don't want to create any volumes." I only want to work in the third dimension—to conceive sculpture out of the plan, the idea, the sketch. That is what I want to make a sculpture with: the thinking and conceiving, the various plans and the planning.

Buchloh: Transforming an industrial logo, for example, into a sculpture: Would that qualify as an example?

Hirschhorn: Exactly. You have a plan, and then create it in the third dimension. Voilà. That additional dimension is the work.

Buchloh: And why is that translation into the third dimension desirable?

Hirschhorn: It's not that it is desirable. It is rather that when you transfer a plan or a sketch into the third dimension, it becomes an altogether different proposition, and also changes its very substance.

Buchloh: And does it address itself to the viewers' demands? Or does it merely address the concept of sculpture?

Hirschhorn: No, it naturally addresses the viewers—quite directly, in fact, just like the protesters that we see in demonstrations, where some group is protesting with signs or logos, or with shapes representing something. They claim they have no jobs, so they nail coffins together, right? Journalists demonstrate because somebody wants to impose a ban on reporting, so they fasten tape over their mouths. This is how their work addresses itself directly to the viewer, and it simply has nothing to do with the notion of sculpture, because these ideas of mass, form, and volume are simply not behind it any longer.

What I have tried to do is to put together different elements, pictures, forms, and photographs, so that they take on a substance that one can translate simply and directly. When I first made sculptures such as the *Skulptur-Sortier-Station*, I started quite simply with these logos, and gave a form to that material. But at the same time, of course, I also wanted to generate a certain resistance, because there is also work behind it; although you might now say it's not a great deal, my own work is in it. That is still important to me. So it is not only somehow an enlarged logo, it is some kind of homemade thing that someone created; it is a *sculpted* logo.

Buchloh: The *Skulptur-Sortier-Station* revealed two dimensions to me quite dramatically. Although they had appeared earlier in your work, I never saw them as clearly: the astonishing fact that your work as sculpture turned again and again to actual history, a feature that differentiates your work and sets it apart from previous generations of sculptors. For example, the fact that in the *Skulptur-Sortier-Station*—along with the corporate logos of Mercedes, for example—you introduce a sudden glimpse of the "Degenerate Art" exhibition of 1937 with the replica of the sculpture of Rudolf Haizmann.

Throughout the 1960s and 1970s it was practically unthinkable that one could encounter a historical dimension or reflection in sculpture. Your work suddenly transported the spectator back into history, back, more precisely, to the political history of art. Yet, you do not simply pay homage to figures of the past; you seem to want to facilitate a form of historical recollection in a present that no longer has any desire for historical memory, that even actively tries to suppress and eradicate it as much as possible.

Hirschhorn: Absolutely. That is my artistic responsibility, and I want to do that. But, on the other hand, this engagement is also . . . it isn't a matter of history. It is a statement about what one finds important. And I am making that statement in forms that aren't my own because I feel altars are something we know, whose forms are familiar. This third dimension has nothing to do with the form of a sculpture but with some other form. And then there is something else that I want: it is, of course, an attack, a conscious one, on architecture, or on art in buildings, or on art in public space. Or on "immortal" art, in quotes—question mark, exclamation point.

Buchloh: This brings us straight to the next question, which concerns the typology of your sculptures, and one type in particular that you call your "altars." Your choices, the artists for whom you built altars, are relatively diverse in certain ways but in others are quite specific. Otto Freundlich,[3] Robert Walser,[4] and Ingeborg Bachmann[5] are very fragile, unusual figures in the history of modernism. Some of them, like Walser and Freundlich, were relatively

unknown figures, and Bachmann is probably the least known of the three now. All three were highly complex, difficult, tragic artists. That can't be mere coincidence. Could you say something about those choices, or were they simply personal selections?

Hirschhorn: No, of course I can say something about it. But I should add that I didn't make an altar for Robert Walser, I made a "kiosk." That is an important difference to stress: the work for Robert Walser is a *kiosk*. There are four altars: one for Raymond Carver,[6] the American writer; one for Piet Mondrian; one for Ingeborg Bachmann; and one for Otto Freundlich. Of course, Mondrian is, in a sense, a marginal figure as well, as a person, as an artist, as a loner. I selected figures about whom I could really say, "I love you," about whom I really meant it; it was a real commitment. And on the other hand, you're right, I selected them because of the tragic nature of their lives. For example, I find reading *Meine Schriften* by Otto Freundlich really amazing. But I could not say, "I love Picasso." Do you understand? That's something I cannot say. I respect his work, I suppose. But I can't say that.

Buchloh: His work has, of course, achieved such a position of authority and total acceptance. By contrast, your altars and kiosks set a certain process of recollection in motion with the figures that you foreground, and one is reminded of the difficulties of their situations. Yet, your efforts at a resuscitation of their memory do not aim at a new cult of these artists. Rather, if one actually gets to know Ingeborg Bachmann, or one gets to know Robert Walser or Otto Freundlich, one gains a more complex understanding of our supposedly modernist history, and of what these artists were actually engaged with, and had to live through.

Hirschhorn: Absolutely. I agree. With Mondrian you don't end up with a star cult either. He is too rigid, or too low-maintenance. It doesn't work, and that's why I selected only these four figures, even though I wished, of course, that there could have been more. I am only making four monuments. Because, again, it is like a sheet of paper, when I have a plan and it has four corners.

There is room inside and out. It could, in fact, have been seven, or six, but I wanted it to be like a limitation of a plan. In that sense, four is enough.

Buchloh: That brings up an additional, important, and related question. You have developed a very precise typology. Within that, could you demarcate the differences between a kiosk, an altar, and a monument? There are four monuments, four altars, and I don't know how many kiosks?

Hirschhorn: Eight. I can explain it to you. The first type, the four altars, are works for these four personalities in public space. Each can be exhibited and transplanted from one site to another. They always have to stand someplace outside. One is in a private collection. Another is in a museum. The *Raymond Carver Altar*, for example, has been exhibited three times so far. The *Ingeborg Bachmann Altar* has been exhibited twice. The second type is the kiosk. There are eight kiosks, and they actually grew out of an "Art in Architecture" project at the University of Zurich. I proposed a project in the foyer of an institute for brain research for a limited period of time. I wanted to create a separate room that would be there for only six months, a kind of kiosk of the sort in prisons or in hospitals. You enter these so as not necessarily to be in one space but [to be] in another space. And I dedicated each of these kiosks to an artist, a poet, or a writer. These works no longer exist, as they were set up only for six months. The first one was dedicated to Robert Walser. Then came Emmanuel Bove, the writer, then Fernand Léger, and then Ingeborg Bachmann got one as well. Then Meret Oppenheim got a kiosk. Then came Otto Freundlich, he got one as well. And then there were two more—Emil Nolde, and Liubov Popova was the eighth one. A kiosk was simply a small place where information could be found about this artist, about his or her work. And it was important for me to know that the information about them was present and accessible in these kiosks for a limited period of time.

And then the third type of work is the monument. The monument is different because it requires the help of neighbors; it is created with the assistance of other people. And I actually want to make four monuments, even though I have only completed three so far. The first three were for the

philosophers Spinoza, Deleuze, and Bataille; and the fourth one will be for Gramsci. And these are also public works, but they reflect something of the local area, or residents, because they are more complex and larger. The *Spinoza Monument* in Amsterdam was the smallest. We only had to find a sex shop in the city's red-light district whose proprietor would allow us to install the monument in front of his shop and provide the electricity. That was the most modest monument.

Buchloh: You actually conceive of sculpture more as an event, rather than as an object, let alone a monument?

Hirschhorn: Absolutely. That was very important; that is what I wanted. I wanted this cluster of meanings, since it is many things—not only a sculpture but also a meeting place.

Buchloh: What, then, is the difference between sculpture as "event" and sculpture as spectacle? Isn't that a dangerous proximity?

Hirschhorn: No, no danger at all. Because my monument produces something, it generates something. That is the intention, at least; it is not just to be looked at, but you participate. In fact, "participation" can be a person sitting at the bar and drinking beer. In Kassel, for example, it was important that the *Bataille Monument* included a bar and a snack counter. Not because it is important that people refresh themselves, or eat or drink, but because it presented a chance for conversation or a place to meet. This actually happens with my monuments: people often sit there, drinking beer, and I wanted to emphasize that aspect. For that reason my monuments aren't spectacles for me but rather events. An event is also something you can't plan ahead of time because you never know what will happen. And, in fact, that is what happened. If I already know in advance what kind of experience will be generated, it wouldn't be an event, it wouldn't be an experience.

I feel that the condition of spectacle always results from thinking of an event in terms of two groups, one that produces something and another that looks at it. That was not the case here. And it is possible to create an event that

will be so difficult and complicated and incredibly exhausting that it will always make excessive demands on the spectator. The first to be overburdened was me, the next were my coworkers, or the people from the housing project, and then perhaps the third, I hope, was the visitor. In this sense, I believe that if there is such constant challenge, one can fend off the spectacle. And naturally part of the challenge is that it is limited in duration.

Buchloh: One of the criticisms raised of your work, especially in regard to your *Bataille Monument*, was that it pretended to communicate with a local audience in a way that could actually never happen. Is the mere intention or the actuality of communication a criterion for you to evaluate the success of your work?

Hirschhorn: That is very easy to answer. First, I didn't want to exclude anyone. I find that anyone who thinks that local Muslim kids could not get involved with Bataille makes a huge mistake. I reject that strongly. That would mean that someone was excluded from the outset, for what reason I don't know. Why should they be shut out? Why would anybody say they can't handle it? I don't buy that. Sadly, it is precisely this argument that frequently comes from a leftist position. If I say I want to make a work for a *collective* public, then I am obliged to, and it is my desire to make a work in which I don't ever exclude anyone.

Buchloh: Yet, it seems that you quite deliberately set up the most extreme confrontations. A Bataille monument in a Turkish workers' housing project in Germany, or a Spinoza monument in Amsterdam's red-light district: those are sites that create the extreme confrontations that are important for the understanding of your work. If you had placed a Spinoza monument in the inner courtyard of Amsterdam University, it would have been less interesting . . .

Hirschhorn: Of course—absolutely. I am the artist, and when I work in an open space, I decide where to place my work. It interests me that my work has to defend itself in *any* surroundings, in *any* sector, and fight for its autonomy. That is another dimension that is very important to me.

Buchloh: But that in itself is a rather utopian assumption, isn't it?

Hirschhorn: I hope it is not a utopian one, of course, but I would say that it is a radical, non-exclusive stance. It is a political stance, although of course this is not political art. What I keep saying is precisely that I want to make my work political in the sense that I do not exclude anyone. Then there is another argument I try to make very clear (and I realize that there are misunderstandings): the first *aim* of the *Bataille Monument* was to generate friendship and social interaction, and the second goal was to provide an opportunity to learn something about Georges Bataille. I have argued, for example, that when someone sits next to the monument, he or she becomes a part of the monument. And, strictly speaking, when children are playing in the TV studio, or making films about their own reality, that is then a part of the *Bataille Monument* as well. There was not a single book in the library by or about Georges Bataille, but books on the themes of Georges Bataille, because I wanted it to go beyond him. And ultimately I never talked to the youngsters I worked with about Georges Bataille. What I wanted instead was to foreground a certain dimension of the work of Georges Bataille, where he talks of "la perte," or loss— where he talks about being stretched beyond one's limits, where he talks about something transcendent. It is possible that, in the end, Georges Bataille's name and his work could be replaced by others.

Buchloh: So when people talk about a failure to communicate, is that altogether false?

Hirschhorn: I try to make this issue very concrete. That is why I said that my presence on the site was not required for communication or discussion with people, but simply in the role of a caretaker, to check that everything was functioning.

Buchloh: One might still misunderstand you, and argue that you benevolently overlook the actual conditions of total alienation and reification that govern the everyday life of the Turkish working class in Germany. Worse yet, one could argue that you assume that their fundamentally alienated living and

working conditions could be improved with relative ease, through spontane-
ous acts of understanding, reading, communication, and exchange. That—for
better or worse—is the utopian dimension of your work. From a less utopian,
but more pragmatically political position, one would argue that under such
conditions it is impossible to generate communication and understanding with
aesthetic tools alone. Isn't it highly improbable, for example, that Spinoza will
suddenly become an event, right in the middle of Amsterdam's red-light dis-
trict? What do you say to such critics?

Hirschhorn: Nothing is impossible with art. Nothing.

Buchloh: Ah, yes, that is the type of conviction that emerged from the Beuys
tradition, right? Warhol would have said the opposite: that nothing is possible
with art, nothing but business.

Hirschhorn: The other possibility is that by letting this autonomy shine through,
by holding fast to this affirmation of art, I want people to think, to reflect,
okay? That is what I want: reflection about my work, art in general, the pas-
sage of time, the world, reality. It is possible, for example, to talk with Turkish
kids about art, because I don't talk with them as a social worker but as an artist,
as someone who believes in art. And those are the points for me that are
extremely important, and I believe that art makes such activity possible. I am
not here to rehabilitate anyone, or not to rehabilitate them. That is not my
job. I quite clearly reject that. At the same time, I find a cynical stance impos-
sible, because it creates no autonomy or activity for me.

Buchloh: But why could you not also depart from the critical and cynical
potential of art, with its own subversive dimension? What about, for example,
that aspect in the Warhol tradition that goes back to Francis Picabia?

Hirschhorn: Well, with Picabia I have to wonder. With Duchamp, for example,
I could even say that I love him. Not Picabia. That is quite clear. Not Picasso
either. It is not about morals or anything. That's not the issue; I don't like
moralizing. But of course I like to argue, to get engaged, and I feel that art

makes that possible. Naturally, my work raises an incredible number of questions. There is criticism, and I don't try to avoid it. But the argument isn't theoretical, I feel. That is a major difference. My work is something that I feel, that I have to make. I, Thomas Hirschhorn, simply, really, not only will make a statement theoretically but will also attempt to sustain this statement in reality. I can then say, for example, that when I maintain that art is not about communication, that is true, because I have not created any kind of communication. But I was there in the field and have tried to defend art and uphold its autonomy.

Buchloh: When you say that you truly believe in the possibilities of art, then I start to wonder where the intensely subversive, antiaesthetic dimension of your work originates? Your work generates a continuous dialectic between aesthetic and antiaesthetic impulses, emphasizing disintegration as much as construction. For example, if you suddenly align sculpture with the forms and processes of spontaneously erected, collective altars in which people's emotions are haplessly manipulated, you seem to affirm a resurgence of ritual and cult value in sculptural experience in the present. Such a strategy appears as an incredible assault, a slap in the face of all modernist and postmodernist sculpture. Does your belief in art comprise this critical antiaesthetic, or is that merely a contradiction?

Hirschhorn: No, that isn't a contradiction. For me, you see, there is no high and low art, or . . .

Buchloh: But objectively they exist, right? That is a contrast that we all have to deal with. Perhaps it doesn't exist for you, but socially it certainly does. We have not resolved the conflicts between mass culture and high culture. Not even Andy Warhol was able to do that.

Hirschhorn: I too will have trouble doing away with it. But believe me, I am not in this to fight a lost cause. And I am not in this to shore up something that has already been established.

———

I want to work on this notion of an exalted high art, a *plus-value*, which doesn't come from one's own mental activity but from history, which somehow derives from external values. I question that, and I criticize that. And that is why I create my work with my own materials. That is very important to me. I am not in this to say from the outset that I won't make it, but rather to say that it is possible to work with incredibly, you could even say miserable—not only discouraging, but miserable—and truly modest results. I try to give form to my ideas. And if I am to give them the kind of form I want, I have to work with materials that everybody knows. They have no special value, and they suggest something other than what I am using them for. It's not a matter of antiaesthetics; in truth, I could force the issue and say that I find these materials beautiful. It is not about that; it is a matter of a different purpose. If a woman puts tape around her suitcase because she fears that it might burst open, she doesn't think about whether it looks nice. She simply wants to fix something that presents a problem to her. And she thereby creates a form, or uses the materials that interest me for what is actually needed: energy. Not Beuysian energy, but energy in the sense of something that connects people, that can connect you with others. And certainly not *quality*, which—and now that you speak of high art—wants to separate us, to divide us. Because there are only very few people, after all (and as a Swiss, I know something about this), who can afford quality, who can afford quality judgments in general. And I loathe that, and oppose it, because it shuts out the vast majority of all the rest simply, quite simply, because they can't afford it.

Buchloh: Do you consider yourself to be a Marxist?

Hirschhorn: I am, but it would be presumptuous of me to say, "I am a Marxist" because I haven't studied it, because I haven't thought about it in any academic way. And also, you understand, because I don't want to. I believe that as an artist, I want to make my work political, to be responsible for each of my actions. And there are many actions for which I am responsible that aren't any good, but I want to be responsible for every act that has to do with my work. That interests me. Declaring myself to be a Marxist, translating this theory into

practice, would also limit me. For example, in the question of my public, of whom I address. You see? I deliberately eliminate that specific question. I admit that one could criticize that elimination, but it's not naïveté, and it's not that I haven't thought about it. But it's an element that, if l wish to be active, and I do, if I want to make something, if I want to give something, I have to eliminate that type of specificity.

Buchloh: Since I started with a question that was odd, I'd like to end this conversation with a question that is equally odd: a proposal to project your simultaneous enthusiasm for Warhol and Beuys back into history, and to ask whether you also initially had to choose between your love for Aleksandr Rodchenko and your love for Kurt Schwitters?

Hirschhorn: As was the case with Warhol and Beuys, there is no "either/or." I love them equally, and they were both on my scarves. I've never been afraid of contradictions because we are here to generate them, not smooth them away. I feel that there is a certain energy in contradictions. I love Schwitters for the explosive force that you still see in his work today. But I love him more specifically for the fact that he built the *Merzbau* three times, against incredible resistance and with unimaginable, admirable persistence. I knew Rodchenko's work quite well, at first from his graphic design. After all, he was the artist who, after painting wonderful pictures and making fabulous photographs, made extraordinary posters and graphic design, but also made clothes for workers. He ignored all of these divisions and media restrictions. [. . .]

One ought to add that when looking at Rodchenko, I recognized for the first time that failure is not the issue. Schwitters was already clearly a solitary figure, maintaining his *idées fixes* and his stance of a refusal to suffer but instead to simply carry on.

Buchloh: One feature of your exceptional book *Les plaintifs, les bêtes, les politiques* that has always intrigued me is its specific referral to various design conventions. For example, at one point the book invokes Rodchenko's constructivist/productivist design, from the moment when it had devolved

into propaganda for Stalin's authoritarian state socialism. In another moment, often side by side with the first, you cite modernist design, which in its own tragic history, in certain instances, suddenly became fascist. Or, just as often, you make references to contemporary corporate design, such as your favorite Chanel advertisement, or to cigarette and perfume ads. When you approach these logos and design languages, you often pose questions in what seems to be a rhetoric of false naïveté, or perhaps more accurately, a Brechtian dialectic: "I don't know what it is, but I love this." You confront yourself with the catastrophic outcome of what was once a utopian design culture, and admit that you cannot resist its seduction any more than anybody else can. You ask the question, "Why can't I detach myself, and simply state that these are regimes of control and strategies of domination?"

Hirschhorn: That's very good. I can assure you that no one has formulated that as you have, of course, and you have already spoken about this book and its contents two or three times. That has helped me tremendously and also helped my work. The book was published in 1995, which means that I made those works in 1993 and 1994. I was trying to settle accounts, in a way.

Buchloh: With your own past?

Hirschhorn: Exactly, and especially with my past as a graphic designer. But when I confront such things as the Chanel design, I simply have to say, "Good, no one could do it better, this type and everything. That can't be improved upon." At a certain point defiance is no longer possible. That is why I also have to say programmatically, "Energy = Yes! Quality = No!" Because there are, in fact, certain pretensions of quality. Our eyes function in such and such a way . . .

Buchloh: In such a way that we cannot defy authority?

Hirschhorn: Yes, precisely. If you cannot defy it by addressing it head-on, or attacking it, then other forms have to be found that clearly indicate that quality doesn't affect or interest me. And I tried to do that with *Les plaintifs, les bêtes,*

les politiques: to take seriously this tightness, this simplistic blandness. I take it seriously myself, and quite simply accept it, this first *degré*.

Buchloh: There is a counterforce to the allures of design in your work and in your strategies of accumulation that one could call an excess of information, materials, and objects. It seems that Georges Bataille's concept plays a major role in your work and is evident in this endless overload of objects and information, of accumulations which lead to devaluation. It seems as though you wanted to confront viewers with the necessity of recognizing the chaotic multiplicity and urgency of your questions, and at the same time to foil their attempts at coming to terms with them. Could you say something more about the concept of "excess"?

Hirschhorn: Yes, absolutely. If philosophers interest me, Bataille is definitely one of them. Philosophers help me in my *life*. When I first encountered Bataille's concept of expenditure, I had the feeling that I had never read such a thing before, and I instantly felt in total agreement with that. This assertiveness, of constant acts of giving and challenging others—that is what I wanted to do in my work. And that is what Georges Bataille also describes in his book *La part maudite*. This idea of the potlatch is based on challenging others by giving, so that they reciprocate with an offering to me. This motive is very important in my work: I want to make a lot, give a lot. And when I say "give"—in the sense of "giving form," not *making* form but *giving* form—I want to do that in order to challenge the other people, the viewers, to get equally involved, so that they also have to give. I always have the feeling that I am still making too little. There is too little there. It is still not dense enough, and I want it to be dense. I want it loaded.

Also, it is very important to me that the gallery space is not simply a white cube—after all, who can afford empty white spaces? I don't want any white spaces! This luxury, I realized, is no longer something merely expensive; it is something that doesn't exist. These empty white spaces rarify objects to

intimidate the viewer. For that very reason it is very important to me that my work always has a lot of elements, a lot of material.

Buchloh: It always struck me that your work's excessive accumulations of pictures, objects, and structures mimetically followed the actual governing principles of overproduction and the technologies of incessantly multiplying meaningless images. If one compares your stance with the original historical context and concept of Duchamp's singular readymades, one recognizes a totally different quantitative and temporal dimension in the present day, in which images and objects proliferate and invade us by the thousands at every turn we take.

Hirschhorn: Absolutely, I agree. I would also like to say something else that is not frequently understood. I don't believe in the superiority of the single image because I know that the single image is utilized as a tool of exerting power. Let's take the example of 9/11—this single image of the collapsing towers, and the resulting ruins—and how this single image wants to have power over me. Although we know perfectly well that there are ruins in Grozny, and that there are ruins in Palestine, and that there are ruins all over the world, this picture alone claims to have the greatest power over me. I want to combat this power by producing a huge number of other images.

Buchloh: Your accumulations of images then induce a process of decentralization . . .

Hirschhorn: Exactly. Not necessarily contradictory pictures, but rather showing the same thing from completely different perspectives . . .

Buchloh: What impressed me so much when I saw your *World Airport* for the first time in Chicago was the fact that the sheer quantity of information forced spectators to give up their desire for the false monolithic centrality of a traditionally conceived and unified work. But perhaps more important, one was also forced to see the existing political links between objects, stories, structures, and situations. Your work suddenly dispelled not only the monolithic isolation

346

of a traditional work, but it also opened up a global way of reading and recognizing relations between phenomena that were previously disconnected and hidden.

Hirschhorn: I am, in fact, concerned that this mass of information might have previously appeared as unrelated. Obviously, I do not only make political statements and assume responsibility; I also want to achieve a sculptural impact. Therefore, I work with and create forms that reflect how I experience the world, how I am forced to confront reality, and how I understand the age in which I am living. For me, that means, first of all, not to create any spaces where one can stand back and maintain distance. Second, it means not to set up any kinds of hierarchies. Third, it means to break through one-dimensional relationships, to try to split up centered vantage points, and to make singular viewpoints impossible. To get back to the work that you are talking about: it is for these reasons that the connections are so important for me. They don't necessarily have to be real connections, although in the *World Airport* they were real.

Buchloh: By establishing these seemingly infinite relations and offering an excess of information, your "displays" deny any hierarchical mode of experience. If, for example, one simultaneously encountered a work by Richard Serra and a work by Thomas Hirschhorn in a sculpture exhibition, one would recognize immediately that Serra's work requires a highly specialized, knowledgeable way of experiencing sculpture. It presumes an extremely differentiated phenomenological approach, one ultimately based on an aesthetic of autonomy. Your work instead sabotages all these appeals to autonomy: the whole discursive system of what could be called sculpture is twisted, spun around, and opened to a whole new array of contexts and contiguities.

Hirschhorn: Quite right. The wonderful thing about art is that positions like Richard Serra's are possible, but my position is also possible. That is why I love art. I don't work against Richard Serra. Rather, he and other artists work so intensely and radically on their own system that I say, "If he does that, I'll

have to demand that of myself as well." That is my job, my mission, as an artist: to make this my own work. But it interests me that there are other positions. My position is not in combat with them, but my position wants to assert itself and clearly maintain its ideas and content.

Buchloh: You mean your work does not engage in a critical dialog with prevailing notions of public sculpture? Does your work not somehow state that certain sculptural concepts of publicness are false? Doesn't your work give us a much more complex definition of the conditions of public space?

Hirschhorn: Absolutely! I think every artist has this intention. Otherwise one couldn't carry on. But for me, for example, the concept of the sublime is one that I despise as being profoundly bourgeois.

Buchloh: So your work wants to desublimate? And excess is an important strategy in your project of sculptural desublimation?

Hirschhorn: Absolutely. This is the direction I have taken, and the path I wish to follow. Although people keep saying, "Those are installations," I don't make installations, you understand? I make my kind of work because I don't want people to be able to step back from it. I want people to be inside my work, and I want spectators to be a part of this world surrounding them in this moment. Then they have to deal with it. That is why it looks the way it does.

Buchloh: It seems there are actually three types of objects and materials that turn up in your larger displays. First, there are the real objects. Then there are the enlarged objects, made of aluminum foil or whatever, which magnify trivial objects of everyday life such as watches, spoons, or mushrooms. Last, there are these abstract forms that are often made with tape or aluminum foil, uncanny bulbous rhizomes or biomorphic links that roam through your displays. And that is a remarkable spectrum. First of all, it seems to expressly refer to specific sculptural practices and conventions. One cannot see a giant object—let's say your Rolex watches—without thinking of the strategies of Claes Oldenburg. Magnifying trivial objects is by now a well-established

strategy invented by the greatest sculptor of the 1960s. But you turn that around, and this strategy suddenly generates precisely the opposite effect: the enlargement does not monumentalize the trivial object anymore, but forces it back into the banality from which it originated. At the same time, you deploy these cheap materials like duct tape and all kinds of foil to sculpt these stalactite/stalagmite forms of almost threatening growth. And these opposing strategies really bring about a decisive effect of desublimation.

Hirschhorn: I'm very touched that you see so clearly what I have in mind with the magnifications of these objects, for example with a book. I am not concerned with any book in particular. I want to say: Every book is important, every book can be important. But no one book is more important than any other; I'm not placing it above something else in a kind of hierarchy.

Buchloh: But in contrast to pop art, you not only work with the *objects* of the everyday; you mobilize the actual everyday practices and experiences of other people. Let us consider your altars once more—citations of those collective forms of behavior in which people spontaneously generate such structures. And in other works, for example the sculptures that deal with the task of removal, where you also perform a common social gesture, virtually the opposite of your principle of excessive accumulation: namely, to get rid of excess material, to throw something away, and then turn it into your own sculptural strategy.

Hirschhorn: I want to make truly a poor art. Poor art, not arte povera. That it is the one thing I wanted to say to you. Something else regarding Oldenburg: I do not have any problem at all with this comparison, but what is very important to me is that even when I enlarge something, it is never monumental. That is my only criticism of Oldenburg's art objects in public space: they naturally become monuments.

Buchloh: Monuments to what, one has to ask oneself.

Hirschhorn: Exactly. That is the only question that is interesting. And in these cases, the monument itself is not criticized, and nor does the work call the underlying concepts of public space into question. That is one of the reasons why I have always tried to enlarge my work myself, by hand. Even though it is large, it is never monumental, never simply magnified by some method. And to go back one more time to this question of *poverty*, and of Filliou: Filliou introduced these strategies of subtraction, of clearing away, as you put it. Accordingly, all the materials that I use are not only used in the realm of art; every time I work with a given element, I try to check whether there are possibilities of linking it with a reality that exists elsewhere. I have always tried to make this bridge to something that has a reality elsewhere. That is very important to me.

Buchloh: There is another dialectic that your work engages with from the very beginning, namely, to isolate existing social rituals, or to refer to cult behavior in mass culture—let us say soccer—and to intertwine these forms of experience with phenomena derived from avant-garde culture. Writing Rodchenko's name in appliqué on a soccer scarf is a great example of that strategy. On the one hand, you seem to recognize that one cannot remove the cultic dimension from everyday industrial mass culture, and that cult behavior continues to define our experience no matter how enlightened we like to think we are. On the other hand, artistic practices that had once consistently opposed myth and cult (and that was certainly one of Rodchenko's most important demands), that had subverted ritual, have long since become part of a new cultlike veneration. That is an insight flashing up from the short circuit established in your *Soccer Scarves*.

But something else becomes evident as well: namely, that you take those actual forms of desire, or the hopes that express themselves in such mass-cultural cult forms, very seriously, and that you want to establish a dialog with these forms of ritual. Instead of considering them only as abject forms of extreme alienation, you take them seriously as possible forms of collective self-expression. Thus, you deal with the mass-cultural object not only iconographically, as

pop art did, but you actually engage with the given experiential conditions that such mass-cultural objects feed upon.

Hirschhorn: Yes, I simply believe that there are, in fact, certain everyday forms, as you have just described, that are in themselves incredibly expressive. Now, I am naturally interested in this seemingly uncreative process, because it is about reproducing something . . .

Buchloh: . . . or creating a memory structure in the seemingly uncreative process.

Hirschhorn: Quite right, to create history. This form interests me tremendously because I believe that there is an explosive force in it, like dynamite. Although it is a weak notion, I would say, in fact, that it is something that resists!

Buchloh: Now, that is an important question. Is it weak, or is it alienated, or is it deformed by mass culture?

Hirschhorn: I would say it is "weak." In the sense of Robert Walser, you understand.

Buchloh: Robert Walser and Robert Filliou perhaps have a great deal more in common than their first name . . .

Hirschhorn: Of course. And in Walser you are drawn into this current where you no longer know what is weak and what is strong. There is a certain resistance inherent in his work, and I like that a lot. After all, he even explicitly says that it is the weak who think of themselves as strong. Or, simply, that the weak are actually strong, because the strong are actually weak. And he places himself in a certain "weak" position. Naturally, I find that this has an explosive force, a kind of resistance despite our mass culture's actual lack of resistance. I am personally very susceptible to these forms, for example, these little altars that are generated outside and inside by all kinds of fans. These are manifestations that are not a matter of strength or weakness, but in which form is given to a particular concern, and that is what matters, and that touches me.

Buchloh: Or it means taking the forms given by others seriously, or using these display forms as the matrix for one's own creation of form.

Hirschhorn: I take them very seriously, and I believe in their innate form. Or I think these are forms *too*, even though I don't believe in them exclusively. They participate in some kind of resistance, but, I mean, what or who resists anyway? Really not many. And most important, they still give evidence of something that we are losing, a relation or an object that is perceived with love—perhaps wrongly.

Buchloh: Or rather, what is left of the ability to love. One more question about removal. This happens in your work not only on the level of materials, but in many of your displays. The removal of boundaries occurs between public and private space, and also between art space and ordinary space, as in your pavilions in Münster, or in the work in Lyon. Both were set up with the express intent to be accessible twenty-four hours per day, which de facto implied that they would be subject to theft and vandalism. Since you do not want to accept a traditional protective boundary between art space and public space, the erasure of that boundary inevitably entails that the work is damaged or vandalized. Could you say something about that?

Hirschhorn: Of course. As a matter of fact, I have produced a lot of exhibitions in museums and galleries, but also in public spaces. What interests me, after all, is precisely *not* to distinguish between public space and the museum or some other private space. What interests me is that it is always the same potential public, only the proportion is different. For, in the museum there are people who afterward go out onto the street. People who go into a museum are, let us say, fundamentally interested in art, perhaps, or perhaps have some time for art. By contrast, on the street, my work confronts the anonymous passerby, people who are not necessarily preoccupied with art. And that interests me. But I don't say there is a public—I'm not an advertising man, after all. I don't say that *this* is a target public or *that* is a target public. That would be totally wrong. But I would like to create conditions with the materials, the way I

create the work, and the theme, of course, which make as many as possible feel included. Or that no one, in any case, feels excluded. [. . .]

Paris, December 19, 2003 (published 2005)
[Translated from German by Russell Stuckman]

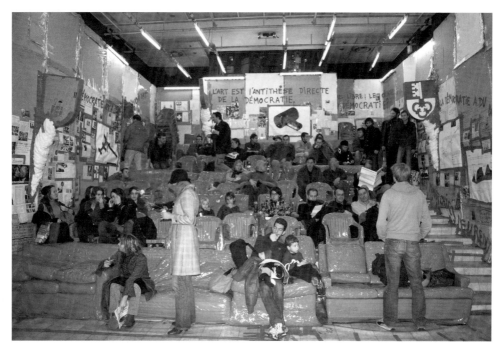

4.1 *Swiss-Swiss Democracy* (The Theater Room), 2004. Centre Culturel Suisse, Paris, France, 2004. (Photo: Romain Lopez.)

Mission: "Tenir le siège": Interview with Thomas Hirschhorn by Jade
Lindgaard and Jean-Max Colard[7]

Jade Lindgaard and Jean-Max Colard: What is your reaction to this political intervention [the Swiss Parliament's vote to cut funding to Pro Helvetia, the Arts Council of Switzerland, which sponsored the exhibition]?[8] Do you consider it an act of censorship?

Thomas Hirschhorn: No, I don't use the word "censorship." I was not censored. Nothing was censored. It's democracy. Politicians have ventured to vote on a budget cut in order to punish Pro Helvetia for having invited me, which is the same as manifesting the will to influence their future choice of artists, indicating to them to choose "nice ones." That's scandalous. It's also very stupid because money isn't indispensable to an artist. Lack of money never stops an artist from working. What's been recorded is that the elected officials who voted for this cut did so based on erroneous information published in the press, and without having seen the exhibition. That's not professional. As for myself: I'm professional. I'm doing my work as an artist and I'm taking care of responsibilities. If you don't like my work, you don't have to exhibit it and you don't have to buy my works.

Lindgaard and Colard: With *Swiss-Swiss Democracy* you violently criticize the present political configuration in Switzerland. By exhibiting at the Centre Culturel Suisse in Paris, the institution devoted to the official representation of the Helvetian scene, are you not setting a trap for Swiss authorities?

Hirschhorn: My name is Thomas Hirschhorn, not Machiavelli! I'm the first one to be surprised at these reactions. I didn't make an exhibition criticizing democracy in Switzerland. This is an exhibition that criticizes democracy in general. Michel Ritter, the director of the CCS, invited me to do an exhibition two years ago. Last December, Blocher's party won the elections. I therefore wanted to carry out a citizen's act, to signify that I did not accept this election, a bit in the manner that certain artists did when Jörg Haider's party

entered the Austrian government. During that period, the exhibition curator Robert Fleck had published an article in *Libération*, calling artists to stop exhibiting in Austria. I heeded his call and refused to participate in exhibition opportunities offered to me there. It was therefore logical for me to stake out a position when a comparable event in Switzerland took place. But it's a personal position. I don't want to become an organizer. I'm not a spokesman either. I'm talking for myself. Because it stems from a personal decision that no one can stop me from making.

Lindgaard and Colard: You've stated: "Doing this exhibition is like *tenir un siège*," adopting bellicose vocabulary. Is it so that you can designate a space of combat?

Hirschhorn: I reject the word "bellicose." No one has been hit, attacked; people look, ask questions. There's no combat, no aggression. I'm not saying that I'm at war, but that I'm a warrior. In assemblies, there are empty seats, people aren't going to vote. That's what "tenir un siège" means to me, it's a form of participation. That was the first thing that was important to me here, and that's why I'm present at the exhibition every day. And it's not being present out of principle, but in order to produce something: every day, I make the newspaper, every day the philosopher Marcus Steinweg lectures, and every day Gwenaël Morin performs *William Tell* with his theater troupe.

Lindgaard and Colard: On the poster for the exhibition, one will recognize a photograph taken at the Abu Ghraib prison: an imposing, menacing, and impassive American soldier facing a naked Iraqi prisoner, covered in excrement, his arms outstretched. Below, three Swiss cantonal coats of arms. What connection are you establishing between Abu Ghraib and Switzerland?

Hirschhorn: First, there is indeed a dominated figure, who is the Iraqi, and he is in his country, and an American dominator. I wanted to draw a parallel with William Tell. As you see in Schiller's play staged by Gwenaël Morin, William Tell—the founding myth of Switzerland—becomes a hero in spite of himself by killing the bailiff, who had forced him to shoot an arrow through an apple

placed on his child's head, punishment for not having bowed before the hat, symbol of authority. In Iraq, the dictator was fought, vanquished, and President Bush wanted to establish a democracy. And what do I see? Scenes of torture. So it's possible to torture in a democracy, or in the name of democracy. Those images of torture in Iraq are precisely what allow me to criticize the notion of democracy. People take the connection to Switzerland as a provocation: but I didn't say that Switzerland is a prison where they torture. What interests me is the idea of a connection between the "too much" democracy there is in Switzerland and the lack of democracy there is elsewhere, in Iraq, for example. It doesn't make sense to have democracy in the canton of Thurgovia if there isn't democracy in Asia or everywhere in Africa.

Lindgaard and Colard: You can often be heard saying that an artist can make mistakes, or do something stupid . . . The somewhat naïve idea of thinking that you could transfer some of the "too much" democracy in Switzerland to Iraq: Is that, to you, the something stupid that an artist can sometimes agree to?

Hirschhorn: Oh no, not that. No, the something stupid is formal in character. They're artistic mistakes that I shouldn't tell anyone about, but I see them in the exhibition, and in the end, it's not very interesting. [. . .]

Lindgaard and Colard: In the huge *Swiss-Swiss Democracy* installation, which offers content with its video images, its books, etc., one also wonders about the presence of sentences written everywhere in red letters, like political slogans or tags, which formulate questions about democracy in a simplistic manner. What is the status of these messages, which lend your exhibition a certain naïveté?

Hirschhorn: They are very important because, precisely, they release thinking. They are quotes from politicians, scientists, ethnologists. And I didn't want to give them a hierarchy. Like in bathrooms: sometimes you read bullshit and other times very accurate things. These sentences aren't even always legible; to me, they're a very important door into the exhibition, as are all the other elements, the electric trains, for example; and it's all part of a collage. It's material

I hope people will read! And I also hope they read the other texts, the newspaper articles, the philosophical texts taped up everywhere around the space. It's not about requiring them, and besides it doesn't all have to be read. It's up to them to think; it's not up to me to provide the answer.

Lindgaard and Colard: Democracy is a very old question that continues to be discussed to this day . . . With respect to all these debates, the exhibition inevitably falls within what has been produced intellectually on the subject.

Hirschhorn: That's true. I've been thinking more and more about the idea of a "superficial engagement." I like to stay on the surface. I don't think I'm a superficial person, but I think that in terms of [being] an artist, it's on the surface that it happens. What I want, and this is what a work of art is to me, is the fact of creating conditions of thinking. When I see images of Abu Ghraib, I don't need to be told what happened, I see it; I see the surface of things and I understand everything. And there's no naïveté in that. I only look at those images, and I like it because it stays precisely on the surface, without information. People say: "The prisoner is bloody all over." But no, look, that's shit, the Iraqi prisoner is covered in shit, and where is it from? I remember that in the Irish resistance, people like Bobby Sands covered their cells in shit because that's a human being's last protest. I don't need to be told the story, I don't need information, because I see it all in the image. [. . .]

2004
[Translated from French by Molly Stevens]

BECOMING ONE'S OWN MUSEUM: CONVERSATION BETWEEN THOMAS HIRSCHHORN AND FRANÇOIS PIRON

François Piron: In the very nature of your work there appears to be a sort of resistance to "museification," not only because of the materials you use, but also in the way in which you occupy space, saturating it, and especially because of the activity that you generate from your works. On several occasions, your proposal for a museum has been an interaction with the architecture of the building, preferring at times to occupy spaces that are not actually dedicated to exhibitions, like at the Guggenheim SoHo, where in 1996 you took over the [gift] shop and extended it out into the street. One of the projects that eventually was kept unrealized at the Musée d'Art Moderne in the city of Paris consisted in building a labyrinthine construction that led to one single piece of the museum's collection: one single person looking at a single work of art.[9] This idea of a direct confrontation is a criticism of the museum and the way it acts as a mediator, its construction of meaning intended for a large number of people. The main function of the museum is to preserve works of art, to record them in time. You, on the contrary, your intention is to activate, to establish a movement, to address yourself very directly and in the moment towards the viewer. And instability, as opposed to the durability or stability of the museum, is the form taken by most of your works. In 2004 you even created a work in a public space, in the Parisian suburb of Aubervilliers, called the *Musée Précaire Albinet*, the title of which juxtaposes these a priori contradictory terms: "museum" and "precarious."[10] I would, in the light of all of this, like to ask you about your relationship with museums, and with the museum as an idea.

Thomas Hirschhorn: I love museums. It was in museums that I found—for the very first time—art; it was in museums that I learned to love art; it was in a museum that, also for the very first time, I became truly involved in a work of art. So my criticism would never be about the existence or idea of a museum itself. The notion of the museum goes beyond that of a museum for art: there

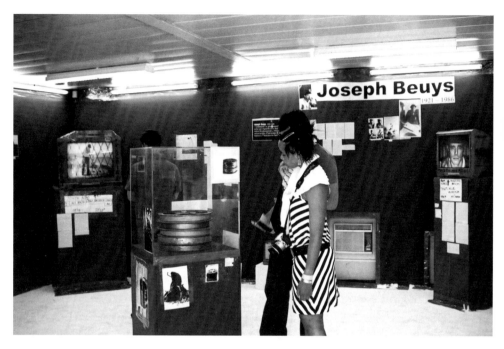

4.2 *Musée Précaire Albinet* (Exhibition, Joseph Beuys week), 2004. Cité Albinet, Aubervilliers, France, 2004. Courtesy the artist and Les Laboratoires d'Aubervilliers, Aubervilliers, France.

are also museums for automobiles and regional history. Just as I termed the *Bataille Monument* or the *Deleuze Monument* "monuments," I named the *Musée Précaire Albinet* "museum." I wanted to offer both a criticism of the existing museum and a proposal for another type of museum. I wanted to create a new genre of museum. With regards to the relationship between these terms "museum" and "precarious," I do not believe them to be contradictory. "Precarious" is a term that is only used in the negative sense these days. I use its literal meaning: anything that has a limited duration, limited by human decisions, not by natural phenomena. That is the difference between "precarious" and "ephemeral": there is no such thing as an ephemeral work; there is precarious work—in other words, the product of a decision, whether it be suffered or accepted. The logic of the ephemeral is death—the logic of the precarious is that it is precious! That is why I wanted to unite "museum" with "precarious." To assert my desire to create a museum with great urgency, out of absolute necessity, with absolute conviction—a decisive yet precarious one. That is how I envisage my idea of a museum. *Musée Précaire Albinet* is a full-fledged museum; this work is not just a construction in a given location, but also a program. The *Musée Précaire Albinet* is a tool. When I wanted to borrow original works of art to be presented there, I submitted my project to the Centre Pompidou as an artist of the *Musée Précaire Albinet*. And within this balance of power, I asserted that I represent a museum, the idea of a museum, just like any other museum, like the MoMA in New York or the Pinakothek in Munich or the Hermitage in St. Petersburg.

A "precarious" museum, for sure, but still a museum, not a cultural entertainment but a real museum. The presence of this museum would be limited in time, it would only exist briefly, but it is a museum with a precarious and universal ambition. That is why I used the term "precarious" in the title of the work, *Musée Précaire Albinet*.

Piron: But what exactly do you want of a museum?

Hirschhorn: My work, the *Musée Précaire Albinet*, is a work of art in the form of a present-day art museum. A museum based on historical fact, but without the

sense of protecting or safeguarding a patrimony, and not merely a reaction to past history. It is an "active" museum which asserts that the works of art have strength, active energy, even today. This museum states that the energy contained in a work of art, in an original masterpiece, that this transforming energy is the reason why this work is actually in the museum. The *Musée Précaire Albinet* aims to prove this. Today's art museums play only a patrimonial role, founded on accumulation of the ideological, cultural, and even economic value of a work of art, without asserting the intrinsic value of the work. For me, it is a question of reasserting what is important for art: that it is an assertion, through an object, an idea, a painting, a sculpture, a video, a film, or any other thing. An assertion has taken form, and that outside the boundaries of time has an effect on who faces it. This form can imply the other—today as yesterday.

My concern is to insist on the assertive relationship between an artwork and a single viewer, in a direct way. Apart from communication, apart from fashion, apart from advertising, and apart from art "in relation to" architecture or design. That is why I insist on the essential, uncompromising confirmation—which is unique, which is magnificent in a work of art. I think that the museums of today lack vision, lack confidence in the art and its sovereignty. If I think about the museums' tiresome efforts in communication and popularization, it seems that there is a great deal of weakness and resignation. What I would like—to answer your question—is that the museum, that all museums be open twenty-four hours a day, every day of the year, and that they be free for everyone.

Piron: You reproach museums for pacifying the relationship between the viewer and the work, domesticating it through mechanisms for inclusion, through genres and typologies which make the artwork understandable, though not active. In short, this is a charge against historicism.

Hirschhorn: I reproach museums—in general—for not producing confrontation. I reproach museums for not believing in the autonomy of art and I reproach museums for not believing in the universality of art. A museum must

place all its bets on the intrinsic force of the works of art to establish a direct confrontation or dialog—one on one—between a person and art. However, there is less and less possibility of direct contact. Everything is designed to establish a distancing: not a physical distancing, but a distancing through history, through communication, through culture. A museum considers viewers as consumers instead of considering each person as sovereign—isolated—yes, someone isolated, the isolated being who can confront and establish a direct dialog with the work of art. Without any preconceptions other than finding himself or herself face to face with the work of art.

Piron: For many people, the tour de force of the *Musée Précaire Albinet* has been the presence of original works by Marcel Duchamp, Kazimir Malevich, Fernand Léger, Piet Mondrian, Le Corbusier, Salvador Dali, Andy Warhol, and Joseph Beuys, in a context and in conditions which a priori are far from those of a conventional museum. Your works, since the 1990s, have often brought such works or artists together, but in the form of images, of postcards, of reduced-scale reproductions. Why has the presence of the originals been of greater importance this time?

Hirschhorn: I have already done several projects which included original works. In Cologne, for the exhibition "*Rolex etc.*, Freundlichs *Aufstieg* und *Skulptur-Sortier-Station*-Dokumentation" at the Ludwig Museum, I moved a work by Otto Freundlich that was part of the museum's collection to include it. I also did this with another work called *Swiss Army Knife* at the Kunsthalle Bern, where there was a painting by the Swiss artist Ferdinand Hodler, and I have also done this in other works. These are the ones I call "integrated" works. The *Musée Précaire Albinet* is different. The *Musée Précaire Albinet* is entirely based on the guideline of "Presence and Production," which are part of my project for art in public spaces today. I never intended to perform what you call a "tour de force," but I understand your question. Why was it important to get the original works? I wanted the *Musée Précaire Albinet* to be a breakthrough. It was necessary to make a real breakthrough for the relationship with the place I had chosen—the Cité Albinet in Aubervilliers, an outer Parisian

suburb. To make a breakthrough in this place, it was important to prove that works of art can be moved, can be geographically and physically in movement, and that a masterpiece can also be moved to the outskirts of a city.

The grand travelling art exhibitions go from one museum to another in the Northern Hemisphere. Where does the magnificent Dada exhibition from the Centre Pompidou travel to? India? Algeria? Colombia? Courbevoie? No! After Paris, the Dada exhibition goes to Washington and New York. It is always the same museums that exchange their exhibitions and works for the very same public.

The fact that I insisted on original works has allowed me to clarify my request to the Centre Pompidou. So that the "loans committee" would ruminate on this question: We lend works to MoMA in New York, we lend works to the national gallery in any large country, yes; but why don't we lend a work to the *Musée Précaire Albinet*—right near here in Aubervilliers? I know that for a work to be on loan certain rules for its security must be followed, but at the same time, I know that the historical, scientific, and artistic interest of the work will also be taken into account. However, the *Musée Précaire Albinet* is showing a real interest. I wanted someone to explain why works were not being lent to less prestigious museums that were complying with the security requirements and which also showed historical, scientific, artistic—and perhaps even political—interest. The "loans committee" at the Centre Pompidou has understood this. It wasn't easy, nor was it ever a sure thing. The museum showed great reticence, though it was never definitive, but time was running out. As for me, I was afraid that the building of the *Musée Précaire Albinet* would be put off due to the delays, or difficulties—that you mention—with the Centre Pompidou lending us the original works. I thought that the inhabitants of the suburb would lose their confidence in me and in my project. Because it is often those inhabitants that we make wait. It is often they who are promised things that don't ever actually happen. I didn't want it to end like that. When I explained to them at a meeting why the Centre Pompidou needed more time to agree to the loan of the works that had been requested and I made it clear that we might have to find an alternative to my initial idea

of having original works of art, they unanimously replied: we will wait, because we want the original works! I was relieved at this determined reaction from the inhabitants, who had clearly understood my project and who were not blaming me for the delay. I was so happy! So, greatly encouraged, I went back to the Centre Pompidou with renewed strength and was able to say to them we really need you to lend us the original works because the people themselves were clamoring for them. It wasn't just me, the crazy artist, who wanted them. It wasn't just the harebrained scheme of an artist. In actual fact, the delay, due to the difficult and lengthy nature of the project, gave added strength to my request, our request for the loan of original works of art from the Centre Pompidou.

Piron: It is easy to imagine the museum barricading itself behind the problem of security.

Hirschhorn: The Laboratoires d'Aubervilliers, the producers of the *Musée Précaire Albinet*, and I took these worries about security very seriously, but I have never been particularly worried about theft or possible damage to the works. Because I knew that the inhabitants had accepted the idea in a very natural and simple way, and that the works could be there with no real danger. The inhabitants attach a different value—not economic—to these works. Even though there were almost daily problems surrounding the *Musée Précaire Albinet*—which were part of the reality of the district—there was never the slightest problem regarding the works, not even the smallest attempt to damage them. It is important and wonderful to be able to say that. Obviously the inhabitants were aware that these were masterpieces, that they were the originals, and that these works were of enormous artistic, historical, and economic value. But it wasn't a question of the specific context of the *Musée Précaire Albinet*, nor of the people involved in the work. Because once in place, the value of the work was measured according to the time taken or given, to the relationship to everyday life, to the relationship to production and the presence that this put forward: the inauguration, the workshops, the debates, the conferences, the excursions, the library, the cafeteria, and the exhibitions each

week. The original work of art was the trigger, the point of departure, for a value other than the historical, scientific, or economic: the value of a discussion, the value of a conversation, the value of a meeting. The value of the event that we created together. The inhabitants and I knew that these events were possible thanks to the presence of the original artworks. That was their value, because they created the conditions for an event and for a coming together.

Piron: Could you tell me about the reasons that led you to choose the artists that have been shown in the *Musée Précaire Albinet*? Is it a personal pantheon? It is perplexing that you have gone back to the great names of the twentieth century, artists so firmly written into history, when your interest has so often lain in more marginal figures, whether they be artists or writers, from Otto Freundlich to Ingeborg Bachmann or Robert Walser.

Hirschhorn: As with my other works in public spaces, those that require the direct involvement of the inhabitants—I am talking about the *Deleuze Monument*, the *Spinoza Monument*, or the *Bataille Monument*—it was a question of including the inhabitants. The right that I grant myself as an artist to involve the inhabitants and establish a dialog with them, is to ask for their help. That doesn't mean asking them, "What do you want? What can I do for you? How can I help you?" It is the opposite. I am an artist, I have a project, I have an idea, I have a mission—but to make this a reality, I need help! Can you—the people who live here—help me make my project a reality? It is I, the artist, who needs help from you, the inhabitants of this area! That is why my work is not social work, but artistic work. The departure point logically comes from me—the artist. So with the *Musée Précaire Albinet* the work stemmed from pieces I love, that I think are important, from works that have changed me. It is imperative that it be I, and I alone, who takes that responsibility. This responsibility is personal, it is what I offer: the choice of works, of artists, is not anything I can justify, it is not based on any historical argument or obvious chronological order, but it is what allows me to speak on equal terms to the inhabitants, because I have given something of myself.

———

366

These are the various reasons that led me to make the decision to want the works of these specific artists in the *Musée Précaire Albinet*: Fernand Léger's commitment, but also his fascination with industrialization; Andy Warhol, who is totally in keeping with his times, with the consumer society. The way he works, his popularity may also be associated with Joseph Beuys and his assertion that each human being is an artist.

Piron: Duchamp, for example, seems to me to be somewhat removed from these questions; here is an artist that is not really in agreement with the society that surrounds him, nor particularly fascinated, nor especially productive . . .

Hirschhorn: Marcel Duchamp is an extremely important artist for me. I love his work. He redefined art, he defined a new way of being the creator of a work, he invented a new term for art. This is an artist with an amazing body of work. He is not—as is so often claimed—lacking productivity. On the contrary, he made a plan with a great many very effective possibilities for creating art. Duchamp has been reduced far too quickly by a certain theory, by the role that he has been assigned to play in the history of art. Marcel Duchamp is simply a brilliant artist who produced a large number of deeply moving works of art! He never repeated himself, he created truly new works.

Piron: Your subjectivity allows you, then, to create ties and associations between artists who are often used by historians to delineate separations, not to span ideological borders. It is often necessary to make a choice between Duchamp and Mondrian, or between Beuys and Warhol . . .

Hirschhorn: When one is an artist, one must confront—with one's work—the work of other artists, of all artists, all of their work. When I was a student, there was an art history professor at my school who spoke passionately to us about the work of Palladio and, with the same passion, about the work of Malevich. I know I must confront theory with practice at all times, in all places, but creating neither theory nor practice. Making art is giving form and asserting that form. The works of different artists—whom I admire—consist in asserting a form, giving form, creating a truth as Piet Mondrian did. When I

see a work by Mondrian, this is very clear to me: His work cannot be argued or discussed, his work is form. It is the absence of justification and argument that allows me to establish a dialog—or a confrontation—with the work, and that is what I wanted to share with the *Musée Précaire Albinet*.

All art is resistance. It is not resistance to anything, it is resistance itself. So it is logical that people are continually shocked or provoked. The provocation is not of very much interest to me in itself, but because I know that a work by Marcel Duchamp or by Piet Mondrian is a resistance, it is the price to be paid—even today. We need to make the effort to establish a dialog with a work of art. We need to be ready to confront resistance itself in a work of art. Because the great works retain all their energy, all their autonomy, and all their force for transformation. The works on show in the *Musée Précaire Albinet* encourage me, I am inspired by their absolutes, by the possibilities that I feel within them, that I grasp in their beauty, their clarity, their will, and their determination. My position with regard to the works of the artists on show at the *Musée Précaire Albinet* is that of a fan. I am a fan of Beuys, Warhol, Malevich, Léger, Dali, Mondrian, Duchamp, and Le Corbusier. I love the term "fan," because it is a position that is beyond the reaches of a judgment of value. A fan is someone who loves absolutely, without having to communicate or justify this. The important thing is the transformation that one experiences from being a fan. If I manage to create a work that, thanks to the love, to the commitment that I pour into it and the energy that this requires of me, makes sense, I would have attained one of the aims of art. That is why it is important to be linked to the artists that one loves and why it is necessary not to be separated from the things one loves. That is why I am, and remain, a fan. You have to understand that art is always, at a given moment, uncontrollable. At certain moments in my work in general, and also with the *Musée Précaire Albinet*, I think I know how things should be done. But at the same time I also know that I shouldn't try to control everything and I can't want to dominate everything. On the contrary, it is necessary to trust the uncontrollable. But to be destabilized like this, you need to be brave, and you need to believe in art.

Piron: We eventually come back to the question of the museum, which has given itself the mission to control and conserve: What do you think should become of your work once it gets into a museum, once it has been acquired and conserved? Do you protect yourself against this?

Hirschhorn: I do not work so that my art—as you say—gets into a museum. What I want is to work, to carry out my work as an artist, to assert and defend it, but above all to do it. I want to confront the museum, as I would any other context that I must confront in my line of work. It is clear that the museum is not an ideal place for art—but public spaces, galleries, collectors' homes, and other spaces dedicated to art are not ideal places for art either. Art does not need an ideal location to exist and it can shine wherever it is. This is what the *Musée Précaire Albinet* has proven.

2006 (edited and published Summer 2009)
[Translated from French by Nexus]

4.3 *The Bijlmer Spinoza-Festival* (Lectures/Seminars: Toni Negri), 2009. "Streets of Sculptures," Amsterdam, The Netherlands, 2009. (Photo: Vittoria Martini.)

CONVERSATION: PRESUPPOSITION OF THE EQUALITY OF INTELLIGENCES AND LOVE OF THE INFINITUDE OF THOUGHT: AN ELECTRONIC CONVERSATION BETWEEN THOMAS HIRSCHHORN AND JACQUES RANCIÈRE

Thomas Hirschhorn: I am happy to have the opportunity to write you. I'd like to suggest that I begin our exchange by sharing with you some experiences I had during *The Bijlmer Spinoza-Festival*, my latest work in public space, conceived for and with the inhabitants of a suburban neighborhood of Amsterdam in 2009. I thought that sharing an experience, an experience I had thanks to my work, would be a good starting point. *The Bijlmer Spinoza-Festival* is a work of art conceived according to the "Presence and Production" guideline: my presence and my production as an artist, but also that of Vittoria Martini, as an ambassador, that of Marcus Steinweg, as a philosopher, and that of Alexandre Costanzo, as an editor. "Presence and Production" is my own term, a guideline I created to define those of my works that require my presence and my production during the entire duration of an exhibition. With "Presence and Production," I want to propose notions of my own because I can assess what is involved and necessary to achieve "Presence" and "Production." I understand what it requires of me. However, I do not know what "community art," "participatory art," "educational art," or "relational aesthetics art" mean. With the "Presence and Production" guideline, my aim is to answer the questions: Can a work—through the notion of "Presence," my own presence—create for others the conditions for being present? And can my work—through the notion of "Production"—create the conditions for other productions to be established?

Over the three months of *The Bijlmer Spinoza-Festival*, I noticed something new, unexpected, and surprising to me: the first local inhabitants to come were inhabitants of the margins, at the margins of the neighborhood, and undoubtedly of society itself. From the very beginning, these inhabitants visited my work regularly; soon they came daily. Of all the visitors, they were the ones who stayed the longest. Being the first from the neighborhood, they really got involved, yet all were people on the margins. Over time, they

formed a kind of "hard core" of *The Bijlmer Spinoza-Festival*. Most of these people were isolated and did not know each other before the festival—or if so, barely. Many lived alone, had family issues, were unemployed, or had problems with work. Some people were disabled, or had an awful lot of problems. Their presence—which was lively and often funny—made me happy at once. I was simply happy because there was "Presence." These first inhabitants to confront my work were not the fathers and mothers, employees, workers, or members of associations, the people who are generally "active." On the contrary, they were the people who are generally "inactive." I had hoped for and worked at having a few people of the Bijlmer neighborhood share their time with me, but I really had not anticipated that it would be these inhabitants!

With time, I understood why they were the first ones—the pioneers—to get involved with and in my work. They all had this thing: free time, "too much time," and time to kill. I was moved by this—for I became aware that my "Presence and Production" guideline had provoked something and that from then on we would share this thing: time passing. These first inhabitants had time, lots of free time to encounter my work. And I, present all day throughout the exhibition, had time to encounter them. I asked myself: Isn't it because I too am on the margins? Don't I have to be, as an artist? Isn't it that I should never stop being on the margins?

Being on the margins is what we had in common, what we could share, and also understand—understand thanks to art. I felt something close to equality between these inhabitants with too much time and me with my precarious project. The fact that we were present on site was the thing to be shared, it was our "common good." With its "Presence and Production" guideline, *The Bijlmer Spinoza-Festival* offered a focus point. It was a powerful experience for me that those who do not have moments and spaces to enjoy in their daily lives were the first to take hold of it. Did *The Bijlmer Spinoza-Festival*, through the presence of the work itself, as well as that of all the participants (including me), create a space, a time, and a moment of public space? A new space in which "excess time" could crystallize and take a form?

The "Presence and Production" guideline allowed me to understand the relationship to the margins as a common good constituting an exchange. Could this connection with the margins and the precarious opening that results be the key to encountering the other? Is this precarious relationship dense enough to create a real event?

The notion of "Presence and Production," which I intended as a challenge, a "warlike" affirmation, but also as a gift—an offensive and even aggressive gift—has taken on a new meaning for me, one that has attained a different and specific power. I realized I had experienced something meaningful to me; and isn't that the experience of art?

Jacques Rancière: Sadly, I wasn't able to participate in the experience of *The Bijlmer Spinoza-Festival*. I am sorry for that. I will therefore try to answer based on what you tell me, on what I know of your previous work, and on my own concerns. The first thing I hear in "Presence and Production" is the sign of equality represented by "and"—equality between two modes of presence that are commonly opposed: the presence of the work of art as a result of the artist's work, offered to viewers, and the presence of the artist as bearer or initiator of an action. Relational art has claimed to substitute the creation of relationships implying an interaction for the presence of the work of art before the viewer. Activist art claimed to demystify the myth of the artist by advocating an art that has become action. For my part, I've always argued that under the guise of demystification, these strategies merely radicalized the traditional figure of the artist by enabling him to avoid the task of relinquishing a product of his work, of separating it from his relationship to himself, to give it over to the examination but also to the temporality of others. There is no art without a production which we give the viewer the means to approach and appropriate within a temporality other than the artist's. "Presence and Production" would then mean two things at once: that the artist exposes himself to being objectified as a producer whose productions are judged by all, but also that the artist is there, not being the work of art himself, but answering for what he has done and answering to those who react to his apparatus by adopting their time.

373

This means, I think, that the artist's presence is not that of an entertainer. This point probably needs to be clarified. If I understand correctly, this festival had in common with events you've organized in the past under other names ("monument," "precarious museum," "24 hours") the joining of a work of visual art with a series of activities ranging from philosophy conferences and open reading areas to theater and creative activities for local children. How exactly would you define the difference between this apparatus and those for debates, publications, workshops, and various activities put in place by biennales and other events of the same type or even simply by museums for exhibitions? Is it the very fact that in your case there is not the usual separation between artistic production and a series of actions intended to make its meaning resonate or to create media impact among the general public? Is that also what "Presence" means, given that what you do is something other than creating a public venue or organizing interactions?

The first element of an answer to this question of presence comes in terms of time: the equality "Presence and Production" would also be a sign of equality placed between heterogeneous times. This has no direct relationship, but I'm reminded of what Pedro Costa says about his work as a filmmaker, shooting *In Vanda's Room* over two years, going every day, the way you'd go to the office, to see these "margin-dwellers" whose time is more than fluctuant.[11] Many artists and various types of activists want to make people "active" by identifying activity with mobility. They want to make them move off the seat they're sitting on, force them to talk when they feel like watching, listening, or keeping quiet. This view of the meaning of "activity" is far too simple. Let's not forget that those we once referred to as "active citizens" and "men of leisure" were one and the same, while "passive" citizens were those whose time was occupied by manual activities. Privilege can be expressed by opposite qualities—activity or idleness—but its core is the disposal of time. The artist's approach to equality is thus the ability to adapt his time to the time of those who do not "possess" time, those whose fate is always to have too much or not enough time.

"Too much" or "not enough" time determines the politics of art. In the past, when we worked to bring art closer to the people, we wanted to bring it closer to those whose work did not leave them enough time: not enough time to live within art, not enough time to travel far enough to get to know it. This entailed a certain economy to concentrate the art-effect. With the Bijlmer experience, you point out an opposite phenomenon: those who were involved in the experience are those who have too much time, those whose time is not taken up by work. Should we call them "margin-dwellers" and imagine a community between the artist and them as a shared position on the margins? I don't like this notion much, both because it threatens to raise certain stereotypes of the artist and to simplify the relationship of the work to its absence, of occupied time with idle time. The general phenomenon revealed by these kinds of experiences is the presence of powerful investments for knowledge, thought, art, and any experience of this type in places where they aren't expected, among individuals whose business they aren't supposed to be. It has often been noted that the presence of time made available by force helps: prison provides more time to think and learn than the factory or the office; being in psychiatric institutions has provided a certain number of people with the time to explore their dramatic possibilities, etc. But more generally, it is the porosity of the dividing line, the fact of circulating between occupied time and idle time that defines a type of experience that was largely present in yesterday's proletarian world but has been made more perceptible by all the current forms of precariousness and intermittence. The "presence" of the artist accompanying his "production" would therefore be a manner of adopting this fluctuating temporality by confronting both his own work with other experiences of work and his available time with other available times. Making different times equal is, in fact, the condition for a public space—that is to say, a space affirming anybody's ability to see, produce, and think—to be created. The political power of art, rather than being in teaching, demonstrating, provoking, or mobilizing, is in its ability to create public spaces thus conceived.

Hirschhorn: Thank you very much for your answer, which raises four points to which I'd like to respond: the question of the artist as an entertainer, the difference between my work and a cultural event, the question of "participatory art" in general, and finally the question concerning the marginal position and stereotype of the artist.

Yes, the artist's presence cannot be that of an entertainer. The artist is not present because he is the artist (the creator of the work)—he is present because the most important thing is to be present. And he is present because he is responsible for everything, He is the concierge and the usher, the cleaning staff, the guarantor of his work: He is there to settle everything, to resolve everything. The artist is responsible for everything and even for what he cannot control or predict: this is why he must be present. I must be responsible for that for which I am not responsible. This is the noble task of my work and the significance of my presence. The artist is present to give his time, the artist shares his time, the artist is present because there is nothing more important to do elsewhere. I was present beside my work for over three months in the Bijlmer neighborhood, night and day, because this was where the important thing for me was taking place; there was nothing more important to do anywhere else. That is the commitment and the meaning of my presence. Presence is also an act of solitude, for I must be able to be alone, due to the complexity of my project, its irreducibility, its placement, its exaggeration, and what it might become. It is only by being alone that I can really be present and not make "just another project." Personally, I don't think in these terms—I couldn't—for a project like *The Bijlmer Spinoza-Festival* requires such a commitment, such open-mindedness, strength, and energy, that it would never have come to fruition if I had considered it "just another project."

The difference between a cultural event and *The Bijlmer Spinoza-Festival* is not about production, the thing produced, whether it is a reading, a seminar, or a workshop. The fundamental difference is the autonomy of the work affirmed and the audience it addresses. I'm interested in this exactness: the simultaneous affirmation of the autonomy and the universality of the work and the "non-exclusive" audience for which the production of the work is

intended. It is not a production specifically adapted to a different audience, it is a production for a "non-exclusive audience." According to me, this means that the production must be able to address an uninterested audience. The production is not trying to satisfy a demand, it is not trying to target "its" audience, and it is not trying to be a success in terms of the size or specificity of the audience. The production—without making any concessions—remains an affirmation and something autonomous. Insisting upon that is what makes the difference. The more I insist upon it, the more exact it is. For, it must also be possible to make this production without an audience, which was the case on some days during *The Bijlmer Spinoza-Festival* when nobody was there! This is possible because the production is based on love. The work is done with the inhabitants in a gesture of love. Therefore, this gesture doesn't necessarily call for an answer—since it comes from me; it's both utopian and concrete. I want to create a new form, based on love for a "non-exclusive audience." And the form itself is the difference and the act that distinguishes it from a cultural event. My love for Spinoza is the love of philosophy, of things I don't understand, the love of the infinitude of thought. It is a question of sharing this, affirming it, defending it, and giving it form.

I agree with you that it is not a question of getting people "moving." I have never used the term "participatory art" in referring to my work—that is a meaningless term, because someone looking at an Ingres painting, for instance, is participating. He can participate without anyone noticing. Similarly, I never used the terms "educational art" and "community art." And my work has never had anything to do with "relational aesthetics." Nor have I read the book about it. If certain superficial critics put me in this category of "relational aesthetics," it is simply an inaccurate representation of what I do. Not a single one of my works in public space has been a project of "relational aesthetics" for the simple reason that I want to create a relationship with the other only if that other has no specific relationship with aesthetics. This is—and has always been—my guideline: to create a form that involves the other, the unexpected, the uninterested, those who don't see the point, a form that involves a neighbor, a stranger, an alien. I have always wanted to work for this "non-exclusive"

audience; it is one of my most important goals. To address a "non-exclusive" audience means to face reality, failure, the unsuccessful, the cruelty of disinterest, and the incommensurability of a complex situation. But it also includes those who love art, the specialists, and those for whom art is important. My work includes them as part of that "non-exclusive" audience without specifically targeting them. I know that as an artist I am always suspected (of doing "relational aesthetics," for instance). That's fine with me—I'm not complaining—for I must be the "usual suspect," but that is precisely why the truly "suspect" must be clarified. What is "suspect" is to remain sovereign in my role as the "usual suspect." This is why I try to define my work with my own notions, like "Presence and Production" and "non-exclusive audience." I am conscious that these notions are not perfect, ideal, or even accurate, but how can you accurately define an artwork in a single word? These notions are not concepts, they are tools I invented for myself and that I built myself.

The notion "marginal" is not accurate or exact either, I admit, and its use can be stereotypical and also sterile. Therefore, I don't want to exploit it, manipulate it, or make it political. I want to be more precise and clearer. I hadn't found an appropriate term to explain my experience at *The Bijlmer Spinoza-Festival* to you, and it's true that we need to look more closely at this question and position regarding the margin. Moved by the experience I was having, I tried to name something that I was thinking and grasping, and which I agreed with. But the difficulty for me is to give a name to such an experience—if it is a real experience, something new—to understand it and speak of this new thing. This thing was coexistence. I want to be more rigorous in describing my experience—as rigorous as I hope my work is.

The difficulty is that as an artist, I must refuse to analyze my work before completing it and experiencing it. This is where the problem lies—and I'm not trying to avoid it—but you must understand that the artist must first do the work before analyzing it. This has always been my guideline: Do first, analyze after. I call it acting in "headlessness." I'm conscious that with *The Bijlmer Spinoza-Festival* or other projects, acting in "headlessness" can be interpreted as a lack of rigor, but I think that is the price to pay for doing the work

in "headlessness." This is also why I believe my work deserves to be discussed in a critical manner, at a level that would engage, for once, the paradoxical and problematic dimension of these questions. For I, who am neither theorist nor "practitioner," must go beyond argumentation in order to be able to give form, a form that comes from me and only from me. I want to make my work in "low control." Acting in "low control" means to refuse to control, it means to put myself at a level of "low control" like someone on the ground, exhausted, overwhelmed, totally out of his depth yet not resigned, not reconciled, and not cynical.

Rancière: Since we have limited space, I won't ask you any new questions, which would remain unanswered. I just want to point out what strikes me in your answer, in order to open the way to other reflections. First of all, the term "responsibility." It seems to me that this term was already at the heart of the experience of the *Musée Précaire Albinet*. The *Musée* was placed under the responsibility—also day and night—of neighborhood youth, who had to fill every function, both practical and intellectual, required by a museum. This amounted to scrambling the usual relationship between activity and passivity, which is always conceived as the reversal of symmetrical positions. And perhaps we have here a more interesting interpretation of "everyone is an artist" than that which puts a paintbrush in the viewer's hand or tries to bring the spectator on stage. Sharing, that is to say re-sharing, touching upon the normal distribution of spaces and times is something other than reversing. And, of course, the artist isn't a good soul, he is first someone who produces, and this production does not allow itself to be dissolved in the simple creation of a relationship with others. I am struck by the fact that you insist so strongly on both the autonomy of production and the taking into account of an other who goes beyond any system prepared to receive him. It strikes me because it also leads me to think about my own presuppositions. I have always adhered to Flaubert's requirement that the author withdraw from his work. Where it was customary to denounce an omniscient position and an aristocratic negation of the other, I always saw, on the contrary, the condition for an emancipation of

the reader and the spectator, to whom the author abandons his work, by giving him the freedom and the responsibility to appropriate in his own way a work that no longer belongs to the one who made it. "Absence" then seemed the appropriate complement to "production." Your watchword calls this pattern into question. It links production with the risk of the presence that verifies the effects while these have never been the object of any calculation. It links production and presence beyond the usual figures of generosity who exile themselves from art venues to reach the "non-audience" or beyond a sacrificial exposure to the cruelty of the one to whom we come, powerless. It may seem contradictory to create a form that involves an other while affirming one's own production, without concession, without the need for a response. The answer might be that the two terms imply the presence of a third party that includes both of them and takes them beyond themselves. A *Spinoza-Festival*, a *Deleuze Monument*, *Twenty-Four Hours for Foucault*: this means bringing into a contained time and space a power of thought, a power of community in which both the artist's absolutely determined, absolutely autonomous proposition and the unpredictable participation of a "non-exclusive audience," an audience without specificity, can be included. The autonomous and the non-exclusive then both appear as two forms of universality that are linked not in the dual relationship of the encounter but because the proposition itself is already permeated by this power of universality and otherness that I call "presupposition of the equality of intelligences" and which you refer to as the "love of the infinitude of thought."

December 2009–February 2010
[Translated from French by Nicholas Elliot]

FRANÇOIS PIRON: INTERVIEW WITH THOMAS HIRSCHHORN

François Piron: In the exhibition "Habiter poétiquement le monde" we are presenting your work *Berliner Wasserfall mit Robert Walser Tränen*, which dates from 1995, a period when you began to realize works that occupy large spaces.[12] Two sentences in the text that you wrote for this piece at the time[13] resonate in particular for this exhibition. Evoking the ballpoint pen scrawls that partially cover your collages on cardboard, you say they are "tries," for "trying out the world." And talking about the plastic in which these collages are wrapped, you insist that it stems from the will to protect and to underline the existence of these presumably negligible objects. These two aspects define an ambivalence in the relationship of a work of art to its environment, to the world that surrounds it and in which it arises: at once an attempt at communication, a try, even if it is still undefined; and at the same time a protection, a shield. This double movement seems straight out of the work of Robert Walser, to whom the piece is dedicated. What relationship do you maintain with this writing, and with Walser as a figure?

Thomas Hirschhorn: I am a fan of Robert Walser; I love him. I love his life and his work. That's why I made my work *Berliner Wasserfall mit Robert Walser Tränen* as a homage to his two visits to Berlin in 1907 and 1912. For Robert Walser, art—poetry—is a tool. That's what I was able to learn from him and to use in my work: using art as a tool. A tool for entering into contact with reality, a tool for living fully in the times in which I live, and a tool for meeting the world around me. Robert Walser did it with his writing; he is the writer of gaiety and rebellion at the same time. He is a very major figure and the greatest Swiss writer. His books describe, pierce through, and embody, above all else, that thing that is "the Swiss being." *The Tanners* was the first book that I read, and I understood immediately that I too was part of the Tanner family. His novel *The Helper* is a story of existential uncertainty and distress. Robert Walser is himself consciously astray. He wrote the phrase, so simple and so surprising: "Wenn Schwache sich für stark halten!" (When the

weak take themselves for the strong.) How can one, as an artist, not like a writer who writes things like that? In his writing he gives form to an incredibly powerful force of spirit. This force of spirit affects only those who love Robert Walser. His force of spirit affects me—with a possessive, exclusive, and selfish love. Only the very great are able to be loved in such a way, to the point that I can state: I'm the only one that has really understood Robert Walser!

Piron: That "Swiss being" that you talk about also makes me think about your relationship to *art brut*, which was, I think, important in your development. It's certainly a generalization, but art brut often saturates the space it occupies, whether it's the space of the page, the painting, or the room, the home; it is often the result of a production in continuous flux, cursive writing, or it is generated by a series of impulses . . . Another reason is also perhaps that the brut artist does not have a space of his own, and constructs his work especially to make space for himself or to appropriate it: [Adolf] Wölfli[14] constructs his entire oeuvre around the idea of a conquest of space, which one can literally see in the thousands of pages he filled.

This saturation often contradicts the measures that modern and contemporary art imposes vis-à-vis its own space, in tending toward reduction, toward the channeling of the gaze toward the art object, in a tamed and dedicated space that is the white cube. You confront this tradition with a movement that is also about occupation, saturation, impulsive urgency, and, consequently, it incorporates the spectator into the work; he is physically connected to it. Did looking at art brut play a role in your development, in your conception of art? In particular, I'm thinking about the need to produce . . .

Hirschhorn: I don't use the term "art brut." There's only art, the big art, the art that is universal. Adolf Wölfli or August Walla,[15] to give another example, created a term of art, a new notion of art, that the classification as art brut would like to oblige us to not take seriously. Perhaps it is so they are better neutralized? What we can understand and admire in the art of Adolf Wölfli or August Walla is their "existential incarnation," their power of production, their pleasure of producing, and their need to produce. These artists didn't let

themselves be backed into a corner or be put on the defensive by critics, by theories, by opinions, and by an evaluation of their work. They understood that the problem is never "being an artist"; the problem is always making art! Their work is autonomous because art is autonomous and the work of art is created in absolute autonomy. But I agree with you, the work of Wölfli is not only the occupation or the saturation of a space, it is an immense and joyous enterprise of seeking form. In any case, that's what I take from it personally— I, who knows the problem of form is the essential problem in art. In my work nothing is impulsive or obsessive, everything is decided, everything is wanted, everything is political: the occupation of the space, the saturation of the place, the charge of the information. My line of conduct is "Less is less, more is more!" and the strategy is to do too much until things stop lying.

Piron: The question of the occupation of space is not a question of lyricism or of authority, if you think about *Microscripts*[16] by Robert Walser, who fills the free space of pieces of paper that are already printed with or occupied by writing. Walser never covers what has already been printed, but slips in his poems in the available interstices. This practice, which Walser hardly ever described, he called the "territory of the pencil" [*das Bleistiftgebiet*, in the original German; also translated as "pencil zone"] where the apparent withdrawal is also the condition of freedom, and where modesty and poverty are sublimated states, transformed in writing that is a dance, a game, a joyous wandering.

Can we make an analogy with the way in which your work articulates the weakness and power of affirmation, precariousness, and resistance?

Hirschhorn: Making something big or making a lot is not a question of grandiloquence, I agree; it's a question of form. In making something bigger, I give it an importance; it is an engagement; at the same time, I distance it from its content. I empty it of its usual content; I therefore create a new meaning. However, is it not the mission of the artist to create new territories and, quite simply, a new world through his work? Does not Robert Walser's "territory of the pencil" signify the will to create a new space, both physical and mental, a space of resistance? Because I know that art, as art, is resistance—not resistance

against something, but resistance itself. To give form, you have to have the courage to affirm, and consequently the term "affirmation" is to be understood as a positive term and as an emancipation. I am for the weak; I want to defend and do everything I can to help the weak, but I am against weakness and against the culture of weakness. I want to make a powerful work, but I want to make it with unintimidating materials, materials without additional value, and precarious materials. I affirm the notion of the "precarious." "Precarious" means "ce qui vient." The notion of the "precarious" interests me as something fragile but free. The "precarious" is political; its logic is survival and life. The ephemeral is only biological, its logic is death. The "precarious" allows me to be attentive, it forces me to stay awake and not fall asleep.

Piron: You are particularly virulent with regard to the way in which museums generate segregations between different modes or conditions of art production, how they frame works in devices of communication and explanation. In a text that you devoted to the Musée de l'art brut in Lausanne,[17] you criticized in particular what you perceived to be the refusal to confer on these productions the status of art and on their makers the title of artist. Historically, this collection, brought together by Jean Dubuffet, also constitutes a resistance to a modernist art history, to the manner in which it is written in museums and in which it also operates in a segregated manner. According to you, is there a need to requalify art and the aesthetic gesture through other tools?

Hirschhorn: I have a mission to accomplish and this mission takes up all my energy, all my time, and all my attention. I know, as all artists know, that I am responsible for what I cannot be considered responsible for, what is beyond my own responsibility. That's the grace in art, and that grace was something I didn't see at the Musée de l'art brut in Lausanne because the artists and their works are presented in a neutralized and deresponsibilizing way for the viewer, as if the artists were not responsible for their works. However, each work creates its own responsibility—that's why we call it "work"! No artist—no genuine artist—allows himself to be neutralized, and no work of art lets itself be neutralized. As for me, I don't want to requalify art and it is not my role as an

artist to qualify my work or the work of other artists; my problem is making art. I don't want to simultaneously analyze my work and make it. What I do want, however, and what my ambition is, is to create through my work a new term of art; what I want is to propose with my work the condition for the implication of a "non-exclusive public"; and what I want is to succeed through my work in constructing a critical corpus.

2010
[Translated from French by Molly Stevens]

NOTES

PREFACE

1. The elements of the work are too many to name here, but they include the juxtaposition of living and synthetic plants, the mirroring (and therefore rendering legible) of printed matter that has itself been reversed, and the gathering and preserving of torn photographs in plastic sleeves.

2. "Letter to Véronique (On Writing, Judging, Reading, Publishing)," reproduced in this volume. All citations to texts by Hirschhorn are reproduced in this volume unless noted otherwise.

3. The "Presence and Production" projects include the *Bataille Monument*, the *Musée Précaire Albinet*, *24h Foucault*, and the *Bijlmer Spinoza-Festival*. For Hirschhorn's open letters, see "Letter to the Residents of the Friedrich Wöhler Housing Complex (Regarding the *Bataille Monument*)," "Letter to Lothar Kannenberg (Regarding the *Bataille Monument*)," "The Matter of Location (Regarding the *Deleuze Monument*)," and "Regarding *Théâtre Précaire* and *Théâtre Précaire 2*."

4. See "Letter to Elizabeth (Inventing My Own Terms)" and "Letter to Véronique (On Writing, Judging, Reading, Publishing)."

5. We have indicated at the end of each text the language of composition and the name of the translator, if known. The translations by Molly Stevens and Kenneth Kronenberg were commissioned for this volume.

6. The texts included in this volume were penned in German, French, or English. German is Hirschhorn's native tongue and French the language of his adopted country since he emigrated to Paris in 1983.

7. The epistolary form appears in all three sections. (An e-mail correspondence between Jacques Rancière and Hirschhorn is included with the interviews.) Whether we grouped a given letter in the Statements or the Projects category depended upon whether it was closely tied to a particular work or addressed broader themes.

8. I refer to concepts in "*Jumbo Spoons*," "*Power Tools*," and "Letter to Frédéric (Regarding "Concretion")," respectively.

9. In one way or another, the following engage the question of democracy, the democratic process, and democratic governments: "*Fifty-Fifty*," "*Swiss-Swiss Democracy*," "Regarding *Hotel Democracy* and *U-Lounge*," "Letter to Bice (Regarding *Wirtschaftslandschaft Davos*)," "I Will No Longer Exhibit in Switzerland," and "I Will Exhibit in My Homeland Again."

10. Consider "'Monuments,'" "Why 'Where Do I Stand?' and Why 'What Do I Want?,'" and "Letter to Elizabeth (Inventing My Own Terms)."

11. See, for example, "*Less Is Less, More Is More*," "Why Is It Important—Today—to Show and Look at Images of Destroyed Human Bodies?" "*Doppelgarage* Project," "*Superficial Engagement*," and "*Ur-Collage*."

12. See, for example, "*Lascaux III*," "My Videos," "'Altars,'" and "Letter to Alison (Regarding *Skulptur-Sortier-Station*)."

13. See, for example, "'Direct Sculptures,'" "'Altars,'" "*Les plaintifs, les bêtes, les politiques*," "Letter to Matthias (Regarding *Virus-Ausstellung*)," and "*The Procession*."

14. Originally published as an edition by the Schweizerische Graphische Gesellschaft in 1998, of which few extant copies can be located.

15. These same means are evident in the series of collages *Les plaintifs, les bêtes, les politiques* (1993), for instance, which was also distributed in the form of a catalog without any additional textual apparatus (Centre Genevois de Gravure Contemporaine, 1995).

STATEMENTS AND LETTERS

1. The Boulevard Périphérique is the fast circular expressway around the city of Paris. It is commonly considered the boundary between the city and its inner suburbs.

2. Künstlerhaus Bethanien, Berlin, offers artist residencies and exhibition spaces.

3. Coraly Suard, documentary filmmaker and producer.

4. This text was written in the context of the Joseph Beuys exhibition that traveled to the Centre Georges Pompidou, June 30 to October 3, 1994.

5. Thierry de Duve, art historian.

6. Konstantin Adamopoulos, critic and curator. Hirschhorn exhibited *Buffet* (1995) at Dorothea Strauss and Konstantin Adamopoulos, Frankfurt am Main.

7. Pascale Cassagnau, art critic.

8. The *Gramsci Monument* will take place July 1 to September 15, 2013, in one of New York City's boroughs.

9. Véronique Bachetta, director of the Centre Genevois de Gravure Contemporaine (now the Centre d'Édition Contemporaine) which exhibited and published *Les plaintifs, les bêtes, les politiques*. The exhibition ran from November 30, 1995–January 27, 1996.

10. The poet Manuel Joseph has contributed "integrated texts" for Hirschhorn's works. "Exhibiting Poetry Today: Manuel Joseph" (May 11–September 26, 2010, CNEAI, Chatou, France) was Hirschhorn's homage to the poet's work.

11. Jean-Charles Masséra, writer and art critic, contributed forty "integrated texts" for the work *Archaeology of Engagement*, exhibited at the Museu d'Art Contemporani de Barcelona in 2001.

12. The philosopher Marcus Steinweg has contributed "integrated texts" for Hirschhorn's works and has played an integral role in some of the artist's "Presence and Production" projects (e.g., *24h Foucault*, *Swiss-Swiss Democracy*, and *The Bijlmer Spinoza-Festival*).

13. Laurence Bossé and Hans-Ulrich Obrist, curators at ARC/Musée d'Art Moderne de la Ville de Paris.

14. ARC (Animation/Research/Confrontation) is a research and exhibition area dedicated to contemporary art within the Musée d'Art Moderne de la Ville de Paris.

15. Hirschhorn initially proposed a project to be entitled "Conduit" when he was invited by Bossé and Obrist to take part in the exhibition "Voilà: Le monde dans la tête" (June 7–October 29, 2000). The project called for a conduit to be built that led directly from the street to a specific artwork inside the Musée d'Art Moderne. Access would be limited to this single work, and admission would be free. The project was refused due to security concerns.

16. The far-right Swiss People's Party (Schweizerische Volkspartei) won the highest share of votes in the federal elections of October 19, 2003, thereby altering the makeup of the Federal Council, which had maintained a balance of power among the four political parties since 1959. The Swiss People's Party ran on a populist, anti-immigration platform.

17. Christoph Blocher, billionaire industrialist and key figure in the Swiss People's Party. Many credit Blocher's nationalist and anti-immigrant rhetoric for the rise of the party. Blocher was nominated for the seat in the Federal Council gained as a result of the 2003 elections.

18. Jörg Haider (1950–2008) was a leader of the far-right Freedom Party of Austria, which won 27 percent of the national vote in the Austrian parliamentary elections of 1999.

19. Jean-Marie Le Pen, French politician, founded the right-wing National Front in 1972 and served as its leader until 2011. The party platform was staunchly anti-immigration and anti–European Union.

20. Robert Fleck, Austrian curator and current director of Bundeskunsthalle, Bonn.

21. This letter pertains to the exhibition of *Doppelgarage*, *North Pole*, *South Pole*, *Not in My Name*, and *Les Quartet Livres* at the Pinakothek der Moderne, Munich (March 3–July 3, 2005). The addressees were visitors to Hirschhorn's exhibition who wrote to him (via the museum) to offer suggestions for reinstallation. In their e-mail, Wallner, Pangratz, and Jung assert that the room containing *North Pole*, *South Pole*, *Not in My Name*, and *Les Quartet Livres* is overcrowded with works and therefore not conducive to viewing. They propose that *North Pole*, *South Pole*, and *Not in My Name* should occupy the entire space.

22. In this statement, Hirschhorn announces the end of his decision to boycott exhibitions in Switzerland. (See "I Will No Longer Exhibit in Switzerland.") Initiated in response to the election of Christoph Blocher to the Swiss Federal Council in October 2003, Hirschhorn's boycott ended when the Federal Assembly chose not to re-elect Blocher to the Federal Council during the December 12, 2007, elections.

23. In the original version of the diagram and in earlier written and spoken statements, Hirschhorn's term was "Specter of Evaluation." In consultation with the artist, we have opted to use "Spectrum of Evaluation" because the idea of a range of evaluative positions is primary in Hirschhorn's conception, whereas the connotation of an apparition or a threat is secondary.

24. Nancy Specter, deputy director and chief curator of the Solomon R. Guggenheim Museum.

25. Richard Armstrong, director of the Solomon R. Guggenheim Museum and Foundation.

26. Elizabeth Presa is a Melbourne-based artist and head of the interdisciplinary Centre for Ideas at the Victorian College of the Arts, University of Melbourne. Together with Dimitris Vardoulakis, Presa organized the conference "Wandering with Spinoza" (September 13–15, 2006), at which Hirschhorn spoke about the *Spinoza Monument*.

33 AUSSTELLUNGEN IM ÖFFENTLICHEN RAUM 1998–1989

1. The format of the dates "1998–1989" reflects the reverse chronological order in which the projects are presented in *33 Ausstellungen im öffentlichen Raum*.

PROJECTS

1. Hôpital Ephémère, a former hospital converted into artist studios, recording studios, and performance and exhibition spaces, in which Hirschhorn rented a studio for a period of time. This text explains Hirschhorn's decisions regarding the installation of his exhibition at Hôpital Ephémère (March 1–April 19, 1992), which featured three works: *233 Travaux*, *Jeudi 17.1.1991–Jeudi 28.2.1991*, and *Périphérique*.

2. *Jeudi 17.1.1991–Jeudi 28.2.1991* encompasses all the works Hirschhorn produced during the First Gulf War. It takes the form of a stack. For a description of *Périphérique*, see "My Videos."

3. Hirschhorn refers to the action *Jemand kümmert sich um meine Arbeit*, 1992, in which he left a number of his works stacked alongside a buildling to be picked up by sanitation workers. See *33 Ausstellungen im öffentlichen Raum*, pp. 40–41.

4. Fabrice Hergott, art historian and curator. Hergott published an essay about *La Redoute* (1991), "Thomas Hirschhorn, une échelle de Jacob," *Omnibus*, no. 1, November 1991. He is now the director of the Musée d'Art Moderne de la Ville de Paris.

5. Matthias Arndt, gallerist (Arndt & Partner, now Arndt Berlin).

6. Hirschhorn was invited by the Institut Français to exhibit at Rekalde-Area 2, a space for contemporary art in Bilbao (May 13–June 8, 1996). Over the course of the month preceding the opening, Hirschhorn produced the work to be exhibited, *W.U.E, World-Understanding-Engine*, in a storefront he converted into a temporary studio.

7. Alison Gingeras was curator of contemporary art at the Centre Pompidou from 1999 to 2004.

8. "Mirror's Edge," curated by Okwui Enwezor, originated at the Bildmuseet, Umeå, Sweden, 1999. It then traveled to the Vancouver Art Gallery, Vancouver; Castello di Rivoli, Turin; Tramway, Glasgow; and Charlottenborg, Copenhagen.

9. Red plastic forms inspired by electrical resistances.

10. Despite the case made in this open letter, the Residents Association of the Cité Louis Gros ultimately rejected the plan for the *Deleuze Monument*, out of fear that it might promote delinquency and insecurity. The project was realized in the Cité Champfleury.

11. Mission 2000 en France was a state-funded program for millennial celebrations.

12. This letter addresses Hervé Laurent and Nathalie Wetzel, two individuals who were attacked by a youth gang while visiting the *Deleuze Monument*. As a consequence of their experience, Laurent and Wetzel asked the mayor to remove the *Deleuze Monument*, which they believed created dangerous conditions.

13. Bice Curiger, curator of the Kunsthaus Zürich.

14. Hirschhorn received the 1999 Preis für Junge Schweizer Kunst, juried by Zürcher Kunstgesellschaft.

15. The Parsenn, Pischa, and Jakobshorn mountains are renowned sites for winter sports.

Ernst Kirchner, still recovering from a mental breakdown prompted by the First World War, settled in Davos in 1917. The alpine landscape became a recurrent motif in his paintings. The Ernst Kirchner Museum Davos is devoted to his work.

Thomas Mann's monumental novel *The Magic Mountain* is set in a sanatorium in Davos. He drew some inspiration from his visits to his wife during her convalescence at the Waldsanatorium in Davos, in 1912.

Wilhelm Gustloff was a key Nazi figure in Switzerland, founding the Landesgruppe Schweiz der NSDAP in Davos in 1932. He was assassinated in 1936 in one of the "Blue Houses," an ensemble of buildings designed by architect Karl Overhoff.

16. Siegfried Kracauer (1889–1966), German writer, cultural critic, and film theorist. The passage quoted appears in Kracauer's essay "The Little Shopgirls Go to the Movies" (1927).

17. This letter was distributed in German, English, Turkish, and Arabic versions to all the residents of the Friedrich Wöhler Housing Complex. It included an invitation to attend a community meeting, during which Hirschhorn would describe the *Bataille Monument* and residents could ask questions and raise concerns.

18. Uwe Fleckner, art historian.

19. Christophe Fiat, writer, actor, and theater director.

20. Lothar Kannenberg, boxer, trainer, and social worker. In 1999, Kannenberg founded a boxing camp for troubled youths in the Philippinenhof district of Kassel. Hirschhorn credits the friendship and alliance forged with Kannenberg and the youth of the Philippinenhof Boxing Camp with the success of the Bataille Monument. See "Letter to Iris (Reflections on the *Bataille Monument*)."

21. Iris Mickein, art historian.

We present an excerpt of this text, the complete German-language original of which can be found in Thomas Hirschhorn, *Bataille Maschine* (Berlin: Merve Verlag, 2004).

22. "Protest and Survive" (September 15–November 12, 2000), at the Whitechapel Gallery, London, was curated by Matthew Higgs and Paul Noble. To this exhibition Hirschhorn contributed *The Bridge*, a makeshift overpass connecting the Whitechapel Gallery to the Freedom Press bookshop next door.

23. *Chalet Lost History* was originally created at Galerie Chantal Crousel, Paris, in 2003. This correspondence pertains to the inclusion of *Chalet Lost History* in the group exhibition "Universal Experience: Art, Life, and the Tourist's Eye" at the Hayward Gallery, London (October 6–December 11, 2005). The exhibition was curated by Francesco Bonami and had traveled from the Museum of Contemporary Art, Chicago (February 11–June 5, 2005). Among its many elements, *Chalet Lost History* includes pornographic images and videos, as well as sex toys. Hirschhorn is responding to the Hayward Gallery's plan to place an age restriction on visitors to the work. The Museum of Contemporary Art, Chicago, addressed the issue of sexually explicit content with a notice posted at the entrance of the exhibition.

24. Clare Carolin, curator of the Hayward Gallery from 1999 to 2006.

25. The original conceit for a doorway cut into the wall connecting the two spaces inhabited by *Hotel Democracy* and *U-Lounge* did not comply with the fire codes. Additional compromises were necessary regarding the incorporation of original artworks from the Tate collection into the *U-Lounge*.

26. *Swiss-Swiss Democracy* is one of the "Presence and Production" projects (along with *24h Foucault*) that were realized in the context of institutions—in this case the Centre Culturel Suisse in Paris—rather than in public space. See note 8 in "Interviews" regarding the controversy generated by this project.

27. Translator's note: *Tenir un siège* means "to hold a seat," as in a parliamentary seat, a function in a government. The phrase *tenir un siège* also means "to lay siege to," even "to occupy."

28. Gwenaël Morin, theater director.

29. See "I Will No Longer Exhibit in Switzerland."

30. Portions of this statement that overlap with "Me and the Military" have been excised. For the complete text, see *Thomas Hirschhorn: Utopia, Utopia = One World, One War, One Army, One Dress*, exh. brochure (Boston: Institute of Contemporary Art; San Francisco: CCA Wattis Institute for Contemporary Arts, 2005).

31. "Anschool" was an exhibition of Hirschhorn's work from 1992 to 2004 at the Bonnefanten Museum, Maastricht, The Netherlands (April 26–September 11, 2005). "Anschool" was intended to defy the conventions of the museum retrospective, from chronological display to historical distantiation. "Anschool II," a slightly different version of the exhibition, took place at the Museo de Serralves, Porto (Portugal) in 2005.

32. Sabine Windlin, freelance journalist.

33. Frédéric Bouglé, director of the Creux de l'Enfer, a contemporary art space in Thiers, France.

34. "Volksgarten: Politics of Belonging," Kunsthaus Graz, Austria (September 23, 2007–January 13, 2008).

35. The "Eternal Flame" of art, one element in *Power Tools*, took the form of handmade logs lit to suggest they were ablaze.

36. "Ce qui vient" was the title of the second installment of Les Ateliers de Rennes—Biennale d'Art Contemporain (April 30–July 18, 2010). Hirschhorn's *Théâtre Précaire* was simultaneously an exhibition "platform" and a theater "platform"—the two functions were integrated. It was set up in the underground parking lot of a shopping center in Gros-Chêne Maurepas, a suburb of Rennes.

37. The *Théâtre Précaire* was originally scheduled to be open from April 30 to July 7.

38. L'Atelier Culturel de Maurepas, Rennes, hosts art workshops, events, and exhibitions.

39. Before the opening, two display cases were broken and two mannequin wigs were stolen.

40. *Théâtre Précaire* was not originally conceived as a "Presence and Production" project. Hirschhorn had planned to travel to Rennes weekly to supervise the performance of the play.

INTERVIEWS

1. This interview has been excerpted. Discussion about the *Musée Précaire Albinet* has been excised due to overlap with the interview with François Piron, "Becoming One's Own Museum," also included in this volume. For the full interview, see Benjamin H. D. Buchloh, "An Interview with Thomas Hirschhorn," *October* 113 (Summer 2005): 77–100.

2. Hirschhorn's *Skulptur-Sortier-Station* was first installed in the international exhibition "Sculpture Projects," organized by Kasper Koenig in Münster, Germany in 1997. [original fn.]

3. Otto Freundlich (1878–1943), important early painter of abstraction, member of the Cologne Progressives Group and later the group Abstraction/Creation in Paris before he was deported by the Nazi Occupation forces in Vichy France, perished in the Majdanek concentration camp. [original fn.]

4. Robert Walser (1887–1956), the Swiss novelist and author of short stories, discovered by Walter Benjamin and considered as a naïve counterfigure to Franz Kafka, committed himself to an asylum in order to be able to write. [original fn.]

5. Ingeborg Bachmann (1926–1973), Austrian novelist and poet, major figure of postwar German literature, from the early 1960s on lived in Rome, where she died in a fire in her home. [original fn.]

6. Raymond Carver (1938–1988), American author who described the life of the lower middle class struggling to survive in the intensifying competition of postwar consumer culture. [original fn.]

7. This interview has been excerpted from the original. For the complete interview, see Jade Lindgaard and Jean-Max Colard, "Mission: 'Tenir le siège,'" *Les Inrockuptibles*, no. 472 (December 2004): 62–65. Translator's note: *Tenir un siège* means "to hold a seat," as in a parliamentary seat, a function in a government. The phrase *tenir un siège* also means "to lay siege to," even "to occupy."

8. *Swiss-Swiss Democracy* inspired controversy virtually from its outset. Inaccurate and inflammatory claims were circulated by the press, which reported that Morin's play included an actor urinating on a poster of Christoph Blocher, the leader of the populist Swiss People's Party and then minister for justice and police. In reality, an actor in the play briefly mimes this action. Fueled by the spurious reports, the Swiss Parliament voted to slash $1.1 million from Pro Helvetia's annual budget.

9. Regarding the proposed project, "Conduit," see "Letter to Laurence and Hans-Ulrich (On Remaining Alert)," note 15 in "Statements and Letters."

10. Yvane Chapuis, then director of the Laboratoires d'Aubervilliers, invited Hirschhorn to do a project with them. The *Musée Précaire Albinet* is documented in the publication *Thomas Hirschhorn: Musée Précaire Albinet* (Paris: Xavier Barral Editions, 2005).

11. *In Vanda's Room* (2000) [original title: *No Quarto da Vanda*] belongs to a trilogy of films by Portuguese director Pedro Costa. The films are all located in the impoverished Fontainhas neighborhood of Lisbon.

12. "Habiter poétiquement le monde," Lille Métropole Musée d'art moderne, d'art contemporain et d'art brut (September 25, 2010–January 30, 2011).

13. See "*Berliner Wasserfall mit Robert Walser Tränen.*"

14. Adolf Wölfli (1864–1930), Swiss outsider artist. Wölfli was a long-term psychiatric patient at the Waldau Clinic in Bern, Switzerland. His doctor, Walter Morgenthaler, published *Ein Geisteskranker als Künstler* [A mental patient as artist] (1921) based upon Wölfli's life and work.

15. August Walla (1936–2001), Austrian outsider artist.

16. Robert Walser developed a practice of writing poems and stories on salvaged scraps of paper using a miniaturized *Kurrent* script. These "microscripts" were initially gathered by Werner Morlang and Bernhard Echte in the six volume *Aus dem Bleistiftgebiet* [From the Pencil Zone] (Frankfurt am Main: Suhrkamp, 1985).

17. See "The Musée de l'art brut in Lausanne."

BIBLIOGRAPHY

(Only original publications are listed here. Sources may have been reproduced elsewhere.)

33 Ausstellungen im öffentlichen Raum 1998–1989. Zurich: Schweizerische Graphische Gesellschaft, 1998.

"*99 Sacs plastiques*." In *Thomas Hirschhorn: 3 Auflage Katalog*, 9–11.

"About My Exhibition at the Hôpital Ephémère (Why I Chose This Exhibition as My 'First Exhibition')." In *No. 1: First Works by 362 Artists*, edited by Francesca Richer and Matthew Rosenzweig, 176–177. New York: D.A.P., 2005.

"Altars." In *Public Art*, 395–96.

"Am I Casting Pearls Before Swine? And Why?" In *Thomas Hirschhorn: 3 Auflage Katalog*, 21.

"Artist Lectures." Published as "Artist-Lecture." *J'aime beaucoup ce que vous faites*, no. 3 (Winter 2007): 132.

Bataille Maschine. Berlin: Merve Verlag, 2003. Exhibition documentation for the *Bataille Monument*, Documenta 11.

"Becoming One's Own Museum: Conversation between Thomas Hirschhorn and François Piron." In *The Subjecters*, 57–64. Madrid: La Casa Encendida, Caja Madrid, 2009. Exhibition catalog.

"Benjamin H. D. Buchloh: An Interview with Thomas Hirschhorn." *October* 113 (Summer 2005): 77–100.

"*Berliner Wasserfall mit Robert Walser Tränen.*" In *Thomas Hirschhorn: 3 Auflage Katalog*, 1–2.

"The Bilbao Failure." In *Thomas Hirschhorn: 3 Auflage Katalog*, 8.

"*Concept Car.*" In *Volksgarten: Politics of Belonging*, 40–43. Cologne: Walter Konig, 2007. Catalog for an exhibition at the Kunsthaus Graz.

"Conversation: Presupposition of the Equality of Intelligences and Love of the Infinitude of Thought: An Electronic Conversation between Thomas Hirschhorn and Jacques Rancière." In *What Comes: Les ateliers de Rennes, biennale d'art contemporain*, 128–135. Dijon: Les presses du réel, 2010. Exhibition catalog.

"*Crystal of Resistance.*" Venice: printed by author, 2011. Flyer published in conjunction with the exhibition of the same name for the Swiss Pavilion of the 54th Venice Biennale, 2011.

Deleuze Monument: Les Documents. Avignon: printed by author, 2000. Published in conjunction with the *Deleuze Monument*, "La beauté," Mission 2000 in Avignon.

"Direct Sculptures." In *Public Art*, 397–398.

"Doing Art Politically: What Does This Mean?" In "Politics of Art." *Inaesthetik*, no. 1 (June 2009): 71–81.

"*Doppelgarage* Project." In *Doppelgarage*, edited by Max Hollein, 2–3. Frankfurt: Schirn-Kunsthalle, 2003. Exhibition brochure.

"*Fifty-Fifty.*" In *Thomas Hirschhorn: 3 Auflage Katalog*, 28.

"For the First Time (About Andy Warhol)." In *In My View—Personal Reflections on Art by Today's Leading Artists,* edited by Simon Grant, 102–103. New York: Thames & Hudson, 2012.

"Force Majeure." In *The Subjecters*, 18–19. Madrid: La Casa Encendida, Caja Madrid, 2009. Exhibition catalog.

"I Will Exhibit in My Homeland Again." In "The Annual." Special issue, *ArtReview* (2007–2008): n. p.

"I Will No Longer Exhibit in Switzerland." In *Centre Culturel Suisse: 2003–2005*, 141. Paris: Centre Culturel Suisse, 2006.

"*Jumbo Spoons.*" In *Thomas Hirschhorn: Jumbo Spoons and Big Cake*, 15. Montreal: Museum of Contemporary Art of Montreal, 2007. Exhibition catalog.

"Kiosks." In *Public Art*, 396.

"*Lay-Out*." In *Thomas Hirschhorn: 3 Auflage Katalog*, 26.

"*Les plaintifs, les bêtes, les politiques*." In Centre Genevois de Gravure Contemporaine, Geneva, Switzerland, 1995.

"*Les plaintifs, les bêtes, les politiques*." In *Thomas Hirschhorn: 3 Auflage Katalog*, 20.

"*Less Is Less, More Is More*." In *Katalog*, 12–13. Berlin: Künstlerhaus Bethanien, 1995. Exhibition brochure.

"Letter to Clare (Regarding *Chalet Lost History*)." In "The Annual." Special issue, *ArtReview* (2007–2008): n. p.

"Letter to Coraly (On Joseph Beuys and *Capital*)." In *Thomas Hirschhorn: 3 Auflage Katalog*, 31–32.

"Letter to Frédéric (Regarding 'Concretion')." In "The Annual." Special issue, *ArtReview* (2007–2008): n. p.

"Letter to Hervé Laurent and Nathalie Wetzel (Regarding the *Deleuze Monument*)." In *Deleuze Monument: Les Documents*, n. p.

"Letter to Iris (Reflections on the *Bataille Monument*)." In *Bataille Maschine*, 5ff.

"Letter to Konstantin (On 'Political Correctness')." In *Thomas Hirschhorn: 3 Auflage Katalog*, 5–6.

"Letter to Laurence and Hans-Ulrich (On Remaining Alert)." In *Thomas Hirschhorn*, 136. London and New York: Phaidon, 2004.

"Letter to Lothar Kannenberg (Regarding the *Bataille Monument*)." In *Bataille Maschine*, 33–35.

"Letter to Matthias (Regarding 'Virus-Ausstellung')." In *Thomas Hirschhorn: 3 Auflage Katalog*, 11.

"Letter to Sabine (Regarding *Superficial Engagement*)." *Das Magazin*, no. 17 (May 2006): 37–40.

"Letter to the Residents of the Friedrich Wöhler Housing Complex (Regarding the *Bataille Monument*)." In *Bataille Maschine*, 42–43.

"Letter to Thierry (On Formalism)." In *Thomas Hirschhorn: 3 Auflage Katalog*, 16.

"Letter to Véronique (On Writing, Judging, Reading, Publishing)." In *Thomas Hirschhorn*, 138–140. London and New York: Phaidon, 2004.

"The Matter of Location (Regarding the *Deleuze Monument*)." In *Deleuze Monument: Les Documents*, n. p.

"*Moins.*" In *Thomas Hirschhorn: 3 Auflage Katalog*, 28.

"Monuments." In *Public Art*, 398–399.

"My Videos." In *Thomas Hirschhorn: 3 Auflage Katalog*, 24.

"The New Videos." In *Thomas Hirschhorn: 3 Auflage Katalog*, 25.

"*The Procession.*" In *The Procession*, 7–8. Hannover: Kestnergesellschaft, 2006. Exhibition brochure.

Public Art: Kunst im öffentlichen Raum, edited by Florian Matzner. Ostfildern: Hatje Cantz, 2001.

"Regarding My Exhibition at Rueil-Malmaison." In *Thomas Hirschhorn: 3 Auflage Katalog*, 33.

"Regarding My Exhibition of *Wall-Display, Rosa Tombola, Saisie, Lay-Out* (1988–1994) at the Galerie Nationale du Jeu de Paume." In *Thomas Hirschhorn: Texts, Projects, Letters*, n. p. Maastricht: Bonnefantenmuseum, 2005. Published on the occasion of the exhibition "Anschool" at the Bonnefantenmuseum.

"Regarding the End of the *Deleuze Monument*." In *Deleuze Monument: Les Documents*, n. p.

"Regarding *Théâtre Précaire* and *Théâtre Précaire 2*." Thomas Hirschhorn flyer made during Les Ateliers de Rennes—Biennale d'Art Contemporain, Rennes, France, 2010, and published in *Thomas Hirschhorn: Establishing a Critical Corpus*, at the occasion of the 54th Venice Biennale, 248–249. Zürich: JRP Ringier, 2011.

"*Skulptur-Sortier-Station.*" In *Skulptur: Projekte in Münster 1997*, edited by Klaus Bussmann, Kasper König, and Florian Matzner, 211–217. Ostfildern-Ruit: Verlag Gerd Hatje, 1997.

"*Spinoza Monument.*" 7–8. Paris: Point d'Ironie, 2001. Published in a series associated with Documenta 11.

Thomas Hirschhorn: Musée Précaire Albinet. Paris: Xavier Barral Editions, 2005.

Thomas Hirschhorn: 3 Auflage Katalog, Luzern. Lucern: Kunstmuseum Luzern, 1996. Published on the occasion of the exhibition "Thomas Hirschhorn, Günther Förg" at the Kunstmuseum Luzern.

"*Untere Kontrolle*." In *Thomas Hirschhorn: Kurt Schwitters-Plattform, Untere Kontrolle*, front and back covers. Köln: Verlag der Buchhandlung Walther König, 2011. Exhibition catalog.

"*Ur-Collage*." In *Ur-Collage*, 2–3. Zürich: Galerie Susanna Kulli, 2008. Exhibition brochure.

"*Utopia, Utopia = One World, One War, One Army, One Dress*." In *Thomas Hirschhorn: Utopia, Utopia = One World, One War, One Army, One Dress*, 13–15. Boston: Institute of Contemporary Art; San Francisco: CCA Wattis Institute for Contemporary Arts, 2005. Exhibition brochure.

"What I Want." In *Thomas Hirschhorn: 3 Auflage Katalog*, 23.

"Works on Paper." *Murmure*, no. 8 (2006): 50–51.

"*World Airport*." *La Biennale di Venezia, 48a Esposizione Internazionale d'Arte, dAPERTutto*, edited by Marsilio Editori, 128–130. Venice: Biennale di Venezia, Marsilio, 1999.

"Why Is It Important—Today—to Show and Look at Images of Destroyed Human Bodies?" *Le Journal de la Triennale*, February 27, 2012. http://www.latriennale.org/en/lejournal/4-heads-and-hear/why-it-important-today-show-and-look-images-destroyed-human-bodies.

Index

OCTOBER Books

George Baker, Yve-Alain Bois, Benjamin H. D. Buchloh, Leah Dickerman, Devin Fore, Hal Foster, Denis Hollier, Rosalind Krauss, Annette Michelson, Mignon Nixon, and Malcolm Turvey, editors

Broodthaers, edited by Benjamin H. D. Buchloh

AIDS: Cultural Analysis/Cultural Activism, edited by Douglas Crimp

Aberrations: An Essay on the Legend of Forms, by Jurgis Baltrušaitis

Against Architecture: The Writings of Georges Bataille, by Denis Hollier

Painting as Model, by Yve-Alain Bois

The Destruction of Tilted Arc: Documents, edited by Clara Weyergraf-Serra and Martha Buskirk

The Woman in Question, edited by Parveen Adams and Elizabeth Cowie

Techniques of the Observer: On Vision and Modernity in the Nineteenth Century, by Jonathan Crary

The Subjectivity Effect in Western Literary Tradition: Essays toward the Release of Shakespeare's Will, by Joel Fineman

Looking Awry: An Introduction to Jacques Lacan through Popular Culture, by Slavoj Žižek

Cinema, Censorship, and the State: The Writings of Nagisa Oshima, by Nagisa Oshima

The Optical Unconscious, by Rosalind E. Krauss

Gesture and Speech, by André Leroi-Gourhan

Compulsive Beauty, by Hal Foster

Continuous Project Altered Daily: The Writings of Robert Morris, by Robert Morris

Read My Desire: Lacan against the Historicists, by Joan Copjec

Fast Cars, Clean Bodies: Decolonization and the Reordering of French Culture, by Kristin Ross

Kant after Duchamp, by Thierry de Duve

The Duchamp Effect, edited by Martha Buskirk and Mignon Nixon

The Return of the Real: The Avant-Garde at the End of the Century, by Hal Foster

October: The Second Decade, 1986–1996, edited by Rosalind Krauss, Annette Michelson, Yve-Alain Bois, Benjamin H. D. Buchloh, Hal Foster, Denis Hollier, and Silvia Kolbowski

Infinite Regress: Marcel Duchamp 1910–1941, by David Joselit

Caravaggio's Secrets, by Leo Bersani and Ulysse Dutoit

Scenes in a Library: Reading the Photograph in the Book, 1843–1875, by Carol Armstrong